CALDER
and
ABSTRACTION

from
AVANT-GARDE
to
ICONIC

CALDER

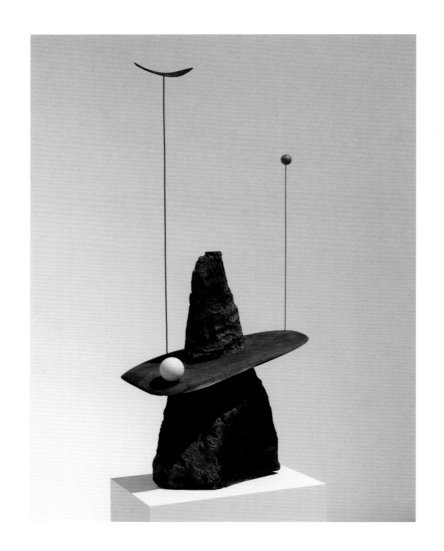

and
ABSTRACTION
from AVANT-GARDE
to ICONIC

Edited by
Stephanie Barron and Lisa Gabrielle Mark

With essays by
Stephanie Barron
Ilene Susan Fort
Aleca Le Blanc
Jed Perl
Harriet F. Senie

Exhibition organized by
Stephanie Barron

Los Angeles County Museum of Art

DelMonico Books • Prestel Munich, London, New York

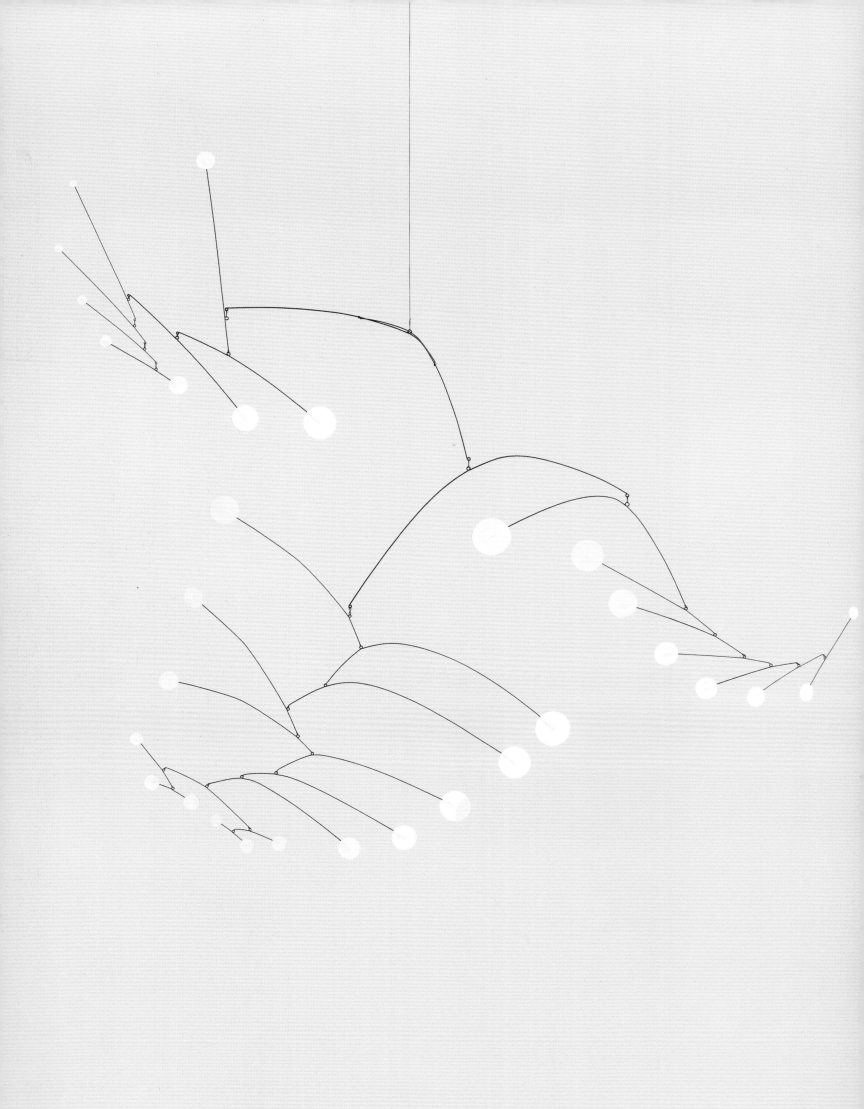

Contents

Foreword

ALTHOUGH ALEXANDER CALDER'S WORK has been shown extensively worldwide, surprisingly no monographic museum exhibition has been mounted in Los Angeles until now. This show takes as its compass *Three Quintains (Hello Girls)*, the result of the Los Angeles County Museum of Art (LACMA) commissioning Calder in 1964 to design a work to inaugurate the newly independent art museum's campus in Hancock Park in 1965. This invitation was made possible by the concerted efforts of a volunteer group later known as the Art Museum Council. At that time, the practice of commissioning abstract site-specific public sculpture was hardly as conventional as it has become. LACMA's Calder commission consequently stands at the forefront of American museums' engagement of contemporary artists to create in-situ works outdoors. (Calder would, only four years later, oversee the inauguration of the public sculpture *La Grande vitesse* in Grand Rapids, Michigan, the first public artwork made possible through the National Endowment for the Arts.) Calder's artwork for LACMA has for decades been seen as an emblem of the museum, and today its campus continues to be enhanced by public art—most recently with the inclusion of Chris Burden's *Urban Light* (2008) and Michael Heizer's *Levitated Mass* (2012).

This exhibition would have been impossible without the encouragement and assistance of the Calder Foundation. We are most thankful to Alexander S. C. Rower, Calder's grandson and president of the Foundation, for his commitment and interest in making this exhibition possible, particularly in light of the number of Calder projects occurring in 2013. At the Foundation, Lily Lyons, director of external affairs, has been a stalwart collaborator, and we are most grateful to Sandy and Lily for their efforts on our behalf. I am most appreciative of the leadership that Stephanie Barron, LACMA's longtime senior curator of Modern Art, has brought to this exhibition and this publication. She has conceived a presentation that takes advantage of the new Resnick Pavilion, built for special exhibitions, in collaboration with Frank O. Gehry, who enthusiastically agreed to work with us on the design of the exhibition. Calder would have appreciated the passion, sensitivity, respect, and inventiveness Gehry has brought to its design.

We thank the lenders to the exhibition, who are listed on page 205. In particular, the Calder Foundation has been exceptionally generous in agreeing to lend a number of key works, and collectors Jon and the late Mary Shirley of Seattle, long and enthusiastic supporters of Calder, graciously loaned several works from their collection. We are heartened that individual lenders and public institutions across the United States share our desire to present Calder's work in Los Angeles in this context.

Exhibition sponsor Wells Fargo Bank provided lead support of this exhibition, and the Art Museum Council—so key to the original commission in the 1960s—contributed generously to the exhibition's funding as well. Thanks are also due to Phillips for its support of the exhibition, and to Lloyd and Margit Cotsen for their assistance with this publication.

We are delighted that, following the Los Angeles installation, *Calder and Abstraction: From Avant-Garde to Iconic* will be presented at the Peabody Essex Museum (PEM) in Salem, Massachusetts. It has been a pleasure to work with our PEM partners, Director Dan Monroe and Chief Curator Lynda Hartigan.

Calder remains one of the most popular American artists worldwide. His public sculptures grace urban plazas from Spoleto to Seattle and hang in the most renowned museums. This exhibition brings together a range of abstract sculptures, mobiles, stabiles, and maquettes from 1931 to 1975 in order to offer a window into the remarkably original thinking of this distinguished artist and to elucidate Calder's revolutionary and pivotal contribution to the development of modern sculpture. We are pleased and honored to be the first museum in Los Angeles to present the work of this monumentally important artist.

Michael Govan
CEO and Wallis Annenberg Director
Los Angeles County Museum of Art

Alexander Calder, *Los Angeles County Museum of Art, April 1, 1965*, 1965; poster; 31¾ × 24⅜ inches; Los Angeles County Museum Art

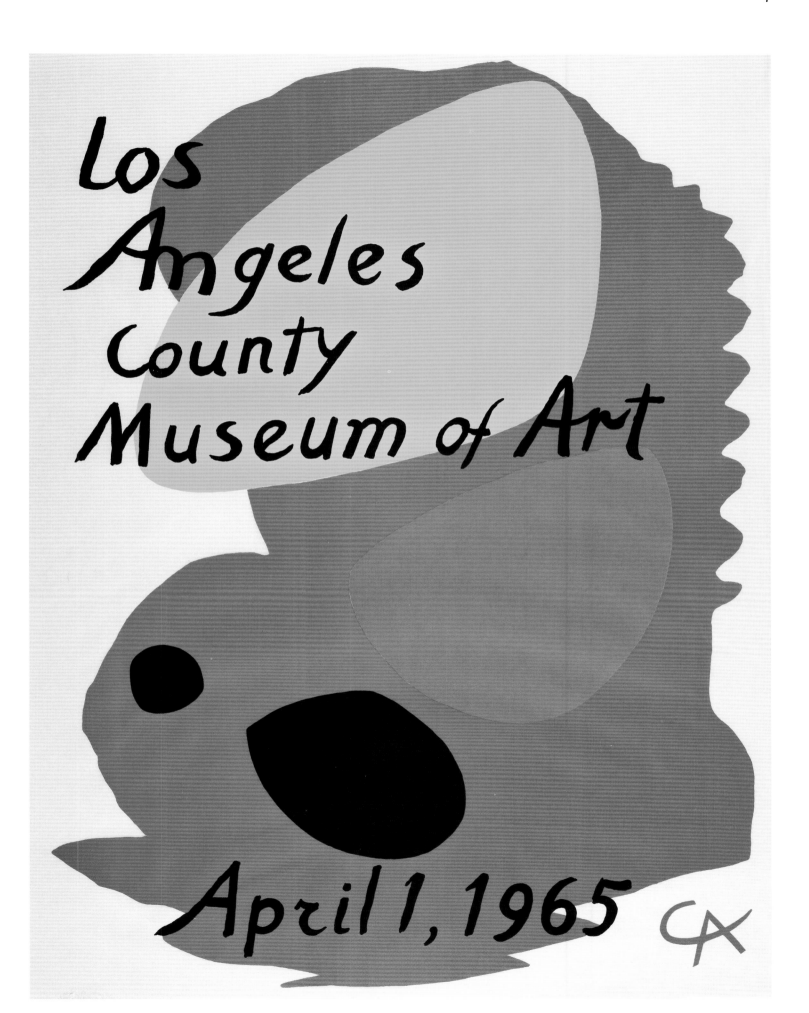

Los
Angeles
County
Museum of Art

April 1, 1965

Acknowledgments

WHEN I ARRIVED at the Los Angeles County Museum of Art (LACMA) in the mid-1970s, its heraldic Calder sculpture *Three Quintains* (*Hello Girls*)—then known affectionately as *Hello Girls*—had already been removed from its original location in pools surrounding the 1965 William Pereira–designed campus. I was fascinated by the large files of correspondence about the commission and tried to understand the climate that precipitated such an invitation. During the 1980s, the sculpture endured the unfortunate fate of being "beached" on a hillside in the museum's sculpture garden, and LACMA was criticized by scholars for not doing justice to the artist's original intention of locating the sculpture amid jets of water. The sculpture was subsequently lent to the Art Center College of Design in Pasadena for display while LACMA underwent construction. Anticipating its return in 1991, the museum embarked on conservation of the work, then relocated it to the Dorothy Collins Brown Fountain in the Director's Roundtable Garden so that aquatic jets could activate the paddles. *Three Quintains* (*Hello Girls*) was once again positioned in water. Decades later, I am delighted to have the opportunity to conceive and present an exhibition of Calder's abstract sculptures at LACMA, which is, surprisingly, his first museum show in Los Angeles.

It has been a pleasure to work closely with the Calder Foundation under the careful leadership of President Alexander S. C. Rower, whose passion for and knowledge of his grandfather's art is unparalleled. At the Foundation, Director of External Affairs Lily Lyons has been constantly available to us at every stage of organization and installation, and Director of Research and Publications Susan Braeuer Dam has offered invaluable assistance in preparation of the catalogue; we are extremely grateful for her collaboration. I would also like to thank Director of Archives Alexis Marotta for her research assistance in the developmental stages of the catalogue. Registrar Kevin Barry and Matt Castle of Castle Art Services provided their intimate knowledge of the mechanics of the sculptures, making the installation of

them a curator's dream. Our visits to the Calder Foundation in New York, where we were able to see a great many sculptures under ideal circumstances, was among the most rewarding and illuminating aspects of preparing this exhibition.

I am grateful to the lenders to the exhibition, who are listed on page 205, for agreeing to part with their works for our presentation. The Calder Foundation, without whose cooperation this exhibition would have been impossible, was exceptionally generous with loans. Lead funding from exhibition sponsor Wells Fargo Bank helped ensure that this exhibition would be realized. I am particularly grateful to LACMA's Art Museum Council for its support of the show; it was this group of volunteers who almost fifty years ago spearheaded the commission to Calder in conjunction with the opening of the museum. I also wish to thank Phillips for its support of the exhibition and extend my appreciation to Lloyd and Margit Cotsen for their funding of the catalogue.

From the beginning I was interested in exploring how best to install the exhibition, having seen several Calder shows over the past fifty years and been greatly impressed by how the works looked in 1964 at the Guggenheim Museum in New York. The challenge of displaying them to maximum effect—being sensitive to lighting strategies and to the need to protect the objects in a public space—required a fresh approach. I was thrilled when Frank O. Gehry, with whom I had most recently worked on *Ken Price Sculpture: A Retrospective*, enthusiastically agreed to design the show. At the Gehry studio, Partner Anand Devarajan played an important role in the evolution of the design—the architects' visits to the Calder Foundation to see an array of early sculptures proved especially inspirational.

At LACMA I thank Michael Govan, CEO and Wallis Annenberg Director, who was instrumental in making the show happen, embracing the idea of presenting Calder's work in the Resnick Exhibition Pavilion. Early on Aleca Le Blanc joined our curatorial team and helped conceptualize the exhibition and catalogue;

we thank her for her efforts as well as for contributing both an essay and a list of selected readings to the catalogue. Lauren Bergman, assistant curator in Modern Art, participated in the design phase of the exhibition and was extremely helpful with the preparation of the catalogue, contributing an illuminating chronology of Calder installations from 1926 until the present. Jed Perl, who is hard at work on the extensive Calder biography, graciously agreed to contribute an essay that would elucidate the artist's relationship to science and engineering, and Harriet F. Senie penned an intriguing text on Calder's role in relation to the burgeoning of public sculpture in America. I thank LACMA colleague Ilene Susan Fort, senior curator and the Gail and John Liebes Curator of American Art, for her fascinating contribution outlining the museum's acquisition of *Three Quintains* (*Hello Girls*), for which several members of the Art Museum Council involved in the original 1964 commission graciously shared their memories. We thank Terry Bell, Lenore Greenberg, Sue Labiner, and Laura-Lee W. Woods for their recollections. This catalogue is the result of a wonderful collaboration with LACMA's Head of Publications Lisa Gabrielle Mark, co-editor of this volume, who expertly worked with all the authors and helped guide this volume to fruition. Stuart Smith, LACMA's art director, contributed an elegant and thoughtful design working under the supervision of Lorraine Wild, creative director.

After its presentation at LACMA, the exhibition travels to the Peabody Essex Museum in Salem, Massachusetts, where Director Dan Monroe and Chief Curator Lynda Hartigan shared our vision to present Calder's abstraction to a wide public; this will be the first Calder museum show in the Boston area since the 1950s. I thank Zoë Kahr, our deputy director for Exhibitions and Planning, for her guidance in making the tour possible. In LACMA's Department of Modern Art, I extend my appreciation to Tiffany Daneshgar, curatorial administrator, who has with good cheer efficiently and deftly handled the correspondence related to the loans, worked seamlessly with the Foundation, and helped in myriad ways. Thanks also to LACMA colleagues Carol S. Eliel, curator of Modern Art, and conservator John Hirx for his many helpful suggestions.

I want to acknowledge the help of Melissa Bomes and Kate Virdone in the Development department; Erika Franek in the Registrar's office; Renee Montgomery, head of Risk Management; Fred Goldstein, general counsel; Michael Pourmohsen and Daniel Young in the Graphics department; Jennifer MacNair Stitt in Publications; Dawson Weber in Rights and Reproductions; Miranda Carroll in Communications; and Amy Heibel in Technology and Digital Media, for creatively responding to the challenge of presenting Calder's sculptures at LACMA.

I relied upon the advice and support of several colleagues during the organization of this exhibition, to whom I am deeply grateful: George Baker, Aaron Curry, Susan Davidson, Thierry de Duve, Gary Garrels, Carmen Giménez, Marc Glimcher, Joanne Heyeler, Thomas Houseago, Meaghan Lloyd, Jed Morse, Jed Perl, Marla Prather, Cora Rosavear, Mark Rosenthal, Edward Saywell, Ann Temkin, and Kulapat Yantrasat. Joan M. Marter's illuminating monograph *Alexander Calder* is a comprehensive text for anyone embarking on an exhibition of his work.

I thank my son, Max Rifkind-Barron, for many thoughtful suggestions related to this catalogue, and friends Judi Freeman, Susan T. Goodman, and Margo H. Leavin, whose support and hospitality during the planning and implementation of this project were most gratefully received. The enthusiastic response of the artists with whom I shared my plans for this project inspired in me the hope that Calder's work could intrigue a new generation.

Stephanie Barron
Senior Curator of Modern Art
Los Angeles County Museum of Art

Stephanie Barron

Time, Space, and Moving Forms:

Alexander Calder— Beyond the Beautiful

THE WORK OF ALEXANDER CALDER seems to resonate especially with both philosophers and scientists. In 1943 Albert Einstein visited the Calder exhibition at the Museum of Modern Art, New York, where he intently studied the 1934 motorized sculpture *A Universe* (fig. 1). He reportedly shooed away patrons who approached and remained transfixed by the piece for forty minutes. "I wish I had thought of that," he later commented. When Calder heard about the incident, he surmised that Einstein was waiting to see all ninety cycles of movement that he had devised (fig. 2).[1] Einstein's instincts were sound. Articles about exhibitions of Calder's work since the 1940s have consistently advised viewers to slow down and engage the works individually, allowing the shadows to add to the mystery of the object.

Calder figures among the most innovative sculptors of the twentieth century and his works among the most iconic; yet his oeuvre, steeped in beauty and humor, remains critically elusive. His unique forms are well known, thanks in part to significant exhibitions organized in New York by the Museum of Modern Art (MoMA) (1943–44, 1967, 1969–70, and 2007–08), the Guggenheim Museums in New York and Bilbao (1964–65, 1973, and 2003–04), and the Whitney Museum of American Art (1971, 1972, 1976–80, 1981, 1987–88, 1991–96, 2006, and 2008–10), as well as his presence at the Venice Biennale (1948, 1952).[2]

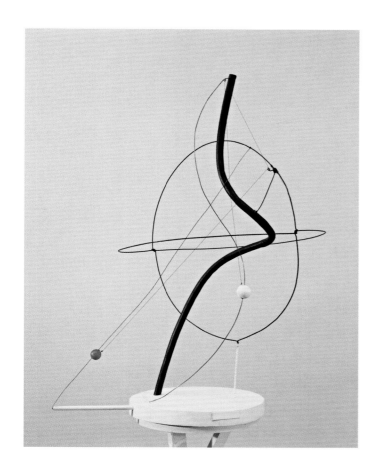

Fig. 1 | Alexander Calder, *A Universe*, 1934; painted iron pipe, steel wire, motor, and wood with string; 40 ½ × 30 inches; The Museum of Modern Art, New York, Gift of Abby Aldrich Rockefeller (by exchange)

Fig. 2 | Mechanism for *A Universe*; photographed by Joan M. Marter and approved by The Museum of Modern Art, New York

His two most significant forms, the *mobile* (a sculpture often made of wire and sheet metal with parts that can be set in motion by air currents) and *stabile* (similar in construction but stationary) [emphasis mine], are now firmly embedded in the lexicon of art history. Most scholars have examined Calder from a biographical perspective, though, rather than through the lens of theory, politics, or revisionism. Writers frequently extol the delicate beauty of his sculptures—particularly the early mobiles and stabiles, and the grace with which their elements are balanced and set in motion by air currents or the touch of a viewer—but his contribution to the development of abstract modern sculpture; his pioneering mastery of a new genre; the poetic, weightless, suspended metal sculptural "ballets"; and his early kinetic sculptures were all underestimated by critics such as Clement Greenberg. Beginning in the 1940s, Greenberg dismissed Calder's achievements in favor of David Smith's, seeing Calder as a failed Constructivist, a wayward abstractionist whose works were "chic, racy, tasteful abstraction" when compared with the Abstract Expressionist canvases of Jackson Pollock, Arshile Gorky, and Willem de Kooning.[3] Calder's work became exemplary of 1960s and 70s public sculpture, garnering him the widespread popularity that may also have clouded the critical assessment of his fundamental contribution to modern sculpture.[4] Painter Carroll Dunham has observed that the ubiquity of Calder's impressive, large-scale

public works has tended to overshadow his "place in our awareness" and suggested that "when given the keys to the city, his capacity for editing may have deserted him ... there can seem to be a generic modernity to Calder's work, almost a *New Yorker*–cartoon version of biomorphic abstract art (a quality Jean Arp certainly shares), but this is the flip side of something deeply essential in modernism: the somewhat cloaked use of nature as a conceptual and philosophical platform."[5]

Beauty was once considered art's highest achievement, but during the twentieth century the relationship between the two became strained. Beauty is often said to be hard to define, the subjective intersection of pleasure and taste. In his *Critique of Judgment* (1790), philosopher Immanuel Kant suggested that aesthetic responses might be categorized as either "beautiful" or "sublime"—the former defined by aesthetic pleasure found in order, harmony, and delicacy, the latter characterized by awe in response to something overwhelming or infinite. For Kant, "*Taste* is the faculty of judging an object or mode of representation by means of a delight or aversion *apart from any interest*. The object of such a delight is called *beautiful*."[6] In the modern era, beauty became not only subjective but contested, taken up by writers such as Theodor Adorno, Dave Hickey, and Arthur Danto. Beauty, Hickey has argued, is a "pleasant surprise" that comes out of nowhere, without the need for validation by experts, and thus can be a potent instrument for change in a democratic society.[7]

As early as 1932 critics celebrated the beauty in Calder's sculptures, which Sebastián Gasch described as "creations, as opposed to copies, imitations, transcriptions, or interpretations of nature. What he meant by creation is the invention of objects that will have a beauty as unprecedented and unique as a natural creation; they will look like no other existing thing. Calder's works are beautiful in themselves and not merely in comparison to something; their beauty is autonomous."[8] French painter and fellow member of the Abstraction-Création group Amédée Ozenfant, while not specifically calling Calder's works beautiful, poetically observed, "[I]n the balanced ensembles he creates, a breath of air can set off a symphony of momentary permutations ... it is like a piece of music in which different melodics occur in different registers and at different speeds, and, after coming close enough to salute each other, retire with the grace that their well-oiled gears allow, with no cacophony whatsoever. There is something astronomical, heavenly, and therefore very natural in these pleasant Calderian mechanics."[9] Art historians Wayne Andersen and Albert Elsen, while acknowledging Calder's popular appeal, have lamented that he was not taken seriously by critics and young artists.[10] This could be because, as Andersen argued, Calder made his work seem effortless: "I do not think that Calder's art has ever been taken as seriously as it should be ... He tends to be uncritical of his work; by personal behavior he supports an image of himself as an easygoing, overgrown child, something of a circus clown himself, with a fascination for clever stunts and, more recently, for great big sculptures to be held in awe."[11]

Despite this perceived simplicity or naiveté, Calder's sculptural innovations have held broad and significant implications for contemporary practice.

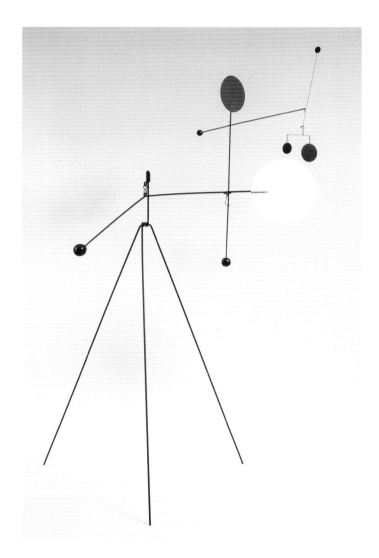

Fig. 3 | Alexander Calder, *Untitled,* 1934;
113 × 68 × 53 inches

A reevaluation of Calder's impact on contemporary artists was undertaken recently by the Museum of Contemporary Art, Chicago, in an attempt to reveal the aspects of Calder's work that influenced a diverse and impressive group of European and American artists.[12] For example, Los Angeles–based sculptor Aaron Curry finds inspiration in Calder's precise play with often-implied movement. His *Black Cat* (2009) toys with the tension between sublime heaviness and graceful fragility; its elegantly demure legs almost impossibly support the solid steel mass that explodes from the work's center, threatening the sculpture's disastrous collapse at any moment.

To some degree, the paucity of critical writing about Calder may be by design. For most of his career, he eschewed critical interpretation: "When an artist explains what he is doing," Calder wrote, "he usually has to do one of two things: either scrap what he has explained, or make his subsequent work fit in with the explanation. Theories may be all very well for the artist himself, but they shouldn't be broadcast to other people."[13]

Calder's 1966 autobiography, which has been the basis for most writing on him for the last fifty years, is written as a conversation with his son-in-law, less as a chronicle than an informal reminiscence toward the end of a remarkable life.[14] In it and later interviews the artist frequently distances himself from both the critical and popular reception of his work, while at the same time acknowledging the affection that viewers may have had for it: "I am not trying to make people happier by my work," he argued. "But it happens that all those who have something of mine, painting, mobile, or static statue, say that it makes them very happy. For example, children adore mobile statues and understand their meaning immediately."[15]

Calder is one of the most popular artists of the twentieth century, but his work also shares sensibilities with less immediately accessible artists, including both the Surrealists and the champions of pure abstraction that made up the Abstraction-Création group. Like Henry Moore, whose early art reveals the hand of a similarly original thinker, Calder would become most known for his late, large-scale public commissions. Calder's radical inventions moved easily between seeming opposites: the avant-garde and the iconic, the geometric and the organic, art and science—an anarchic upending of the sculptural paradigm. Calder's mature abstract work challenges the tradition of monumental, figurative sculpture. His delicate, linear elements and open shapes replace solid volumes; his flat planes take the place of three-dimensional forms (fig. 3).

Given Calder's inventiveness and far-reaching influence, it is surprising that there has never been a solo museum exhibition in Los Angeles, especially since his work has been shown extensively worldwide. This show takes as its compass the Los Angeles County Museum of Art's (LACMA's) 1964 commission to Calder to design a suitable work for the opening of the museum's new campus in Hancock Park in 1965. *Three Quintains* (*Hello Girls*), an ambitious fountain whose paddles are moved not by air but by jets of water, is characteristic of the grace and lyricism found in his mobiles. Though large in scale, the moveable paddles balance and rotate with the same element of chance that is the hallmark of his more delicate, intimate sculptures. *Calder and Abstraction: From Avant-Garde to Iconic* includes a group of Calder's abstract sculptures, beginning with the early mobiles and stabiles, as well as several later maquettes for larger outdoor works. Collaborating closely with the Calder Foundation, we have been able to assemble fifty small and large-scale works dating from 1931 to 1975.

The accompanying catalogue provides a critical foundation with which to understand Calder's work of this period, bridging as it does his Surrealist origins and his internationally renowned public sculpture. In one way or another, the texts address issues of transformation and relationship—to family, to other artists, and to the various contexts in which the work is seen. Jed Perl's essay looks at how Calder's work represents a synthesis of science and poetry by examining the issue of numbers, systems, and relationships. Harriet F. Senie's contribution explores how Calder's popular public commissions often served as civic sculptures that stood for local or national identity. Ilene Susan Fort's essay provides

the story behind the commission LACMA offered Calder in 1964, while Aleca Le Blanc's text considers his exhibition history and impact in Brazil as a case study of how Calder came to achieve such international stature and appeal.

Born in Lawnton, Pennsylvania, in 1898, Calder was the son and grandson of traditional sculptors who excelled at canonical carved and cast images. He grew up with the Ashcan artists as family friends and earned a degree in mechanical engineering at Stevens Institute of Technology in New Jersey.

Calder had the good fortune to become an artist in the right place and at the right time. During the 1920s and 30s, he traveled frequently between the United States and France, renting studios in Paris from 1926 to 1933. Calder was considered a full-fledged member of the European art world, becoming friendly with Marcel Duchamp, Joan Miró, and Piet Mondrian, and exhibited alongside Arp, Jean Hélion, Wassily Kandinsky, Fernand Léger, and many of the Surrealists (fig. 4). He and Man Ray were the most important Americans artists to be fully integrated into the avant-garde scene. During the 1920s, the French capital was the epicenter of creative production and Surrealism was the most important artistic activity in France. Artists, writers, poets, musicians, dancers, and choreographers from France, Belgium, Russia, Germany, Spain, Italy, Holland, Eastern Europe, the United States, and South America made up an avant-garde that was at times convivial, at times contentious. Soon after arriving in 1926, Calder created his miniature *Cirque Calder* (1926–31) from wire and found materials, drawing upon the late nineteenth-century fascination with these plebian spectacles. His facility for bending and twisting medium-gauge wire into engaging portraits and animal figures drew widespread acclaim. Years later, sculptor Isamu Noguchi reflected on the significance of the work, calling it "a natural outburst into the particular situation of life we call the circus. And each of these characters took on a very definite personality as they emerged."[16] He often "performed" the extensive work in his studio with music and running commentary, attracting the attention of the international art world, many of whom were also drawn to the circus and its performers (fig. 5).[17] At one such performance, Calder invited a number of luminaries at the suggestion of Viennese architect Frederic Kiesler, an enthusiastic fan of the work: Le Corbusier, Theo van Doesburg, the critic Karl Einstein, Léger, and Mondrian. Calder's account of the event tellingly reveals the sometimes tense atmosphere that prevailed in Paris:

> I saw Kiesler before the performance, and there was a great consternation in his camp because I had invited van Doesburg with the others. He apparently was a friend of Mondrian, but on cool terms with Karl Einstein and maybe Léger.
>
> That was Paris, and I never understood the battles of these coteries—and somehow or other I remained aloof from all this.
>
> But Kiesler insisted we must head off van Doesburg at all cost, so we finally sent him a telegram, explaining that there was some error and that he could come the following day.

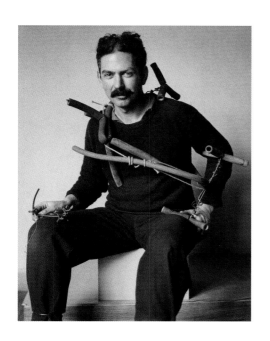

Fig. 4 | André Kertész, *Calder in Paris*, 1929

Kiesler and his gang came to the circus, and this time I do not remember any reaction. However, Léger was interested in what I did and we became very good friends. The following day, van Doesburg came with his wife Petro, of whom Louisa and I later became very fond ... I got more of a reaction from van Doesburg than I had from the whole gang the night before.[18]

The Surrealists championed artistic inspiration drawn from the unconscious and fixed both the comic and grotesque as hallmarks of the movement. The humor in *Cirque*, or "the Circus," likely resonated with them, and they enthusiastically received Calder's work.[19] A few years later, Calder in turn embraced the movement's vocabulary of curvilinear, organic shapes. Calder met Miró in 1928,

Fig. 5 | Brassaï (Gyula Halász), *View of* **Cirque Calder** *in Calder's Studio, Paris,* **1931**; Centre Pompidou, Musée national d'art moderne, Paris; gift of Gilberte Brassaï, 2002

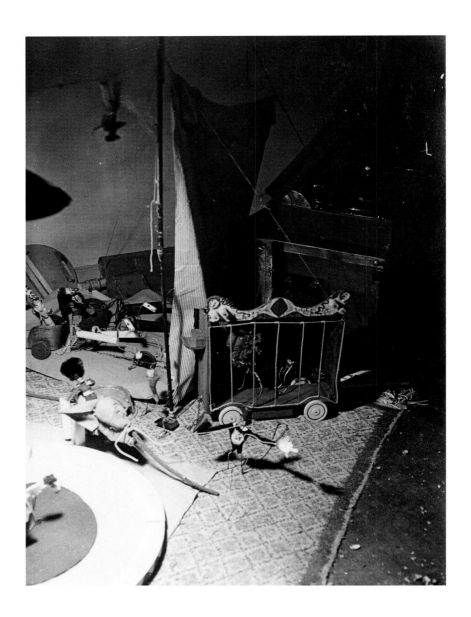

whereupon the two discovered a shared sensibility and admiration for each other's work (fig. 6). Their friendship has been well documented and was the subject of the 2004 exhibition *Calder/Miró*, which examined the visual relationships between their work and their mutual attraction for biomorphic forms. As Calder admitted, "Well, the archaeologists will tell you there's a little bit of Miró in Calder and a little bit of Calder in Miró."[20]

In 1930 Calder made a radical transition: he set aside the circus-themed wire and wood figures and embraced abstract constructions. Perhaps realizing the limitations of his earlier work, he began to acknowledge the impact that Mondrian had on him[21] following a 1930 visit to the Dutch artist's studio (fig. 7): "The visit gave me a shock... Though I had heard the word 'modern' before, I did not consciously know or feel the term 'abstract.' So now, at thirty-two, I wanted to paint and work in the abstract."[22] He said, "I was particularly impressed by some rectangles of color he had tacked on his wall in a pattern after his nature. I told him I would like to make them oscillate—he objected. I went home and tried to paint abstractly—but in two weeks was back again among plastic materials."[23] Calder would subsequently draw his palette from Mondrian's example as well, using black, white, red, and occasionally blue and yellow. Art historian George Baker, however, argues that Calder's abstraction may owe more to the work of Duchamp and

Fig. 6 | Joán Miró, *Female Nude*, 1926; oil on canvas; 36 ⅜ × 29 inches; Philadelphia Museum of Art, The Louise and Walter Arensberg Collection

Fig. 7 | Michel Seuphor, Piet Mondrian's
Paris studio, 26 rue du Départ, c. 1930

Fig. 8 | Alexander Calder, *White Panel*, 1936,
detail; 84 ½ × 47 × 51 inches

Arp, as well as to Dada in general, and it seems likely that other dominant art
movements in this period played a role in shaping Calder's singular innovations
as well.[24] Calder scholar Joan M. Marter also suggests that the switch from the
circus motif to more "serious" abstract sculpture coincided with his engagement
and marriage to Louisa James, whose parents he sought to impress with his
respectability as an artist.[25]

The decade that followed his meeting Miró and Mondrian would prove
to be the most radical of Calder's career, during which time he developed both the
mobile and the stabile. His first hanging sculptures, with flat and graphic lines,
are like diagrams of discrete movable parts stirred by air; Duchamp named them
mobiles in 1931, after a visit to Calder's home and studio.[26] In 1966 Calder described
the interaction in which Duchamp coined their name:

> There was one motor-driven thing, with three elements. The thing had just been
> painted and was not quite dry yet. Marcel said: "Do you mind?" When he put his
> hands on it, the object seemed to please him, so he arranged for me to show at Marie
> Cuttoli's Galerie Vignon…. I asked him what sort of a name I could give these things
> and he at once produced "Mobile." In addition to something that moves, in French
> it also means motive.[27]

Calder was well aware of the metal sculptures Pablo Picasso and Julio González
had created by soldering wire and found objects into welded, soldered, and
bolted open form—abstract sculptures that blur the boundaries between painting
and sculpture.[28] Calder rejected welding, however, preferring to bend and
twist wire by hand. He was a highly inventive artist who could almost effortlessly

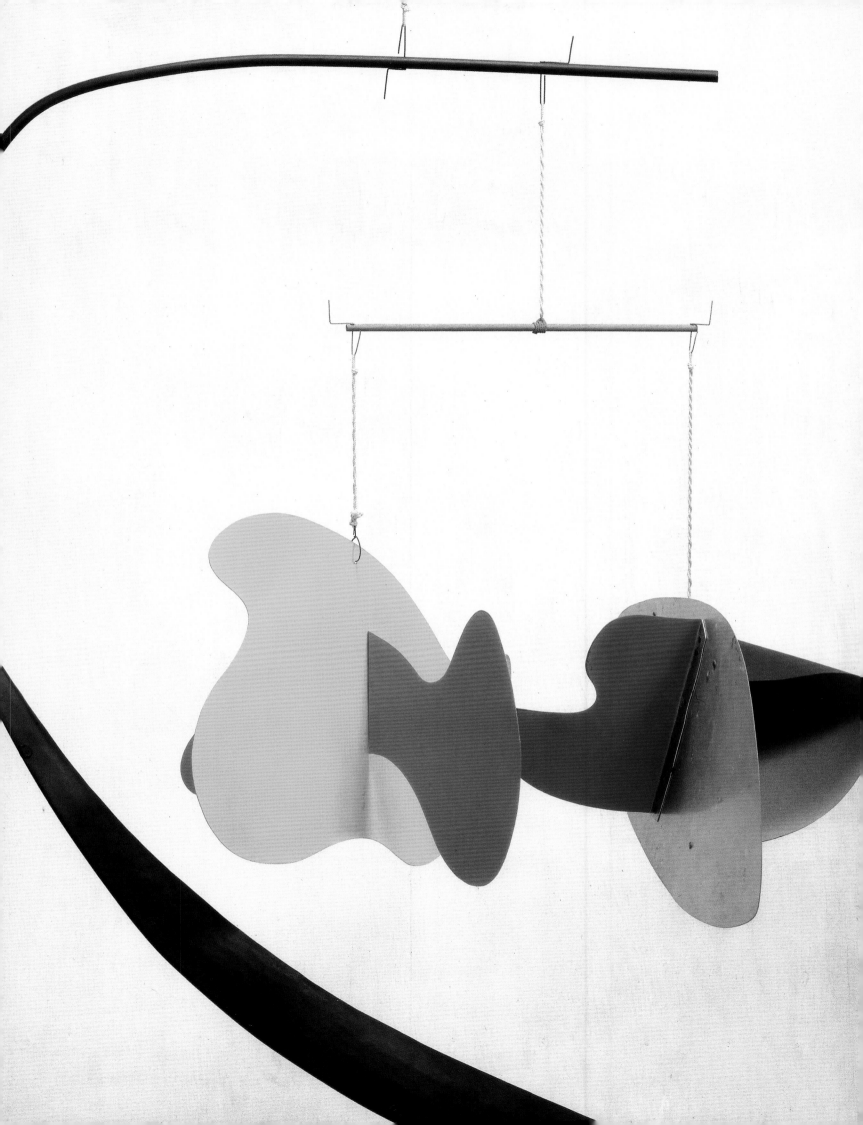

create sinuous and delicate drawings in space. In *White Panel* (1936, fig. 8) Calder suspended biomorphic abstract objects of brightly painted sheet metal from an arm attached to a rectangular panel hung on the wall, creating a kind of kinetic, three-dimensional painting. The elements dance within the rectangular framework, in response to the winding of the cords with cranks situated above each object, as well as to gently flowing air currents. Baker asserts that Calder's early, mechanized constructions—works that rotate with hand cranks and jerry-rigged motors whose movements might be seen as sexual or as representing the body in some way—are directly related to Duchamp's "bachelor machines" and "Dada diagrams" (fig. 9).[29]

Advanced European art jolted Calder into realizing that sculpture did not have to mean traditional carving like that of his father or the "shaving cream" or "marble mousse" of Auguste Rodin's *Kiss* (1889), and he explicitly sought to

Fig. 9 | Marcel Duchamp, *The Bride Stripped Bare by Her Bachelors, Even (The Large Glass)*, **1915–23**; oil, varnish, lead foil, lead wire, and dust on two glass panels; 109 ¼ × 70 × 3 ⅜ inches; Philadelphia Museum of Art, Bequest of Katherine S. Dreier, 1952

avoid making sculpture that looked like "mud piled on the floor."[30] As art historian Francisco Serraller has observed, Calder's connection to the Constructivists and members of the Abstraction-Création group helped him see and clarify the potential of ideas he was already engaging with and explains in part why he could so nimbly move back and forth between these groups.[31] Although Calder's practice found support with artists of different camps, the only group he actually joined was the Abstraction-Création, an international cohort of more than forty artists—including Arp, Robert Delaunay, van Doesburg, Hélion, Kandinsky, František Kupka, Mondrian, and Kurt Schwitters—that between 1931 and 1936 promoted the principles of pure abstraction (fig. 10).

As Calder's art evolved, he began to exhibit the new work in Paris. In 1932 his friend Duchamp helped him arrange a show of his mobiles at Galerie Vignon (fig. 11).[32] Calder was interested in the complex relationships between elements and the descriptions of various types of motion. Like the Surrealists, he embraced the idea of chance in his mobiles, unafraid to relinquish artistic autonomy. In *Object with Red Ball* (1931), the red and black spheres dangle from wires that can slide along their cantilever, placing the composition's success on the viewer, who can decide the arrangement; Calder's reliance on audience participation is key to understanding the revolutionary nature of these early works. Moreover, it poses the question of how the unifying forces of these discrete elements bind together to create a singular, coherent work. In further investigations of the engagement with exterior forces, his kinetic sculptures rely on the seemingly random movement of their elements as effected by their environment. The mobiles hang from a thin wire filament; the horizontal members cantilever, often in several layers, and are anchored by metal discs that serve as counterbalances, all carefully determined by the weight of the elements. Rosalind Krauss has noted that Calder's Constructivist roots can be observed in the way the viewer sees the mobile slowly spinning around the points of connection and imagines a sense of virtual volume.[33] Although generally nonfigurative, the mobiles moved by imperceptible air currents and often reference the observable world—the pivoting and floating forms suggesting a dancer's choreography.

La Demoiselle (1939) combines the graceful sway of black and red mobile forms that arch and turn with a delicate triad of thin wire. This work prefigures Calder's sculptures of the early 1940s, which became more vertical and sometimes grounded on legs, with sinuous curved silhouettes suggesting forms more closely associated with plants or animals. In *Un effet du japonais* (1941), Calder seems to blend the silhouette of a black stabile with fragile, diagonal rods resolutely extended, balancing and swaying in the air like giant fans. Sculptures with tripod bases eventually yield to works that are fully floating mobiles or those in which the base is more sculptural, gracefully formed, and offering a counter to the delicate branches that balance and drift in space.

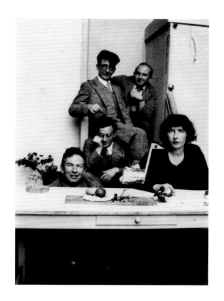

Fig. 10 | Jean Hélion's studio, Impass Nansouty, Paris, 1933; standing: Jean Hélion, Anatole Jakovsky; sitting: Alexander Calder, William Einstein, Louisa Calder

Fig. 11 | Invitation to *Calder: ses mobiles* at Galerie Vignon, Paris, February 1932

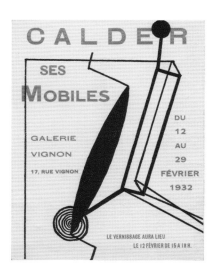

Calder credited Arp with naming his static abstract works *stabiles*, but
Baker also suggests another source of inspiration among the Paris Surrealists:
Alberto Giacometti, whose work Calder would surely have known. In *Gibraltar*
(1936, fig. 13), two thin off-kilter rods, thrust upward from the horizontal plane
that encircles the wood base, suggesting a kind of personal solar system, while the
wooden shape piercing the plane seems to echo Giacometti's *Disagreeable
Object* (1931). Calder artfully combined painted and unpainted wood and steel, manip-
ulated and natural materials, in a composition that feels at once delicate and
humorous. And Giacometti's *Suspended Ball* (1931, fig. 12) an ambivalent sugges-
tion of male and female sexuality in which the hanging ball barely caresses the
elongated recumbent wedge, may, as Baker suggests, have laid the groundwork for
Calder's fascination with the relationship of spheres and torpedo shapes, such
as those found in *Untitled (The McCausland Mobile)* (1937, fig. 14) or *Dancing Torpedo
Shape* (1932). The influence of Surrealism may be most apparent, though, in
one of Calder's more mature mobiles, the all-black *Eucalyptus* (1940). Executed
during the war, it can be seen as a composition of violent, tortured shapes: gaping
mouths, body parts, sexual organs, and sinister weapons.[34]

In essence, Calder synthesized the nonobjective art of Abstraction-Création,
Miró's and Arp's biomorphism—even a bit of Giacometti's Surrealism—bringing

**Fig. 12 | Alberto Giacometti, *Suspended Ball*,
1931** (version 1965); plaster and painted
metal; 23 ¾ × 14 × 14 ¼ inches; Fondation
Alberto et Annette Giacometti

Fig. 13 | Alexander Calder, *Gibraltar*, 1936,
detail; 51 ⅞ × 24 ¼ × 11 ⅜ inches

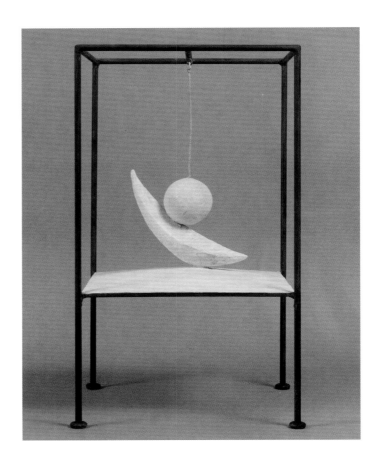

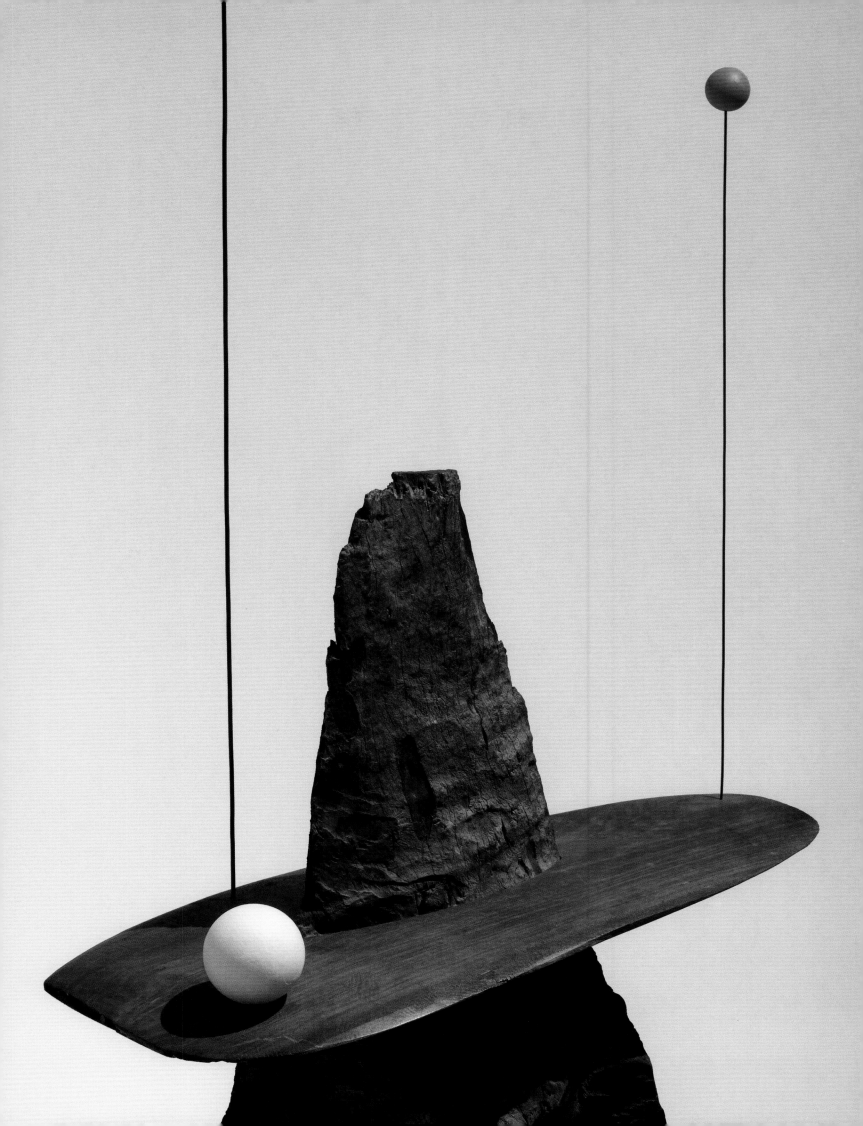

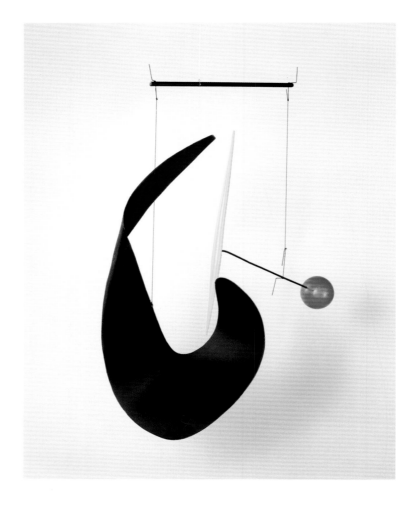

Fig. 14 | Alexander Calder, *Untitled (The McCausland Mobile)*, 1937; painted sheet metal, painted wood, wire, and string; 25 × 23 inches; National Gallery of Art, Washington, DC, Gift of Mr. and Mrs. Klaus G. Perls

Fig. 15 | László Moholy-Nagy, *Vertical Black, Red, Blue*, 1945; polychromed and incised Plexiglas on artist's wood base; 18 × 14 ¼ × 6 ¼ in. Los Angeles County Museum of Art, purchased with funds provided by Alice and Nahum Lainer, the Ducommun and Gross Acquisition Fund, the Fannie and Alan Leslie Bequest, and the Modern and Contemporary Art Council, M.2012.135a–b

his interests in astronomy and engineering, as well as his own mechanical resourcefulness, to bear. The artist also paid close attention to the Constructivists' edict to incorporate space into sculptures. By initially removing the sculpture from its base and then suspending objects from the ceiling and allowing them to move freely, Calder addresses issues articulated by Naum Gabo, László Moholy-Nagy, Alexander Rodchenko, and Vladimir Tatlin, who all attempted to free painting and sculpture from their traditional constraints. In surrendering to natural forces and displacing space through motion, Calder released sculpture from the constraints of gravity and traditional sculptural mass. His work thus occupies the liminal space between sculpture and painting. Much like Moholy-Nagy's *Vertical Black, Red, Blue* (1945, fig. 15), in which painted Plexiglas erupts from a traditional sculptural base, its painted forms seemingly suspended in midair, Calder's work complicates the viewer's comprehension of it as a sculpture or a painting.

Calder can also be viewed as one of the progenitors—along with Duchamp, Gabo, and Moholy-Nagy—of European Kinetic art. Between 1931 and 1936 he created a series of sculptures in which the elements move with simple mechanical means, casting random shadows (fig. 16). He would soon abandon spool- and

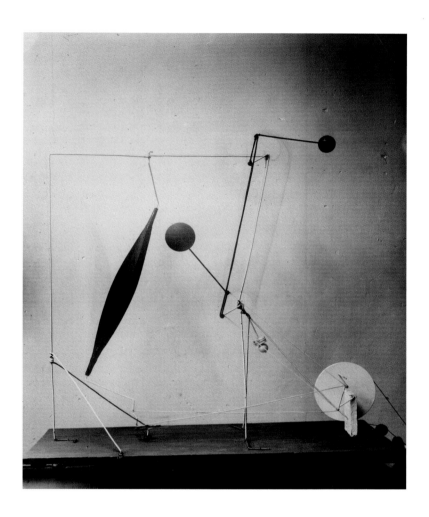

Fig. 16 | Alexander Calder, *Untitled*
(The motorized mobile that Duchamp liked),
1931; Calder Foundation, New York

belt-driven works, however, embracing instead an abstract aesthetic based increasingly on balance and counterbalance. No doubt influenced by Calder's innovations, artists like Julio Le Parc and Jesús Rafael Soto in South America, George Rickey in the United States, and those of the Zero Group in Düsseldorf began in the 1950s and 60s to make sculpture based on the principle of movement using new industrial materials, divorced from earlier avant-garde biomorphic abstraction.[35] French artist Jean Tinguely said of Calder, "He worked a quarter of a century before me and managed to create real, absolutely extraordinary sculpture, with joy and substantial humor. This gave me confidence. Let's just say that [he] ... opened a door through which I could enter. So I strolled in that direction and discovered extraordinary possibilities of motion" (fig. 17).[36]

With the outbreak of World War II, Calder returned to the United States. A number of European artists fleeing the Nazis would seek shelter there, some of whom had never visited the US. Since 1934 he had exhibited regularly at Pierre Matisse's gallery in New York, which primarily showcased European artists; consequently, Calder was one of the few artists whom the refugees knew before their arrival in New York. (Man Ray, another American familiar to the European avant-garde, would spend the war years in Hollywood) (fig. 18). Calder's friendship

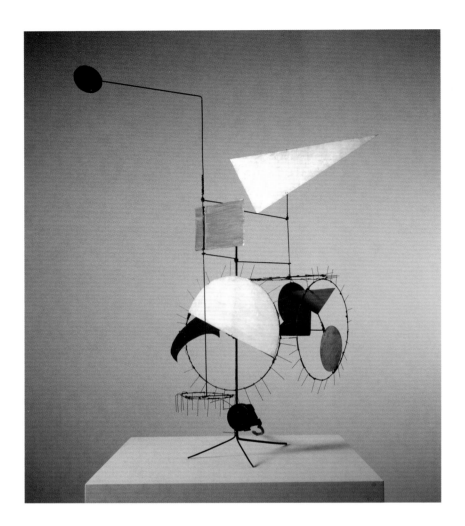

Fig. 17 | Jean Tinguely, *Méta-mécanique,*
1955; iron tripod, metal rods and wires,
nine variously colored metal elements, electric
motor; 35 × 32 ¼ × 25 ½ inches; Museum
Tinguely, Basel

Fig. 18 | Herbert Matter, Alexander Calder,
Marianne Moore, Marc Chagall, and
Martha Graham at *Alexander Calder: Sculptures
and Constructions,* The Museum of Modern
Art, New York, 1943

with Mondrian and Duchamp, as well as his association with the Surrealists
and the Abstraction-Création artists in Paris, ideally situated him to become one
of the emigrés' closest allies. Calder had brought back with him a European
approach—a unique blending of Constructivist, Bauhaus, and Surrealist sensibili-
ties—and with it he would achieve a unique place in the history of American art.

Immediately after the war, Calder had a show of his mobiles, stabiles, and
constellations at Galerie Louis Carré in Paris, and then a group of the mobiles
was shown in 1947 at Curt Valentin's Gallery in New York. Calder was friendly with
Existential philosopher Jean-Paul Sartre, who would write one of the most elo-
quent observations of the sculptor's work, stressing its life-affirming principles.
Brought to Calder's Connecticut studio by artist André Masson, Sartre reflected
on his experiences with the mobiles in the studio, revealing his fascination
with the mobile as "an object defined by its movement and nonexistent without
it … Calder suggests nothing. He captures true, living movements and crafts
them into something…. They [Mobiles] feed on air, breathe it and take their life
from the indistinct life of the atmosphere." They are "midway between matter
and life … [and] are neither entirely alive nor wholly mechanical."[37] Calder's 1940s
"constellations" suggest astral configurations and allowed him to organize the
elements into abstract arrangements (fig. 19). (Some were cleverly constructed
from wood due to the scarcity of metal available during the war.) It was the

continuation of a theme that had long interested him: Calder maintained an ongoing fascination with antique astronomical devices and models of the solar system.[38] A number of his works from the 1930s had also referenced astronomy, as well as the then-contemporary preoccupation with the cosmos shared by artists such as Kandinsky, Moholy-Nagy, Rodchenko, Mondrian, and Miró:[39]

> When I have used spheres and discs, I have intended that they should represent more than what they just are. More or less as the earth is a sphere but also has some miles of gas about it, volcanoes upon it, and the moon making circles around it, and as the sun is a sphere but is also a source of intense heat, the effect of which is felt at great distances. A ball of wood or a disc of metal is rather a dull object without this sense of something emanating from it.[40]

In *Red Disc* (1947) the black and red forms seem to defy gravity by balancing precariously on a delicate wire fulcrum. In several works from the late 1940s, Calder effectively blends the mobile and stabile forms. Stabiles support graceful, arcing branches that cut a broad swath as they rotate at an irregular rhythm. Sartre observed a piece "at work" in the studio, "But suddenly, when the agitation had left it and it seemed lifeless again, its long, majestic tail, which until then had not moved, came to life indolently and almost regretfully, spun in the air and swept past my nose."[41] *Snow Flurry* (1948) is an efflorescence of seemingly perfect delicate white petals. As the mobile rotates in a gentle wind, it constantly changes.

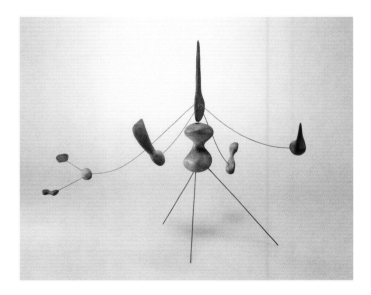

Fig. 19 | Alexander Calder, *Constellation*, c. 1942;
22 ½ × 28 ½ × 20 inches

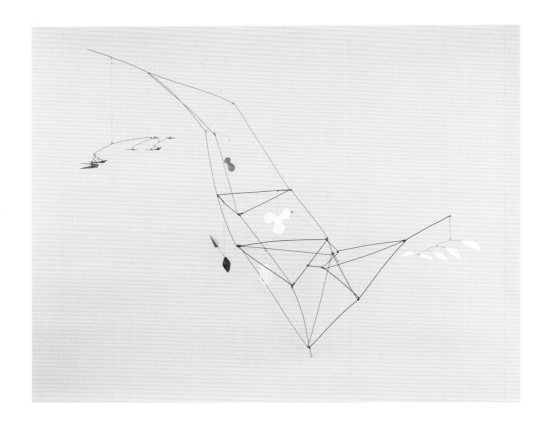

Fig. 20 | Alexander Calder, *Bifurcated Tower*, **1950**; 58 × 72 × 53 inches

In the early 1950s, Calder invented a new type of stabile-mobile construction: the so-called "tower," featuring painted wire struts and beams that form "scaffolding,"[42] which supports geometric wooden shapes protruding from the wall (fig. 20). When Calder returned to France in 1953—first renting a summer house near Aix-en-Provence and then purchasing a home and studio in Saché and dividing his time from then on among Saché, New York City, and Roxbury, Connecticut— he created five large standing mobiles intended to be placed out of doors. *Myxomatose* (1953, fig. 21), whose title refers to a virus affecting rabbits, spans thirteen and a half feet and rotates a full 360 degrees, representing a definitive shift in scale for the artist. While acknowledging this change, Calder commented, "My work may have gotten a little more shipshape, but the general idea is the same."[43]

Escutcheon (1954) was made during a trip Calder took to Beirut on the occasion of a commission from Middle East Airlines. Though the title suggests a coat of arms, like other Calder titles, it is not meant to be read literally. The delicate, branchlike forms of this human-scale work, hung high on the wall, shift slightly depending upon the wind. *Trois Pics* (intermediate maquette) (1967), a muscular yet graceful stabile in which the architectural forms are cut from quarter-inch steel (thicker than the aluminum he had worked with during the 40s), reflects a new aspect of the work. Using this stronger material, Calder was able to construct larger, more durable sculptures with the help of foundries and metal shops near his studios in both Roxbury and Saché, positioning him ideally as a collaborator with architects to create works for public spaces. With commissions

from the city of Spoleto, Italy (1962), Montreal's Expo (1967), and the city of Grand Rapids, Michigan (1969), Calder began a virtually constant output of giant commissioned public sculpture until his death in 1976, receiving invitations to create works sited in relationship to public buildings, museum plazas, corporate headquarters, and government offices. At the end of his life, the focus of his practice moved toward muscular, ambitious, large-scale public works only possible with the collaboration of fabricators, coinciding with a time when communities were becoming increasingly interested in public sculpture. Today, encountering Calder's iconic sculpture in the center of a city, in front of a courthouse, in the midst of government buildings, in a bustling airport, or at the entrance to a museum is a hallmark of the postwar public art movement that he helped to invent.[44]

Fig. 21 | Alexander Calder with *Myxomatose* (1953), Paris, 1954; photograph by Agnès Varda

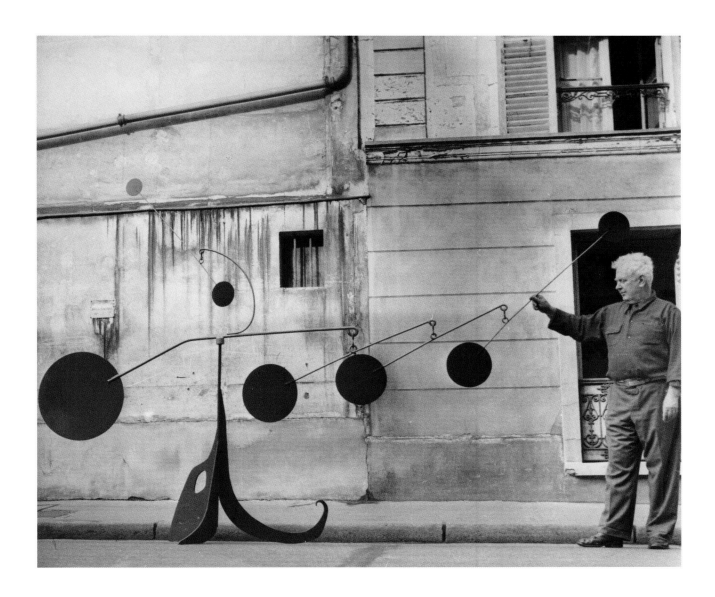

Installing Calder

Installing a sculpture exhibition—particularly one in which works are wall bound, sit on pedestals, hang in the air, hover close to the ground, and vary significantly in scale—can be tricky. In developing this exhibition, I reviewed historical photos of Calder's studio and presentations he designed and compared them with exhibition design from the past forty years. During Calder's lifetime, displays seemed to mimic those found in his studio: crowded together, overlapping, presenting a riotous cacophony of competing forms far removed from contemporary concerns of conservation and visitor-circulation paths (figs. 22–23). In the past few decades, museum exhibitions have had to grapple with these real concerns, which are exacerbated by increasingly large museum crowds. Extensive plinths, protective barriers, and pedestals mitigate intentional or inadvertent touching but can hinder the viewer's ability to relate intimately with the works. Clearly, decisions about density, space, light, and color would need to be weighed against concerns for the safety and protection of the artworks.

Fig. 22 | Alexander Calder's Roxbury Studio, Connecticut, 1941, showing *The Great Yucca* (1941), *Uprooted Whip* (1940), and *Yucca* (1941); photograph by Herbert Matter

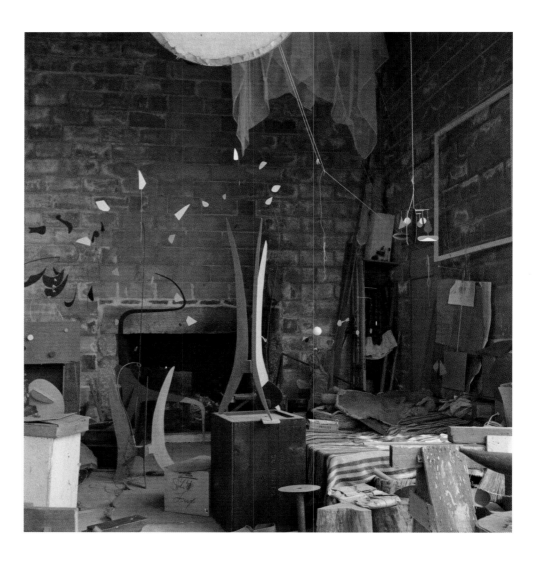

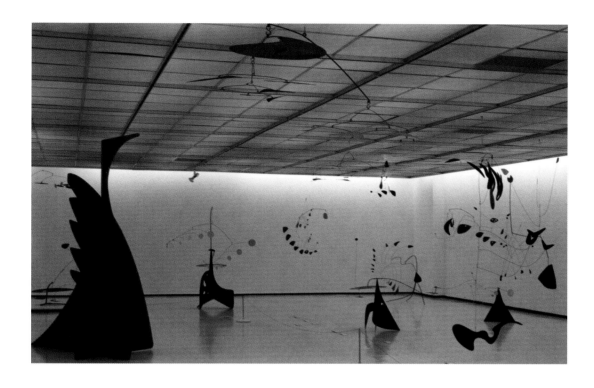

Fig. 23 | *Alexander Calder: A Retrospective Exhibition, Work from 1925 to 1974,* installation view, Museum of Contemporary Art, Chicago, 1974

We were fortunate that architect Frank O. Gehry shared an enthusiasm for Calder's work; his experience of seeing the artist's 1964–65 exhibition in Frank Lloyd Wright's Solomon R. Guggenheim Museum had made an indelible impression. The gently curved walls that frame many of the sculptures in LACMA's exhibition recall the harmony between art and architecture found in the Guggenheim's presentation—its rounded walls emphasizing the organic nature of Calder's works (figs. 24–25). Furthermore, Gehry's own method of developing architectural forms is inherently tactile, sharing some of the same hands-on techniques of a sculptor. Working through successive models—in paper, gatorboard, basswood, and Plexiglas, and in a variety of scales—Gehry's models are conceptual drafts, or three-dimensional sketches, integral to the final design of a project. From my early discussions with Gehry about Calder, it became clear that he could produce a remarkable and unique installation that could create a memorable experience for visitors. Although Calder was known to work with architects and luminaries from other fields during his lifetime,[45] no exhibition of Calder's work has engaged a major architect in three decades.

Another essential challenge to incorporate into the design plan was how best to light the sculptures. Calder himself seemed to prefer shadows. Writing to collector A. E. Gallatin regarding the purchase of some of his sculptures for the New York University gallery, the artist noted, "Unless you have already decided on a new lighting system I would like it very much if you would permit me to make some suggestions as to fixtures, etc.—for I have made many and consider myself something of an illuminating engineer."[46] Additionally, as the introduction to *17 Mobiles by Alexander Calder* states:

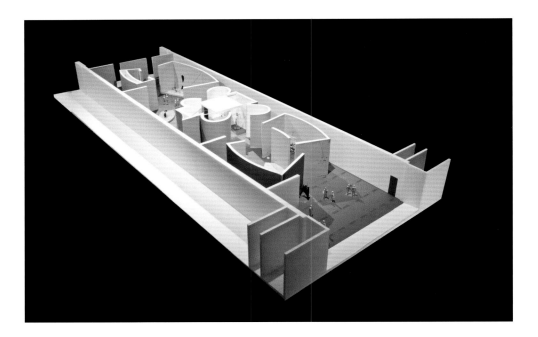

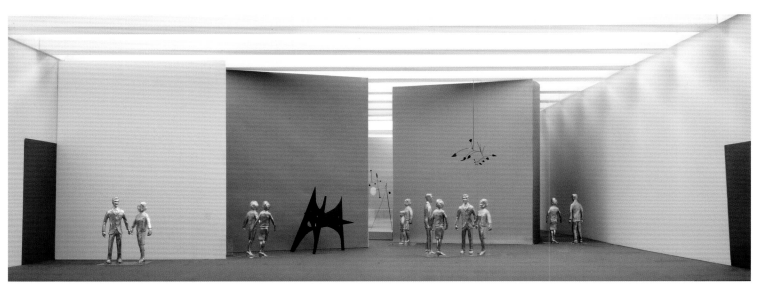

Figs. 24–25 | Gehry Partners, LLP, model photographs for *Calder and Abstraction: From Avant-Garde to Iconic,* Los Angeles County Museum of Art, 2013

It is natural to ask for an explanation of these mobiles made by Alexander Calder, as natural as it is to ask about the wind and the swaying shapes of trees. An explanation will not be found in words but in listening, watching, and feeling. The mobiles are man-made yet they create themselves and obey in some unfathomable way impellent laws of balance, force, and tension as they slowly carve patterns in the space around them. It is this unpredictable yet ordered action, a sort of abstract dance, which intrigues the fancy and makes other explanations superfluous.[47]

The photographs we reviewed—including those taken during Calder's lifetime by Ugo Mulas, the Italian art photographer, and Herbert Matter, the Swiss designer, photographer, and occasional filmmaker[48]—revealed disparate strategies. Matter was given unprecedented access during Calder's lifetime, and his dramatically spotlit, slightly mysterious photos have taken on a life of their own, contributing

to the public memory of Calder's work of the 1930s, 1940s, and 50s.[49] Just as the installations from Calder's lifetime inform latter-day presentations, the Matter photos helped us determine the "right" way to photograph and approach Calder's work. To that end, Gehry's design for LACMA's show allows for quiet moments of contemplation, unexpected juxtapositions of related works, and opportunities for both intimate and long-range views of the works. One of the most intriguing challenges Gehry's design takes up is how to animate some of the works. The manner in which the mobiles move in space and the best way to view them were of great concern to Calder, who in 1943 wrote:

> A mobile in motion leaves an invisible wake behind it, or rather, each element leaves an individual wake behind its individual self. Sometimes these wakes are contracted within each other, and sometimes they are deployed. In this latter position the mobile occupies more space, and it is the diameter of this maximum trajectory that should be considered in measuring a mobile.
>
> In their handling, i.e. setting them in motion by a touch of the hand, consideration should be had for the direction in which the object is designed to move, and for the inertia of the mass involved … A slow gentle impulse, as though one were moving a barge is almost infallible. In any case, gentle is the word.[50]

It is remarkable to watch Calder's sculptures carve their path in space, and respond to air and manipulation, but for obvious reasons this cannot usually happen in a public space with hundreds of visitors without putting the works at some risk. Yet with the assistance of technology and effective planning, the LACMA exhibition features a few sculptures that are animated throughout the course of the day, provoking in the viewer surprise and anticipation.

Also key to the design was the desire to slow down visitors' engagement with the sculptures. Like watching puffy clouds move across an expansive sky, observing Calder's mobiles undulate and quiver in gentle air currents encourages meditative contemplation. This phenomenon echoes early twentieth-century child-development theories espoused by Maria Montessori that were revived in the 1960s, at which time the practice of using small mobiles to promote infant development was popularized—the idea being that gazing at these types of hanging structures improves focus and concentration.[51] Viewers, then, may be best able to appreciate Calder's unique works by looking slowly and thoughtfully.

The exhibition features individual indoor works presented in such a way as to encourage a more languid apprehension, allowing the subtleties of the works to reveal themselves gradually; whereas Calder's large-scale public sculptures compel the spectator to be in constant motion around the sculpture, approaching it from multiple lines of sight. Yet they, too, reward multiple encounters over a long period of time. As Einstein discovered for himself as he scrutinized the movement of a single sculpture for nearly an hour, slow looking returns a more satisfying understanding and nuanced appreciation of Calder's work.

NOTES

1. Alexander Calder, quoted in Nicholas Guppy, "Alexander Calder," *Atlantic Monthly*, December 1964, referenced by Albert E. Elsen in *Alexander Calder: A Retrospective Exhibition, Works from 1925 to 1974* (Chicago: Museum of Contemporary Art, 1974), n.p., n28.

2. See exhibition history in this volume, p. 168.

3. Clement Greenberg in 1950 wrote, "The prompt, easy facility with which Calder handles a vocabulary of shapes taken over wholesale from Miró provides a kind of modern art one is prepared for. There is novelty—even if only mechanical—and abstractness that seems racy and chic. This is modern the way it looked when it was modern, and the old excitement and up-to-dateness seem recaptured. But a longer look reveals the lack of inner necessity and the jejune reliance on tastefulness and little more." Greenberg, "The European View of American Art," in *Clement Greenberg: The Collected Essays and Criticism, Vol. 3: Affirmations and Refusals, 1950–1956* (Chicago: University of Chicago Press, 1993), 61.

4. See the following: Greenberg's review of Alexander Calder's 1943 show at the Museum of Modern Art, New York, in which he acknowledges Calder's great wit and facility with materials, owing much to Picasso and Miró, but lacking the seriousness of David Smith ("Review of Exhibitions of Alexander Calder and Giorgio de Chirico," *The Nation*, October 23, 1943, 57); Alex Potts's dismissal of Calder as hardly contributing a new vision to sculpture (*The Sculptural Imagination: Figurative, Modernist, Minimalist* [New Haven: Yale University Press, 2000], 103); and, more recently, artist Carroll Dunham's dismissal of the seriousness of Calder's work in his review of the exhibition *Alexander Calder: The Paris Years, 1926–1933* at the Whitney Museum of American Art ("High Wire Act," *Artforum*, February 2009, 164–71).

See also George Baker, "Calder's Mobility," in *Alexander Calder and Contemporary Art: Form, Balance, Joy*, by Lynne Warren (Chicago: Museum of Contemporary Art, 2010), 95.

5. Dunham, "High Wire Act," 170–71.

6. Immanuel Kant, *Critique of Judgment*, trans. James Creed Meredith (1790, repr. Oxford, England: Oxford University Press, 2007), 42.

7. See for example Dave Hickey, *The Invisible Dragon—Four Essays on Beauty* (Los Angeles: Art Issues Press, 1993; revised and expanded Chicago: University of Chicago Press, 2009), 79. Citation refers to the 2009 edition.

8. Sebastián Gasch, "The American Sculptor Calder," AC, no. 7 (1932), 43; reprinted in Carmen Giménez, ed., *Calder: Gravity and Grace* (Madrid: Tf Editores, 2003), 66–67.

9. Amédée Ozenfant, extract from "Mémoires 1886–1962" (Paris: Seghers, 1968), 549–50; reprinted in Giménez, *Calder: Gravity and Grace*, 76.

10. See Wayne V. Andersen, "Calder at the Guggenheim: Why Calder Should Be Taken Seriously," *Artforum*, March 1965, 37–40; and Elsen in *Alexander Calder: A Retrospective Exhibition*, n.p.

11. Andersen, "Calder at the Guggenheim," 40.

12. See Lynne Warren, *Alexander Calder and Contemporary Art: Form, Balance, Joy* (Chicago: Museum of Contemporary Art, 2010).

13. Alexander Calder, "Mobiles," in *The Painter's Object*, ed. Myfanwy Evans (London: Gerold Howe, 1937), 62–67.

14. See Alexander Calder, *Calder, An Autobiography with Pictures*, ed. Jean Davidson (New York: Pantheon Books, 1966).

15. Maurice Bruzeau, "Alexander Calder, a Blacksmith in the Town," *Revue Française des Télécommunications* (December 1973), 47–49; cited in Giménez, *Calder: Gravity and Grace*, 54.

16. Isamu Noguchi, letter to Jean Lipman, August 21, 1971. Archives, Whitney Museum of American Art, New York. Excerpt published in Lipman, *Calder's Universe* (New York: Viking Press, 1976), 61–63.

17. Circuses in Paris attracted and inspired many nineteenth-century artists, including Edouard Manet, Georges Seurat, Henri de Toulouse-Lautrec, and Edgar Degas. Sophie Taeuber-Arp created a series of wooden puppets, while Pablo Picasso depicted a number of circus performers and collaborated with Erik Satie on the sensational set designs for the 1924 ballet *Mercure*, which continued to be talked about long afterward. *Cirque Calder* (1926–31), inspired by Calder's visits to the Ringling Brothers Circus in the United States, is arguably one of the greatest circus-inspired works of the twentieth century. See *Alexander Calder: The Paris Years, 1926–1933* (New York: Whitney Museum of American Art, 2008).

18. Jean Lipman with Nancy Foote, *Calder's Circus* (New York: E. P. Dutton & Co. in association with the Whitney Museum of American Art, 1972), 14.

19. For a discussion of Calder and Surrealism, see Pepe Karmel, "The Alchemist: Alexander Calder and Surrealism," in *Alexander Calder: The Paris Years, 1926–1933*, 212–19; and Mark Rosenthal, *The Surreal Calder* (Houston: The Menil Collection, 2005).

20. Calder, quoted in Elizabeth Hutton Turner, "Calder and Miró: A New Space for the Imagination," in *Calder/Miró*, ed. Elizabeth Hutton Turner and Oliver Wick (London: Philip Wilson Publishers in collaboration with Fondation Beyeler and The Phillips Collection), 28. See also Joan Punyet Miró, "Alexander Calder and Joan Miró: A Friendship, a Complicity," in *Calder* (Barcelona: Fundació Joan Miró, 1998).

21. See Calder, in *17 Mobiles by Alexander Calder* (Andover, MA: Addison Gallery of American Art, 1943), 6; and in H. H. Arnason and Ugo Mulas,

Calder (New York: Viking Press, 1971), 202; for examples. Calder also acknowledged Mondrian in his autobiography, and in his unpublished manuscript "The Evolution," in which he draws a diagram of the studio and writes further about the experience.

22. Calder, quoted in Joan M. Marter, *Alexander Calder* (New York: Cambridge University Press, 1991), 103.

23. Calder, "What Abstract Art Means to Me," *Museum of Modern Art Bulletin* 18, no. 3 (Spring 1951), 8–9; cited in Giménez, *Calder: Gravity and Grace*, 52.

24. Baker, "Calder's Mobility," 97.

25. Marter, *Alexander Calder*, 97.

26. See Calder, *Calder, An Autobiography*, 126–27.

27. Ibid.

28. Dore Ashton charts the development of Picasso and González's working relationship as well as Calder's activities in Paris. See "The Forging of New Philosophical Armatures: Sculpture between the Wars and Ever Since," in *Picasso and the Age of Iron*, ed. Carmen Giménez (New York: Solomon R. Guggenheim Museum, 1993). In that same catalogue, M. Dolores Jiménez-Blanco presents a full account of that chronology on pages 257–79.

For example, from 1928 to 1932, Picasso and González collaborated on several iron sculptures, such as *Head* and *Figure* (both October 1928), which are often seen publicly and in the artists' studios. In 1928 Picasso submitted two metal-rod sculptures, with accompanying drawings, as possible maquettes for the monument to Apollinaire, which were turned down. In 1929 González exhibited his forged-iron sculptures for the first time at the Salon d'Automne and *Cahiers d'art* published a number of essays by Christian Zervos that reproduced Picasso's *Construction in Wire* and *Painted Iron Head*. In May 1931, González's sculptures were exhibited at Galerie de France, as advertised in *Cahiers d'Art*. In 1932, Picasso had his first major retrospective exhibition at Galerie Georges Petit in Paris.

29. Baker, "Calder's Mobility," 100.

30. Elsen, *Alexander Calder: A Retrospective Exhibition*, n.p.

31. Francisco Calvo Serraller, "Calder: Gravity and Grace," in Giménez, *Calder: Gravity and Grace*, 30.

32. Marter, *Alexander Calder*, 115. Duchamp had first used the term "mobile" for his Readymade of the bicycle wheel in 1913. It was in conjunction with Calder's solo show at Galerie Vignon, Paris, *Calder: ses mobiles* (February 12–29, 1932), that Duchamp helped to arrange the works.

33. Rosalind Krauss, *Passages in Modern Sculpture* (New York: The Viking Press, 1977), 216.

34. Baker, "Calder's Mobility," 105.

35. Jack Burnham, *Beyond Modern Sculpture* (New York: George Braziller, 1968), 224–38.

36. Jean Tinguely, in *Jean Tinguely* (Paris: Musée National d'Art Moderne/Centre Georges Pompidou, 1989), 362.

37. Jean-Paul Sartre, "Les Mobiles des Calder," from *Alexander Calder: Mobiles, Stabiles, Constellations*, exh. cat. (Paris: Galerie Louis Carré, 1946); translation from *The Aftermath of War*, trans. Chris Turner (Calcutta: Seagull, 2008). Hans Richter's experimental Surrealist film of the same year, *Dreams That Money Can Buy*, which reflects the unease artists felt about their role in the world, features Calder with Max Ernst, Fernand Léger, and Duchamp and showcases color footage of Calder's sculpture.

38. In 1930 the discovery of Pluto (classified until 2006 as a planet), sparked increased interest in the cosmos.

39. Marter, *Alexander Calder*, 109.

40. Calder, quoted in Marla Prather, *Alexander Calder, 1898–1976* (Washington, DC: National Gallery of Art, 1998), 62.

41. Sartre, *The Aftermath of War*, 70.

42. Prather, *Alexander Calder, 1898–1976*, 232–33.

43. Geoffrey T. Hellman, "Onward and Upward with the Arts: Calder Revisited," *New Yorker*, October 22, 1960, 169.

44. Examples of these works would include *Four Arches* (1973), which is at the entrance to the Security Pacific National Bank in Los Angeles; *Flamingo* (1973), installed in front of Chicago's Federal Center Plaza (the Dirksen Courthouse, the Klucynski Building, and the Loop Postal Station); *Mountains and Clouds* (1976/87) in the atrium of the Hart Senate Office Building, Washington, DC; *.125* (1957) in the International Terminal 4 of the John F. Kennedy International Airport, New York; and *Gallows and Lollipops* (1960) at the Yale University Art Gallery, New Haven.

45. Calder was close friends with architect Josep Lluís Sert, who designed with Luis Lacasa the Pavilion for the Spanish Republic, where Calder installed his *Mercury Fountain* in 1937. Additionally, they frequently worked on projects together (for example, the United States Embassy in Baghdad where Calder created *Starry Web* and the Fondation Maeght building in the south of France) and corresponded throughout their lives; the full archive of their correspondence as well as materials relating to their projects is housed at Harvard University Library's Special Collections, Frances Loeb Library, Harvard Design School (The Josep Lluís Sert Collection, 1925–1983). Sert also contributed a letter on his relationship with Calder to Jean Lipman, *Calder's Universe* (1976, repr. New York: Harrison House in cooperation with the Whitney Museum of American Art, 1980), 30.

Dancer and choreographer Martha Graham asked Calder to design mobiles that her dancers could operate and impel with strings for *Panorama*, which was performed in Vermont on August 14, 1935 (Marter, *Alexander Calder*, 161–62). Calder was also commissioned by his friends A. Everett Austin, director of the First Hartford Music Festival and director of the Wadsworth Atheneum, and Virgil Thomson, music director of the Friends and Enemies of Modern Music, to design the set for *Socrate*, a play written by Erik Satie in 1920 (Marter, 163). Architect Wallace K. Harrison commissioned Calder to create a mobile for the ballroom of the Hotel Avila in Caracas, Venezuela (Marter, 204). Calder had also in 1939 created an aquatic "ballet" for the fountain outside the pavilion of the Consolidated Edison Company in New York, designed by Harrison and Jacques André Fouilhoux (Marter, 194). Composer John Cage wrote music to accompany the segment on Calder's sculptures in *Dreams That Money Can Buy*, directed by Hans Richter in 1947, as well as for Herbert Matter's film on Calder in 1950 titled *Works of Calder*.

46. Alexander Calder, quoted in Joan M. Marter, "Alexander Calder: Ambitious Young Sculptor of the 1930s," *Archives of American Art Journal* 16, no. 1 (1976): 4. Originally in a letter from Calder to Gallatin, November 4, 1934, New York Historical Society.

47. Author unknown, introduction to *17 Mobiles by Alexander Calder*, exh. cat. (Andover, MA: Addison Gallery of American Art, 1943): 6; reprinted in Giménez, ed., *Calder: Gravity and Grace*, 50.

48. Matter directed, filmed, and edited *Works of Calder* with music by John Cage for the Museum of Modern Art, New York, in 1950. Matter's first Calder film was *Alexander Calder: Sculpture and Constructions*, also for the Museum of Modern Art, in 1944.

49. See Alexander S. C. Rower, ed., *Calder by Matter*, with contributions by Jed Perl and John T. Hill (Paris: Cahiers d'Art, 2013).

50. Alexander Calder, "A Propos of Measuring a Mobile," manuscript, Archives of American Art, Smithsonian Institution, 1943.

51. Looking at mobiles was also thought to offer a visual experience, convey kinetic information, and educate the aesthetic sense. A rebirth of interest in the Montessori approach to child development occurred in the United States in the 1960s, following her death in 1952. For further discussion, see Keith Whitecarver, Jacqueline Cossentino, "Montessori and the Mainstream: A Century of Reform on the Margins," *Teachers College Record* 110, no. 12 (December 2008): 2571–2600 (New York: Teachers College, Columbia University).

Jed Perl

Sensibility and Science

ALEXANDER CALDER JOINED sensibility with science, the empathetic with the engineered. Very few artists had done that before, and no artist since Leonardo da Vinci had so closely studied not only the magic but also the mechanics of forms moving through air. Born in 1898, Calder was in his thirties when he started exhibiting the works his friend Marcel Duchamp named mobiles. Although Calder was not quite the first and certainly not the last artist to set sculpture in motion, he sent volumes moving through space with more conviction and imaginative power—with more eloquence and elegance—than any other artist has. These are the works of a poet, but a poet guided by the steady instincts of a scientist. Calder's mobiles signal a paradigm shift in the history of sculpture—an unprecedented innovation. The integration of the time element into sculpture is an innovation that no artist since Calder has fully assimilated, much less superseded, although Calder certainly had an impact on a generation of kinetic artists, beginning in the 1950s with figures such as the Swiss sculptor Jean Tinguely and the Venezuelan artist Jesús Rafael Soto.

Philadelphia is where Calder's story began. His family had abiding connections with the City of Brotherly Love, which Calder and his family left when he was eight years old, spending formative periods of his childhood and adolescence in Pasadena, New York, and San Francisco. Calder's paternal grandfather, Alexander Milne Calder, had studied sculpture in his native Scotland and immigrated to the United States in the 1860s, eventually devoting much of his life to the creation of hundreds of carvings for the Philadelphia City Hall, as well as the monumental bronze statue of William Penn atop the building's dome. Milne's oldest son, Alexander Stirling Calder, studied sculpture at the Pennsylvania Academy of the Fine Arts in the 1880s, where he met Nanette Lederer, who had come from Milwaukee to become a painter. They were very much part of the excitement of artistic Philadelphia in the 1890s, when it was second to no city in the United States when it came to contemporary painting and sculpture.

Stirling and Nanette married in 1895 and immediately left for Paris, where their daughter, Margaret, was born a year later (the family referred to her as Peggy from Paris). Back in Philadelphia they had a son, who would eventually be known to all the world as Sandy Calder. And Stirling Calder began a career that would soon enough earn him a place among the most admired creators of large public sculpture in the United States. By the time Calder committed himself fully to sculpture—around age thirty—he had witnessed at close range the trials

and triumphs of the creative life. Stirling was a man inclined to deep and sometimes melancholy introspection, and this may well have set off a reaction in his son, who struck many people as taking an almost happy-go-lucky attitude toward his art. Calder, who was utterly serious about everything he was doing, probably associated an excess of introspection with troubling aspects of his father, whose career stalled and then collapsed in the 1930s; he died in 1945, a broken man in many respects.

More than a few major modern artists had fathers who were artists, including Pablo Picasso, Alberto Giacometti, Balthus, and Ben Nicholson, a friend of Calder's in the 1930s. Calder's parents, like Balthus's and Nicholson's, were both artists, and the deep sense of security that grounded Calder's audacious experiments beginning in the late 1920s certainly had its origins in the apprenticeship in modernism he received as a young man. Although Stirling Calder's figurative sculptures look conservative to us today, he and his wife, Nanette, saw themselves as moderns; they were friends from Philadelphia student days with artists such as John Sloan and William Glackens, who became famous in the early 1900s as part

Fig. 1 | The Calder Family, Roxbury, Connecticut, 1947; photograph by Herbert Matter

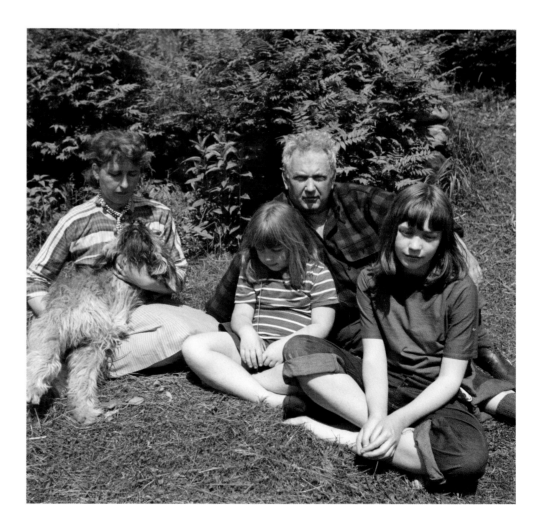

of the Ashcan school, and they admired the sculpture of Auguste Rodin and the writings of Oscar Wilde. After leaving Philadelphia for the West in 1906, the Calders made a home in Pasadena, California, where they moved in the social circles of the Arts and Crafts movement (fig. 2). It is likely that their exceedingly bright boy, who was always encouraged by his parents to have a workshop, had some contact with craftspeople using sheet metal, a material essential to his mature work. Calder, who as an adolescent was both academically accomplished and unabashedly easygoing, caused some worry to his parents, who feared that for all his gifts he lacked direction and ambition. Without a clear sense of where he was headed, he enrolled at the Stevens Institute of Technology, an engineering college in Hoboken, New Jersey, and graduated in 1919, but the dozens of jobs he found and lost in the next four years suggested that his heart was never in engineering, certainly not in the sort of executive positions for which Stevens was grooming its graduates.

Calder was twenty-five by the time he turned to what he could not help but regard as the family business, returning from Washington State where he had been working in lumber camps and spending time with his sister and her husband, whose family had interests in banking and timber. When Calder began to attend the Art Students League in New York in 1923, it was with the intention of becoming a painter like his mother; his father had taught sculpture at the League and his parents knew many of the teachers from their student days, including Sloan, who remembered Calder as a little boy. Sloan's easygoing graphic gifts certainly affected Calder's first drawings and paintings of New York and may even be echoed in

Fig. 2 | Nanette Lederer Calder, actress Gladys Sills, Margaret "Peggy" Calder, and Alexander Calder, Pasadena, California, 1909

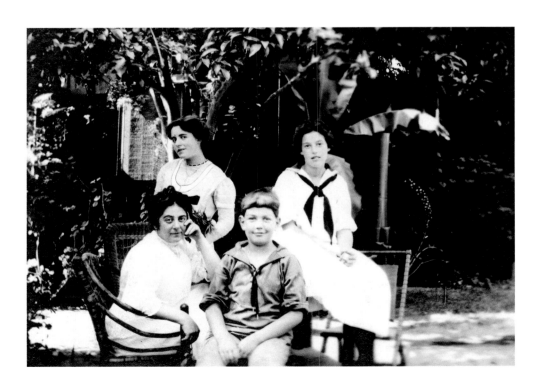

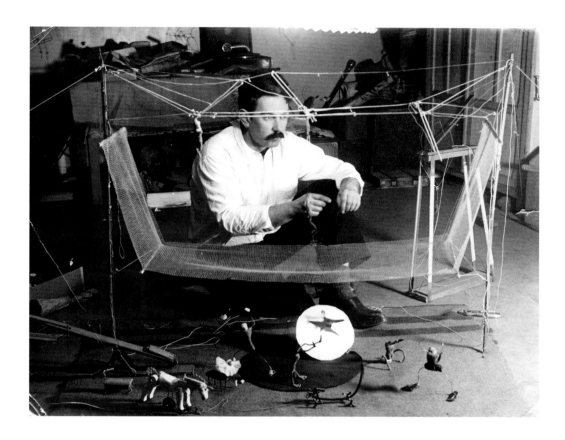

the gestural power of his wire sculptures of the late 1920s. In 1926, with his parents' encouragement and the promise of a small monthly check, Calder headed for Paris, where he would spend much of his time in the next seven years. He lived in Montparnasse and thereabouts, setting up a first home with his wife, Louisa, whom he married in 1931 (fig. 1) and who came from a well-to-do Boston family with artistic and progressive connections; Henry James was her great uncle, and her father, Edward Holton James, took a great interest in the work of the League of Nations.

Calder had completed a small amount of sculpture before leaving New York, but he arrived in Paris still considering himself a painter, although a painter who was unsure of his direction. In Paris, some of his earliest efforts in the third dimension were not created as works of art, pure and simple. He made maquettes for toys that he hoped might be put into mass production, and the first performances of what would come to be known as the *Cirque Calder* (1926–31, fig. 3), in his small studio on the Rue Daguerre, took him into a region of experimental puppet or marionette theater—as the circus was invariably called in early reports—that was quite popular at the time both in Europe and the United States. Significantly, the earliest reviews of his work were written by André Legrand, who went under the pen name Legrand-Chabrier and who was not an art critic but a critic of the popular theatrical arts. *Cirque Calder,* which was only first exhibited in a museum in 1969, more than forty years after Calder began it, cannot be regarded as a work of sculpture in any ordinary sense, but rather as a theatrical performance involving sculptural elements. If the circus had significant implications for Calder's progress as an artist, it was because of the insistent desire to simplify and summarize naturalistic experience that he brought to his figures made of wire, cloth, cork, and other materials. The figures of *Cirque Calder*—some recognizable as

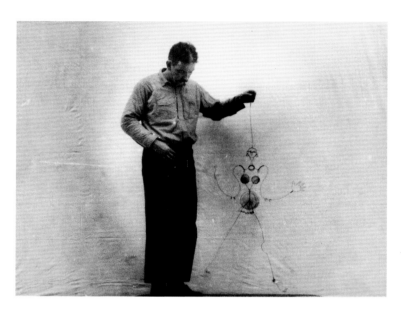

Fig. 4 | Alexander Calder with *Josephine Baker IV* (c. 1928) during the filming of a Pathé newsreel, 1929

Fig. 5 | Calder working on *Kiki de Montparnasse I* (1929) in *Montparnasse—Where the Muses Hold Sway*, Pathé Cinema, Paris, 1929

performers of the day in America and France—are reduced to skeletal images through a process of abstraction that would fuel Calder's work in the years to come.

It was in the late 1920s that Calder produced his first great body of work, sculptures made of lengths of wire twisted into dazzling curves and angles so as to evoke athletes, popular theatrical performers, friends, and a few personages from Greek and Roman myth. Calder immortalized in wire some of the erotic icons of Paris (Josephine Baker, with her banana skirt, and Kiki, the legendary artists' model of Montparnasse, figs. 4–5) and highlighted some of the men and women who excelled at the competitive games (including Babe Ruth and the tennis player Helen Wills) that were receiving ever-growing public attention at a time when the Olympic Games were an international sensation. Calder's wire sculptures convey a champagne high, the exhilaration of a moment when Europe had shaken off the nightmare of World War I and not yet been drawn into the cataclysmic events that began with the Depression and ended with World War II and the atom bomb. Projecting a graphic impulse into the third dimension, Calder arrived at forms that, as we move around them, reveal a startling liquidity and variability. The figure of an acrobat or the head of a friend, which may initially appear a closed, completely resolved form, is transformed as we shift our vantage point, until we are seeing near-abstract ribbons and waves of movement. There is something of a juggler's nerve and esprit in these constantly mutating configurations.

Although Calder occasionally turned to representation throughout his career, the wire sculptures of the late 1920s would be his last immersion in the

figure, at least until near the end of his life. In his *Autobiography with Pictures* from 1966 and in many other statements and interviews, he said that it was a visit to Piet Mondrian's studio in 1930 that provoked his dramatic turn to abstraction, rapidly precipitating the ascetic constructions of spheres, arcs, and angles that are his signal achievement of the early 1930s. But if Calder's first abstract sculptures were a response to the revelation of Mondrian's abstraction, I believe there is no question that Calder also recognized, in some deep, instinctive way, that in the wake of the stock-market crash of 1929 and the rapidly darkening European scene, the comic exuberance of his jugglers, acrobats, and athletes could no longer be sustained. Calder knew that his feelings for paradox and play had to be reimagined in a more severe and austere mode, one consonant with a world increasingly overtaken by catastrophe.

Although Calder's achievements were grounded in developments in abstract art nearly a quarter of a century old when he began making his mobiles in the early 1930s, he was always in some deep sense an empiricist. He grasped the inextricable relationship between immediate appearances and the hidden forces that shape our world. The lyricism of the works that one of his earliest supporters, the critic and curator James Johnson Sweeney, referred to as his "wind mobiles," has everything to do with Calder's genius for turning to art's advantage an investigation of the nature of the world generally believed to be the purview of physics, a way of seeing inaugurated not by artists but by the primary texts of Euclid and Isaac Newton.[1] Calder, although not a scientist in any traditional sense, was moved by a desire, common among early twentieth-century thinkers, to see the poetry of everyday life as shaped by heretofore invisible principles and laws.

We sometimes forget that the intimate relationship between science and alchemy and magic of all kinds, taken for granted in early modern times, was still very much a factor around the turn of the century; even Pierre and Marie Curie, scrupulous scientists, took an interest in paranormal experiments. Calder, although far too matter-of-fact and pragmatic a personality to feel the pull of the dark sciences, certainly dedicated his art to the proposition that magic could be engineered. This liberal-spirited man came of age when artists were on easy terms with the mystical and the transcendent, and although he would not have embraced Erik Satie's interest in the Rosicrucian Order or Wassily Kandinsky's and Mondrian's interest in Theosophy, he might well have agreed with Georges Braque, whom he knew, that making a work of art was like reading tea leaves. Writing in his *Occult Diary* around 1900, the Swedish playwright August Strindberg, who took an interest in alchemy, remarked that "if you would know the invisible, look carefully at the visible."[2] Surely the elusive movements of Calder's greatest mobiles of the 1940s and 50s are echoes or afterimages—if not indeed embodiments—of the invisible. That fascination with the hidden sources of appearances, which animated Albert Einstein's theories about the nature of matter and Sigmund Freud's, Carl Jung's, and Henri Bergson's investigations of the human

mind, animated Calder's art as well. No wonder Calder's mobiles inspired
an extraordinary essay by Jean-Paul Sartre, composed in the wake of World
War II, when the French Existentialist's ideas about the nature of human experi-
ence were taking the world by storm.

As widely admired as Calder is more than a generation after his death in 1976
at the age of seventy-eight, the reach of his vision remains to be fully appreciated.
Could it be that the immediate pleasure of his work has stood in the way of some
more profound comprehension? Confronted with artists of enormous originality,
even the most discriminating minds of the past hundred years have sometimes
found it difficult to sustain any measured critical response. Many of these critical
failures have expressed themselves through outright rejection, most famously the
mocking reactions to Henri Matisse's *Woman with a Hat* at the Salon d'Automne
in 1905 and Vaslav Nijinsky's choreography for *Le Sacre de printemps* in 1913. There
are, however, other responses to extreme originality, one of the oddest being a
cheerful acceptance that can itself signal a collapse of critical discrimination. That
may be the curious fate not only of Calder's mobiles, but of other beguiling prod-
ucts of the modern imagination, including Maurice Ravel's music and Colette's nov-
els and essays. The ease with which these works are experienced and appreciated
leaves the artists in danger of being underestimated. The works are regarded as mostly
a matter of amusement or seduction—as entertainments engineered for the plea-
sure of adults.

Vladimir Jankélévitch, in his brilliant book about Ravel, writes that "technique,
in his magic hands, becomes the instrument of an incantatory action—it might
be called a spell."[3] And so it is with Calder. His technique, grounded in an instinctive
feeling for the fundamentals of physics, becomes the means by which he casts
his spell—the spell of movement through space, of matter animated by energy. If the
language with which we generally speak about the visual arts is inadequate to dis-
cuss Calder, it is because for Calder the fundamentals of aesthetics are so inextricably
engaged with the fundamentals of physics. For Calder, physics is not a question
of theories in a textbook but of sensations registered through the immediacy of nature.
Physics is physicality. It is as simple as that. Such thoughts are by no means alien
to the scientific imagination. If you have any doubt, you have only to consult a textbook
called *First Principles of Physics*, published in 1912, four years before Calder
studied elementary physics at the Stevens Institute. The authors begin by arguing
that "countless physical *phenomena* are taking place around us every day," and
that all of them "are examples of matter and associated energy." They catalogue
a number of everyday occurrences: "a girl playing tennis, a boy rowing a boat,
the school bell ringing, the sun giving light and heat, the wind flapping a sail, an apple
falling from a tree."[4] These are of course precisely the varieties of experience
that Calder evokes in his art—sometimes literally, as in an early wire sculpture of the
tennis player Helen Wills, but more usually metaphorically, for what are the ele-
ments in a mobile if not sails flapping in the wind, fruits falling from a tree, one piece
of metal clanging against another?

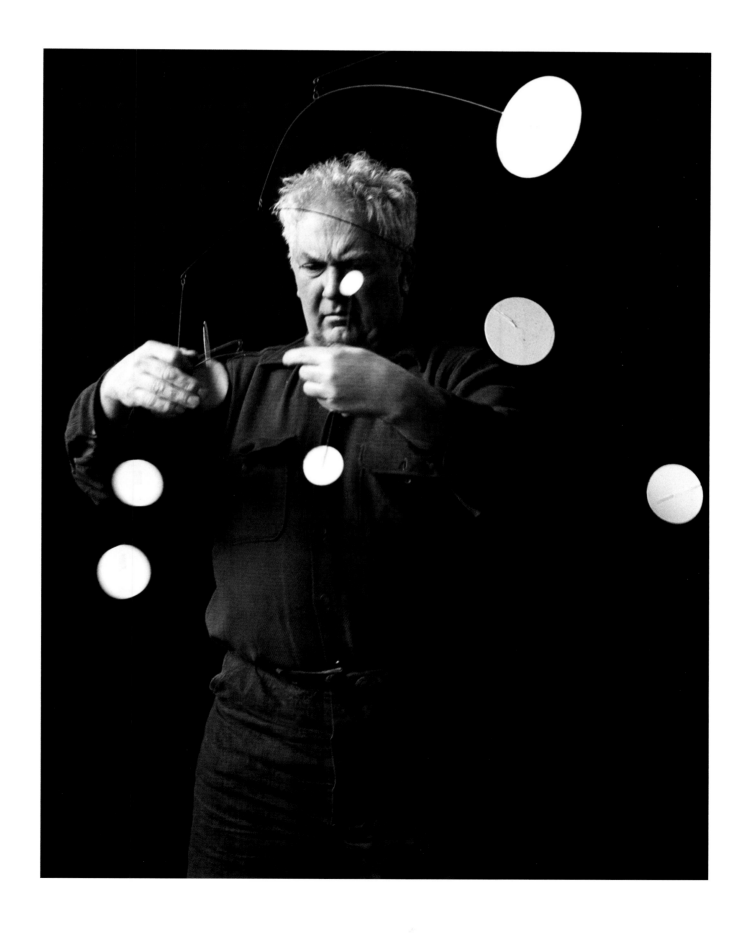

Fig. 7 | Alexander Calder, *Little Face*, 1962;
42 × 56 inches

For all their immediate impact, by turns opulent and ascetic and sometimes both at the same time, Calder's sculptures, and especially his mobiles, make considerable demands on his audience. There is always the physics—and the geometry, of course—that underpins and animates the poetry. Calder's mobiles require particular forms of attention, a sensitivity to kinetic possibilities that is not called for when looking at many other types of abstract art. Captivated at once by the lyric power of Calder's art, we may only with repeated viewings begin to perceive its multilevel power, a heterodox spirit that begins with a play of like and unlike forms and then pushes those forms into a constantly shifting dynamic as air currents reconfigure the composition. To see Calder's mobiles in their full complexity, we must begin by paying the closest attention to the parts that make up the whole. Are the shapes of one color, or two or more colors? Are the shapes similarly formed, as in the panoply of white circles in *Snow Flurry, I* (1948, fig. 6), or is there a range of shapes, from circles to petals to shapes with cutouts, as in *Little Face* (1962, fig. 7)? Are the metal forms arranged vertically, like sails catching the wind, or horizontally, like islands floating in the heavens? Are there shapes that are rendered singular by virtue of their color or form, or by the cutouts in the form, so that they register as loners or outliers or heroic presences in relation to the groups of shapes that would otherwise dominate the composition?

With a mobile, everything depends on our vantage point and on how the elements are arrayed at a particular moment. To analyze Calder's mobiles in terms of the planar geometry of his forms and in terms of sets of forms hardly takes us to the beginning of their richness, because their richness has everything to do with the extent to which geometry is so often complicated or even trumped by physics. What we are seeing, more often than not, are not shapes or groups of shapes as stable elements, but shapes or groups of shapes as constantly shifting possibilities.

As critical as the shapes themselves are to the mobile's impact, at least equally critical is the way that the elements are attached to one another, ranging from the wooden elements in *Constellation Mobile* (1943), which hang from strings affixed to horizontal wires, to the metal shapes in a work such as *Little Face*, each shape arranged at the end of a wire, the other end of which fastens to yet another wire at the end of which there is yet another shape. How the shapes are connected affects their movements and their relationships. In *Little Face* there is a single shape punctured with three openings, creating the abstracted face of the title. And this is a unique, stand-alone element. But then so is the singular petal-like shape, which looms solitary on one side of the string from which the mobile is suspended, achieving an unexpected importance because it must balance, or at least appear to balance, so many of the elements on the other side of that central axis.

The longer we look at one of Calder's mobiles, the more we become convinced that any impression we have is subject to revision—sometimes radical revision. There are times when all the elements are arrayed so that we experience each one of them as distinct and independent, as if we are regarding a two-dimensional composition suspended in a three-dimensional space. At other times, the elements pile up, creating a sensation of deep perspective, or they overlap and for a time obliterate one another, so that we see far fewer elements than we know are actually present. From certain vantage points, we may not know whether a shape has a cutout or what the cutout looks like, because the shape is overlapped by another, or the shape is seen at an extreme angle, the plane telescoped and becoming little more than a line. Calder builds into his greatest mobiles—and to some degree into all his mobiles—an astonishing sense of variety and variability, of affinities and associations. Surely what really matters is the constant play of symmetry and asymmetry, odd and even, singular and plural, faster and slower, higher and lower, wider and narrower. Surely what was mostly on Calder's mind were matters of difference and distinction, not a certain number of forms versus a certain other number of forms, but form versus space and *versus* as a principle in itself.

From what we know of Calder's process, the creation of works of such intricacy and complexity would have been impossible were the imagining not inextricably linked to the making, were the lyricism not encoded in the engineering. That some might see a paradox here was suggested by the sculptor George Rickey in his 1967 book *Constructivism: Origins and Evolution*, a pioneering attempt to define the modern artist's conquest of form in space. While acknowledging Calder's key role in the integration of movement into sculpture and praising his late stabiles, Rickey could not resist observing that Calder's "mobile constructions...were too lyrical and subjective to be considered Constructivist."[5] Whatever such a comment tells us about the limits of Rickey's imagination, his resistance certainly underscores the challenges that Calder's mobiles pose to deep understanding. Apparently it is not easy to see that lyricism is a matter of construction, that a poetic subjectivity can be grounded in the fundamentals of matter and energy. Rickey probably

associated Constructivism with straight lines and the most regular geometric forms, but the truth is that a whole range of curvilinear movements occur far more frequently in nature, as any physicist or biologist knows. And if Constructivism is indeed somehow related to the artist's deepening sense of the structure of the world, how can the irregular curve, which is at the heart of Calder's lyricism, not be an essential factor?

This instinctive fusion of immediate poetic image and underlying scientific thought is evident in an anecdote from Calder's autobiography. In the years after he had finished college, but had not yet committed to a life in art, Calder decided to spend some time in the Pacific Northwest, where his sister was living with her husband. Calder worked his way to California on a ship that went through the Panama Canal, and "early one morning on a calm sea, off Guatemala" he recalled seeing "the beginning of a fiery red sunrise on one side and the moon looking like a silver coin on the other." Forty years later, he remarked that "of the whole trip this impressed me most of all; it left me with a lasting sensation of the solar system."[6] Of course what Calder was seeing that morning off the coast of Guatemala was not the solar system, but an effect of the workings of the solar system, the movement of the moon in relation to the earth and the sun viewed from his own moving vantage point on a boat on the sea. What is significant here is how Calder drew from that particular morning some larger lesson about the nature of the solar system. For Calder the experience could not be reduced to a science lesson; he recognized something magical in the convergence of the sun and the moon, a union that alchemists had long associated with the compounding of the philosopher's stone, a wedding of sun and moon, sulfur and mercury, Hermes and Aphrodite. At the end of the 1920s, in the Paris where Calder first made a name for himself, the American writer Harry Crosby observed in his diary "that in solar symbolism there are rules which connect the sun with gold, with heliotrope, with the cock which heralds the day, with magnanimous animals such as the lion and the bull, that 92,930,000 miles is the sun's distance from the earth; that no fewer than one half a million of full moons shining all at once would be required to make up a mass of light equal to that of the sun."[7] Calder would never have succumbed to such a flight of literary fancy, but when he came, in 1968, to mount an abstract ballet in Rome that he described as "my life in nineteen minutes," a radiant sun with a human face dominated the stage.

It may be in the informal back-and-forth of one or two interviews, given when he was already middle-aged, that Calder suggested how deeply encoded the logic of physics was in his most delicious inventions. Speaking to the art critic Katharine Kuh, Calder said, "My whole theory about art is the disparity that exists between form, masses, and movement."[8] It is immediately evident that "masses and movement" takes us back to the primary factors in physics: matter and energy. It is the mass of three or four larger elements in *Little Face* that balances a relatively large number of elements. And the movement of any individual element in a mobile has everything to do with how its particular mass encounters some amount of energy. This

statement of Calder's also leaves me thinking that "disparity," which is not a word frequently heard among visual artists, is a play on a concept essential to the thinking of physicists and mathematicians, namely parity. In physics, parity refers to the relationship between a phenomenon and its mirror image, most simply described in the equation P: (a) → (-a). One need not grasp much about the physics of such an idea—and the idea goes as far back as Newton but also figures in quantum mechanics—to see that Calder was always playing with parity and disparity. A mobile is a matter of disparities that also make parities, its parts achieving parity in the sense that they balance or mirror each other insofar as their

Fig. 8 | Alexander Calder, *Little Blue Under Red,* **c. 1947**; painted steel; 58 × 82 inches; Harvard Art Museums/Fogg Museum, Louise E. Bettens Fund, 1955.99

mass is concerned, and a scientist may forgive an artist for arguing that even as P: (a) → (-a), (a) and (-a) can be composed of rather different elements, although not entirely different.

But perhaps the most striking moment in Calder's conversation with Kuh, at least in terms of the extent to which the artist's imagination was informed by the thinking of an engineer, comes when Kuh asks Calder about which of his works he likes best and he mentions a standing mobile called *Little Blue Under Red* (c. 1950, fig. 8). "That one," he says, "develops hypocycloidal and epicycloidal curves."[9] In this conversation with an art critic, Calder quite casually mentions what are in fact highly technical terms. Hypocycloidal and epicycloidal curves are curves generated by the path left by a point on a smaller circle that rolls either outside of or inside of a larger circle; the interlocking interactions of gears in watches and many other types of machinery use such curves for the profile of the gear teeth. What Calder is describing here is a form of movement found in a group of standing mobiles from the late 1940s that includes *Little Parasite, Parasite, Laocoön, Bougainvillier,* and *Little Pierced Disc.* The stable element in these works, shaped like the first shoot of a plant emerging from the earth, resolves into a point that functions as a fulcrum. On this is balanced a single serpentine wire with elements hanging from its two ends. At one end there is often a circular plate, pierced in the center, that drops to encircle the fulcrum. At the other end there is usually a more elaborate construction. And these elements at the two ends of the main serpentine wire, which rotate at the ends of the wire even as the serpentine wire rotates, create the hypocycloidal and epicycloidal curves. They are curves outlined in the air that we do not so much see as sense, as energies inscribed in space. They are realizations in time and space of whirling arabesques, not entirely unlike some of the arabesques the eighteenth-century English painter William Hogarth described in the enchanting diagrams in his treatise, *The Analysis of Beauty.*

Calder was not the first modern artist to make things that moved. Naum Gabo had created a *Kinetic Construction* (fig. 9) early in the 1920s; and there were works by the Futurists Giacomo Balla and Fortunato Depero, by László Moholy-Nagy, and by Duchamp. But even Rickey, by no means one of Calder's stronger supporters, did acknowledge in his *Constructivism* that "it was Calder who succeeded in securing a place for Kinetic art."[10] If it remains difficult to fully appreciate the scale of Calder's achievement, it is because Calder's fascination with movement has been insufficiently distinguished from a more general concern with the relationship between time and space in twentieth-century art. The struggle to integrate an experience of movement into the painter's planar geometries was essential to the multiple vantage points of the Cubists, to Paul Klee's fascination with the journey of a line, and to Kandinsky's evolution from point and line to plane. Cinema, jazz, electricity, airplanes, automobiles, the workings of chance: these were all of great interest to artists a decade and more before Calder became an abstract artist.

Fig. 9 | Naum Gabo, *Kinetic Construction (Standing Wave)*, **1919–20** (replica, 1985); metal, wood, and electric motor; 24 ¼ × 9 ½ × 7 ½ inches; Tate Gallery, London, Presented by the artist through the American Federation of Arts, 1966

But whereas Picasso, Braque, Matisse, Kandinsky, Klee, and Mondrian reacted to nature and abstraction in terms of planar geometries, and Constantin Brancusi and Jean Arp considered geometry in three dimensions, Calder alone found a way to project this fascination with the movement of forms through time and space back into the real world as an artistic actuality. This is the miracle of the mobile.

Although Calder was always in some deep sense a classicist, dedicated to the freestanding integrity of the work of art, he approached the process of purification in an audaciously improvisational spirit. When the critic Selden Rodman visited Calder's studio in the 1950s to interview the artist, he imagined he was in the workshop of the Wright brothers. Calder had indeed been enchanted by the heroism of early flight; in his autobiography he recalled that while in Paris in 1927 he went out to Le Bourget with friends to see Charles Lindbergh land. Calder's studio, Rodman wrote, was "a machine shop. The floor was deep in steel shavings, wire, nuts and bolts, punched sheet metal..... The air was busy with dangling 'contraptions,' as the brothers in Dayton used to call their experimental warped airfoils and rudimentary engines."[11] Asked by Rodman about his process of composition, Calder responded that he used to "begin with fairly complete drawings, but now

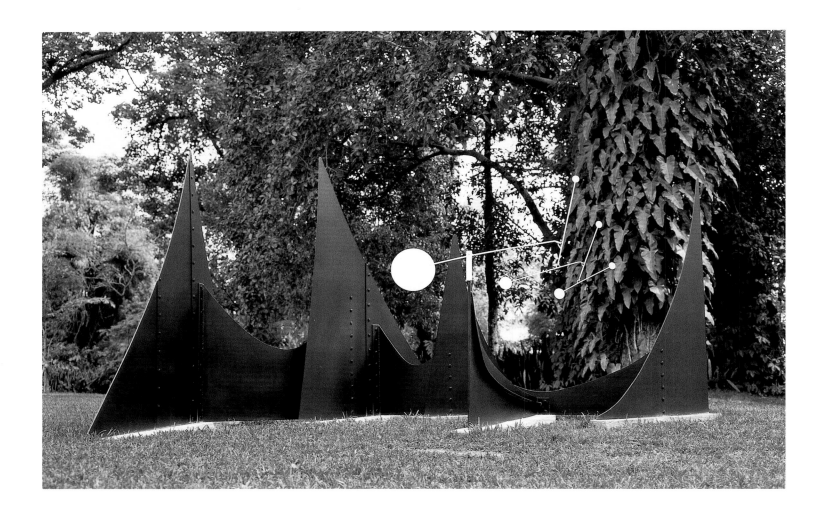

Fig. 10 | Alexander Calder, *The City,* 1960;
iron and steel painted in black and white;
93 × 202 ½ × 120 inches; Collection Fundación
Museos Nacionales, Museo de Bellas Artes,
Caracas

I start by cutting out a lot of shapes." The process of bringing a mobile into being was a matter of a man taking command of his materials. "Next," Calder explained, "I file [the shapes] and smooth them off. Some I keep because they're pleasing or dynamic. Some are bits I just happen to find. Then I arrange them, like *papier collé,* on a table, and 'paint' them—that is, arrange them, with wires between the pieces if it's to be a mobile, for the overall pattern. Finally I cut some more on them with my shears, calculating for balance this time."[12] So the process is irregular, somewhat unpredictable, the finished work combining elements made especially for the occasion with other elements that may have been found lying around the studio.

Asked by Katharine Kuh about *The City* (1960, fig. 10), a large stabile with triangular forms, Calder explained that he made the "model for it out of scraps that were left over from a big mobile. I just happened to have these bits, so I stood

them up and tried them here and there and then made a strap to hook them together—a little like *objets trouvés*."[13] It is interesting to find Calder, in these interviews conducted at midcentury, invoking *papier collé* and *objets trouvés*, those terms of the Cubists and Surrealists that suggest the incorporation of elements from the world beyond the studio—newspaper, wallpaper, postcards, just about anything—into the work of art. The lucidity of Calder's art was wrested from the multiplicity of life, but only after "calculating for balance," as Calder put it in his conversation with Rodman.

Calder was never as concerned with some particular type of form as he was with families of forms, with the relationships between forms. While most of the great abstract artists crystallize a moment in the relations of forms, with Calder such relations remain fluid, provisional, never entirely known. Calder could hardly have brought such fluidity to the art of sculpture had it not been for his encounters with the fundamentals of physics at the Stevens Institute of Technology more than a decade before he conceived of the mobile. But these basic laws of mechanics were in turn enlarged through a poetic spirit's feeling for the ways in which forms act and are acted upon in the workaday world. Some studies of Calder's work, taking their lead from the artist himself, have emphasized his interest in the solar system as the essential key to his art. Calder apparently told Rodman that "even before he studied engineering, he had been enthralled by eighteenth-century toys demonstrating the planetary system."[14] And Joan M. Marter, in her monograph on the artist, speculated that Calder might have seen in the Conservatoire des Arts et Métiers in Paris eighteenth-century models of the solar system, which indeed suggest early works such as *Croisiére* (1931).[15]

But however important this fascination with the movements of the solar system was for Calder, I think there was much that was closer to hand that fueled his feeling for the never-ending collisions and collusions of matter and energy in our lives. All movements mattered to Calder, even and perhaps especially the humblest and the most human, the memories of seeing things move in childhood, or the way somebody he liked or loved happened to move. A book Calder remembered fondly from when he was a boy, Daniel Carter Beard's *The Outdoor Handy Book*, has an entire chapter on "Malay and Other Tailless Kites," with detailed instructions for making these fantasy objects that float through the air. Nearly half a century later, on the eve of a trip to India, Calder said that he very much wanted to see a famous kite festival. Although Calder was a worse than indifferent athlete and by all accounts an idiosyncratic dancer, during his college years he was always eager to take his chances on the athletic field and the dance floor. Athletes, acrobats, and dancers were themes in his first mature work, the wire sculptures of the late 1920s, and sometimes they actually moved, not only the figures he created for the *Cirque Calder* that he began performing in 1926, but also some of his studies of the great dancer Josephine Baker, which had moveable joints so that they could be manipulated as if they were

marionettes. A taste for the theater, where movement of all kinds is framed within the proscenium arch, was inculcated in Calder by his father, who closely followed the theatrical arts. Calder worked for a brief time in 1924 as a stage-hand at the Provincetown Players in Greenwich Village; he created sets for the revolutionary modern dancer Martha Graham in the 1930s; and in 1968 he mounted *Work in Progress* (figs. 11–12), a ballet without dancers in which mobiles took their places on the stage, at the Opera House in Rome. Calder and his wife Louisa loved to dance, and were enchanted by samba and other dance music they encountered in Brazil in 1948; the dance parties in their Connecticut farmhouse were famous among their friends.

Calder was a heavy man but light on his feet and extraordinarily agile with his hands, and in some deep sense his art must have grown out of a desire to find his proper balance in the world. Although he jealously guarded his solitude in his studio, he thrived on his close relationships with his family and his friends. His allegiance to his parents, his sister, and his children was thoroughgoing and intense, and although Calder and his wife were bohemians to their fingertips, they were sometimes saddened by and perhaps even somewhat disapproving of the divorces of good friends. As for friendship, it was something Calder quite simply could not do without, and to the end of his life he remained close to many people he had first known in the 1920s and 30s—and not only the famous ones. That Calder saw the constantly shifting interactions of elements in his mobiles as some-how reflecting the experience of a person in a family or a person among friends is not mere speculation, for on at least two occasions Calder created mobiles in which each element stands for a member of the family. The first and most interesting of these was made in the late 1930s for the English artists Ben Nicholson and Barbara Hepworth, who when they were married not only had triplets together but also

Fig. 11 | Alexander Calder, *Work in Progress*, 1968; at the Teatro dell'Opera di Roma, 1968

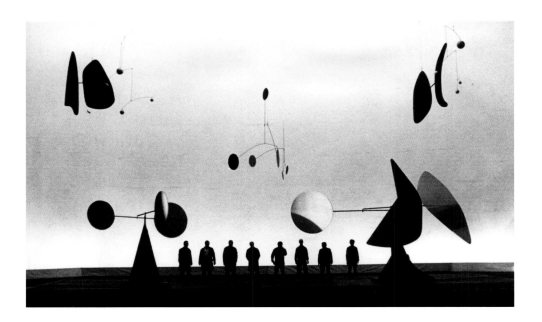

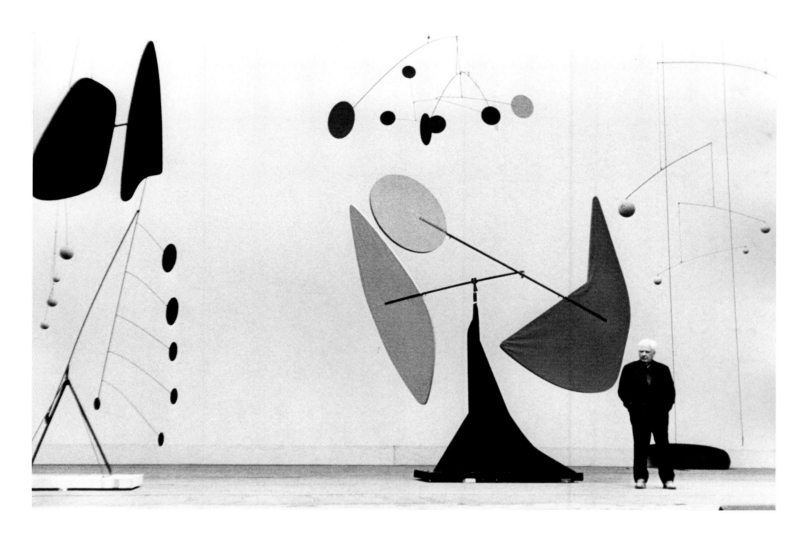

Fig. 12 | Alexander Calder on the set for *Work in Progress* (1968) at the Teatro dell'Opera di Roma, 1968

had children from Nicholson's previous marriage. That Calder thought to turn the essentially abstract nature of the mobile to the representation of a family and its dynamics is extraordinarily telling, underscoring as it does the extent to which any mobile is a kind of family, a family of forms.

And here, at least so I believe, we come to the crux of the matter. A mobile is a genealogy of forms, a family tree, a gathering of a particular tribe. Sometimes a mobile contains two families; sometimes a mobile contains three. There are mobiles that gather together many similar elements. And there are mobiles in which a single element (the face of a clown, an exotic flower) stands out from all the rest. Sometimes Calder's mobiles suggest utopian families, sometimes dysfunctional ones. Sometimes Calder's families are vegetal, sometimes mineral, sometimes astral. Whatever the temperament in a particular mobile, and it can range from disquietude to ebullience, there is always the possibility that the temperature will rise or fall, the relationships and the situations change yet again. Always, with Calder, there is this deep, abiding optimism, this sense that when matter and energy meet, miracles can happen. Always, a mobile is a dance to the music of time.

NOTES

1. James Johnson Sweeney, *Alexander Calder* (New York: Museum of Modern Art, 1943), 38.
2. Quoted in Sue Prideaux, *Strindberg: A Life* (New Haven, CT: Yale University Press, 2012), 11.
3. Vladimir Jankélévitch, *Ravel,* trans. Margaret Crosland (New York: Grove Press, 1959), 85.
4. Henry S. Carhart and Horatio N. Chute, *First Principles of Physics* (Boston, New York, and Chicago: Allyn and Bacon, 1912), 1.
5. George Rickey, *Constructivism: Origins and Evolution* (New York: George Braziller, 1967), 65.
6. Alexander Calder, *Calder, An Autobiography with Pictures* (London: Allen Lane, The Penguin Press, 1967), 54–55. Originally published 1966.
7. Harry Crosby, *Shadows of the Sun: The Diaries of Harry Crosby*, ed. Edward Germain (Santa Barbara, CA: Black Sparrow Press, 1977), 197.
8. Katharine Kuh, "Alexander Calder," in *The Artist's Voice: Talks with Seventeen Artists* (New York: Harper and Row, 1962), 39.
9. Ibid., 44.
10. Rickey, *Constructivism: Origins and Evolution,* 195.
11. Selden Rodman, *Conversations with Artists* (New York: Devin-Adair Co., 1957), 137.
12. Ibid., 140.
13. Kuh, "Alexander Calder," 50.
14. Rodman, *Conversations with Artists*, 139.
15. Joan M. Marter, *Alexander Calder* (New York: Cambridge University Press, 1991), 106.

Works
in the
Exhibition

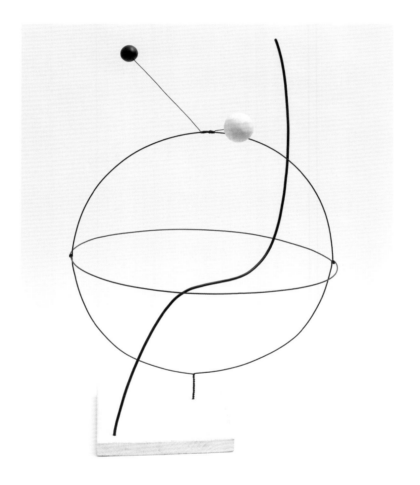

Croisiére | 1931 | 37 × 23 × 23 inches

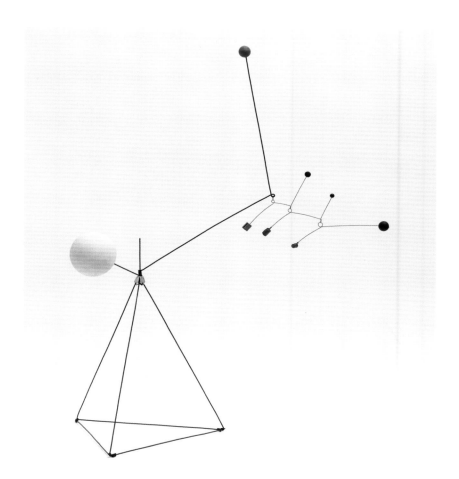

Small Feathers | 1931 | 38 ½ × 32 × 16 inches

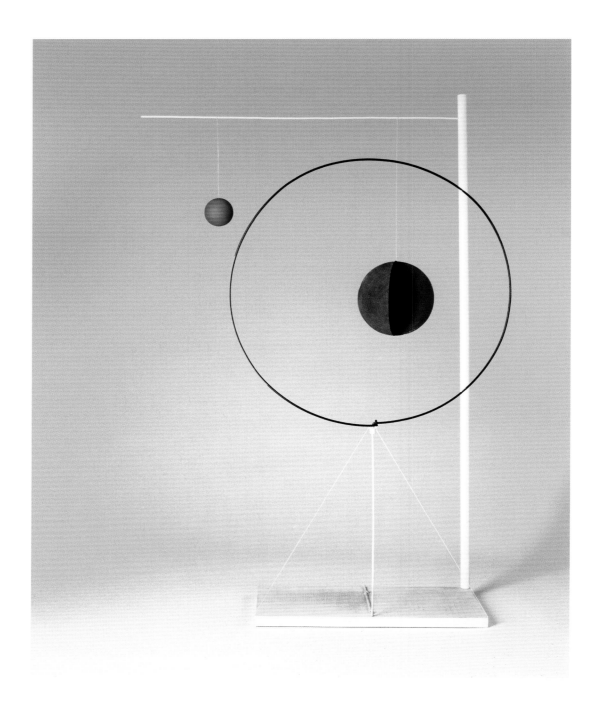

Object with Red Ball | 1931 | 61 ¼ × 38 ½ × 12 ¼ inches

Untitled | 1934 | 113 × 68 × 53 inches

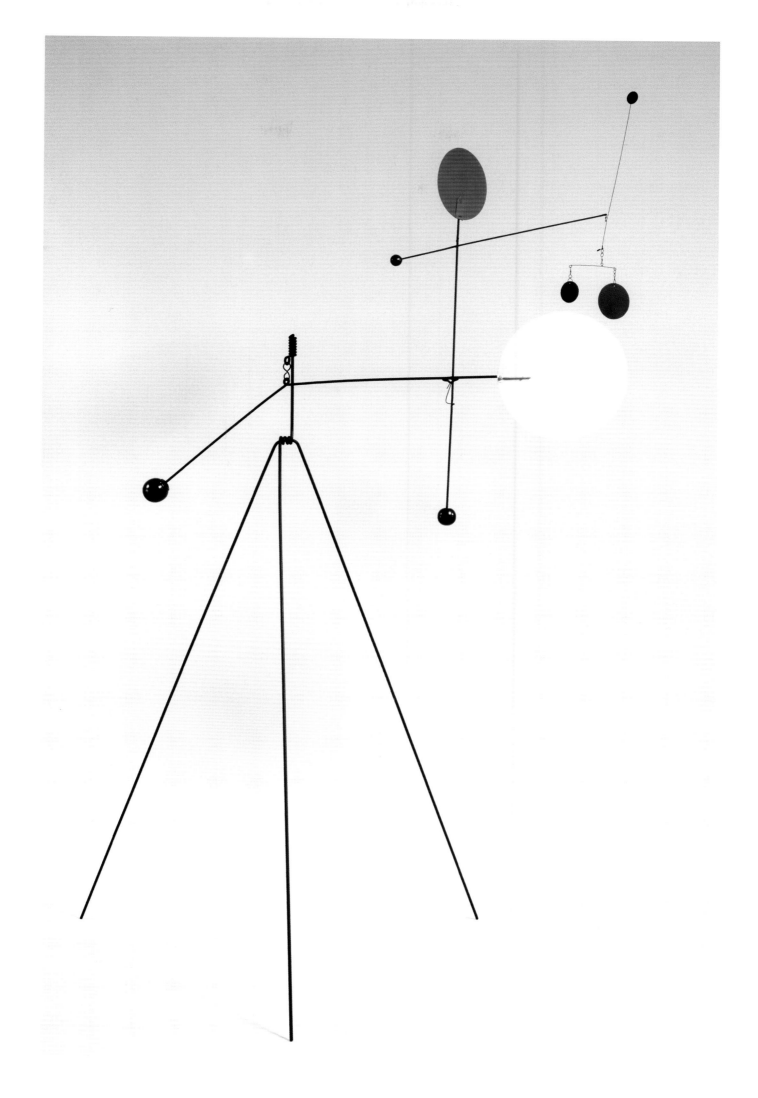

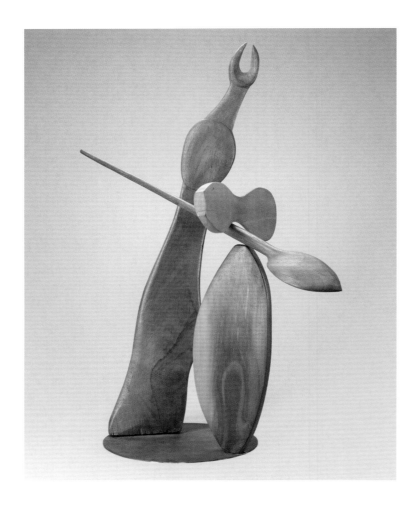

4 Woods (Diana) | 1936 | 30 ½ × 17 ¾ × 19 ¼ inches

Gibraltar | 1936 | 51 ⅞ × 24 ¼ × 11 ⅜ inches

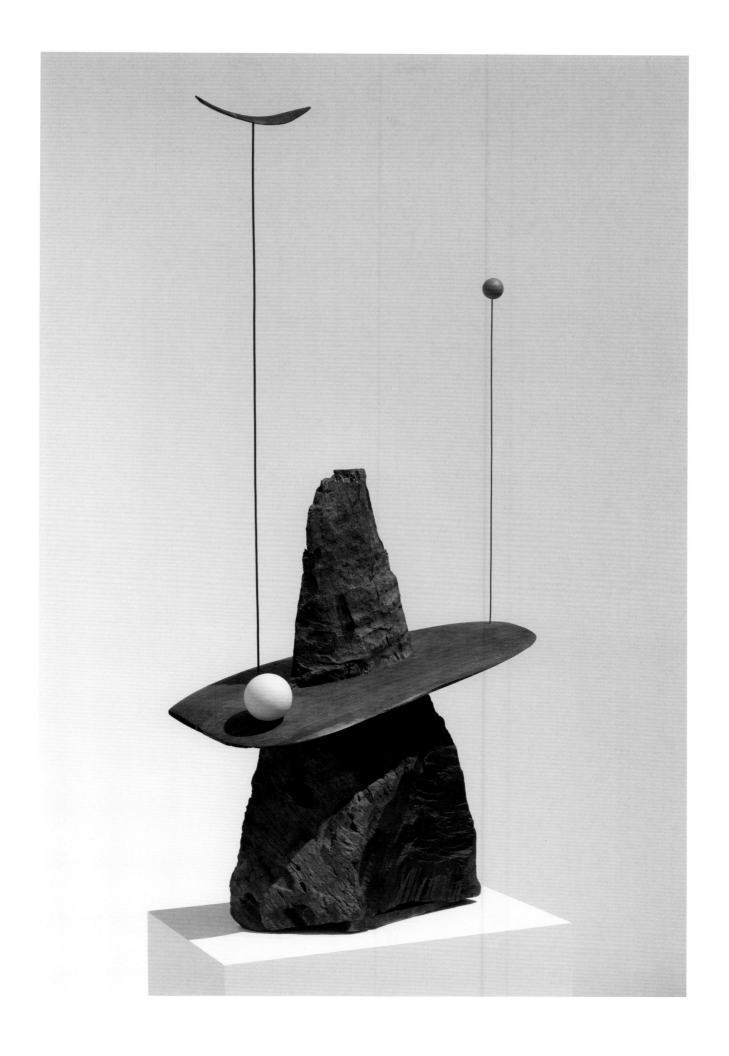

Red Panel | c. 1938 | 48 × 30 × 24 inches

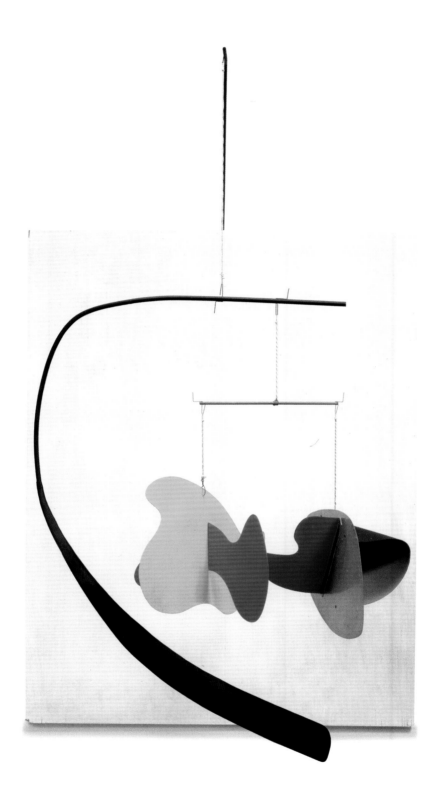

White Panel | 1936 | 84 ½ × 47 × 51 inches

Snake and the Cross | 1936 | 81 × 51 × 44 inches

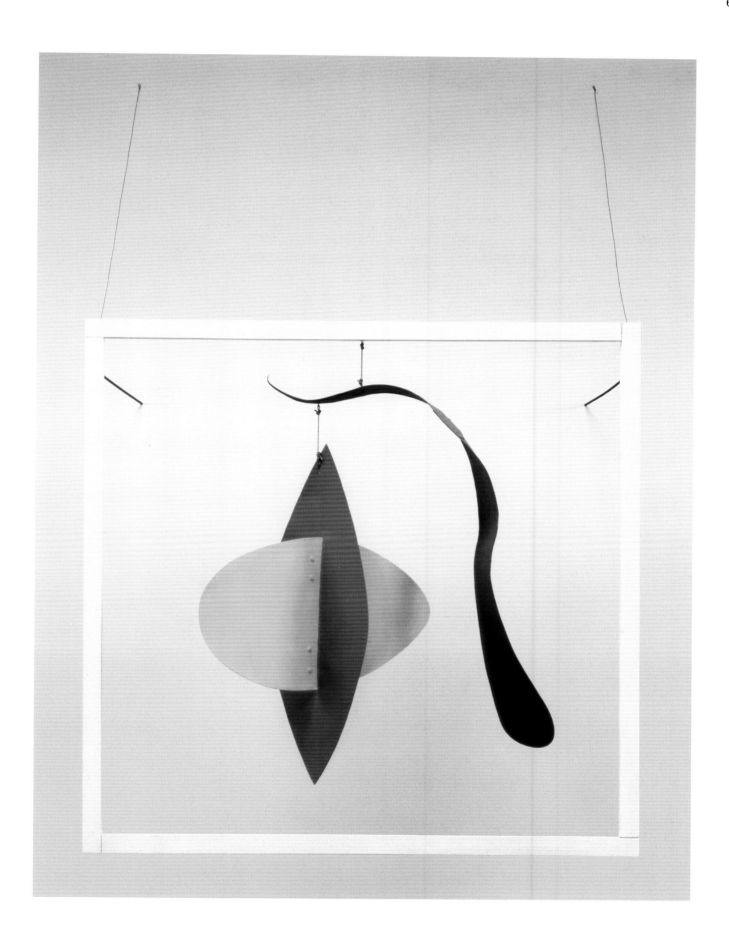

Untitled | c. 1938 | 31 × 48 × 39 inches

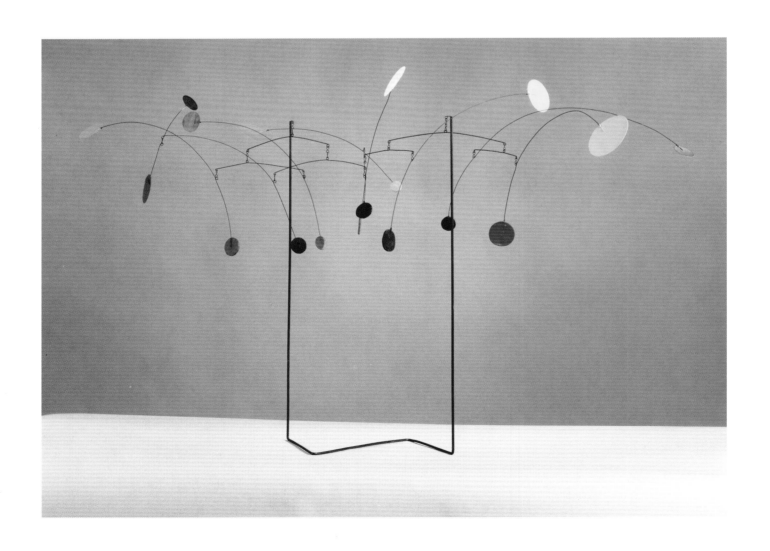

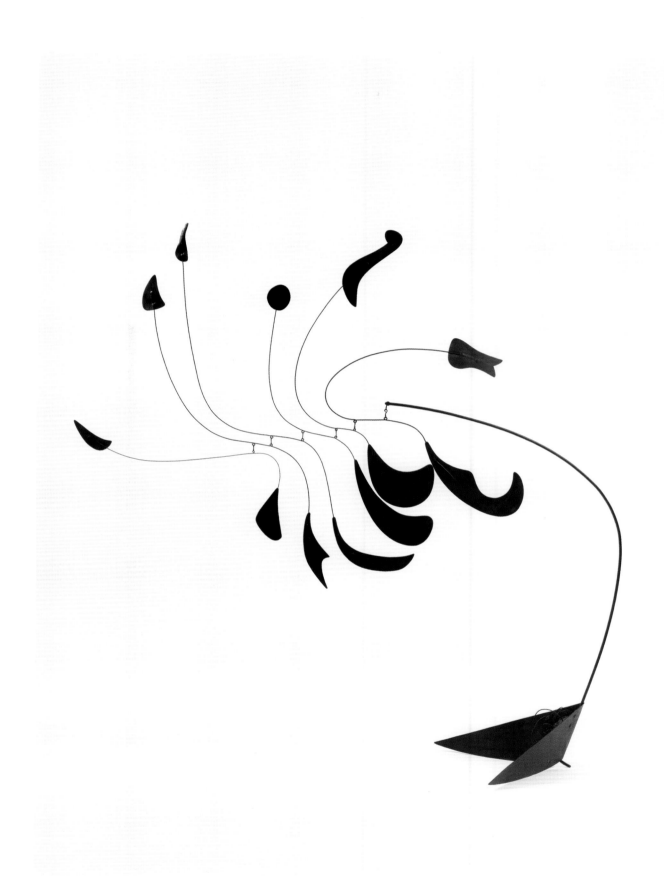

Untitled | 1939 | 55 ½ × 64 ½ inches

La Demoiselle | 1939 | 58 ½ × 21 × 29 ½ inches, and detail

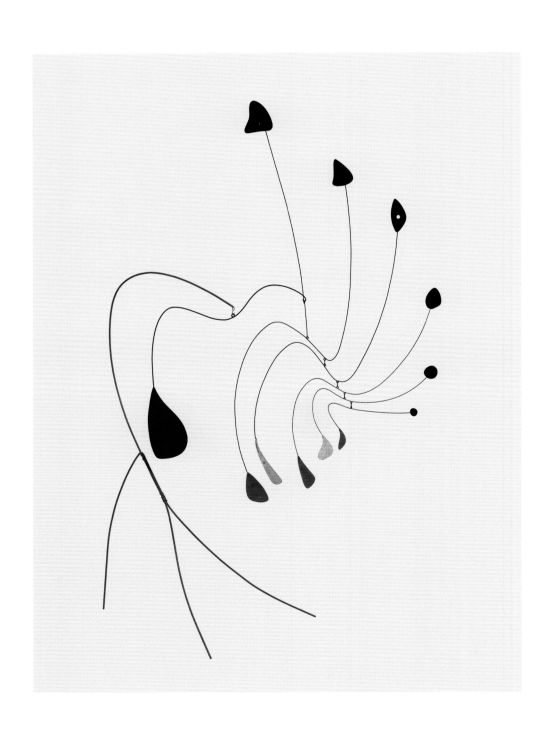

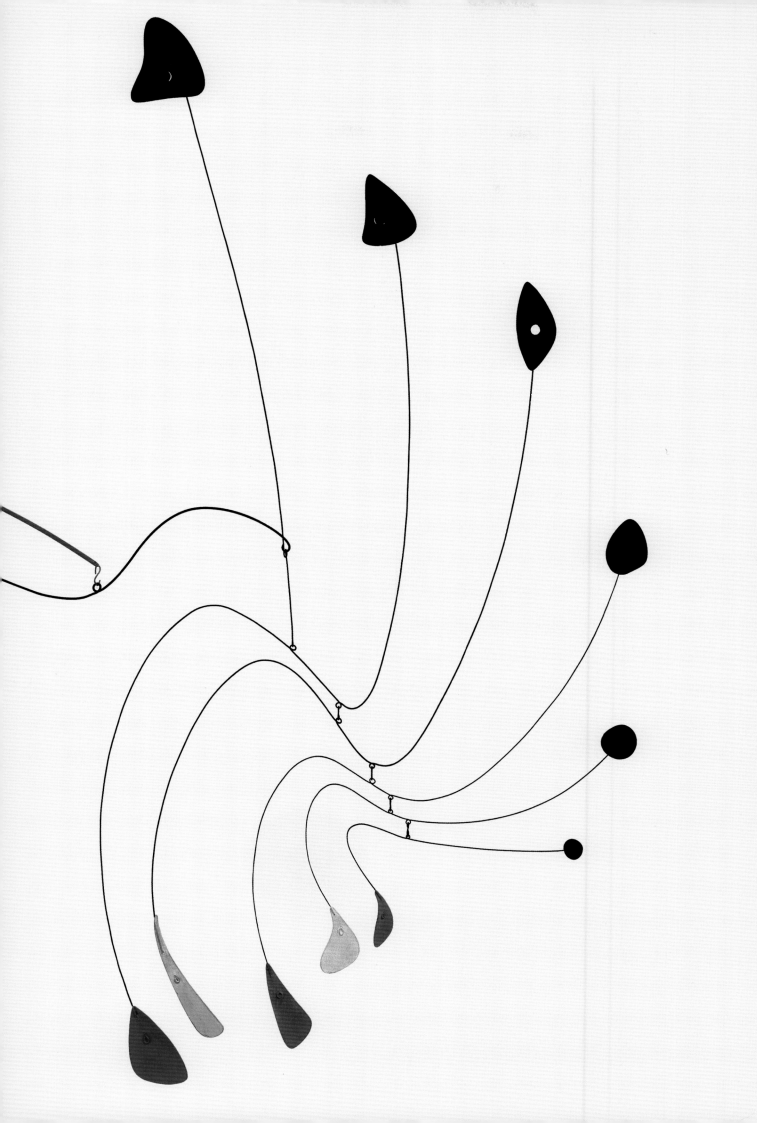

Eucalyptus | 1940 | 94 ½ × 61 inches

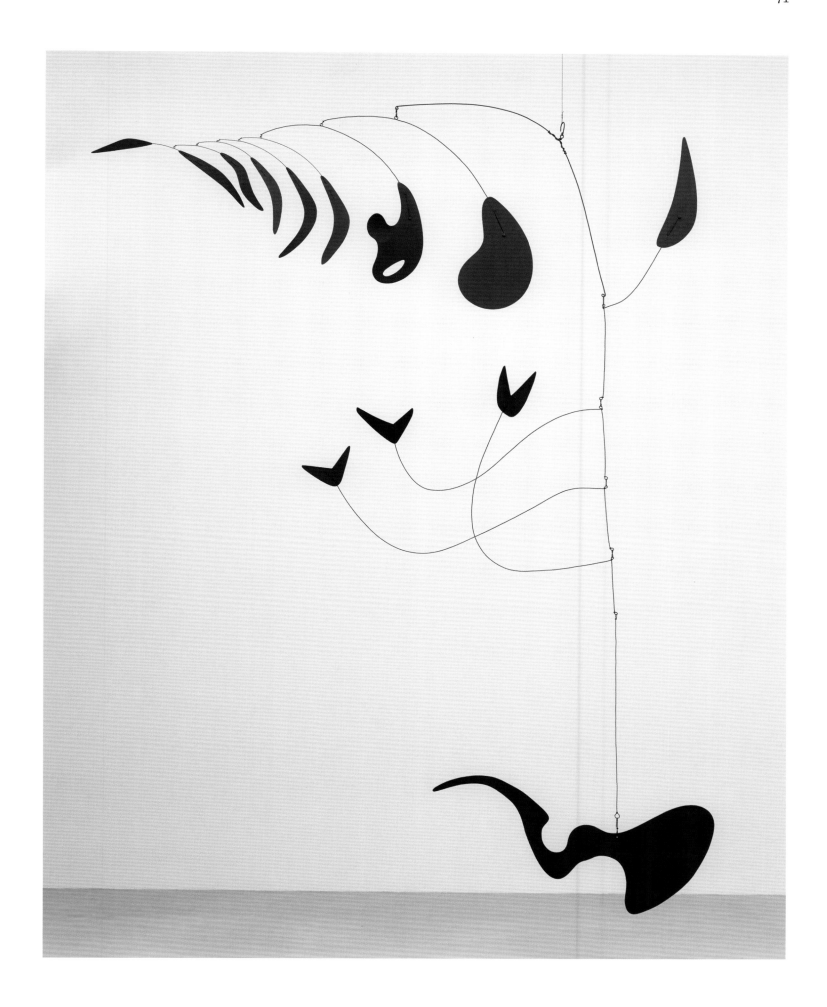

Un effet du japonais | 1941 | 80 × 80 × 48 inches

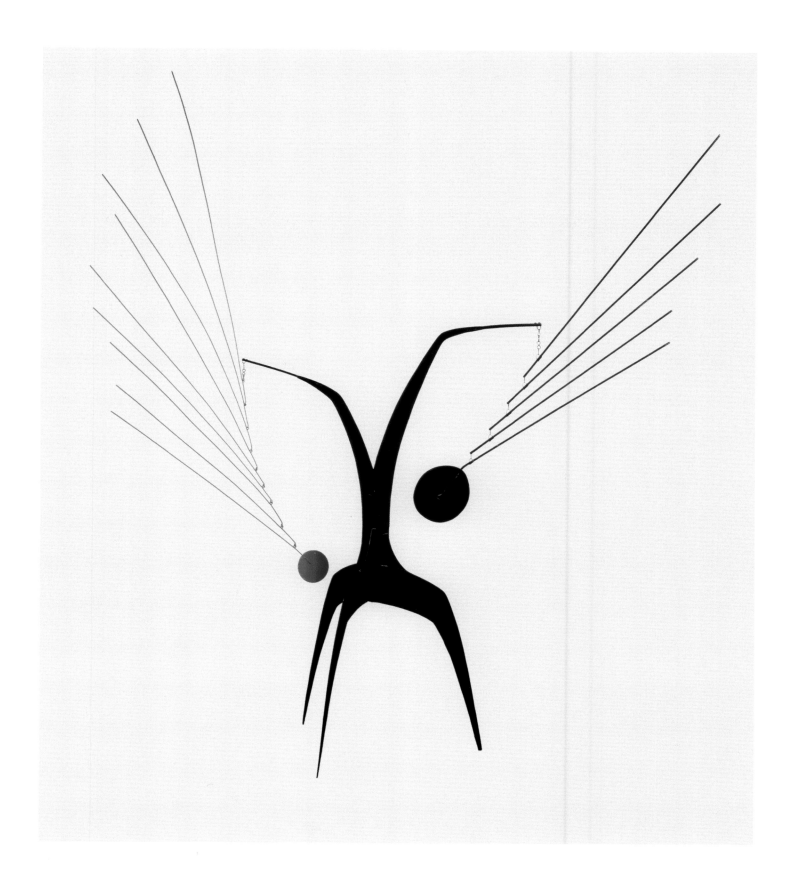

Tree | 1941 | 94 × 54 × 51 inches, and detail

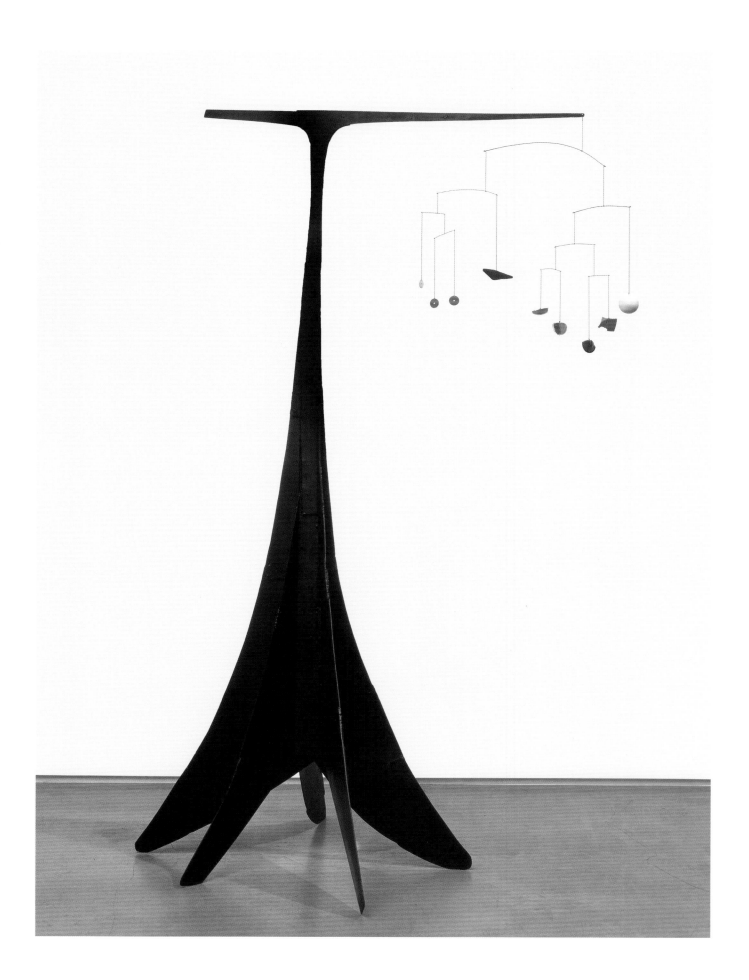

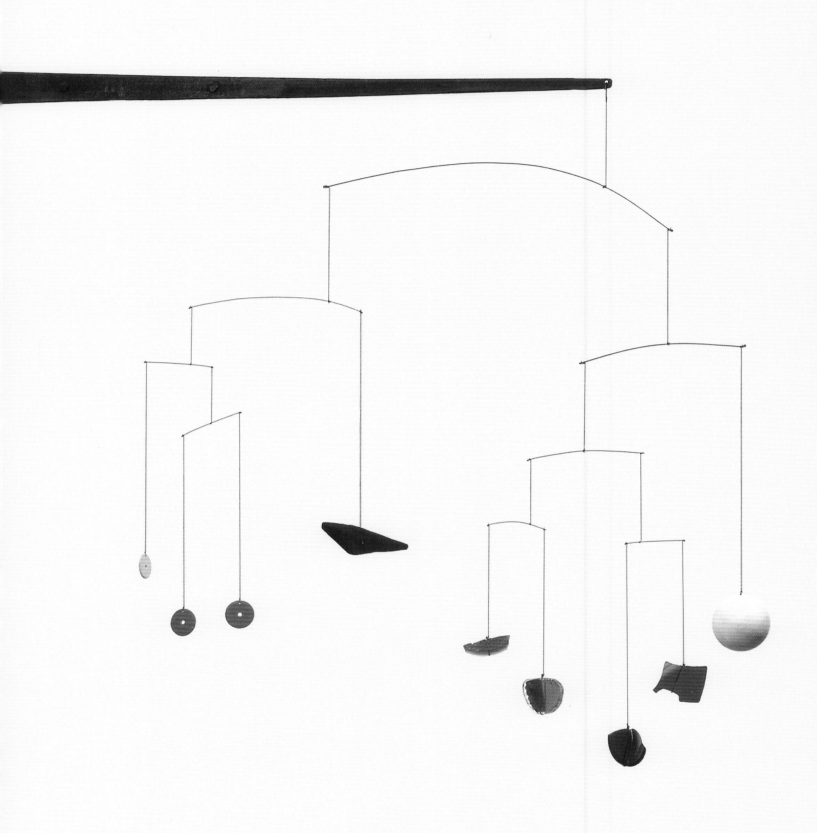

Boomerangs | 1941 | 45 × 117 inches

Yucca | 1941 | 73 ½ × 23 × 20 inches

Constellation with Two Pins | 1943 | 24 × 17 ½ × 17 inches

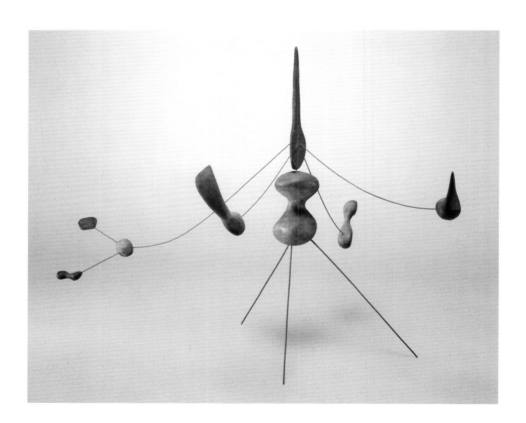

Constellation | c. 1942 | 22 ½ × 28 ½ × 20 inches

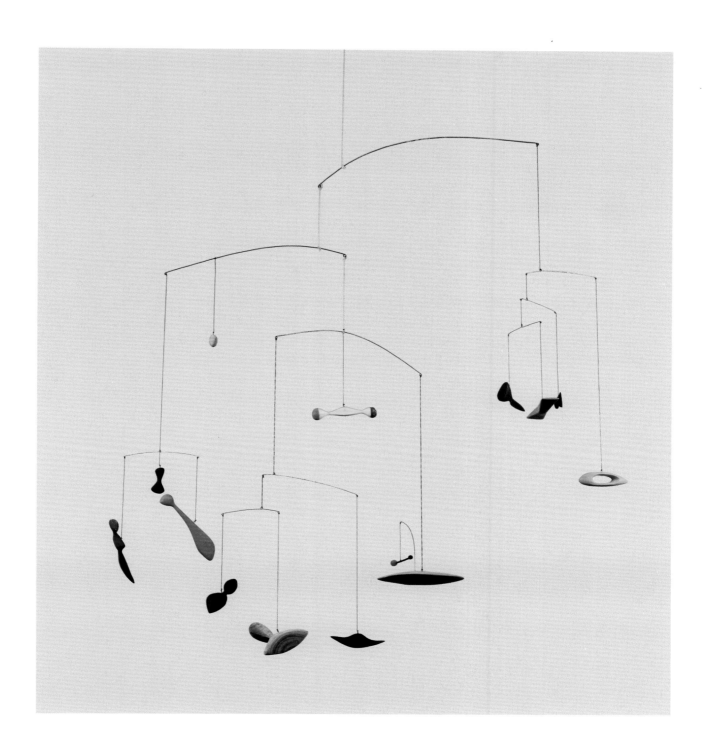

Constellation Mobile | 1943 | 53 × 48 × 35 inches

Horizontal Spines | 1942 | 54 ½ × 50 × 22 ½ inches

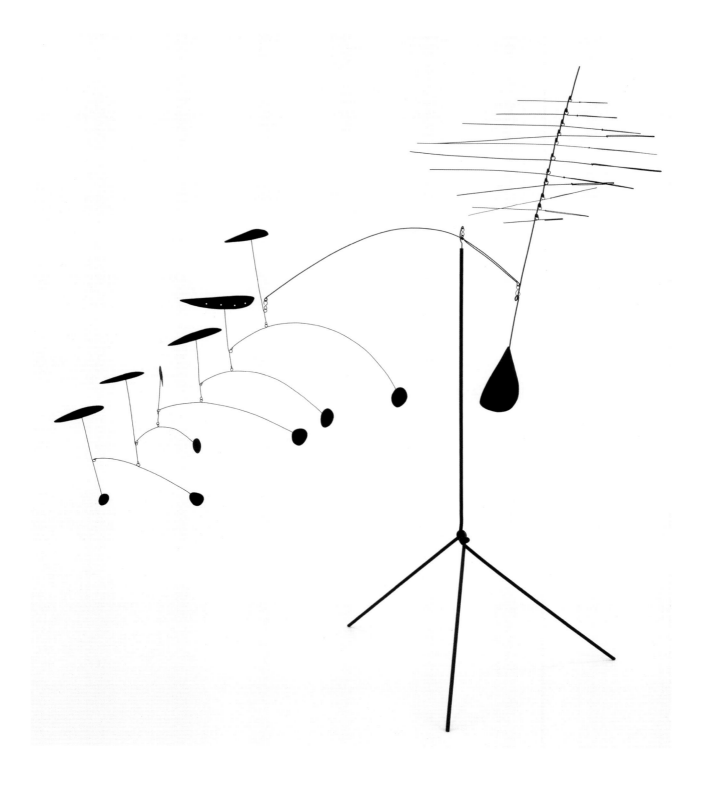

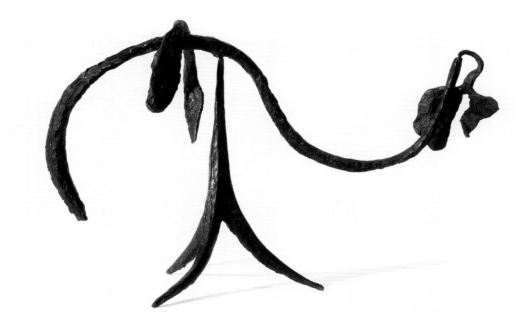

The Vine | 1944 | 26 × 40 × 16 ¼ inches

Fake Snake | 1944 | 44 × 13 ½ × 15 inches

Snow Flurry | 1948 | 73 × 81 inches

Gamma | 1947 | 58 × 84 × 36 inches

Orange Under Table | c. 1949 | 72 × 82 × 82 inches

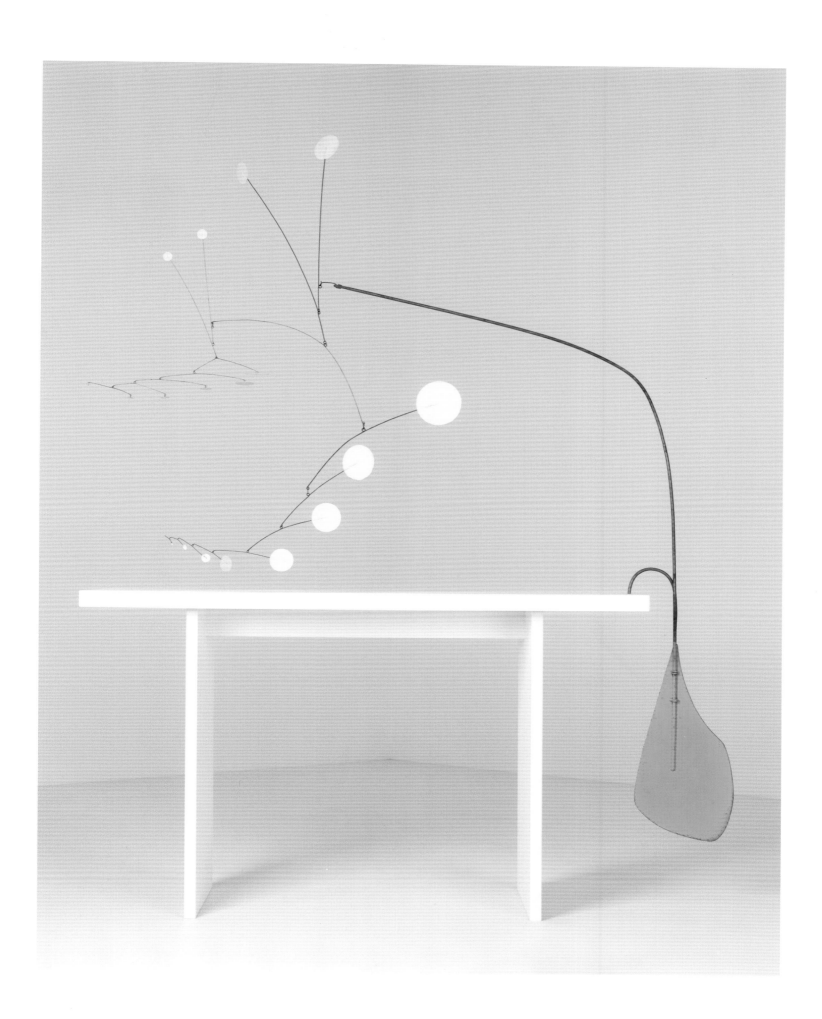

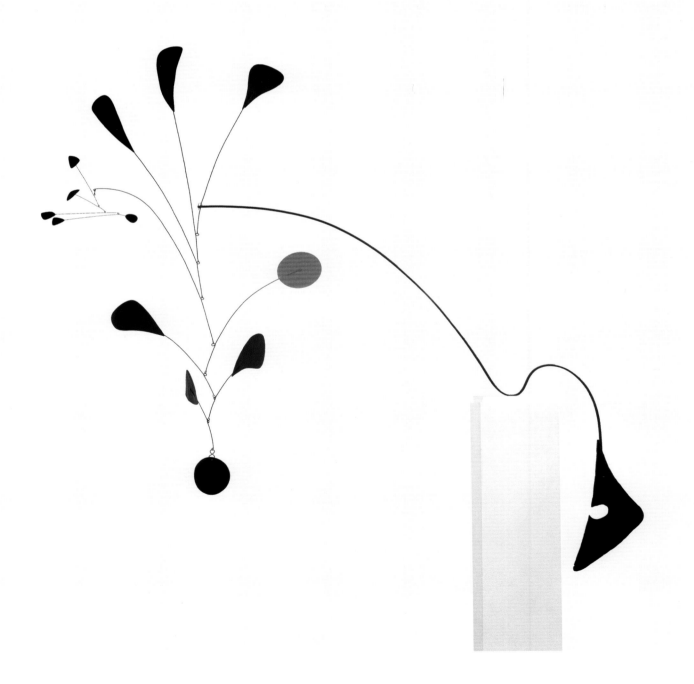

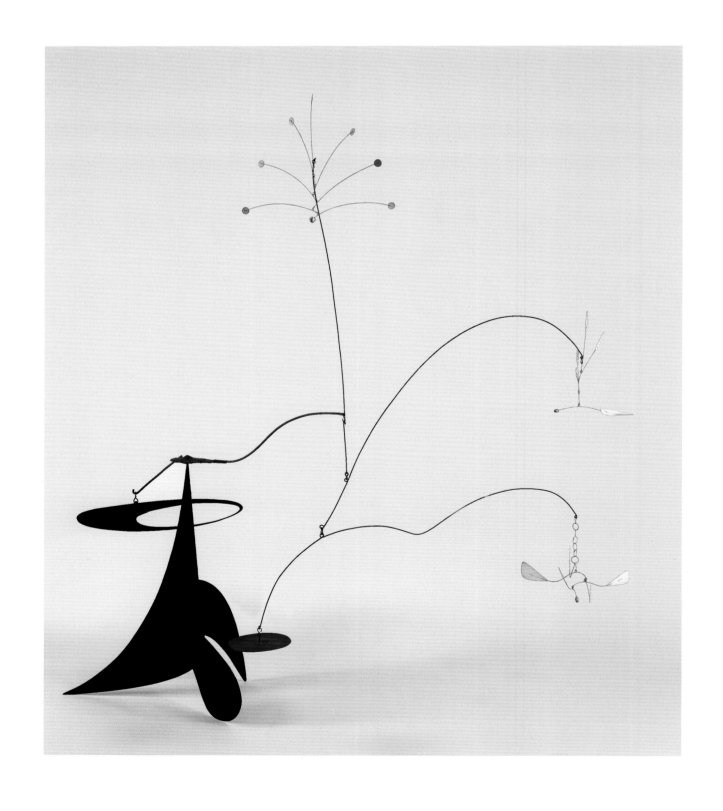

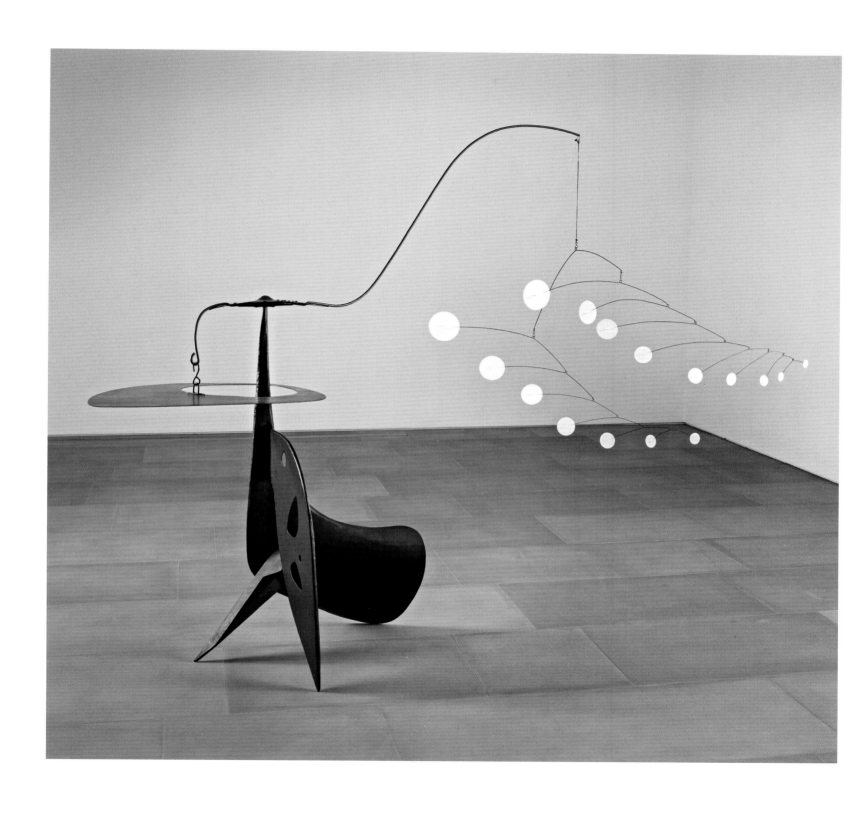

Bougainvillier | 1947 | 78 ½ × 86 inches

Laocoön | 1947 | 80 × 120 × 28 inches

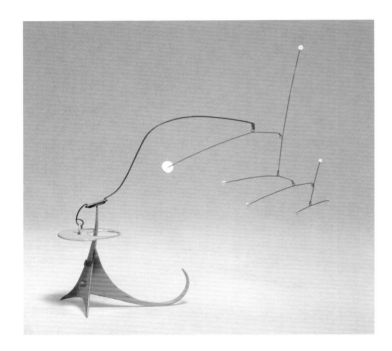

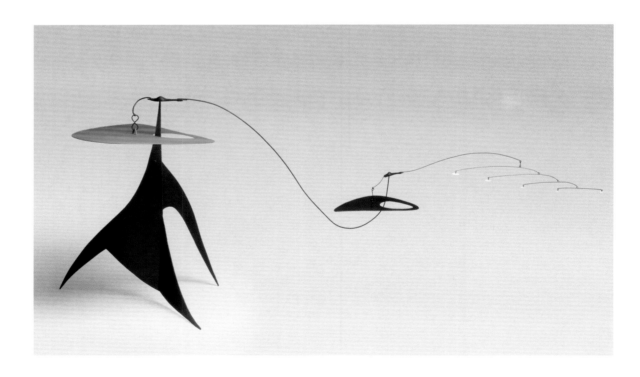

Little Pierced Disc | c. 1947 | 11 × 14 ½ × 3 ½ inches

Little Parasite | 1947 | 19 ½ × 53 × 18 ¾ inches

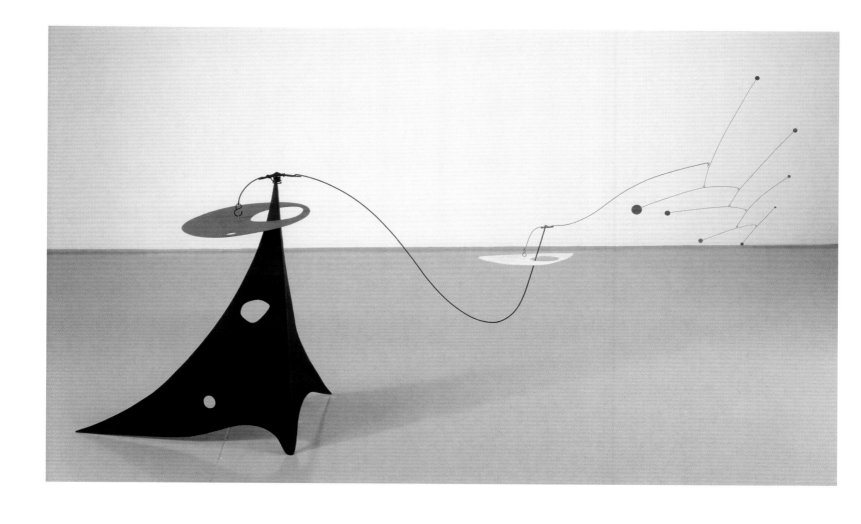

Parasite | 1947 | 41 × 68 × 28 inches

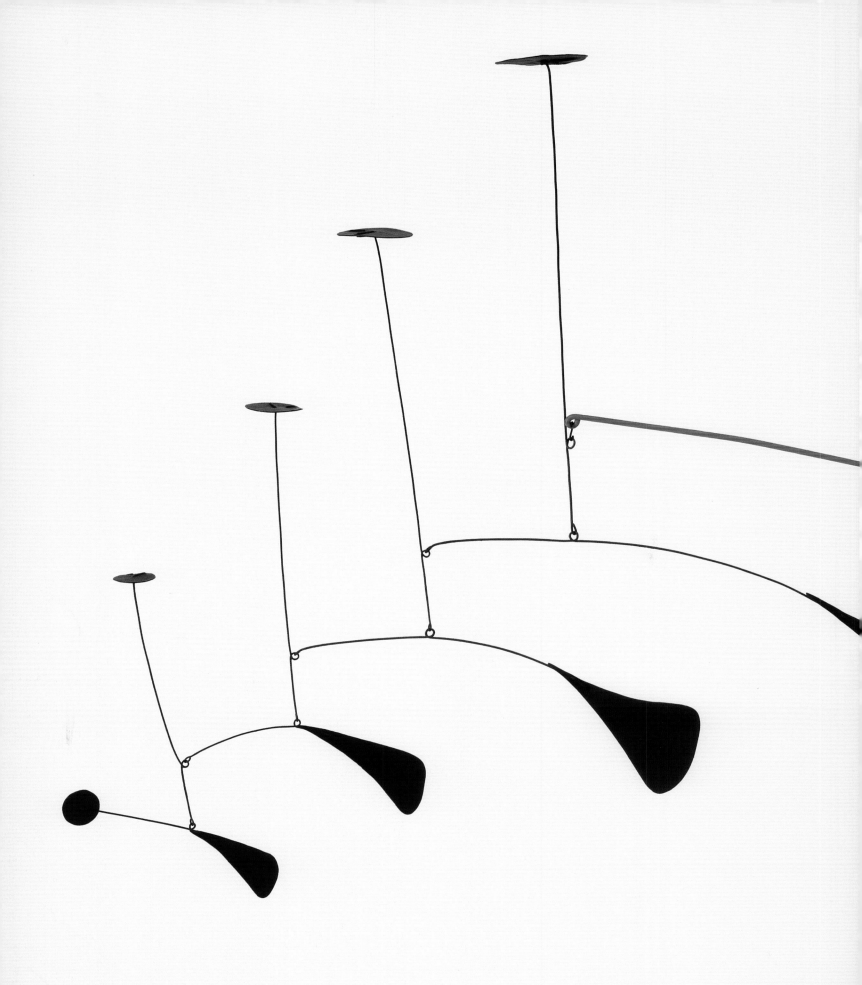

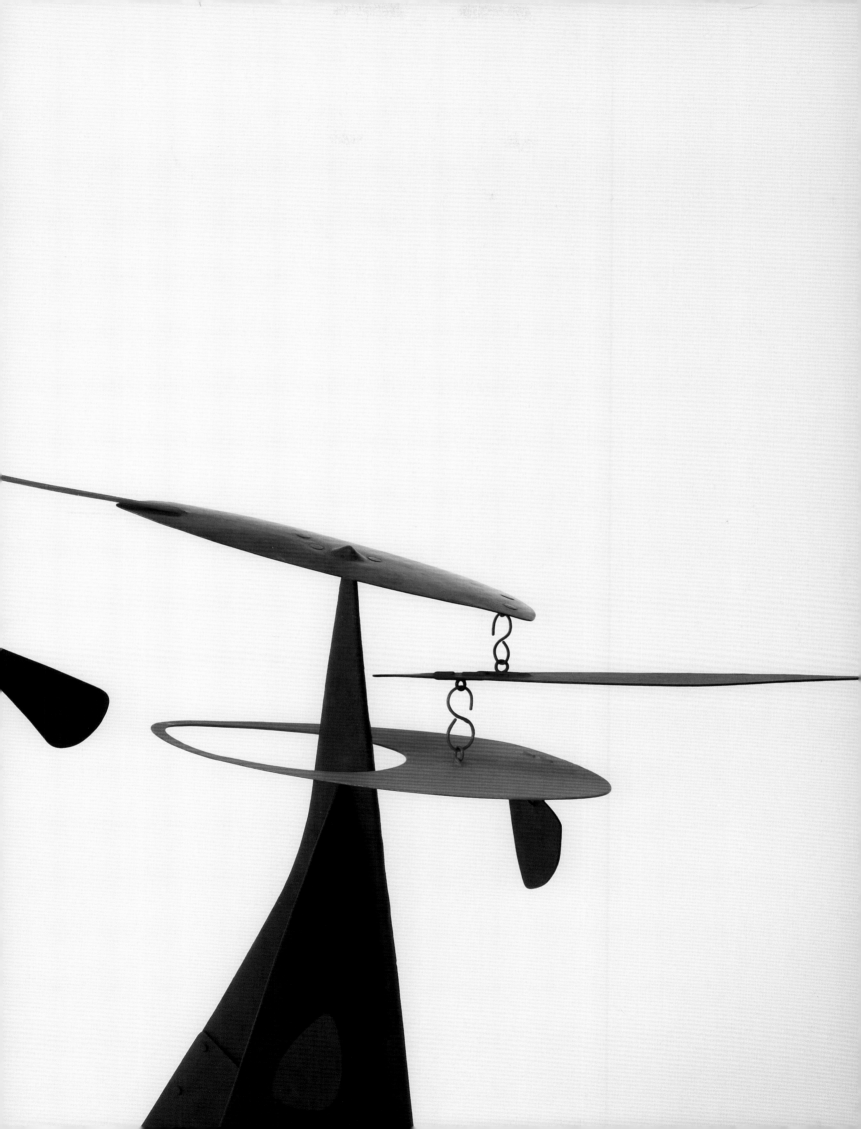

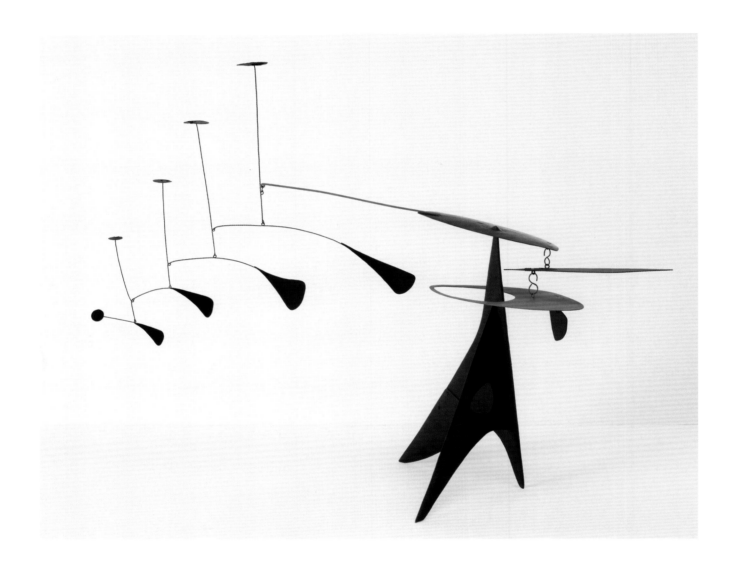

Blue Feather | c. 1948 | 42 × 55 × 18 inches, and detail (previous pages)

Red Disc, Black Lace | 1948 | 29 × 65 × 46 inches

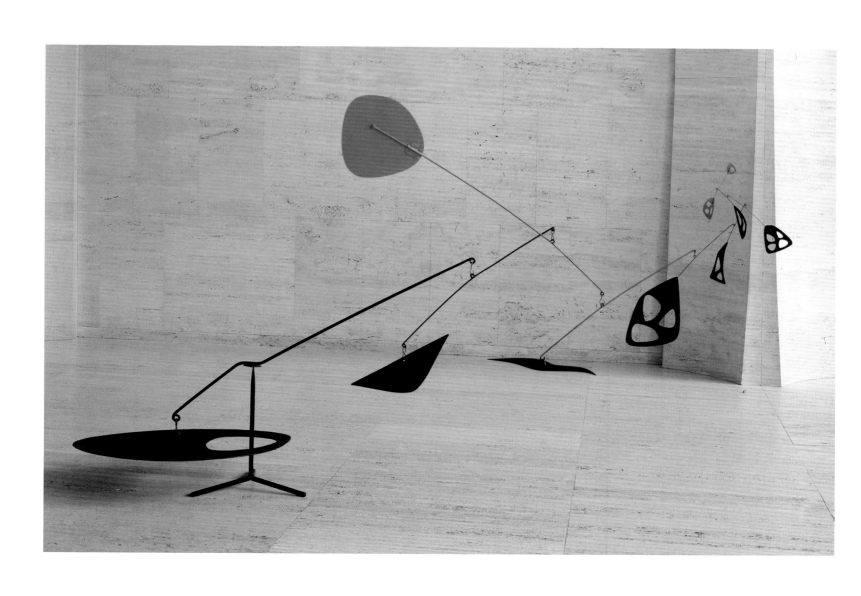

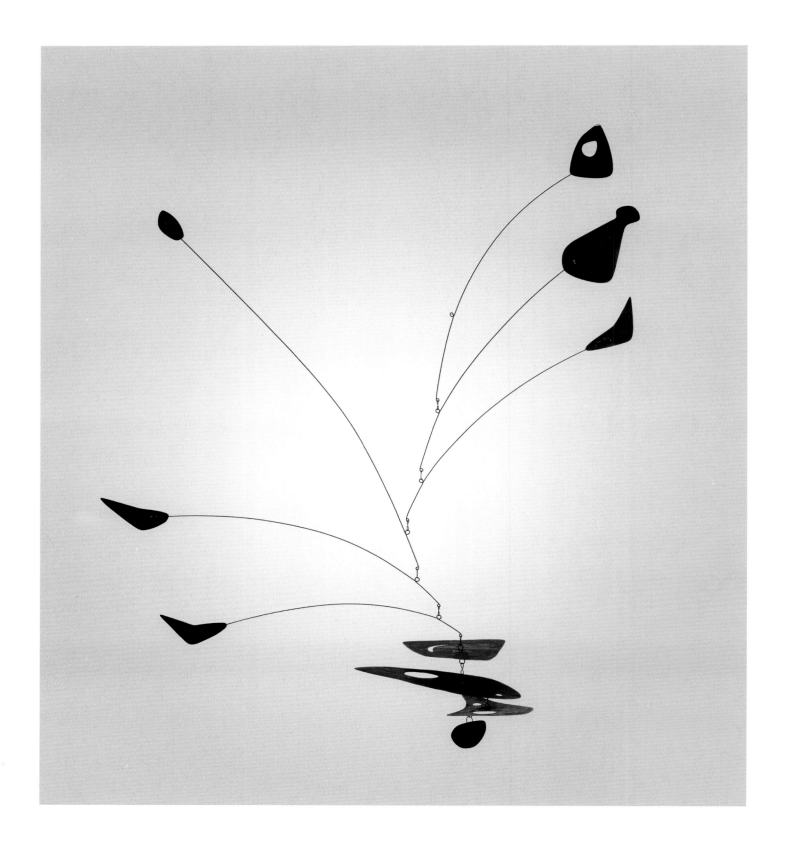

Untitled | 1947 | 66 × 53 inches

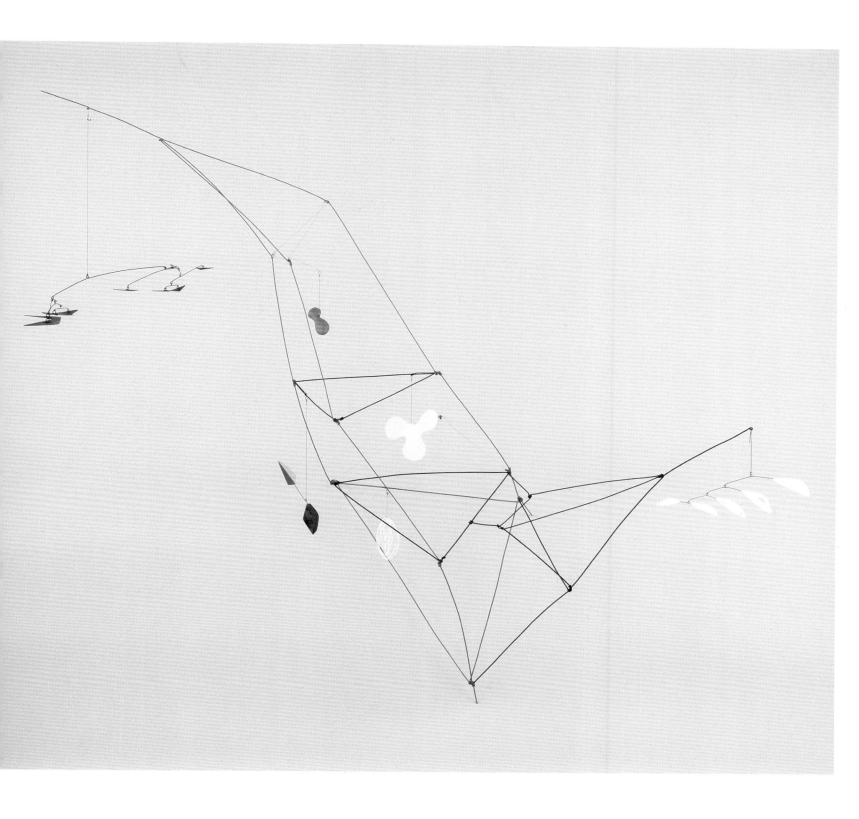

Bifurcated Tower | 1950 | 58 × 72 × 53 inches

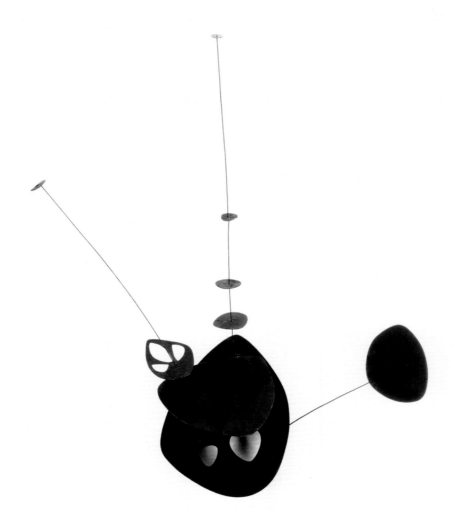

Escutcheon | 1954 | 45 × 35 × 29 inches

Black Mobile with Hole | 1954 | 88 × 96 inches

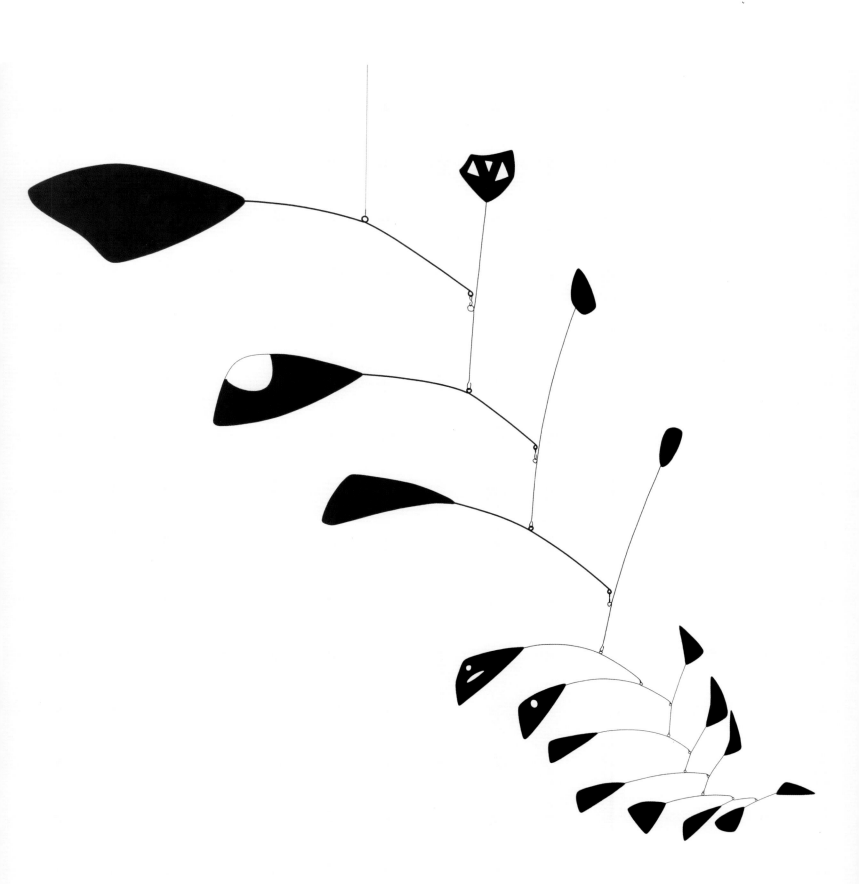

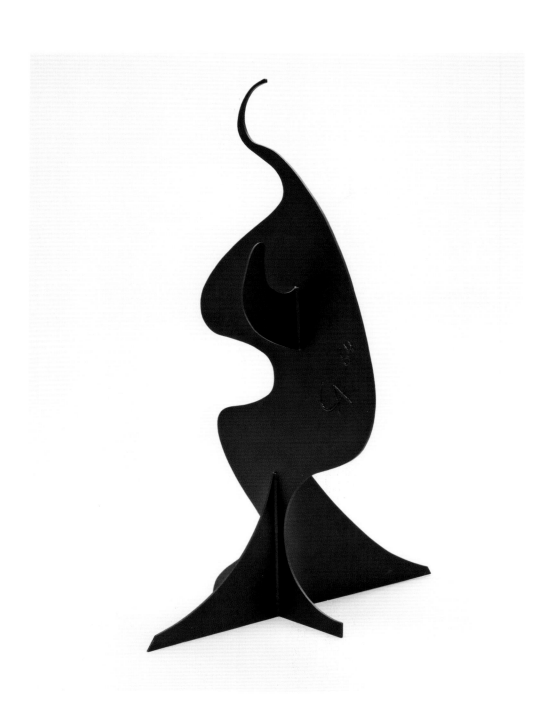

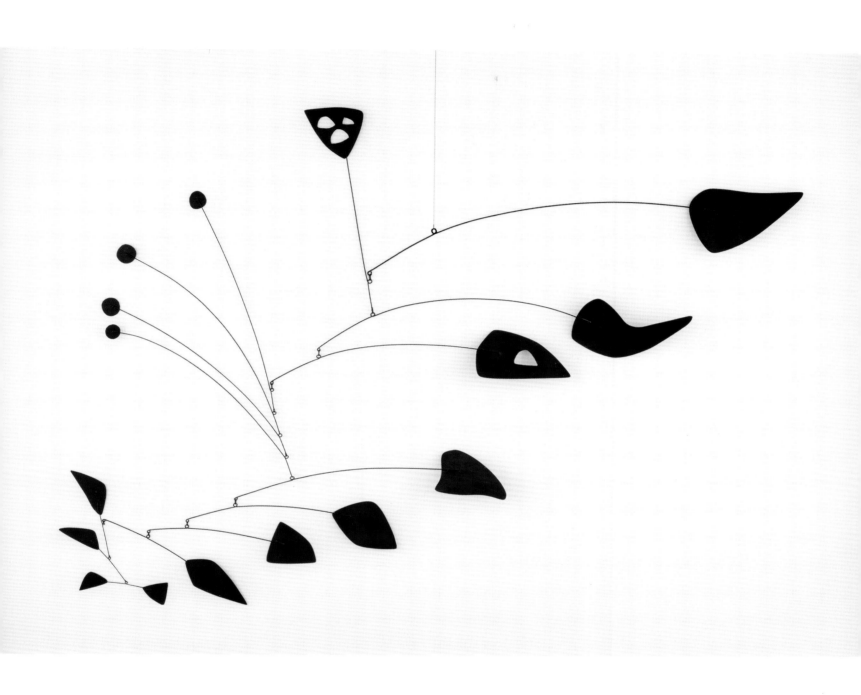

Portrait | 1964 | 52 ¼ × 37 × 25 inches

Little Face | 1962 | 42 × 56 inches

Ilene Susan Fort

Calder's
Hello Girls:

History
of a
Commission

ON MARCH 31, 1965, the Los Angeles County Museum of Art (LACMA) opened its doors in a new complex graced with several large outdoor sculptures.[1] Among them was Alexander Calder's monumental *Hello Girls*, now known as *Three Quintains* (*Hello Girls*),[2] a seminal achievement for both the region and the artist. The work heralded a new era for Southern California as Los Angeles expanded its population, geography, and cultural sophistication, and it marked only the second large, public Calder sculpture to be installed in the state—and the first on the West Coast to be specially commissioned for its site. The work would become one of only a few fountain sculptures that the artist realized during his long, productive career.

At the time of the opening, critic and former Chicago gallery owner and curator Katharine Kuh noted that the "art business" was flourishing in Los Angeles. "Well over one hundred" commercial galleries, "had appeared in the last decade, appreciably outnumbering those in any other American city except New York."[3] The county had established its first museum in 1913 when the Los Angeles Museum of History, Science, and Art was opened in Exposition Park south of downtown. The art division thrived beyond those of history and science, however, and by the late 1950s the administration, as well as local collectors and patrons, saw the need for a separate building. The new, independent art museum was to be located between Hancock Park and Beverly Hills, both thriving upper-class residential sections of the city. The structure was erected on county-owned property that had been donated by developer Captain George Allan Hancock in 1913. The art museum was situated on the southwest side of the small park along Wilshire Boulevard (one of the most important thoroughfares in the city, running from downtown to the ocean) and next to the La Brea Tar Pits.

Throughout the planning, designing, and construction of LACMA, the trustees were the primary decision makers, in consultation with the museum director and senior staff. As the minutes of their meetings demonstrate, they aimed to present the city and country with a building complex that was modern both inside and out, thus signaling the progressive nature of the region. Five of the most esteemed architects in the United States were considered: Philip Johnson, William L. Pereira, Eero Saarinen, Edward Durell Stone, and Mies van der Rohe.

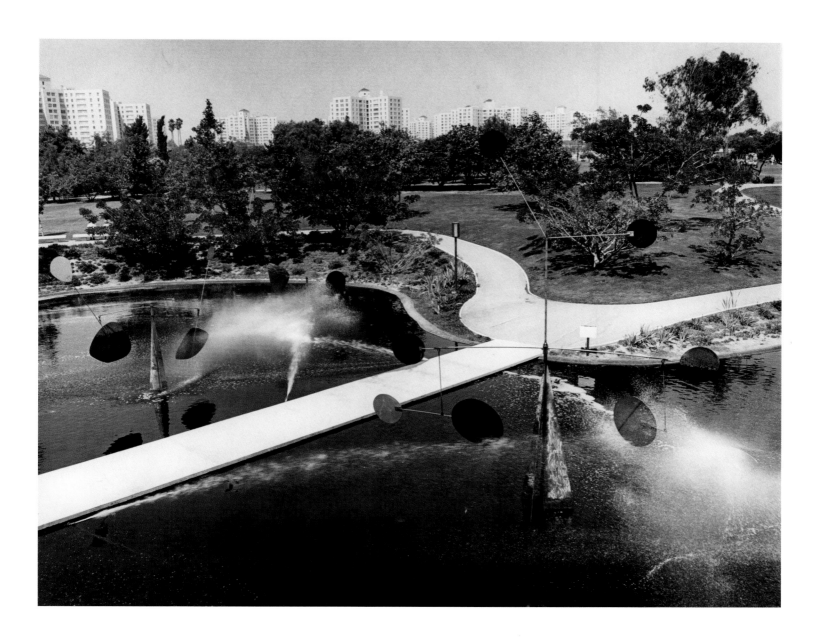

Fig. 1 | Alexander Calder, *Three Quintains*
(*Hello Girls*), **1964**; showing the original
placement of the sculpture, 1966

The trustees asked insurance and financial tycoon Howard Ahmanson, who would
become the benefactor of the building on the museum's west side, to select two
finalists from the five candidates, and then the board would make the decision. The
board ultimately chose Pereira, a transitional figure on the West Coast who was
moving the region from tradition-bound public buildings to a modernist idiom, albeit
one that avoided any radical or controversial elements.[4] His design consisted of
three separate buildings connected by a plaza that took advantage of the site and
the mild Southern California climate. Surrounding the buildings was a large,
moatlike reflecting pond whose borders undulated gracefully, melting into the nat-
ural park setting of trees and shrubbery.

Dr. Richard F. Brown, director of the new art museum, realized the museum's
setting was essential to its success. In the spring of 1962, six months before the
project broke ground, he consulted with the artist Isamu Noguchi about the gardens
and plaza design.[5] Although Noguchi began his career as a portrait sculptor, by
the 1950s he had broadened his scope, becoming a renowned designer of modern
furniture and an innovator in public gardens. Noguchi agreed with Brown that the

landscape was crucial to the museum's reception. Brown explained to the trustees, "Mr. Noguchi sees the landscape as a setting for the future increase of the museum's collections and would like to design it so that it would be like a gallery. He would control design, flow of water, and the kind of plants that would be used, and would like to work this out with a local plant man." Although a few trustees thought it was a good idea to commission someone with knowledge of sculpture, no further discussion of sculpture occurred at the time,[6] nor was Noguchi ever mentioned again in the minutes of the trustee meetings. Noguchi conceived his gardens as sculpted environments, large in scale and often with more concrete than grass. He based his designs on the excavation and shaping of earth, just as a sculptor models clay (see, for example, his Sunken Garden at the Beinecke Library at Yale University, 1960–63). Such an approach was not in accord with the Southern California aesthetic that Pereira and others had begun to promote in the postwar era, though.

Landscape architects would not join the LACMA project until early in 1963. Thomas D. Church and Associates was engaged by Pereira as the consulting landscape architectural firm and, with the recommendation of Church, they hired local landscapist Robert Herrick Carter and Associates.[7] Church was a brilliant choice: trained in classical form he was one of the most influential promoters of the modern landscape movement. A decade before the museum hired him, he wrote the book *Gardens Are for People: How to Plan for Outdoor Living,* which further encouraged what became known as the postwar California Style.[8] Since his gardens were most often in residential settings and came to be identified with the California suburban lifestyle, local visitors would immediately have felt comfortable with his design for the museum. Although his original drawings are no longer extant,[9] Church probably designed the undulating border of the reflecting pond that surrounded the buildings as well as the border of grass that slightly opened the area between the complex and the actual park. Carter devoted most of his career to campaigning for more vegetation and open space in commercial Los Angeles; his work at the museum was one of his earliest major projects.[10]

The Commission

In 1962, about two years before the trustees began discussing sculpture at their meetings, the Art Museum Council (AMC) organized a "fountain committee" in the hope that they could acquire for the museum a significant, large outdoor sculpture for the new group of buildings. This was in keeping with the art museum's overall campaign in its early years to acquire major works, especially landmarks of the modern style. Founded in 1952, the AMC was LACMA's first volunteer support group dedicated to the full range of museum endeavors, including acquisitions. Primarily young, college-educated women—often the wives of the city's banking, real estate, and medical professionals—who were intellectually curious about modern art, the AMC members were quite enthusiastic about presenting the new museum in the best light.[11] The fountain-committee members diligently researched

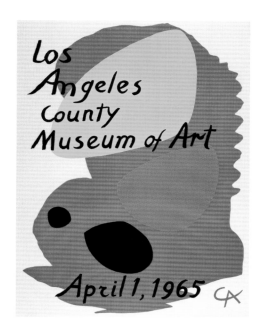

Fig. 2 | Alexander Calder, *Los Angeles County Museum of Art, April 1, 1965*, 1965; poster; 31 ¾ × 24 ⅜ inches; Los Angeles County Museum of Art

and considered countless artists, among them some of the most progressive American sculptors of the time, including David Smith and Alexander Calder. Smith was well represented by the Everett Ellin Gallery in West Hollywood, as Ellin met Smith while living in New York City; he accorded Smith his first solo exhibition in Southern California in 1960.[12] Smith's bold, industrial sculpture was eventually rejected, though, because some of the committee members disliked the lack of elegant surfaces on his welded stainless-steel constructions.

Calder was an internationally popular sculptor, and since the late 1950s had become increasingly known for his monumental works. The Frank Perls Gallery of Beverly Hills had sponsored three solo exhibitions in the decade just prior to the LACMA commission.[13] The sculptor's first solo show in Southern California was mounted as early as 1937, and by the time of the initial Perls Gallery exhibition in 1953, Calder's invention of the mobile had reached commercially notorious proportions, as noted by historian Donald Goodall, writing for the national magazine *Art Digest*: "Readers ... may recognize in the Calder exhibition an idea which has blossomed into a $10,000,000-a-year industry. Packaged mobiles, to be assembled later, are available now at both the more or less recherché of our furniture stores, and gadgeteers have made swinging things a household hazard."[14] Calder's third Frank Perls Gallery exhibition, in 1963, featured recent mobiles and stabiles and offered attendees—which included museum trustees and AMC members—a good forecast of what to expect for the fountain commission.[15]

The mid-1960s marked the expansion of Calder's large-scale art into California, as he received two public commissions there, one in Los Angeles, the other in Fresno. Calder would have been pleased to reconnect to the state of his youth: in 1906 his family had moved to Pasadena due to his father's frail health, and later, in 1912, when his father Alexander Stirling Calder was appointed Chief of Sculpture for the Panama-Pacific International Exposition (PPIE), the family had moved to the Bay Area. Calder would visit his father frequently at his workshop on the fairgrounds to watch the construction of the elaborate sculptures and fountains. In February 1964 Perls forwarded for the AMC a letter to Calder asking him to consider making a fountain for the new museum and requesting sketches of some of his ideas.[16] Although several AMC members and their families visited Calder at his homes both in Connecticut and in France during the spring to encourage his participation, it was not until June that he responded, "I *am*, indeed, *very much* interested in designing you a fountain."[17] The AMC was equally thrilled, as they understood the importance of the commission. AMC President Laurelle Burton, who corresponded with the artist during the entire project, announced the commission in a letter to the council and added, "There is a very important thing to remember. To have a man of Alexander Calder's prominence be the first to design a sculpture specifically for the new museum would set the standards for future efforts, on the part of the artists and donors."[18] So cordial was the process between Burton and Calder that when she later asked Calder to design a poster celebrating the opening of the museum, he quickly agreed (fig. 2).[19]

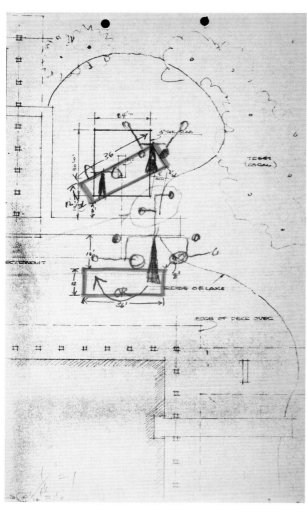

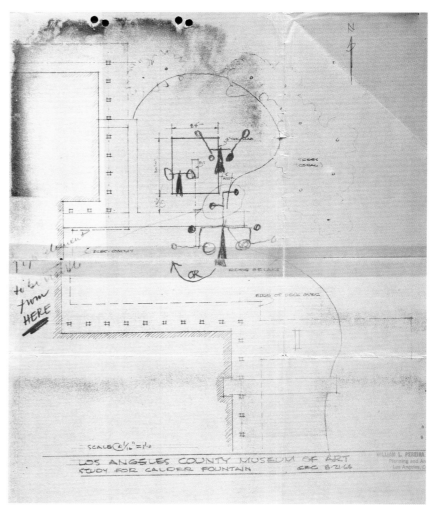

Figs. 3–4 | Drawing with letter from Alexander Calder, 1964

Figs. 5–6 | Architectural plans by George Carey of William L. Pereira and Associates, 1964; showing the early placement of the three parts of the fountain, one with green correction marks by Alexander Calder

Calder hastened his pace, visiting Los Angeles to inspect the site and consult with the architects and landscape designers as well as the museum staff, trustees, and fountain committee. Sketches and a model went back and forth during the rest of the summer, then discussions ensued about the feasibility of constructing a fountain, the placement of the mobiles, and costs (figs. 3–6). The mobiles were made in Connecticut at the Waterbury Iron Works, one of three iron fabricators Calder regularly used.[20] They were on their way to Los Angeles after Thanksgiving 1964. Calder revisited the site in mid-December accompanied by his favorite ironworker Chippy Ieronimo to indicate the placement of each mobile and oversee their installation (figs. 11–12).

The Work

The LACMA fountain consisted of three separate mobiles and four water jets arranged and set into the moat that surrounded the building complex. The mobile components embodied Calder's trademark design, grace, and lyricism. The movable parts were balanced and supported by a pylon fabricated out of a single triangular metal sheet, folded. Each rotated gently around the fulcrum of its base. The forms and minimal design hark back to the Abstraction-Création group that Calder associated with in Europe in the early 1930s. Calder's aesthetic accorded perfectly with that of landscape architect Church, who preferred modernist idioms such as biomorphic shapes and the zigzag.[21]

The paddles were in Calder's favorite palette of basic colors, with black dominating. The rods were colored in the model (see p. 157), but in the final fountain, they were left unpainted; according to the Calder Foundation, Calder did not paint them because he wanted to foreground the essential nature of the stainless-steel material used. The smallest mobile consisted of two dark discs, one a perfect black circle and the other a dark blue Reuleaux triangle, a rounded triangular shape, connected by a horizontal beam balanced on the apex of the pyramidal base. The middle-size one consisted of a horizontal spar balanced at the fulcrum of the base with each side sprouting a swinging vertical rod with a paddle at each end, all painted in the limited palette of red, white, and black. The largest mobile had the greatest variety of color and branches: two black circles connected by a long rod from which other rods and paddles dangled (white and red circles at one end and a yellow oval and white Reuleaux triangle at the other); a mast emerged from the fulcrum straight up into the air, as if it were part of a growing flower, and then split into two shorter branches emerging at about a one-hundred-degree angle, with each ending in a black circular disc. The three mobiles increased in height and in number of branches and petals. The largest was originally planned with six paddles but had eight in its final version.

Calder appreciated the warm reception the council members and their families showed him when he first visited the construction site. According to museum lore, the title of the fountain, *Hello Girls*, was a tribute to the council women who

commissioned and paid for it.[22] Calder, however, remembered the rationale behind the titling of the fountain somewhat differently,

> The mobile I made for the Los Angeles County Museum ... I called 'Hello Girls!' The title was the result of a little difficulty in placing the piece. It was originally designed to be in a little pond among several buildings, but oil was discovered there so they moved it and put up a derrick instead. In its new location there was some question of the general visibility, so I added a couple of elements to increase the height and since that gave the effect of a gay salute, hence the title 'Hello Girls.'[23]

Whether the title was intended as a thank-you to the council or as a welcoming gesture to visitors does not matter, for both ideas accord with the lightheartedness and warmth of many of Calder's mobiles.

Returning home from the July trip to Los Angeles, Calder referred for the first time to the phrase "Hello Girls" in a letter to Burton.[24] At the time the phrase was misconstrued as referring to the entire sculpture, but recently an annotated photograph in the Calder Foundation archives has come to light that suggests he originally meant for the fountain to be titled *Three Quintains*.[25] On the back of a photograph of the model (figs. 7–8), Calder wrote in the upper left corner, "This section is called "Hello Girls" (for people on the balcony)" and drew an arrow to a circle with two capital *N*'s (standing for "noir," French for black). Lower down, across the entire photograph verso, he wrote, "Three Quintains L.A." The annotations suggest that "Hello Girls" referred only to the top component of the tallest mobile— the two black discs added to increase the height of the sculpture to ensure that visitors standing on the plaza balcony above the lake would see the tall mobile waving to them—while Calder intended "Three Quintains" to refer to the entire fountain design.[26]

However, Calder's titles were not literal guides to his sculpture. The artist preferred more abstract references to ideas, concepts, and forms. He often only titled his works after he had completed and experienced the sculpture, and in some cases, he renamed them later, over the course of his career. *Three Quintains* is a cryptic title. *Quintain* is an ancient term that referred to a street in army encampments; in medieval times it was the name of an object supported by a crosspiece on an upright post, used as a target in tilting.[27] Several of Calder's works from the mid-1960s have titles that reveal the sculptor's wide-ranging literary and historical interests: *Bucéphalus* (1963), a stabile on view in Fresno, California, was the name of the horse that Alexander the Great rode in battle—a story that, according to Calder's sister, was one of the sculptor's favorite books as a child.[28] *Jousters* (also 1963) consists of two stabiles, *Little Knight* and *Big Knight*, and shares with *Three Quintains* not only the reference to medieval times but also jousting-related themes, a large scale, multiple parts forming a single work, a palette of basic hues, and simplified geometric shapes. It may be that Calder considered the lake surrounding the building complex a moat, protecting the "palace of art" from outside intrusions in the same way that moats were

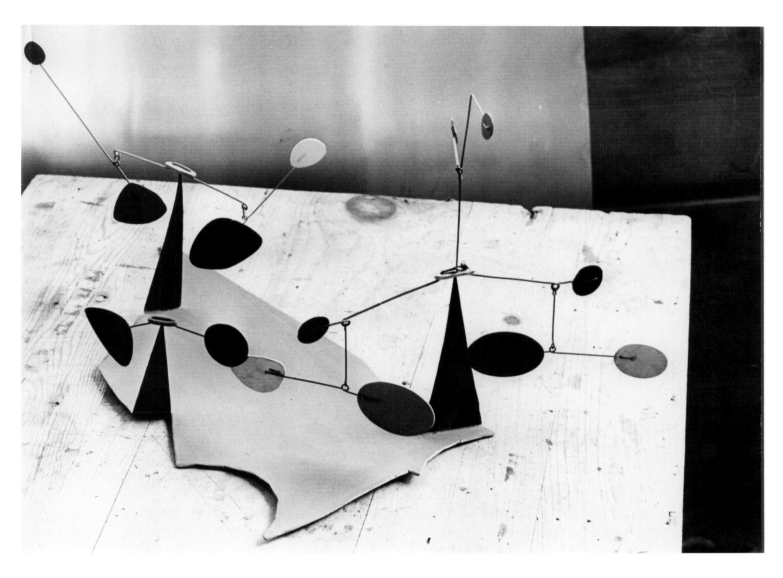

Figs. 7–8 | Alexander Calder, *Three Quintains*
(***Hello Girls***) **(maquette), 1964**; showing
recto and verso of photograph by Inge Morath

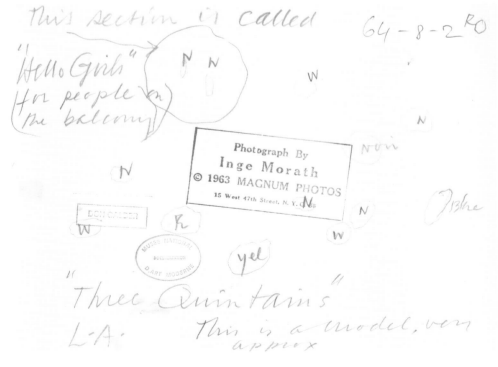

built around medieval fortresses. The "three" in the title obviously refers to the fountain's three mobiles.

Originally, *Hello Girls* was to be sited in the reflecting pond at the northeast corner of the complex but was moved to a location farther south, along the east edge of the north structure (now the Hammer Building), because tar was found at the first location.[29] Its final placement was in front of some of the windows of both the north building and east building (the Bing Center Building), between the Members Lounge and the Board Room and visible from the public cafeteria,[30] so the sculpture could be quietly contemplated from the museum interior as well as from the garden exterior. The new placement was also next to the circular outdoor staircase that brought visitors from the elevated plaza courtyard above to the garden below. A pedestrian causeway leading out to the rest of the park, divided the lake at that point; by placing two of the mobiles north of the causeway and the third and largest one south of it, Calder led the eye from one section of the lake to the other and thereby ensured that it visually remained a single entity flowing around the complex (fig. 1).

Fountains and Waterworks

The museum had requested "a working (splashing) fountain," and Calder was thrilled to provide it.[31] Although he was not known for creating fountains, he was actively searching for opportunities to design them. His enthusiasm was due to his fascination with the interaction of solid materials with water, wind, and movement. Elaborate public fountains first became popular during the Renaissance. Not surprisingly, as early as 1935, two years before his first fountain design was realized, Calder's mobiles were likened to Italian fountain sculptures by his devoted supporter James Johnson Sweeney, then curator at the Museum of Modern Art in New York City:

> His work [the mobiles] offers an interesting parallel with that of the fountain sculptors of the fifteenth and sixteenth centuries in Rome and Florence. Just as out of their playing with water, and their free and often fanciful solutions of technical problems, grew what we recognize today as some of the earliest hints of the Baroque style in sculpture; so Calder's realizations, vividly vernacular to the present age as they are, offer, at the same time, more possibilities of relationship with plastic expression of the next, then does the work of any other American sculptor today.[32]

Fountains that combined sculptural elements with waterworks had a strong precedent in Calder's own family. His father Alexander Stirling Calder was associated with the designs of several fountains. For the PPIE of 1915, he not only oversaw all the water displays, which in the tradition of late nineteenth-century academic aesthetics were very elaborate, but designed several of the most significant ensembles. One of Stirling Calder's best-known late works is the *Swann Memorial Fountain* (aka *The Fountain of the Rivers*) in downtown Philadelphia.

Fig. 9 | Alexander Stirling Calder, *Swann Memorial Fountain*, 1924; Logan Square, Philadelphia

Fig. 10 | Alexander Calder, *Mercury Fountain*, 1937; installed at L'Exposition Internationale, Pavillon de la République Espagnole, Paris, 1937

His son would have been quite aware of this large urban fountain, as he had begun studying art in New York City just a few months before it was unveiled in 1924 to great fanfare and a crowd of thousands. In that work, water spouts toward the center allegorical figures from bronze frogs and turtles in the lower basin, as well as from jets and a geyser in the center that shoots water upward about twenty-five feet in the air (fig. 9).[33] Jet sprays would become an essential element of the younger Calder's fountain designs.

The Spanish architect Josep Lluís Sert commissioned Alexander Calder's first fountain for the Spanish Pavilion at the 1937 Paris Exposition. Honoring the Loyalists who withstood a siege by Francisco Franco's insurgent forces at the mercury mines in Almadén, Spain, the fountain was to symbolize the importance of mercury to the national cause (fig. 10). The use of mercury rather than water determined the fountain's materials, height, and design. According to Calder's longtime friend William B. F. Drew, commenting in the first article about the fountain, it was arranged in "a series of fulcrums and levers," and set low to the ground, because mercury is so heavy. Three slightly curved steel sheets were cut in irregular shapes and covered with pitch to prevent the mercury from corroding the plates. Calder added several mobile elements (rods and a red disc) to invigorate the design and increase its height.[34]

Although Calder incorporated the idea of chance into his mobiles, he was concerned about the fitful movements of the parts when a work was installed in open air under variable weather conditions. In the early 1930s he used small electric motors to determine movement in his mobiles. As he explained, "With a mechanical drive you can control the thing like the choreography in a ballet and superimpose various movements: a great number, even, by cams and other mechanical devices. To combine one or two simple movements with different periods, however, really gives the finest effect, because while simple, they are capable of infinite combinations."[35] Calder loved dance. Scholar Joan M. Marter considered the wind-driven mobiles "intensely theatrical," comparing them to a ballet, because they required a considerable length of time to be fully experienced, and included a series of elements that "perform." To her, the moving shapes became

Figs. 11–12 | Alexander Calder and ironworker Chippy Ieronimo overseeing the installation of *Three Quintains* (*Hello Girls*), 1964

"metaphors for dancers."[36] Given Calder's love of performance, first demonstrated in his *Cirque Calder* (1926–31), and his love of choreography, it is not surprising that he incorporated these interests in his fountains.

Programmed waterworks became increasingly important to Calder, a spectacle in themselves. In his second fountain commission, he eliminated the traditional solid form altogether. For the Court of Power and Light at the New York World's Fair of 1939, the architectural firm of Harrison and Fouilhoux featured along the façade of their Consolidated Edison Building a two-hundred-foot basin with a line of jets, each spouting water directly upward. Calder proposed a five-minute performance during which groups of jets with rotating nozzles would create different water formations in timed sequences: 1. The two end nozzles eject short arcs, 2. Four nozzles create four bombs, 3. Seven slender jets shoot long, high, and slowly rotate into inverted cones, 4. A single nozzle forms a fan-shaped spray, and 5. Seven jets reappear and form tall arches while the two end ones play a finale.[37] Unfortunately, the water jets were incorrectly installed, so the choreography of Calder's water ballet never functioned as intended.[38]

In 1951 Eero Saarinen, a friend of Calder's and the architect of the General Motors Technical Center in Warren, Michigan, hired him to design a sculpture and fountain within the huge (twenty-two-acre) man-made lake located next to the research laboratory.[39] As with the LACMA commission of a decade later, Calder had to work within Thomas Church's set parameters for an artificial lake. (It is thought the landscape architect suggested the four islets of trees, sort of "wings" of tree groupings aligned at right angles to the sides of the rectangular pool, to spatially divide the vast expanse of water into more manageable areas.)[40] Calder decided not to include a mobile or stabile but instead considered the ephemeral shooting water the actual sculpture. Initially based on his 1939 World's Fair design, the GM water ballet was so complicated that it was still not working properly in April of 1956 when the campus was dedicated.

Calder's design of a functioning fountain that included both sculpture and spraying jets first came to fruition in 1958. As with the Spanish Pavilion and the GM fountains, he owed the commission to a friend, Edward Durell Stone, the architect of the United States Pavilion at the Brussels Universal and International Exhibition. Although Stone asked the sculptor to design a mobile for the interior, Calder demonstrated his passion for fountains by persuading not only Stone but George W. Staempfli, the coordinator of the fine arts program of the State Department for the Brussels fair, to allow him to do something for the oval pool next to the pavilion.[41] The result was *The Whirling Ear,* a motorized monumental sculpture consisting of two angular black forms meeting at a fulcrum, set into a huge basin. Although Calder originally wanted the head (top section) to be activated by one or two jets, instead a motor was placed inside and the row of numerous jets along the perimeter of the basin ejected water vertically, far from the metal sculpture.[42]

When LACMA approached Calder for a fountain in early 1964, the sculptor was still determined to realize his goal of a grand water ballet. In her August 11, 1964, letter announcing the commission, Burton explained the sculptor's aim: "Mr. Calder's original idea was to have a piece of sculpture *moved* by a programmed series of, perhaps, 28–36, jets of water."[43] Echoes of his grandiose, earlier fountain endeavors, however, were destined to experience a similar disappointment. Burton went on to explain that Calder's ambitious program "proved impractical because of the high cost of plumbing for that many jets, so, he came up with another

Fig. 13 | Alexander Calder, *Three Quintains (Hello Girls),* 1964; showing the original placement of the sculpture, 1966

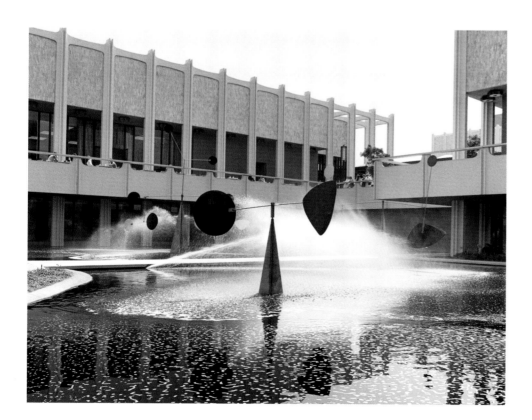

idea of using fewer (like 6–8), jets of water and designing the sculpture so that it would be moved by the jets of water." By September 16, 1964, Pereira's firm had determined that four jet nozzles were all the museum could afford.[44] Issues of water pressure capabilities as well as other related problems, such as drainage, would haunt the LACMA commission as they did the GM project.

The final design of the reflecting pool around the LACMA complex included water spouting vertically in the air. If a viewer did not know Calder's history with fountains and water ballets, one might conjecture that he suggested the jets for *Hello Girls* to accord with the waterworks in the entrance way. The jets there did not interact with any sculpture, however. Calder intended his jets to gently hit some of the discs so the mobiles would move slightly in response to the water as well as to the wind. In this respect he successfully integrated sculpture with water to create a "splashing fountain." As the photograph (fig. 13) of the completed work demonstrates, *Hello Girls* was an exuberant fountain, with simple geometric mobile forms floating in the air and jets spraying them while the surface of the lake's water gently rippled and sparkled under the sunlight. Calder definitely succeeded in creating a joyous modern fountain for a new age.

NOTES

*Author's Note: The Calder sculpture is extant and on public view, but this essay is written in the past tense as it focuses on the commission as a historical phenomenon. The sculpture is no longer in its original placement nor presented exactly as Calder designed it. The entire moat around the building complex, of which the fountain was a part, was removed over the course of several years. Situated next to tar pits, the moat did not function properly. It is not uncommon for such changes to occur with outdoor public sculptures.

1. *Space Sculpture* by Norbert Kricke rose high into the air at the entranceway of the complex, and a large Henry Moore sculpture was placed on the plaza level in front of the Lytton Gallery (now the Hammer Building). See "A Noble Contribution to the World of Art," *Art Museum,* special magazine in honor of the museum's opening, *Los Angeles Times,* March 28, 1965, 20.
2. *Hello Girls* was the title used for the commission in all correspondence to the museum, including the bill of sale. However, recently the museum has learned that Calder intended a different title (see discussion in this essay, pp. 112–14, for details). In this essay, the title *Hello Girls* will be used for clarity, as the fountain has been known as such at the museum and in the published literature up until now.
3. Katharine Kuh, "Los Angeles: Salute to a New Museum," *Saturday Review,* April 3, 1965, 30.
4. Minutes, Special Meeting, Board of Museum Associates, January 7, 1960, 5. Museum Archives,

Balch Library, Los Angeles County Museum of Art (LACMA). Although Saarinen and van der Rohe were internationally renowned, and Stone had designed the original Museum of Modern Art building, Ahmanson and the board members were probably more familiar and comfortable with selecting Pereira, who was well known on the West Coast. Ahmanson, working with the artist Millard Sheets, used Pereira for his Home Savings bank buildings. The author would like to thank Jessica Gambling, museum archivist, for bringing the January 7, 1960, minutes to her attention.
5. Minutes, Art Museum Management Committee Meeting, March 20, 1962, 8. Museum Archives, Balch Library, LACMA. The "management committee" later, when the building was erected, became the art museum's board of trustees. Although Brown was instructed to find out the cost of hiring Noguchi, no further mention of the sculptor designing for the museum is in the trustee minutes; perhaps it was because the chairman, Edward Carter, had never heard of Noguchi.
6. Ibid. Trustee Mrs. Rudolph Liebig suggested this.
7. Minutes, Board of Trustees, Los Angeles Art Museum, February 5, 1963, 3. Museum Archives, Balch Research Library, LACMA.
8. Thomas Dolliver Church, *Gardens Are for People: How to Plan for Outdoor Living* (San Francisco: McGraw-Hill Book Co., 1955).
9. There is no reference to Pereira nor to the museum in his papers, Thomas D. Church Collection, Environmental Design Archives, University of

California at Berkeley. The author would like to thank Miranda Hambro, assistant curator at the Environmental Design Archives, for confirming this. There is also no mention of the museum project in the primary monograph on Church: Marc Treib, ed., *Thomas Church, Landscape Architect: Designing a Modern California Landscape* (San Francisco: William Stout Publishers, 2003).
10. "Obituary: Robert H. Carter: Used Flowers to Beautify City," *Los Angeles Times,* January 26, 1989, http:latimes.com/1989-01-26News/mn-2006-1-los-angeles; and "Robert Herrick," *Television and Movie Wiki,* online; both accessed December 30, 2012.
11. Suzanne Labiner, telephone interview with the author, December 5, 2012. The author would like to thank Labiner, formerly of the fountain committee, for providing so much information about the committee and the commission.
12. Liza Kirwin, interview with Everett Ellin, April 27–28, 2004. Archives of American Art, Smithsonian Institution, Washington, DC, transcript online at: http://www.aaa.si.edu/collections/Everett-ellin-gallery-records-relating-to-david-smith-10459. Accessed January 15, 2013. The author would like to thank Carol S. Eliel for bringing the Ellin connection to her attention.
13. Frank Perls was the older brother of Klaus Perls, the New York dealer who represented Calder from 1955 to 1976.
14. Donald Goodall, "Los Angeles," *Art Digest* 27 (June 1953): 15. These commercial enterprises

were not authorized by Calder. The 1953 exhibition had actually originated at the Walker Art Center in Minneapolis.

15. Museum trustee David Bright purchased the most expensive work in the show, the black stabile *Button Flower.* He bequeathed it to the Franklin Murphy Sculpture Garden at the University of California, Los Angeles. Sale noted in *Alexander Calder*, Frank Perls Gallery, Beverly Hills, 1963. Annotated copy in the Frank Perls Gallery Papers, Archives of American Art, Smithsonian Institution, Washington, DC; copy also in Calder Foundation archives, New York.

16. It was one of the fountain committee members, Penelope Rigby, who suggested that the group first approach the artist on the top of their list, Alexander Calder, even though they thought he would be too expensive.

17. Calder, letter to Laurelle Burton, June 23, 1964. Copy in *Hello Girls* (M.65.10) accession file, Registrar, LACMA.

18. Laurelle Burton, mimeographed letter to Art Museum Council members, August 11, 1964, 2. In *Hello Girls* (M.65.10) accession file, Registrar, and Archives, Art Museum Council, LACMA. The author would like to thank Joel Ferree, council associate of the AMC, for unearthing this letter and other related material.

19. The poster was to be a fund-raising effort. Minutes, Board of Trustees, November 17, 1964, 5, and December 15, 1964, 4, Museum Archives, Balch Library, LACMA.

20. Waterbury Iron Works, invoice to Calder, December 10, 1964. Invoice 4442, Waterbury Iron Works folder, Calder Foundation archives. It lists "Mobile-California-'Hello Girls' for $2623.64." In H. H. Arnason's 1971 book *Calder*, one of the Ugo Mulas photographs featured is of *Hello Girls* at the iron works (see endpaper illustration).

21. Marc Treib, ed., *Thomas Church, Landscape Architect: Designing a Modern California Landscape* (San Francisco: William Stout Publishers, 2003).

22. Laurelle Burton, *AMC Newsletter*, January 1965, quoted in Ann Costello, "The Way We Were—AMC's 1964 Gift, Calder's 'Hello Girls' Is the Only Work Ever Created for LACMA," *AMC Newsletter*, March 2001, 7–9.

23. Alexander Calder, quoted in *Calder*, introduction by H. H. Arnason (New York: Studio Book, Viking Press, 1971), 4. This memory is part fiction and part truth. By oil, Calder probably was referring to the tar that to this day still oozes through the grass in Hancock Park. As for the supposed derrick, this was probably the artist's fabrication. Neither Jessica Gambling, museum archivist at LACMA, nor Dr. George Kuwayama, curator emeritus of Far Eastern Art, who was working at the museum in 1964, recall any derricks in the park. Gambling and Kuwayama, conversation with the author, January 18, 2013.

24. Calder, letter to Laurelle Burton, July 17, 1964. Copy in *Hello Girls* (M.65.10) accession file, Registrar, LACMA.

25. Calder inscription, verso of photograph of study

for mobile, n.d., in *Hello Girls* file, Calder Foundation archives.

26. To add further confusion, as early as December 1964, Calder told reporters that the two black discs at the top of the largest mobile "represented the salute or waving gesture the title suggests," thus referring to "Hello Girls"; he did not mention the title *Three Quintains* at that time. Calder, quoted in "'Hello Girls' Went Bye-Bye: First Event at the Art Museum—A Bust," *Los Angeles Times,* December 18, 1964, part II, 8.

Moreover, the bill for the fountain, sent by Perls Gallery to the museum, lists the work only as *Hello Girls* (*Hello Girls* [M.65.10] accession file, Registrar, LACMA).

27. The word is almost identical in English and French. See *Webster's Third New International Dictionary* (Springfield, MA: G&C Merriam Co. Publishers, 1965), 1867.

28. Margaret Calder Hayes, quoted in "Bucéphalus Is 'Not Meant' to Look Like a Horse," *The Fresno Bee*, October 11, 1967. Copy in *Bucéphalus* file, Calder Foundation archives.

29. The placement issue is based on institutional memory at LACMA, as the author has found no physical documentation to confirm. To this day tar continues to bubble from the ground all over the park, the largest eruption being the La Brea Tar Pits, which have become a popular tourist attraction. In fact, the Tar Pits are located next to the art museum complex.

30. Minutes, Board of Trustees Meeting, August 4, 1964, 6. Museum Archives, Balch Library, LACMA; and per diagram of the entire complex illustrated and annotated in *Orientation*, brochure, n.d. [probably 1965 or 1966], in LACMA Miscellaneous Publications Box, 1915–1971, Balch Library, LACMA. The Members Lounge was not used much because it was out-of-the-way of the main galleries; today it houses the Rifkind Center for German Expressionist Studies.

31. Penelope Rigby (president, Art Museum Council), letter to Calder, in care of Frank Perls Gallery, February 20, 1974 [*sic*, should be 1964]; and Calder, letter to Laurelle Burton and William Osmun, August 29, 1964. *Hello Girls* (M.65.10) accession file, Registrar, LACMA.

32. James Johnson Sweeney, "Mobiles by Alexander Calder," exhibition brochure, Renaissance Society of the University of Chicago, 1935, n.p.

33. Victoria Donohoe, "Swann Fountain," in Fairmount Park Art Association, *Sculpture of a City: Philadelphia's Treasures in Bronze and Stone* (New York: Walker Publishing Co., Inc., 1974), 230–39; see also "Swann Memorial Fountain," Wikipedia, http://en.wikipedia.org/wiki/Swann_Fountain; and "Logan Square," Welcome to Fairmount Park website, http://fairmountpark.org/LoganSquare.asp, both accessed October 26, 2012. The basin was designed by architect Wilson Eyre.

34. William B. F. Drew, editorial comment in Alexander Calder, "Mercury Fountain," (MIT) *Technology Review* 40 (March 1938): 202.

The fountain was also described in detail in "Calder's Mercury Fountain," *Stevens Indicator* 55 (May 1938): 2–3, 7; and Phyllis Tuchman, "Alexander Calder's Almadén Mercury Fountain," *Marsyas* 16 (1972–73): 97–106.

35. Alexander Calder, "Mobiles," in *The Painter's Object*, ed. Myfanwy Evans (London: Gerold Howe, 1937), 67.

36. Joan M. Marter, *Alexander Calder* (New York: Cambridge University Press, 1991), 159–60. He worked with Martha Graham and her company beginning in the mid-1930s.

37. Alexander Calder, "A Water Ballet," *Theatre Arts Monthly*, August 1939, 578–79.

38. Since the water ballet never performed as Calder intended, some scholars state that it was not realized, thereby causing confusion. See Jean Lipman, *Calder's Universe*, ed. Ruth Wolfe (New York: Studio Book, Viking Press for Whitney Museum of American Art, 1976), 186 and 332 with contradictory statements. David Gelernter in his book on the fair states that the water ballet was performed after dark with blue lighting. (Gelernter, *1939, The Lost World of the Fair* [New York: The Free Press, 1996], 266).

39. The chronology of the commission has been ascertained by copies and originals of correspondence between Calder and Saarinen and his architectural firm, found in General Motors Technical Center, Michigan, file, Calder Foundation archives.

40. Treib, *Thomas Church, Landscape Architect*, 232.

41. Edward Durell Stone, letter to Calder, December 21, 1956; March 1, 1957; and April 12, 1957; and George Staempfli, letter to Calder, February 6, 1957, and March 18, 1957; in *The Whirling Ear* fountain, Brussels Universal and International Exhibition file, Calder Foundation archives. Stone owned a Calder mobile.

42. Calder, handwritten notes with diagrams, n.d., five pages in *The Whirling Ear* fountain, Brussels Universal and International Exhibition file, Calder Foundation archives; and "Calder's International Monuments," Calder interview by Robert Osborn, *Art in America*, March–April 1969, 35.

43. Burton, mimeographed letter to AMC members, 1.

44. Vincent Lau of William L. Pereira and Associates, letter to William Osmun, September 16, 1964. *Hello Girls* (M.65.10) accession file, Registrar, LACMA.

Aleca Le Blanc

Traveling through Time and Space:

Calder in Brazil

THE YEARS AFTER WORLD WAR II saw significant changes to the cultural sphere in the West. As Serge Guilbaut and others have convincingly written, in the 1940s European art capitals such as Paris and London were drained of artists and artworks by the war.[1] To fill the void, new institutions dedicated to modern and contemporary art were quickly conceived and established in cities around the world. Increased access to modes of long-distance travel made seemingly far-flung places, like San Francisco or Rio de Janeiro, more reachable for critics, curators, and collectors living in Europe or on the East Coast of the United States. These new venues thus cultivated local and regional patrons but also became known to an ever-larger international audience through increased cultural tourism. Biennials and other recurring exhibitions began to proliferate during this period as well.[2] In the first half of the twentieth century, art patrons had to travel to the Venice Biennale or Pittsburgh's Carnegie International for a snapshot of the state of contemporary art. In 1951, however, that configuration changed when São Paulo began hosting a biennial exhibition, and again in 1955 when the first installation of *documenta* opened in the ruins of the Fridericianum in Kassel, Germany. As the field expanded and more cities began to open museums and host art exhibitions, so too did the field of art criticism, which led to the founding of the International Art Critics Association (AICA) in 1950.[3] AICA's activities those first years illustrate how the art world was broadening to cities outside of the North Atlantic. The organization had held its first six meetings in Europe, but in 1954 members gathered in Istanbul. Meetings in Mexico, Israel, and Brazil soon followed.[4] This rapid growth and internationalization of the art world profoundly affected artists' careers as well; they began to be

known in multiple national contexts. Success increasingly would be measured by the size of their international audiences.[5]

 Alexander Calder benefited greatly from these cultural and political shifts and his career trajectory is illustrative of many of these changes. Over the course of the 1950s Calder exhibited in San Francisco, Caracas, Amsterdam, Rome, and Bombay, in addition to New York and Paris.[6] His *Arc of Petals* had been included in a 1948 presentation of Peggy Guggenheim's collection curated by art historian Giulio Carlo Argan, and in 1952 his work was included in the Venice Biennale, winning the grand prize for sculpture. By the late 1950s, Calder's mobiles were well known in cosmopolitan centers around the world. As his reputation and fame grew, so did the scale and complexity of the objects he made. With each passing year, the span of his mobiles widened and his stabiles asserted ever-larger footprints. In 1953, for example, Venezuelan architect Carlos Raúl Villanueva commissioned him to design a permanent installation for the Aula Magna, the principal theater on the main campus of the Central University of Venezuela, the new University City of Caracas.[7] His resulting *Acoustic Ceiling* was made up of several large panels in irregular ovoid shapes, "clouds" or "flying saucers" as they were frequently called, splayed across the ceiling and walls (fig. 1).

Fig. 1 | Alexander Calder, *Acoustic Ceiling*, 1953; in the Aula Magna at the Central University of Venezuela, Caracas; Carlos Raúl Villanueva, architect

Fig. 2 | *Alexander Calder*, installation view;
Museu de Arte Moderna do Rio de Janeiro,
Ministério da Educação e Saúde, 1948

Although they resemble the individual elements of his graceful, kinetic mobiles, these objects are permanently arrested in time and space.[8] Other large-scale works with international significance soon followed. In September of 1957, his large mobile *.125* was unveiled in New York's Port Authority terminal at Idlewild (now John F. Kennedy) Airport and the following year, *La Spirale*, a standing mobile, was installed in Paris at the headquarters of UNESCO (United Nations Education, Scientific, and Cultural Organization). In 1960, he proposed another large standing mobile for the new Brazilian capital of Brasília and two years later, *Teodelapio*, Calder's first colossal stabile, standing fifty-eight feet tall and large enough for buses to pass under it, was realized in an intersection in the ancient Italian city of Spoleto. These projects demonstrate Calder's growth in scale and concept as well as the increasing diversity of the patrons that embraced his work.

This essay considers Calder's burgeoning international career in the years after World War II and questions why his aesthetic was so easily adopted in such divergent contexts. Focusing on Calder's reception in Brazil—specifically, how his work circulated and signified outside of North Atlantic artistic centers during the postwar expansion of the art world—it posits that Calder's success in Brazil proved to all who saw his work there that vanguard art production was no longer exclusive to Europe. Great international art could now be created in the Americas.

In large part, the positive reception Calder received in Brazil can be attributed to the friendships he established in New York with two Brazilians: the architect Henrique Mindlin and the art critic and intellectual Mário Pedrosa.[9] Having seen Calder's celebrated midcareer retrospective at the Museum of Modern Art (MoMA)

in 1943, both men became ardent fans and enthusiastic supporters. Calder had previously been included in an exhibition in São Paulo—he had three works in the III Salão de Maio in 1939—but he began receiving much more commercial and critical success in Brazil after his introduction to Mindlin and Pedrosa. As early as 1944, Pedrosa published an essay about the MoMA exhibition in Brazil's *Correio da Manhã*.[10] That same year, Mindlin wrote to Calder describing the enthusiasm some Brazilian collectors had for his works: "Your mobiles are having a terrific success here. The big wooden one is hung at [the artist, Cândido] Portinari's. Marcelo Roberto, the architect whose IRB building [Instituto de Resseguros do Brasil] was published in the August issue of *Architectural Forum* is crazy to have a small one of the size of my yellow one. I tried to get Henry Petter to sell his, but had no success. Do you think you could send a snapshot of one or two from which he might choose?"[11] Subsequent correspondence from Mindlin mentions others who might be interested in purchasing Calder's work, and by 1945, he was happy to have eight pieces to sell.[12] Mindlin then began to promote in earnest the idea of an exhibition of Calder's works in Rio de Janeiro. In 1948, his plan came to fruition with Pedrosa's help when they organized Calder's first solo show there, installed at the Ministry of Education and Health building, a landmark of Brazilian modern architecture.[13] The event even enticed Calder and his wife, Louisa, to travel to Rio de Janeiro for an extended stay.[14]

In response to the postwar climate, the Brazilian cultural landscape was undergoing many exciting transformations during the late 1940s, as new organizations emerged.[15] In fact, for Calder's exhibition at the ministry to be possible, several local institutions had to collaborate: the Museu de Arte Moderna, the Instituto de Arquitetos do Brasil, and the Instituto Brasil–Estados Unidos all pooled their resources with the ministry, which provided the gallery space. The works were installed on the second floor of the building with groups of Alvar Aalto–designed chairs and tropical plants clustered below the mobiles and among the objects (fig. 2); the exhibition plan encouraged visitors to linger, contemplate, and interact with the artworks.[16] The catalogue (fig. 3) included two texts, a translation of Jean-Paul Sartre's 1946 essay about Calder, which was written for his show at the Galerie Louis Carré in Paris, as well as a previously written profile by Mindlin; it also featured photographs of Calder's 1943 MoMA exhibition taken by Soichi Sunami, as well as additional photographs of Calder's works by Herbert Matter and Jorge de Castro.[17] Pedrosa delivered a public lecture titled "Calder a poésia dos ritmos visuais" (Calder; the poetry of visual rhythm) that lauded the vanguard direction of the artist's development.[18] Although the lecture was well received, many of the comments registered in the guest book, now stored at the Calder Foundation, indicate that the public had a mixed reaction to the works themselves. While one visitor applauded the artist, writing, "Congratulations, Mr. Calder, you have courage!" others exclaimed "Que bobagem!" (What baloney!) and "Seu peixe morrerá de indejestão" (Your fish will die from indigestion), a comment directed at *Fish* (1947), which was prominently displayed.[19]

Fig. 3 | Exhibition catalogue for *Alexander Calder*, Museu de Arte Moderna do Rio de Janeiro, Ministério da Educação e Saúde, 1948

Following the Rio de Janeiro installation, Calder's show traveled to the recently founded Museu de Arte Moderna de São Paulo, where it received a warm reception from the local press (fig. 4). One journalist hyperbolically described himself as "triumphantly stimulated" by the mobiles.[20] P. M. Bardi, the museum's director, wrote about the show in the *Diario de São Paulo* describing Calder as being at the forefront of the school of abstraction. He also declared that "the exhibition will offer the public a new topic of discussion, especially as we take the initiative to install, after this show, a didactic exhibition documenting a panoramic view of abstractionism."[21] This last comment is significant because it indicates that the Calder exhibition served a much larger agenda on the part of Brazilian curators—a move away from the figuration that had dominated Brazilian artistic production since the early 1930s. In addition to the show to which Bardi referred, another exhibition with a similar agenda, *Do Figurativismo ao Abstracionismo* (From figuration to abstraction), was held at the Museu de Arte Moderna de São Paulo in 1949.[22] Organized by guest curator Léon Degand of Belgium, Calder was represented in this landmark show by five metal mobiles, all borrowed from local collections. In it, Degand made an argument in visual terms for retiring figurative conventions, which he positioned as retrograde, and embracing abstraction, which was considered the harbinger of modernity and advancement. In his essay, Degand celebrated abstract sculpture for being constrained only by "the law of gravity" and because it "approaches architecture."[23] In considering this statement, one cannot help but think of Calder's mobiles and stabiles, because of both the pivotal role that gravity plays in his kinetic works and their intimate relationship with architecture. But Degand's characterization was prescient, since in 1949 Calder was not yet working on an architectural scale.

Fig. 4 | *Alexander Calder,* installation view;
Museu de Arte Moderna, São Paulo, 1948

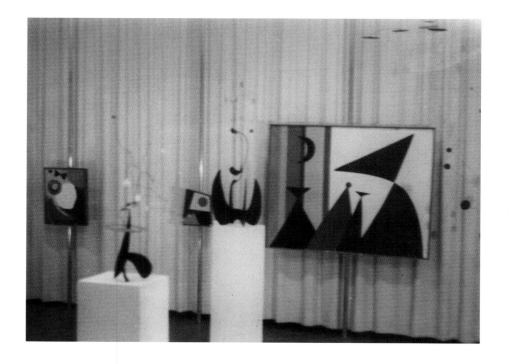

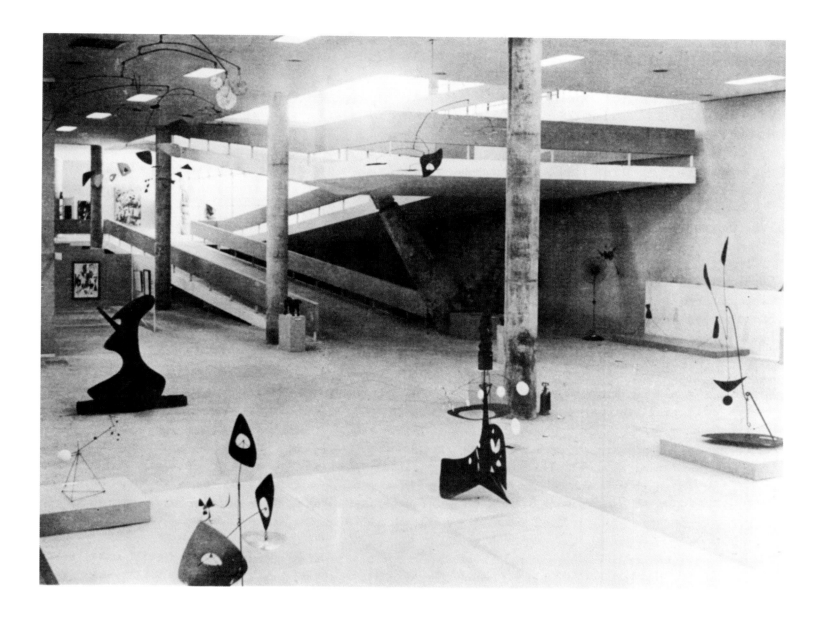

Fig. 5 | *II Bienal do Museu de Arte Moderna de São Paulo*, installation view; Museu de Arte Moderna, São Paulo, 1954

Building upon these successes, Calder's reputation continued to grow in Brazil and in 1953 he received an even more prestigious exhibition on the occasion of the II Bienal de São Paulo (fig. 5). MoMA director René d'Harnoncourt was responsible for curating the US contribution to the international exhibition. In a memo housed at the Calder Foundation, d'Harnoncourt describes how, in addition to the sixteen artists that had been selected to represent the US, "we have been asked by the directorate of the Bienal to prepare a larger exhibition of one outstanding artist. We have accordingly assembled a one-man show of sculptor Alexander Calder, whose rare qualities of invention have won him international recognition."[24] Having just been awarded the sculpture prize at the Venice Biennale, Calder was a logical choice for the honor and was represented in São Paulo with forty-five objects.[25] What is interesting in the context of the Bienal program, though, is that Calder's installation was separated from the other national groupings, occupying a prominent but liminal space on the ground floor of the Pavilion of States. The newly erected building, designed by the architect Oscar Niemeyer, housed the installations by all of the participating nations from the Western Hemisphere, whereas the European delegates were found in the Pavilion of Nations,

a completely separate structure. The ground floor of the Pavilion of Nations featured a large Picasso exhibition, which included his famously itinerant painting *Guernica* (1937). With Calder's show installed on the ground floor of the other building, his work served as a visual introduction to contemporary art from the Americas and set the tone for the entire Pavilion of States. This installation echoed the broader geographical dynamics of the art world divided by the Atlantic Ocean, positioning Picasso as the founder of Cubism, whose work was emblematic of prewar traditions, and Calder as the hero of the postwar avant-garde, which, according to the organizers, had proudly relocated to the Americas.

Calder's Americanness was central to critic Walter Zanini's effusive description of the installation. In São Paulo's *O Tempo*, he wrote, "The imposing Calder exhibition is one of the most significant galleries at the Bienal … In the mobiles, we can feel the noteworthy creative force of his irreverent and turbulent art palpitating … A fabulous world of rhythms and proportions is born from these fragile armatures, as if blood circulated through the fine wires that compose their forms. In Calder one finds all the pragmatic overtones of American life and the expressive power of an artist capable of finding hitherto unsuspected paths."[26] Another critic, António Bento, described the Calder installation this way: "Among the revolutionary artists, Calder is the most discussed…. He has created objects that would have been inconceivable before the beginning of the century. His largest mobiles glide or spread out majestically in space; one can hardly imagine the effect they might make in great offices—gigantic mobiles a hundred meters in diameter, turning in the air at great height to constitute one of the absolutely fantastic decorations of art of tomorrow. They will be landmarks like the Eiffel Tower."[27] Bento's view is yet another prophetic characterization of the future of Calder's oeuvre.

The European-American rivalry played out in other ways during the exhibition and was particularly present in the discourse surrounding awards. There was considerable press about the fact that the jury decided to give French artist Henri Laurens the sculpture prize instead of Calder. Pedrosa, who was a vocal member of the jury and had argued vehemently on Calder's behalf, stated that whereas Laurens had evolved from Cubism, "Calder … is a typical representative of our time, of our modern civilization, of optimism, and of good humor."[28] In other words, like Picasso, Laurens represented a bygone European tradition, whereas Calder epitomized the great potential of contemporary art in the Western Hemisphere.

As much as the cultural sphere was expanding in Brazil, so was the architectural landscape. Indeed, the 1940s and 50s are often considered a golden age of Brazilian modern architecture. These decades saw the rapid expansion of the modernist style, as numerous projects would radically reshape urban landscapes. After all, in 1956, the federal government broke ground on one of the most audacious urban projects of the twentieth century: a new national capital that would be constructed from the ground up on the barren central plateau in the interior of the country. In less than four years time, the iconic modernist city of Brasília, which united Lúcio Costa's innovative urban plan with Niemeyer's bold

architectural designs, was built.[29] Although Brasília's construction was physically removed from the main population centers, images of the expansive project were published and broadcast constantly in the media, both in Brazil and abroad.[30] Amazingly, by the late 1950s, these images had become somewhat of a trope. Indeed, many of the most widely circulated photographs depicting Brazilian culture were representations of modernist buildings, filling the pages of architectural journals as well as gracing the cover of *Time* magazine.[31] Even Mindlin had used Brazilian architecture as a selling point to Calder as early as 1944, telling him that the prominent architect Marcelo Roberto was eager to have a Calder mobile of his own after seeing Mindlin's.[32]

It therefore must be emphasized that in Brazil, Calder's exhibitions were installed in landmark modernist buildings. His 1948 exhibition at the Ministry of Education and Health was held in what is considered the first civic building in this style in the nation (fig. 6). Costa had overseen this building project with a team of young architects, including Niemeyer and Affonso Eduardo Reidy, as well as with consultation from Le Corbusier.[33] Built between 1936 and 1945 in Rio de Janeiro's downtown, it is a rectangular tower with Corbusian *pilotis*, or support piers, and *brises-soleil*, adjustable louvers that shielded the interior from the tropical heat. In the installation photographs of Calder's show, one can see the *pilotis* at regular intervals among the mobiles, stabiles, paintings, chairs, and plants. At the Bienal, Calder's works were installed in Niemeyer's brand-new Pavilion of States. In that building, Niemeyer repeatedly utilized one of his signature architectural devices, the ramp. Calder's works sat beautifully within this bold architectural program, his angular bases seemingly echoing the ramps, once again punctuated by a series of *pilotis*.

Fig. 6 | Ministério de Educação e Saúde, Rio de Janeiro, 1937–43; architects: Lúcio Costa, Oscar Niemeyer, Affonso Reidy, Jorge Moreira, Carlos Leão, Ernani Vasconcelos, with consultation by Le Corbusier; photograph by Lucien Hervé, 1961

At the very end of the 1950s these dual significations, avant-garde American art and Brazilian modern architecture, were marshaled one more time when Calder installed a large-scale show at the Museu de Arte Moderna in Rio de Janeiro, the last he would have in Brazil during his lifetime.[34] On September 23, 1959, the museum opened the ambitious exhibition, which included thirty gouaches and forty-four mobiles and stabiles. The works on paper were installed in the glassed-in gallery on the top level of the museum's education building, the School Block, and the sculptures were, for the most part, placed outside on the surrounding terraces and gardens (fig. 7).[35] The installation was remarkable for its use of interior and exterior spaces in the museum's newly inaugurated building and physical surroundings, both of which were quite spectacular. The campus with three modernist buildings—two of which were still under construction in 1959—was designed by Reidy, a colleague of Niemeyer and Costa and part of the cohort of modernist architects then working in Brazil.[36] The modern art museum was also situated in a prime location on the Aterro do Flamengo, a new park designed by landscape architect Roberto Burle Marx right at the water's edge, boasting picturesque

Fig. 7 | *Alexander Calder: Escultura, Guache,* installation view; Museu de Arte Moderna do Rio de Janeiro, 1959; photograph by Marcel Gautherot

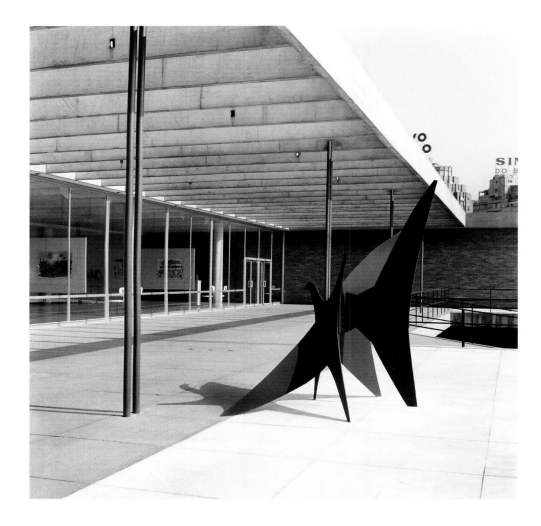

views of Rio de Janeiro's famous landscape, including vistas of the celebrated Pão de Açucar, visible from all of the galleries.

Although Calder had shown successfully in other Brazilian modernist structures, this exhibition was particularly striking because his unique formalism complemented equally the museum's architecture and the surrounding landscape, drawing the visitor's attention to the newness of the site, both topographically and architecturally. In many of the photographs of the exterior installation, one can see how the organic and geometric shapes of Calder's sculptures resonate with the curvilinear coastline of Guanabara Bay and the iconic silhouette of the Pão de Açucar (fig. 8), as well as with the rectilinear profile of the building and the shadows it cast in the intense tropical light.[37] Anyone who has ever stood near a Calder mobile can also imagine how the undulating arms on his sculptures would have synchronized with the subtle movements of the abundant flora in the coastal breeze of the Aterro do Flamengo. Indeed, many of the titles of his works refer directly to tropical vegetation, such as *Eucalyptus* (1940) and *Jacaranda* (1949). But one must also consider the photographer's subjectivity in presenting the

Fig. 8 | *Alexander Calder: Escultura, Guache,* installation views; Museu de Arte Moderna do Rio de Janeiro, 1959; photograph by Marcel Gautherot

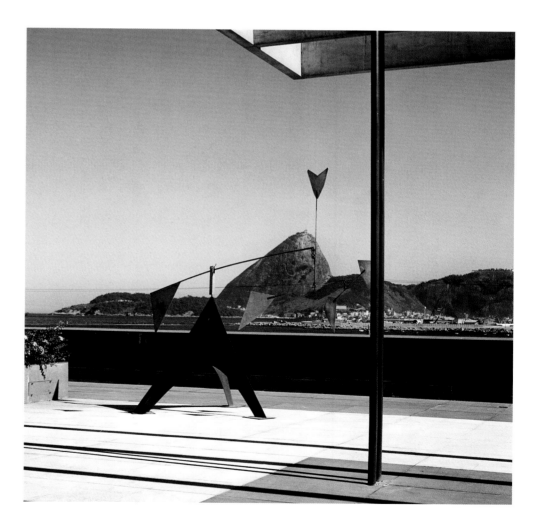

Fig. 9 | *Alexander Calder: Escultura, Guache,* installation view; Museu de Arte Moderna do Rio de Janeiro, 1959; photograph by Marcel Gautherot

vistas in these images, because directly to his back Reidy's massive Exhibition Block was under construction and would have dominated almost every exterior view.[38] In fact, as soon as someone circled a sculpture, the Exhibition Block would have been impossible to ignore (fig. 9). Surprisingly, though, there is just one image in this group that reveals the building's prominence on the site.[39] And yet, Calder's works still harmonized with the unfinished modernist structure. The angular bases of the stabiles, with arms positioned at various diagonals, echoed the fourteen V-shaped ribs—the architectural hallmark of the campus—that extended the length of the building and served as an external framing device. Contemporary viewers of these photographs should also keep in mind that they are static images and cannot capture the dynamic nature of the site. With the Exhibition Block under construction there would have been a constant stream of people, including foremen, engineers, and laborers, as well as city and museum officials, coming and going from the construction zone. Machinery would have appeared as needed—powered up, been used, then switched off— only to disappear on a daily and weekly basis. In the photograph, we see silhouettes of workers, wooden scaffolding, ladders, sawhorses, pulleys, and cables, all of which would have been in constant motion during the workday, moving, lifting, foisting, and gradually placing the materials of modernist architecture— steel, concrete, and plate glass—into place. Despite what the photograph suggests, this site was not static but would have been in nearly perpetual motion, not unlike a Calder mobile.

The circumstances of this installation made the timing of his 1959 exhibition in Rio de Janeiro all the more fitting, since it coincided with a visit from the AICA delegation. That September, sixty-five delegates from Europe and the Americas, including the organization's president James Johnson Sweeney (then director of the Solomon R. Guggenheim Museum, New York), as well as Meyer Schapiro, Giulio Carlo Argan, Bruno Zevi, and Tomás Maldonado, attended events in Brazil.[40] AICA's Brazilian delegates, Pedrosa and Mário Barata, conceptualized the conference around a utopian theme, "The New City—A Synthesis of the Arts," which was the focus of various sessions dedicated to such topics as fine and applied art, architecture and urbanism, and art and education. These conversations, coupled with the impressive sites they visited in Brasília, São Paulo, and Rio de Janeiro, would have revealed the impressive cultural makeover that Brazil was undertaking at that time. In Brasília, the group's first stop, President Juscelino Kubitschek oversaw the inaugural session in the newly completed Palace of Justice, which was designed by Niemeyer. The group then traveled to São Paulo in time for the opening of the fifth Bienal, the first to be held in Niemeyer's buildings in the newly rehabilitated Parque do Ibirapuera (fig. 10). And in Rio de Janeiro, the congress met at the Museu de Arte Moderna for three days, initiating their activities with the *vernissage* of Calder's exhibition there. Although it may seem peculiar that Pedrosa and Barata would have chosen to showcase a US sculptor rather than a Brazilian artist, to the AICA delegation, by the time of his

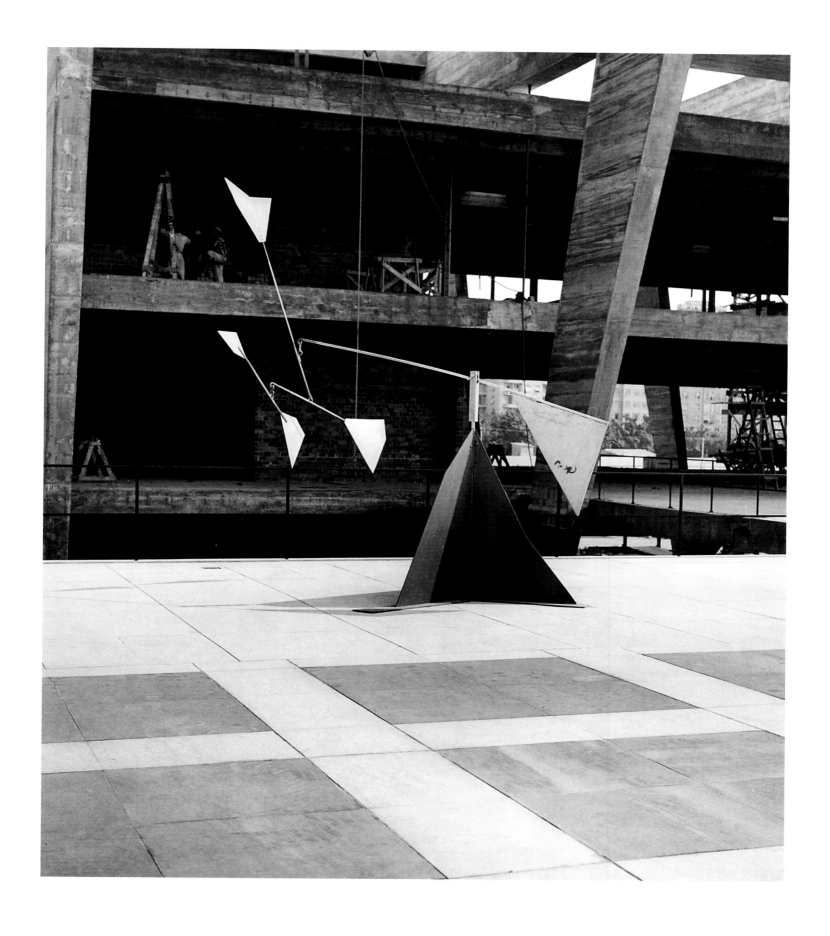

Fig. 10 | Parque do Ibirapuera, 1951, São Paulo;
Oscar Niemeyer, architect; photograph
by Nelson Kon, 2004

1959 exhibition, Calder's works had taken on multiple significations for Brazilian audiences.[41] Not only were his installations closely connected to the history of Brazilian modern architecture, but they also epitomized the most vanguard work being created in the Western Hemisphere.

Given the positive exhibition history outlined here, as well as the respect and admiration that so many culturally elite Brazilians held for Calder, it is not surprising that the sculptor was encouraged to visit Brasília, Niemeyer's magnum opus, during his 1959 trip. Just before his exhibition opened in Rio de Janeiro, Calder traveled there and met with the architect, who gave him a tour of the still-unfinished city. Niemeyer also invited him to propose a work for the Praça dos Três Poderes, the principal plaza of the city, which conjoined the three branches of government.[42] Calder took this task to heart and, although he returned to the US shortly after the opening of his exhibition, he traveled back to Brazil in February of 1960, making a return trip to Brasília in order to show his maquette to Niemeyer (fig. 11). His proposal, which he registered with Novacap, the organization over-seeing the construction of the new capital, was a standing mobile made of iron and stainless steel that would stretch ten meters high. It was to have a slightly curved triangular base and two projecting arms balanced across the top, with a red circle at one end and two white circles on the other ends. Although not identical, the subtle curvature of the base perfectly echoed the arabesque forms that Niemeyer had used to great effect in his government buildings. The press generally praised Calder's proposal and several of the most influential art critics wrote in support of this work.[43] Pedrosa also publicly extolled its virtues, writing that Calder had "understood superbly the urban and architectural spaces that provide not only the physiognomy but also the spirit of the city. In Calder's piece ... there is the same purity, the same simplicity and clarity of conception as the

urban plan structures and Niemeyer's architecture.... His mobile will add a touch of poetry and evocation to the intrinsic monumentality of the whole.... The presence of Calder's mobile there will be a felicitous example of integration, something which is still sorely lacking in the project for Brasília."[44]

Despite the outpouring of enthusiasm for Calder's sculpture, it was never realized in the new capital, though explicit reasons why have never been publicized. Calder did make several attempts to move the project forward, reaching out to Brazilian friends from the US and France, but they were mostly met with silence from Novacap and Niemeyer alike.[45] Perhaps it was Pedrosa's enthusiasm for Calder's ability to ameliorate what he perceived to be the deficiencies of Niemeyer's architecture that sealed the sculpture's fate. Even though Calder's work was a harbinger of modernity, a message that harmonized with the overall scheme of Brasília, Niemeyer ultimately rejected him—most likely because Calder signified so strongly as an American artist, in the broadest sense of the term, rather than a Brazilian artist.[46] Nonetheless this Brasília episode is but a postscript to what had already been an immensely rich and productive relationship for more than a decade. Brazil as a nation engineered and manifested its modernization through art and architecture, and Calder's exhibitions in Rio de Janeiro and São Paulo proved to the world that Brazilian institutions were showing the most vanguard work of the postwar milieu. Nonetheless these same exhibitions helped build and enhance Calder's own reputation as a truly international artist at a time when that distinction was increasingly valued. The exchange that took place between Calder, Pedrosa, Mindlin, and others in Brazil was mutually beneficial, even as it made history.

Fig. 11 | Alexander Calder, *Untitled*, 1959; sheet metal, wire, and paint; 7 ¼ × 6 ½ inches; private collection, San Francisco, California

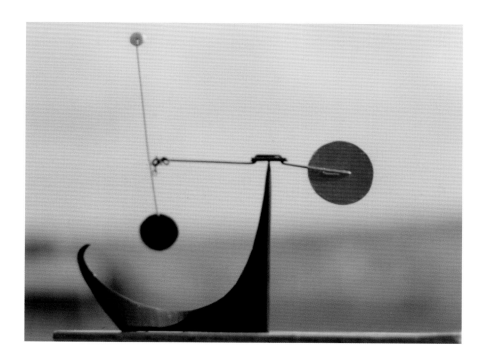

NOTES

1. Serge Guilbaut, *How New York Stole the Idea of Modern Art: Abstract Expressionism, Freedom, and the Cold War* (Chicago and London: The University of Chicago Press, 1983).

2. Biennial exhibitions and art fairs structure today's art world in very different terms. See Bergen Kunsthall, *The Biennial Reader* (Ostfildern, Germany: Hatje Cantz, 2010).

3. The AICA is a nongovernmental organization affiliated with UNESCO (United Nations Education, Scientific, and Cultural Organization). The objective of this professional organization was to serve as a central body for those working in various capacities in the art world, including curators and critics as well as art historians and art educators. Members came together out of a profound sense of responsibility toward artists as well as the public, and because they wanted to communicate the developments in the fields of art history and art criticism internationally. A significant amount of historical information can be found on their website; http://www.aica-int.org.

4. AICA's 1954 meeting took place in Istanbul; 1959's in Brazil; 1962's in Mexico City; and 1963's in Tel Aviv.

5. In the US context, MoMA's international program made a significant impact in this regard, sending its exhibitions on extended international tours. See Helen M. Franc, "The Early Years of the International Program and Council," and Lynn Zelevansky, "Dorothy Miller's 'Americans,' 1942–63," in *The Museum of Modern Art at Mid-Century: At Home and Abroad* (New York: Museum of Modern Art; distributed by H. N. Abrams, 1994).

6. For an extensive and richly detailed chronicle of Calder's exhibitions and travels see Marla Prather, *Alexander Calder, 1898–1976* (Washington, DC: National Gallery of Art 1998). Additionally, the most up-to-date chronology of his life can be found on the Calder Foundation's website, www.calder.org. Another good source, which focuses on Calder's postwar exhibition practices, is Alex Taylor, "Unstable Motives: Propaganda, Politics, and the Late Work of Alexander Calder," *American Art*, March 2012, 24–47.

7. Two sources for more information on this installation are Carlos Brillembourg, "Architecture and Sculpture: Villanueva and Calder's Aula Magna," in *Latin American Architecture, 1929–1960: Contemporary Reflections* (New York: Monacelli Press, 2004); and Enrique Larrañaga, "Toward the Visibility of the Invisible: Notes on Caracas, Modernity, and the University City of Caracas by Carlos Raúl Villanueva," in *Cruelty and Utopia: Cities and Landscapes of Latin America*, ed. Jean-Francois Lejeune (New York: Princeton Architectural Press, 2005).

8. The panels' installation and fabrication were very carefully calibrated. In fact, Calder worked closely with Robert Newmans, an engineer at MIT, to turn his sculptural forms into functional elements of the building; the clouds, or flying saucers, were actually acoustical panels, their shape, material, and precise angle and location of installation all determined by engineers to best serve the theater's acoustics.

9. Henrique Mindlin was a practicing architect who perhaps is best known for the survey text that he published in multiple languages in 1955, making Brazilian architecture well known to a vast international audience. Mário Pedrosa was the principal art critic and intellectual of the period, working in a range of fields. This meeting is described in Roberta Saraiva, *Calder no Brasil: Crônica De Uma Amizade* (São Paulo: Cosac Naify, 2006), 32. This volume, published on the occasion of an exhibition of the same name at the Pinacoteca do Estado de São Paulo, exhaustively catalogs all of Calder's relationships and exhibitions in Brazil. I am grateful to the author for her research; the publication is a trove of information and was the source for many of the historical facts described in this essay.

10. Originally published by Mário Pedrosa as "Calder, escultor de cata-ventos," *Correio Da Manhã*, December 10 and 17, 1944; reprinted in Mário Pedrosa, *Modernidade cá e lá*, org. Otília Arantes (São Paulo: Edusp, 2000), 51–66.

11. At this point, Mindlin was collecting Calder's work himself and acting as an intermediary on his friend's behalf to help sell his works in Brazil. Henrique Mindlin, letter to Alexander Calder, November 8, 1944. Mindlin file, Calder Foundation archives, New York.

12. Letter from Mindlin to Calder, 1945. Mindlin file, Calder Foundation archives, New York.

13. Throughout the essay I have used the phrase, "Brazilian Modern Architecture," as opposed to "Modern architecture in Brazil." Mário Pedrosa wrote about the distinction between the two phrases; the first connotes a local creation and the latter suggests the importation of a foreign idea. In Fernando Luiz Lara, *The Rise of Popular Modernist Architecture in Brazil* (Gainesville, FL: University Press of Florida, 2008), 96.

Furthermore, the term modernism is also frequently confused in the Brazilian context since the Portuguese correlative, *modernismo*, refers specifically to the Brazilian avant-garde literary and visual arts movements of the 1920s, 30s, and 40s, which were sparked by the *Semana do Arte Moderna* in São Paulo in 1922. It should not be confused with the larger international movement called modernism. This distinction is made in Jacqueline Barnitz, *Twentieth-Century Art of Latin America*, 1st ed. (Austin: University of Texas Press, 2001).

14. In addition to strengthening these preexisting friendships, Calder met many of the nation's most influential cultural figures during his stay and established many more lifelong friendships. These friendships, in particular with Mindlin and Pedrosa, but also with Carlota de Macedo Soares and Roberto Burle Marx, are well documented through letters in the artist's archives at the Calder Foundation. Macedo Soares even helped Calder set up a studio in downtown Rio. Alexander Calder, *Calder, An Autobiography with Pictures*, ed. Jean Davidson (New York: Pantheon Books, 1966).

15. Between 1946 and 1951, the following institutions were founded: the Museu de Arte Moderna do Rio de Janeiro, the Museu de Arte de São Paulo, the Museu de Arte Moderna de São Paulo, and the Bienal de São Paulo.

16. The number of works included in this show is unknown because no checklist exists. In his autobiography, Calder reminisced about the installation help provided by Pedrosa and Mindlin as well as the landscape architect Roberto Burle Marx and one of the building's young architects, Oscar Niemeyer. Saraiva, *Calder no Brasil,* 69.

17. *Alexander Calder: Setembro 1948* (Rio de Janeiro: Ministério da Educação e Saúde, 1948).

18. Photocopy of photograph of event. Pedrosa file, Calder Foundation archives, New York.

19. Guest book, Calder Foundation archives, New York.

20. Anonymous, "Os 'mobiles' estimularam triunfalmente," *Diario de São Paulo,* October 7, 1948.

21. "O mais expressivo dos representant desta tendencia abstracionista, Alexander Calder, cuja exposição servirá para oferecer ao public um tema novo de discussão, tanto mais que tomaremos a iniciativa de realizer, depois dessa mostra, a exposição didatica e panoramica do 'abstracionismo … Calder é o artista que se encontra em posição mais avancada." (The most expressive of those who represent the abstractionist tendency, Alexander Calder, whose exhibition will serve to offer the public a new topic for discussion, especially as we take the initiative to realize, after this show, a didactic and panoramic exhibition of abstraction … Calder is the artist at the most advanced position.) P. M. Bardi, *Diario de São Paulo,* October 7, 1948.

22. This exhibition, which holds an important role in the historiography of twentieth-century art history in Brazil, is described by Serge Guilbaut in the following essay "Ménage à Trois: Paris, New York, São Paulo, and the Love of Modern Art." In *Internationalizing the History of American Art: Views*, ed. Barbara S. Groseclose and Jochen Wierich (University Park, PA: Pennsylvania State University Press, 2009), 244. See also Leon Degand, *Do Figurativismo ao Abstracionismo* (São Paulo: Museu de Arte Moderna de São Paulo, 1949).

23. Degand, *Do figurativismo ao abstractionismo*, 55.

24. Undated memo from René d'Harnoncourt, Calder Foundation archives, New York.

25. For a detailed discussion of this exhibition, see Adele Nelson's essay, "Monumental and

Ephemeral: The Early São Paulo Bienais," in Mary-Kate O'Hare, *Constructive Spirit: Abstract Art in South and North America, 1920s–50s* (Newark, NJ: Newark Museum, 2010).

26. Walter Zanini, writing in *O Tempo*, São Paulo, n.d. Taken from MoMA press analysis, copy in São Paulo Bienal file, Calder Foundation archives, New York.

27. António Bento, *O Jornal*, Rio de Janeiro, n.d. Taken from MoMA press analysis, copy in São Paulo Bienal file, Calder Foundation archives, New York.

28. J. C. Ribeiro Penna, reporting a conversation with Pedrosa. "Calder, com sua arte, é um representante tipico de nosso tempo, da civilização moderna, do otimismo, do bom humor." In 'A batalha secreta do grande premio da II Bienal" *Folha da Noite*, 17/ Dec /53 [Title can be translated as "The secret battle about the grand prize of the second Bienal."]

29. Although there are many books about the architecture of Brasília, James Holston's text provides a very thorough anthropological reading of the creation of the city. James Holston, *The Modernist City: An Anthropological Critique of Brasília* (Chicago: University of Chicago Press, 1989).

30. In fact, Niemeyer's firm began publishing a journal, *Módulo*, in 1955 to convey information about the construction of the new capital to Brazilians as well as to an international audience; the entire magazine was alternately translated into English, French, Spanish, and German.

31. According to architectural historian Fernando Lara, "More than one hundred articles about Brazilian architecture were published outside Brazil between 1947 and 1949." This is according to his search of the Avery Index to Architectural Periodicals database and originally published in his article of 2000. Fernando Luiz Lara, "Espelho De Fora: Arquitetura Brasileira Vista Do Exterior," *Arquitextos* 4 (2000). See also Lara, *The Rise of Popular Modernist Architecture in Brazil* (Gainesville, FL: University Press of Florida, 2008), 5; *Time*, February 13, 1956, and April 25, 1960.

32. Mindlin, letter to Calder, 1944. Mindlin file, Calder Foundation archives, New York.

33. Le Corbusier visited Rio de Janeiro in 1936 and, at Costa's request, redesigned the preliminary drawings for the building. Although Costa's team ultimately modified his design, they kept many of his key elements, and Le Corbusier is acknowledged as one of the building's architects. This structure has been prominently featured in scores of books about Brazilian architecture and generally credited as the origin of the movement.

34. One exception stands out, the previously mentioned Saraiva exhibition at the Pinacoteca do Estado de São Paulo.

35. This show, which ran from September 23 through October 25, 1959, is described and photo-documented in Saraiva, *Calder no Brasil*, 199–201.

36. I have described the Museu de Arte Moderna's campus extensively in Aleca Le Blanc, "Palmeiras and Pilotis: Promoting Brazil with Modern Architecture," *Third Text*, February 2012, 103–16.

37. In fact, the surrounding landscape was an important element in Reidy's design. His objective was to create a series of buildings that did not obstruct views of the bay, one of the reasons most of the second-story galleries have glass walls. Affonso Eduardo Reidy and Klaus Franck, *The Works of Affonso Eduardo Reidy* (New York: Praeger, 1960), 66–84.

38. Marcel Gautherot, a French photographer who relocated to Brazil in 1940, dedicated his career to photographing Brazilian architecture, both colonial and modern. He worked for the Serviço do Patrimônio Histórico e Artístico Nacional. His photographs of the building of Brasília are some of the most iconic images of the city. He also documented the construction of Rio's modern art museum and Calder's installation there in 1959. Marcel Gautherot, *O Brasil De Marcel Gautherot: Fotografias* (São Paulo: Instituto Moreira Salles, 2001).

39. It is quite likely that there are more of these images at the Instituto Moreira Salles in Rio de Janeiro, where his archive is kept. Perhaps, then, the selection of images that focuses on the landscape rather than the construction reflects a contemporary bias.

40. Details about this conference are found on the organization's website as well as in Mário Pedrosa's papers in the Biblioteca Nacional do Brasil in Rio de Janeiro. In particular, Henry Meyric Hughes's essay was of particular help in writing this essay. Henry Meyric Hughes, "Art Criticism Comes of Age: Brasília, AICA, and the Extraordinary Congress of 1959," 8th DOCOMOMO Congress, Rio de Janeiro, Brazil, 2009, http://www.aica-int.org/spip.php?article933.

41. Calder's celebrated mobiles were also a type of sculptural abstraction similar in concept to works that a younger generation of Rio-based artists was beginning to experiment with. Mário Pedrosa also supported these younger artists such as Hélio Oiticica, Lygia Pape, and Lygia Clark, who were testing the limits of geometric abstraction and the boundaries between painting and sculpture. In 1960, the year after Calder's show in Rio, they began creating objects that incorporated movement and demanded greater viewer participation.

42. Alexander Calder, *Calder, An Autobiography with Pictures*, ed. Jean Davidson (New York: Pantheon Books, 1966), 253.

43. Mário Pedrosa in *Jornal do Brasil* March 3, 1960; Vera Pacheco Jordão in *O Globo* March 5, 1960; Ferreira Gullar in *Jornal do Brasil* March 10, 1960.

44. Mário Pedrosa, "Calder e Brasília,"*Jornal do Brasil*, March 9, 1960.

45. Although Calder maintained epistolary relationships with his Brazilian friends, he never returned. He kept abreast of the political climate and at least twice publicly supported friends during the military dictatorship. In 1969, he supported friends who boycotted the Bienal de São Paulo and in 1972, he wrote an open letter, and published it in the *New York Review of Books*, protesting the arrest of Pedrosa. Alexander Calder, Henry Moore, Cristiane Du Parc, Crůz Diez, and Jovenal Ravelo, et al., "The Case of Mario Pedrosa," *New York Review of Books*, May 9, 1972.

46. In 1965, Calder finally executed the work he had proposed for Brasília, but in a smaller scale and in a very different location. Instead, the sculpture with the subtly curved triangular base, the two arms, and the three circles, was nestled in a verdant alpine landscape. This unexpected fate for the work proposed for Brasília, a modernist city of soaring architecture in the middle of a vast and arid plateau, brings many questions to mind related to Calder's works with respect to how important the site was to seemingly site-specific objects. Saraiva, *Calder no Brasil,* 217.

Harriet F. Senie

Calder's Public Art as Civic Sculpture:

The Realization of a Modernist Ideal

ALEXANDER CALDER WAS A PROLIFIC public artist, creating works for a variety of patrons, including museums, universities, corporations, and cities. It is easy to understand how his graceful mobiles and monumental stabiles could have an aesthetic function in any number of those sites but, surprisingly, quite a few of his public commissions also came to serve as civic sculpture, works that represent a local or even national entity. Of course once public art[1] is installed, it has a life of its own and is sometimes put to unexpected uses. Thus, a work commissioned for Montreal's Expo 67 was featured on an announcement for a series of rave events in 2005. Calder's varied commissions and numerous awards are evidence of the way his art was perceived as an expression of modern times, a somehow appropriate symbol for a variety of sites in Europe, North America (both Canada and the United States), and Australia. His family heritage perhaps foreshadowed his success, but three key elements in Calder's background also made him especially well suited to a career in public art: his training as an engineer, his experience with stage design, and his accommodating nature in regard to naming his works and to the functions they might serve.

Calder was born into a family of civic sculptors.[2] His grandfather, Alexander Milne Calder (1846–1923), was responsible for the sculptural

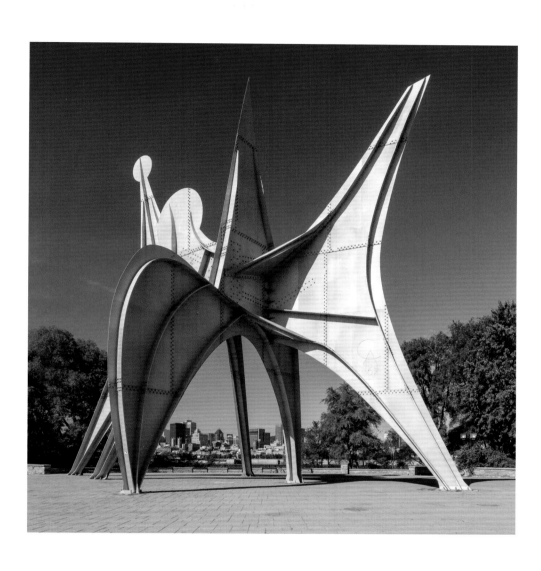

Fig. 1 | Alexander Calder, *Trois disques*, **1967**; stainless steel; 838 × 866 × 640 inches; Collection de la Ville de Montréal

program for Philadelphia's City Hall, including the iconic thirty-seven-foot-high statue of William Penn on top of the building. His father, Alexander Stirling Calder (1870–1945), was chief of sculpture for the Panama-Pacific International Exposition in San Francisco in 1915, sculpted *George Washington as President* on the Washington Square Arch in New York City, and created the *Swann Memorial Fountain* at Logan Circle in Philadelphia. Calder was thus well aware of the collaborative nature of producing art for the city, particularly the realities of working with architects. Although he came to art after abandoning an engineering career, he advanced the family profession in a hugely successful and very visible way, and he did so with a modern abstract style.

Calder's inclination for making things dated to an early age and has been well documented, as has his training at the Stevens Institute of Technology in Hoboken, New Jersey, which awarded him a degree in mechanical engineering in June 1919. His technical expertise proved especially useful for creating large-scale works for open spaces. His interest in how things were put together may also explain his fondness for displaying the bolts used to join various sections of his works, emphasizing their facture.

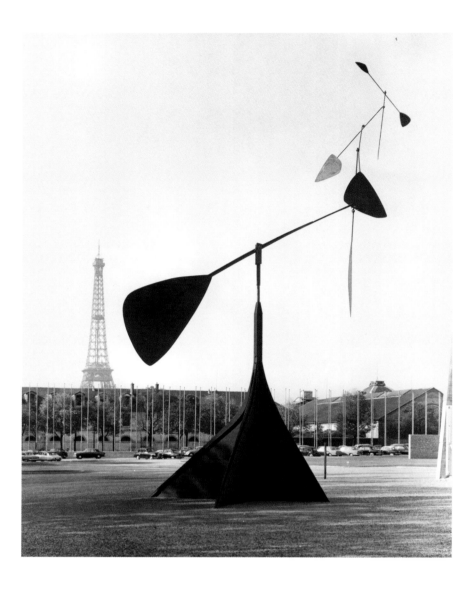

Fig. 2 | Alexander Calder, *La Spirale*, 1958; painted steel; 360 inches high; Palais de l'UNESCO, Paris

His large-scale civic works were informed as well by his experience creating sets for the theater. Stage design provides a kind of microcosm for a work of public art. Set pieces occupy and sometimes define a space in which people move and interact. Calder's father had shared his love of theater and opera with his son, who demonstrated his own theatricality early in his career with his *Cirque Calder* performances, begun in Paris in 1926. The earliest of Calder's stage designs predate his public sculpture commissions. In 1935, Calder created stage sets and props for Martha Graham's dance *Panorama*, and in 1936 he made a mobile setting for the performance of Erik Satie's cantata *Socrate*. Calder later provided stage designs for Henri Pichette's play *Nucléa* (1952), and in December 1963 his sets for Pierre Halet's *La Provocation* appeared in a performance by La Comédie de Bourges. He went on to create sets for a 1969 production of *Metaboles*, choreographed by Joseph Lazzini and scored by Henri Dutilleux, for the Theatre Francais de la Danse, and in 1971 Calder designed both sets and costumes for the ballet *Amériques,* which was choreographed by Norbert Schmuki, scored by Edgard Varèse, and performed by the Ballet-Théâtre Contemporain in Amiens, France.[3] Perhaps most interesting, though, given the nature of his oeuvre, was his *Work in Progress*, a ballet consisting almost entirely of mobiles, an idea that dated from 1962 and was first performed at the Rome Opera in 1968. This work was closely related to *Water Ballet,* his fountain design for General Motors Technical Center in Warren,

Michigan (1956), which in turn referenced his father's design for the fountain in Philadelphia's Logan Circle.

Calder was happy to create work that was not considered art in a traditional sense and to exhibit his work in sites not typically defined as art spaces. He made jewelry and toys. He designed graphics for airplanes in the fleet of Braniff Airlines and a BMW race car. He allowed his work to be used as a logo in Grand Rapids, Michigan, and even changed the title of a work to coincide with a patron's wishes in Montreal.[4] In this respect he was much more accommodating than many public artists about how his art was put to use. Although he was not a member of the Bauhaus, in many ways he shared its disregard for the distinctions between high and low art, or art and craft. Since Calder spent much of his time in Paris and was acquainted with Joan Miró, Piet Mondrian, and others, he certainly would have been familiar with Bauhaus philosophy, although he seemed to come to it independently. In fact, one of his earliest public commissions, *La Spirale* (1958), was an expression of the integration of the arts, an ideal championed by the influential school.[5]

In 1956 the architect Marcel Breuer and the International Congress of Modern Architecture (CIAM) had invited Calder to create a sculpture for the headquarters of UNESCO (United Nations Education, Scientific, and Cultural Organization) in Paris.[6] Breuer was one of a three-member international team of architects: Pier Luigi Nervi and Bernard Zehrfuss were the others, working with an advisory committee of Lúcio Costa, Le Corbusier, Walter Gropius, Sven Markelius, and Ernesto Nathan Rogers. Calder was one of the first six artists chosen, along with Miró, Jean Arp, Henry Moore, Isamu Noguchi, and Pablo Picasso. It was the first civic commission for all except Moore.[7] Although the project was touted as a model for the integration of contemporary art and architecture, it was criticized for lacking any collaboration between artists and architects. Works by famous artists instead were added to the building in the manner of amassing a "blue-chip" collection, a practice that became common and continues to this day.

La Spirale, Calder's contribution, is a thirty-foot-high standing mobile, his largest monumental work to date and one of the few to include mobile elements (fig. 2). Calder described it as "a helix, the top is a sequence of bars and plates that spiral off in decreasing size."[8] The placement of the sculpture is especially significant: from the site it can be seen isolated against the Eiffel Tower, the symbol of Paris. Calder had chosen the site precisely for this reason.[9] John M. Kyle, chief engineer for the Port Authority of New York and New Jersey wrote to Calder in November 1958 to comment on the site of the work because he thought UNESCO had done Calder "a great disservice in placing [his work] in such an inconspicuous spot." Calder responded with a drawing that indicated that this was for him a key placement, marking the vista to the Eiffel Tower as "View 1." He noted: "[O]n the contrary, I think it is well placed ... It is not lost in the middle of the arena and it acts as a sentinel."[10] Silhouetted in this way, *La Spirale* can be seen in tandem with the Paris landmark, and it is most often photographed from this perspective.

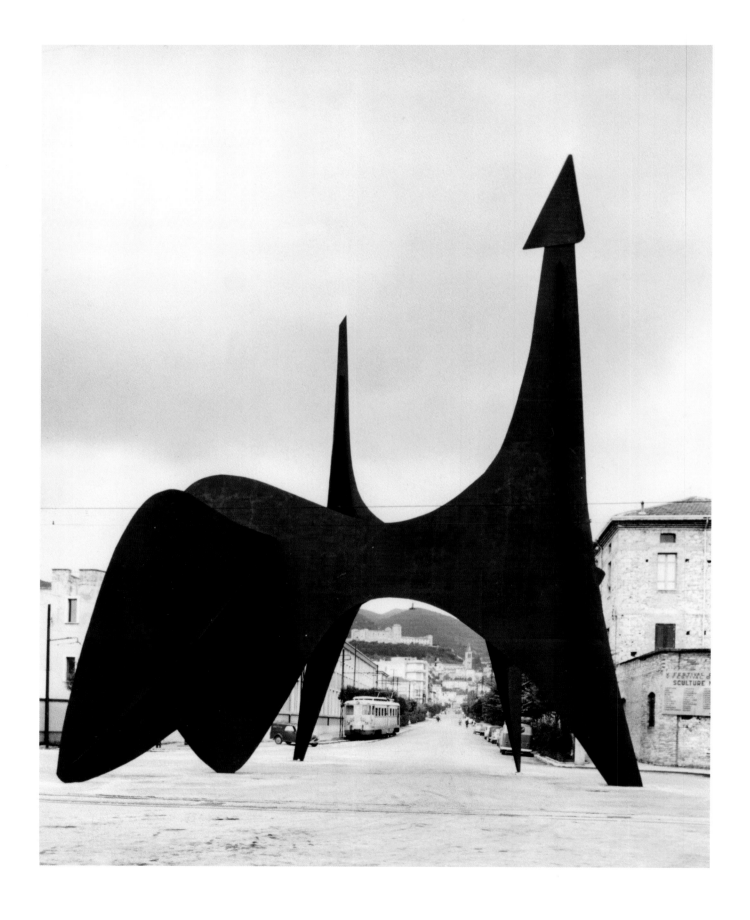

Fig. 3 | Alexander Calder, *Teodelapio*, 1962;
Spoleto, Italy; photograph by Ugo Mulas

Interestingly, one photo caption from the time mistakenly noted the sculpture's title as *Moderne Zeit* (Modern Times).[11]

While Calder thought of *La Spirale* as a guard, his *Teodelapio* (1962)—a fifty-nine-foot-high, thirty-ton stabile—was intended as a gateway to the city of Spoleto, Italy (fig. 3). It is possible to drive under the work, and its enormous scale made it visible from trains arriving at or departing from the station. Italian curator Giovanni Carandente had commissioned *Teodelapio* from Calder and suggested its placement marking the entrance to the Fifth Festival of Two Worlds, an exhibition of some 150 works by fifty sculptors.[12] Calder's preparatory drawings indicate specific local architectural influences: the spires of the Spoleto Cathedral (Cathedral of Our Lady of the Assumption) and the arches of the walls of Spoleto's Castle (La Rocca Albornoziana).[13] Some nevertheless saw suggestions of phallic imagery but Calder insisted, "I wasn't aware of any such influence, but that may give it its nice force."[14] The sculpture's title refers to a former duke of Spoleto who ruled from 602 to 650 under the Lombard supremacy. *Teodelapio* thus referenced its site in historical and formal ways. As Calder scholar Joan M. Marter observed, "Spoleto became the first city to introduce a Calder stabile as a provocative landmark,"[15] one that came to be used in various ways as a civic logo. Like Calder's UNESCO work, the sculpture appears on a postcard of the city. A silhouette of the sculpture outlined on a green circle adorns sugar packets in the Bar Buffet Stazione,[16] and local street signs advertising a 1970 conference on medieval studies featured a schematic of the sculpture with a castle in the background.[17] Calder's sculpture, created in a cultural context, continues to impose a cultural identity on Spoleto.

Five years later, Calder created *Trois disques* for the 1967 world's fair, known as Expo 67, held in Montreal (fig. 1). Commissioned the previous year by the International Nickel Company of Canada, the sculpture, measuring sixty-five by eighty-three by fifty-three feet, was the artist's largest to date and the only one he created in stainless steel. Calder titled the monumental stabile *Trois disques* in reference to the circular forms atop several points of the sculpture, but when officials asked him to change the name to *Man* to coincide with the theme of the exposition, "Man and His World," he complied, apparently without argument.[18] Calder's flexibility on this issue seems rather remarkable, suggesting that he felt the patron was entitled, to a certain extent, to use his sculpture in a way that best suited the purposes of the commission.[19] Calder was not at all compliant about issues with other works, however. When the color of his sculpture was changed for the Pittsburgh Airport, Calder removed his name from the work.[20] He was always adamant about the placement of his work and its aesthetic parameters.

In Montreal Calder's sculpture was seen in a defining civic context from the beginning. "Man, Trois disques," a poem by Jacques Prévert written at the time of its installation, compared the sculpture to the Eiffel Tower.[21] Brodie Snyder, writing in *Montreal 67*, included a summary of remarks made at its dedication, which likened the work to the Statue of Liberty, both in its initial mixed response

to its aesthetic merit and its "interpretation of mankind, his humanity, his free-
dom, [and] his search for what is good and fine in life."[22] *Trois disques* was
originally placed near the Scandinavian Pavilion, with predictions that it would
"become a lasting symbol of Expo."[23] At one point there were plans to have the
city of Montreal send *Trois disques* to Osaka for Expo 70 as a civic symbol of their
participation.[24] A period of apparent disinterest in the work followed, however,
accompanied by a physical decline in the condition of the site and that of the sur-
rounding area, which included Île Sainte-Hélène and the nearby Ile Notre-Dame,
enlarged and built for Expo 67 as a stop on the Montreal Metro. Decades later,
in 1991, after these problems were acknowledged, it was moved to the belvedere
lookout on Parc Jean-Drapeau's Île Sainte-Hélène.[25] An official opening for the
conserved sculpture in its new location was held in June 1992 to coincide with
the twenty-fifth anniversary of Expo 67 and the three-hundred-fiftieth anniversary
of Montreal.[26] In recent years *Trois disques* has been appropriated by a subculture
of electronic music fans who stage what they call "electronic picnics" underneath
and around the sculpture. Eventually, the City of Montreal granted official per-
mission for these previously impromptu dance parties. By the spring of 2003, it had
become the central location for "Montreal's favorite outdoor rave ... a popular
spring and summer Sunday event with families as well."[27] Advertisements for these
celebrations feature the Calder sculpture atop a sphere decorated with images
related to the event (fig. 4).[28] Its original celebratory purpose thus has been trans-
formed into a more contemporary expression.

In the same year that *Trois disques* was installed in Montreal, Calder's *Crossed
Blades* (1967) was placed outside the Australia Square Tower, a circular office
and retail complex in the central business district of Sydney (fig. 5). The building
by Harry Seidler, Australia's most renowned architect, was the most significant
architectural commission in the country at the time and is still admired today.
The architect and sculptor conferred at length about the placement of the work
next to the building and other details; Calder insisted that the sculpture be black.[29]
It features archlike openings that allow for pedestrian traffic, much like his
subsequent sculpture *Flamingo* (1973), commissioned for Chicago by the United
States General Services Administration (GSA).

The prospect of having a Calder sculpture seemed to generate great excite-
ment in Sydney. Seidler sent news clips that compared it to the artist's other
sculptures in Montreal and Spoleto.[30] At the time of its installation one writer
predicted: "It'll knock people's eyes out. Nothing like this has ever been seen in
Australia." Another observed that "the most pressing themes of art in our time are
all caught up in it ... It is at the same time an object and an event."[31] A decade later
the architect informed Calder that his sculpture was "more appreciated than ever
by the public."[32] This was also true of the building. In 2004 Australian writer
Stephen Lacey observed: "[I]t is hard to find an architect, critic, or urban designer
with anything negative to say about the building—now or in the past." According
to Lacey, "It eclipsed every other building in the nation in scale and scope and

Fig. 4 | Poster for 2005 Piknic Électronik Music
Festival, Montreal, Canada, 2005

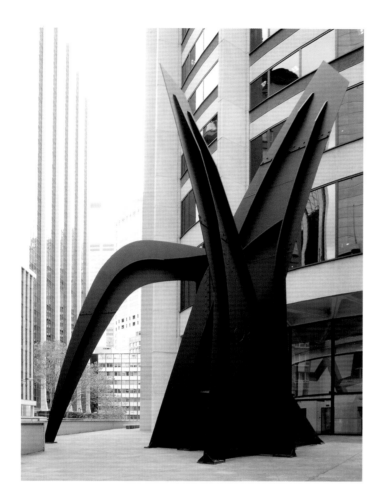

Fig. 5 | Alexander Calder, *Crossed Blades,*
1967; painted steel; approx. 354 × 315 × 315
inches; Harry Seidler & Associates, Sydney

set a benchmark in engineered architecture that few, if any, other Australian sky-scrapers would ever meet."[33] In 2012 the Australia Institute of Architecture presented Australia Square with the National Enduring Architecture Award, crediting both the fifty-story tower with being "an icon of Australian architec-ture" and, together with its surrounding public space, having "shaped the redevel-opment of Australian cities for the remainder of the twentieth century."[34] Lacey described *Crossed Blades* as a "menacing black sculpture" that "serves as a coun-terpoint, almost a challenge, to the hustle and bustle of George Street," while architect Ian Moore found the work as important as the building and without doubt the most significant sculpture in Australia.[35] Eventually *Crossed Blades* came to be listed in the city archives as part of its heritage inventory.[36]

The inclusion of art in the project in fact was based on the principle of the integration of the arts espoused by the Bauhaus. Seidler had studied with Gropius at the Harvard School of Design, earning a master's degree in architecture in 1946, after which he took a design course at Black Mountain College in North Carolina, working with Josef Albers. In January 2013 an exhibition opened at VIVACOM Art Hall in Sofia, Bulgaria, titled *Architecture, Art, and Collaborative Design: Harry Seidler Exhibition,*[37] signaling the importance of the collaborative effort in his work. The interior of Australia Square Tower originally included tapestries by Calder, Le Corbusier, Miró, and Victor Vasarely.[38] Le Corbusier's work was titled *Unesco,*

perhaps in reference to that model of the integration of the arts in Paris to which Calder also contributed.

Calder's sculpture in Australia Square provided a national image emblematic of modernism but his work in Grand Rapids, Michigan, perhaps more than anywhere else, became both a civic logo and an impetus for the formation of a new local cultural identity (fig. 6). *La Grande vitesse,* a French translation of the city's name, was the first sculpture to receive funding from the National Endowment for the Arts's (NEA's) Art in Public Places program. Established in 1967, it offered matching grants to local entities.[39] Installed in Vandenberg Center Plaza in downtown Grand Rapids in 1969, it was commissioned as part of an urban renewal project. Prominent local citizen Nancy Mulnix played a key role, prompted by a conversation she had about the new initiative with Henry Geldzahler, then director of the NEA's Visual Arts program, who was visiting the city to give a lecture.[40] The grant for the sculpture was expedited by the efforts of Michigan Representative Gerald Ford and Mayor C. H. Sonneveldt. It would replace previous plans for a fountain with a reflecting pool. The selection

Fig. 6 | Alexander Calder, *La Grande vitesse*, 1969; Grand Rapids, Michigan; painted steel; 360 × 648 × 516 inches

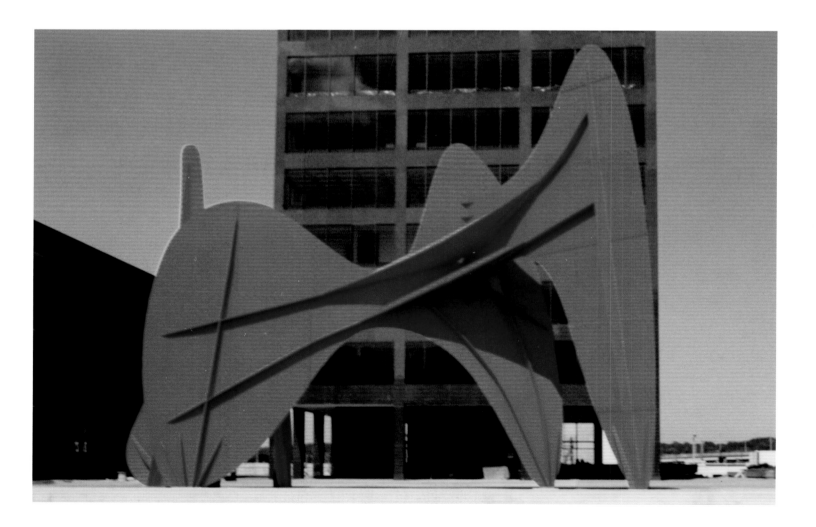

Fig. 7 | City of Grand Rapids stationery with Alexander Calder's *La Grande vitesse* (1969) incorporated into the city logo in 1971, Grand Rapids City Archive

Fig. 8 | City of Grand Rapids stationery with Alexander Calder's *La Grande vitesse* (1969) incorporated into the city logo in 1981, designed by Joseph Kinnebrew, Grand Rapids City Archive

Fig. 9 | City of Grand Rapids garbage truck with Alexander Calder's *La Grande vitesse* (1969) incorporated into the city logo in 1981, designed by Joseph Kinnebrew, Grand Rapids City Archive, photographed 2013

committee, which included Walter McBride, the director of the Grand Rapids Art Museum, chose Calder "in part because of his stature as an artist, and in part because the scale, color, and composition of his work could be relied upon to provide a commanding focal point for the large plaza."[41]

La Grande vitesse initially prompted controversy based on several issues, though. Calder was then living and working in France, and thus was not immediately perceived to be an American. His art was in an unfamiliar abstract style, and his work replaced a planned fountain that had generated no opposition.[42] Eventually, however, the sculpture was adopted as a literal civic symbol. It became the logo on official stationery and city vehicles, including garbage

trucks (figs. 7–9). A brochure published by the Grand Rapids Chamber of Commerce proclaimed that to "gaze up along its massive sweeping planes is to catch something of the vitality, newness, and progress that is Grand Rapids today." The sculpture essentially gave the city a bright new image. A local businessman remarked: "We had lost our identity. The Calder was like a big heart bringing us to life again."[43] It became "the symbol of urban optimism."[44] The community's experience with the Calder inspired the Women's Committee of the Grand Rapids Art Museum to sponsor a citywide exhibition of large-scale outdoor sculpture, *Sculpture off the Pedestal* (1973), prompting the acquisition of even more public art for the city.[45] Calder Plaza, as it came to be known, continues to serve as a venue for a variety of local events, from cultural performances to ethnic food fairs. When Senator Barack Obama came to Grand Rapids in 2008 to campaign for the presidency, he spoke at the site.

Although most of Calder's civic sculptures are in urban settings, he chose to have his last large-scale sculpture, *Jerusalem Stabile*, placed on the outskirts of the city (fig. 10). To entice Calder to Israel, Mayor Teddy Kollek, Dr. Martin Weyl (then chief curator of the Israel Museum), and the Mexican sculptor Mathias Goeritz (who had commissioned two Calder sculptures for Mexico), visited him at his home in France and urged him to create a sculpture for Jerusalem. He and his wife, Louisa, made the trip in 1975.[46] The mayor showed Calder around the city and pointed out possible locations, including Paris Square in the center of New Jerusalem, an urban environment surrounded by both modern and late nineteenth-century buildings; and the area leading to the Israel Museum complex, a more open space overlooking the museum, the campus of Hebrew University, and the Knesset (Parliament). Calder selected instead a site in Holland Square, described as "a simple, undeveloped intersection on the southeastern slope of Mount Herzl," overlooking the neighboring village of Ein Kerem. The western view of the site overlooks the Judean Hills, and Calder wanted to place his sculpture there.[47] The artist provided a model for the work and it was built before he died the following year; in response Kollek enthused: "My cable could not possibly convey to you the excitement here at seeing the sculpture you will be creating for the city of Jerusalem. This is a truly monumental work which will blend into the vista of the surrounding Hills of Judea."[48]

The project was part of a program intended initially to provide art in a number of areas, especially underprivileged neighborhoods, which would "not only enhance the urban environment, but will also actively be 'used' by the population."[49] Niki de Saint Phalle's *Golem* (1972) was cited as a good example of a sculpture that was "used" in this sense. This initiative was developed with help from the Jerusalem Foundation and the guidance of the Israel Museum. An American collector, Philip Berman of Allentown, Pennsylvania, had funded *Jerusalem Stabile*.[50] Sometimes referred to as *Le Jerusalem* and *L'Israel*, it clearly had a larger focus than previous works, providing a sense of civic identity from the start. The sculpture was also seen as a monument for peace and "a structure delineating what

looked like the interlocking portals of a grand imaginary place of worship."[51] Mayor Kollek considered it a tribute to the artist as well. He wrote: "The Calder stabile in Jerusalem will not only adorn the city but it will also be a most meaningful memorial to a great artist and a fine human being."[52] Berman, the work's patron, interpreted it in even more far-reaching terms. He praised "the symbolic value of the *Jerusalem Stabile* embodying peace, location, and stability" and how it provided an "identity for all Israelis in a time of political, economic, and security difficulties. Jerusalem has a most significant identity to the present and the future through this work of art adding to its illustrious past."[53] In a subsequent letter to friends, Berman wrote that the sculpture "identifies the country in a beautiful, sensitive, and colorful way and … represents the combination of the United States and Israel with its people expressing themselves together in peace and harmony."[54]

Open to a variety of interpretations, Calder's public artworks appeared to fill the deep need of communities for a visual symbol to focus civic goals and provide

Fig. 10 | Alexander Calder, *Jerusalem Stabile*, 1976; sheet metal, bolts, and paint; approx. height 452 ¾ inches; The Jerusalem Foundation

an affirmative sense of local identity. They were not necessarily commissioned with that clearly stated purpose, however. The works discussed here were realized in several different contexts: to mark the occasion of a local art exhibition or international exposition; in conjunction with architecture as a vital element of the complete building; or as part of a civic initiative to provide a more positive local image. When combined with significant architecture or used as a catalyst for civic pride, the works were often a component of larger urban renewal projects.

Teodelapio in Spoleto and *Trois disques* in Montreal were from their inception part of endeavors meant to identify their locales as cultural centers, and served as the defining images of their respective festivals. *Crossed Blades*, at Australia Square, like *La Spirale* at UNESCO, was explicitly commissioned in conjunction with a new building destined to play a key role in a national and international context. This practice reflected the philosophy of the integration of the arts, as articulated by Gropius at the Bauhaus, championed in architectural journals, and realized elsewhere in Europe and the United States.[55] The Bauhaus embraced individuals "trained in industry and handicraft," and considered itself "an arts and crafts school... Its credo was: 'The Bauhaus strives to coordinate all creative effort, to achieve, in a new architecture, *the unification of all training in art and design.*"[56] Gropius wanted to unite the efforts of all involved, "from the simple artisan to the supreme artist" in the project of creating great architecture.[57] In practice, many of the Bauhaus buildings created under this philosophy were also part of larger urban renewal efforts. This was also true of *Crossed Blades* and *La Grande vitesse*. *Jerusalem Stabile* was part of a broader civic undertaking intended to have a regenerative effect on a declining neighborhood; it was not related to a specific building.

Considering that Calder worked in an abstract style, it is remarkable how well his sculpture seemed to fulfill its (often) unstated civic mission, when so often abstraction has proved antithetical to public taste, which favored figural sculpture. That was not, of course, the dream of the creators of abstraction at the start of the twentieth century, who saw art as an expression of, if not a parallel to, the new reality of modern times. Arp understood his works as "constructions of lines, planes, forms, colors" seeking "to approach the ineffable truth concerning mankind and the eternal."[58] According to Theo van Doesburg, a member of the De Stijl movement whose writings were translated and reproduced by the Bauhaus, "The work of art is a metaphor of the universe obtained with artistic means... [It] becomes an independent, artistically alive (plastic) organism in which everything counterbalances everything else."[59] Mondrian, who subscribed to these principles and articulated them in writings of his own, initially inspired Calder to make his own work move.[60] Elsewhere van Doesburg proclaimed: "Art, just like science and technology, is a method of organizing our shared life in general... Art is a universal and real expression of the creative energy which organizes the progress of humanity."[61]

Calder's fascination with movement, obvious in his mobiles, is still suggested in his stabiles. The wide arcs of *Teodelapio*, *Trois disques*, and *Jerusalem*

Stabile both frame their surroundings in dramatic ways and encourage pedestrians to walk around and through them. Here his previous experience as a designer of stage sets is writ large in the context of architecture and the relationship of urban spaces. In a 1991 essay artist and writer David Batchelor argued, that "a Mondrian or a Rothko or a LeWitt is an image of something, but not an image of some thing. It seems safer to think of the work as representing, or attempting to express, a kind of conception or understanding of a world, to be like that world in an abstract way."[62] Calder's civic sculptures suggest a world that is newly imagined, vital, never static, and often colorful. They activate their sites, implying that the places themselves are dynamic, and simultaneously seem to energize the people who walk under or around them. With their thrusting verticals and circular or ovoid forms, Calder's public artworks suggest a kind of positive growth, or at least the possibility thereof. Certainly the artist's international reputation as one of the most important sculptors of his time gave this interpretation credence. Calder essentially realized one of the basic modernist ideals of an abstract language that seemed accessible to a wide audience.

NOTES

1. For the purposes of this essay, public art is considered to be any work installed in a public space that is readily accessible by the general public. How that work is perceived is often determined by the nature of its site, so work that is part of an outdoor exhibition might be understood differently than one placed in front of a commercial building.

2. See Joan M. Marter, *Alexander Calder* (New York: Cambridge University Press, 1991), 1–9, on this aspect of Calder's artistic heritage.

3. Isamu Noguchi, with whom Calder was well acquainted and who enjoyed a long and successful public art career as well, also worked on set designs, collaborating with Martha Graham, among others.

4. *La Grande vitesse* in Grand Rapids and *Trois disques* in Montreal are discussed in detail in this essay.

5. For a discussion of public art and its relationship to the philosophy of the integration of the arts, see Harriet F. Senie, "Sculpture and Architecture: A Changing Relationship," in *Contemporary Public Sculpture: Tradition, Transformation, and Controversy* (New York: Oxford University Press, 1992), 61–92. Portions of the following account are based on this source.

6. Numerous accounts of the UNESCO building campaign exist. One of the most comprehensive is "Le Siege de L'Unesco a Paris," *Architecture d'Aujourd'hui*, December 1958, 4–33.

7. Aline B. Saarinen, "Six Top Artists to Brighten UNESCO Home," *New York Times*, June 13, 1956, 10.

8. Calder is quoted in Geoffrey T. Hellman, "Onward and Upward with the Arts: Calder Revisited," *The New Yorker*, October 22, 1960, 175.

9. See Marla Prather et al., *Alexander Calder, 1898–1976* (Washington, DC: National Gallery of Art; New Haven, CT: Yale University Press, 1998), 281. The exhibition was at the National Gallery of Art, Washington, from March 20 to July 12, 1998, and at the San Francisco Museum of Modern Art from September 4 to December 1, 1998.

10. John M. Kyle, letter to Calder, November 12, 1958; Calder's response to "Jack," November 15, 1958. Calder Foundation archives, project file.

11. *Humanite*, August 27, 1958, Calder Foundation archives, project file.

12. Prather et al., *Alexander Calder, 1898–1976*, 281ff.

13. Berenice Mancewicz remarked: "It was designed as an arched gateway to the city. With its towering spires, it is suggestive of a Gothic structure." Mancewicz, "Artist's Sculpture Moves," *Grand Rapids Press*, December 19, 1967. See also fig. 3.

14. Calder is quoted in Prather et al., *Alexander Calder, 1898–1976*, 281.

15. Marter, *Alexander Calder*, 239.

16. Calder Foundation archives, project file.

17. The signage posted by the Azienda Turismo reads: "Spoleto, Citta del Festiva, XVIII Settimana Di Studi Altomedievale, 2 Aprile–6 Aprile 1970," Calder Foundation archives, project file, A01333.

18. Although known as *Man* in the context of Expo 67, the work's official title is *Trois disques*. See also John Russell, "Calder," *Vogue*, July 1967.

19. On titles Calder once remarked: "I give names to the things I'm working on just like license plates." In Grace Glueck, "Ticket Window (Nonfunctional) Is Installed at Lincoln Center," *New York Times*,

November 12, 1965, 49. Calder modified titles over the course of his career, perhaps indicating his indifference in expressing something about a work through its title, which he primarily used as a way to identify or differentiate a work, not as a guide to comprehend it.

20. For a discussion of the Pittsburgh commission, see Marter, *Alexander Calder*, 227–29.

21. Jacques Prévert, "Man, Trois disques," *Derriere le Miroir*, no. 156, Maeght Editeur, 1966; see http://ville.montreal.qc.ca.

22. Brodie Snyder, "A New 'Statue of Liberty'?" *Montreal 67*, vol. 4, no.6, 29.

23. Catherine Milton, "'Man'—A Living Symbol," *Boston Sunday Globe*, March 5, 1967, 10A.

24. Charles Lazarus, "Stabile Is Mobile," 1969, Calder Foundation archives, project file. Lazarus referred to the Calder sculpture as "one of Expo 67's best-known symbols," and Expo 67 as "the most successful world exhibition ever held."

25. Martineau Walker, a Montreal lawyer, letter to Kathleen Verdun, a member of the executive committee of the City of Montreal, February 24, 1989, Calder Foundation archives, project file, states that Renato Danese, director of Pace Gallery, was concerned that the "treatment of the work discredits the reputation of the late Mr. Calder and the quality of this important work." The Calder family offered to purchase the work for one million dollars and relocate it to New York with no resale intended or, alternatively, consider proposals from Montreal to present the work properly at an appropriate location at their expense. However, the sculpture

was moved in May 1991, prompting objections from the Calder family that they had not approved the site or been consulted on the move. Stephen Godfrey, "Calder Family Objects to Relocation of Sculpture," *New York Times*, May 4, 1991. Calder Foundation archives, project file.

26. Jean Dore (Mayor of Montreal), letter to Renato Danese at Pace Gallery, April 10, 1989. Calder Foundation archives, project file.

27. Evelyn Reid, "Alexander Calder: L'Homme," *About.com Montreal*; http://montreal.about.com/od/historypeopleplaces/a/alexander_calder_sculpture_l_homme_man_montreal.htm; accessed October 26, 2012.

28. My thanks to Johanne Sloan for calling this to my attention. E-mail to the author, November 4, 2012.

29. Calder's note appears on a letter from Harry Seidler dated February 21, 1966, Calder Foundation archives, project file. On June 6 of that year Seidler inquired if Calder designed tapestries and indicated that he might like to buy a Calder sculpture for a house he was building.

30. See, for example, Gavin Souter, "The Big Name May Be Calder," *Sydney Morning Herald*, August 25, 1966, 5. Seidler, letter to Calder, August 25, 1966. Calder Foundation archives, project file.

31. Keith Willey, "Giant Sculpture Will Tower over City"; Donald Brook, "A Steel Symbol of Our Time." Calder Foundation archives, project file.

32. Seidler, letter to Calder, April 12, 1976. Calder Foundation archives, project file.

33. Stephen Lacey, "Top of the Town," May 15, 2004; http://www.smh.com.au/articles/2004/1084289865200.html.; accessed October 26, 2012. Other remarks by Lacey are taken from this source.

34. The text of the award is included on the architect's website; http://seidler.net.su/; accessed January 13, 2013.

35. Lacey, "Top of the Town."

36. My thanks to Ruth Fazakerley, editorial board member, *Public Art Dialogue*, for valuable information about this commission and its reception. E-mail to the author, November 6 , 2012. For the Central Sydney Heritage Inventory see http://torve.nla.gov.au/work/168251268 and http://www.cityofsydney.nsw.gov.au?AboutSydney/HistoryAndArchives/Archives/

37. "Architecture, Art and Collaborative Design: Harry Seidler Exhibition," http://www.archdaily.com/315464/architecutre-art-and-collaborative-design-harry-seidler-exhibition/, accessed January 13, 2013.

38. See Elwyn Lynn, "Calder, Le Corbusier, Vasarely at Australia Square, Sydney," *ART and Australia*, March 1968, 582. Again, my thanks to Ruth Fazakerley for this reference. Lynn relates the formal purity of Calder's work to Le Corbusier's purist aesthetics.

39. Much of the following account is adapted from Harriet F. Senie, "The Public Sculpture Revival of the 1960s: Famous Artists, Modern Styles," in *Contemporary Public Sculpture: Tradition,*

Transformation, and Controversy (New York: Oxford University Press, 1992), 100–104.

40. The extent of Nancy Mulnix's role is evident from the correspondence in the project file at the Calder Foundation. Robert Sherrill, "What Grand Rapids Did for Jerry Ford—and Vice Versa," *New York Times Magazine*, October 20, 1974, 31–32, 72–92, describes her role in some detail. Betty Ford, wife of Gerald Ford, had gone to school with Nancy Mulnix's mother-in-law. Previously, Ford had hardly been an arts advocate; he had, in fact, voted against funding for the NEA. However, *La Grande vitesse*, according to Sherrill, became "a fabulous store of political riches."

41. The selection process is described in detail in John Beardsley, *Art in Public Places* (Washington, DC: Partners for Livable Places, 1981), 15ff.

42. For a discussion of the controversy, see *Controversial Public Art from Rodin to di Suvero* (Milwaukee: Milwaukee Art Museum, 1984), 48–49.

43. The businessman is quoted in Sherrill, "What Grand Rapids Did for Jerry Ford—and Vice Versa," 32.

44. Kathy Halbreich, "Stretching the Terrain: Twenty Years of Public Art," *Going Public* (Amherst, MA: Arts Extension Service, 1988), 9.

45. For more information about the exhibition and subsequent public art commissions, see *Sculpture off the Pedestal* (Grand Rapids: Grand Rapids Art Museum, 1973).

46. The postcard he sent to Goeritz confirming the visit featured an image of his work in Grand Rapids. See Yona Fischer, ed., *Calder: The Jerusalem Stabile* (Jerusalem: The Israel Museum, 1980), vol. 2, 8.

47. Ibid., vol. 3. See also Abraham Rabinovich, "Calder in Jerusalem," *Jerusalem Post*, May 5, 1977.

48. Teddy Kollek, letter to Calder. Calder Foundation archives, project file.

49. Fischer, *Calder: The Jerusalem Stabile*, vol. 2, 8.

50. For correspondence of 1975–76 surrounding funding issues, see Calder Foundation archives, project file. At one point Berman requested to buy a sculpture and a mobile he had seen at Calder's home in Saché, France, for his residence in Allentown.

51. Andreas Freund, "Artist Inspires Workmen after His Death," *International Herald Tribune*, December 29, 1976.

52. Teddy Kollek, letter to Stanley Cohen, an attorney and neighbor of Calder's in France, November 21, 1976. Calder Foundation, project file.

53. Letter by Philip Berman, signed by him and his wife, Muriel, May 5–6, 1977. Calder Foundation archives, project file.

54. Philip and Muriel Berman, letter to Sarah and Yaacov Lior, Tel Aviv, May 23, 1977. Calder Foundation archives, project file.

55. For a discussion of this development, see Senie, *Contemporary Public Sculpture*, 62–69.

56. Walter Gropius, "The Theory and Organization of the Bauhaus, 1923," in Charles Harrison and Paul Wood, eds., *Art in Theory: 1900–2000* (Malden, MA: Blackwell Publishing, 2003 edition), 311.

57. Ibid., 314.

58. Jean Arp, "Introduction to a Catalogue, Galerie Tannert, Zurich, 1915," in Harrison and Wood, *Art in Theory*, 276.

59. Theo van Doesburg, "Principles of Neo-Plastic Art," (1919), in Harrison and Wood, *Art in Theory*, 281.

60. See, for example, Piet Mondrian, "Plastic Art and Pure Plastic Art," in Harrison and Wood, *Art in Theory*, 387–93. For Calder's response to Mondrian's work, see for example, Marter, *Alexander Calder*, 102.

61. Van Doesburg et al., in Harrison and Wood, *Art in Theory*, 315.

62. David Batchelor, "Abstraction in the Context of Modernism," *Journal of Art*, June–August 1991, 26.

Author's Note: I would like to thank Aleca Le Blanc for first introducing me to LACMA's Calder exhibition and catalogue and Lisa Gabrielle Mark, head of publications, and her staff for their guidance and patience. My thanks to the Calder Foundation and Alexis Marotta for her assistance in providing access to their invaluable project files. My enthusiasm for this project was partly prompted by Sheila Gerami's, and I would like to thank her both for lending me all her Calder books and making insightful observations on this essay. I also owe a special thanks to Cher Krause Knight and Elke Solomon for their careful reading and comments.

Works
in the
Exhibition

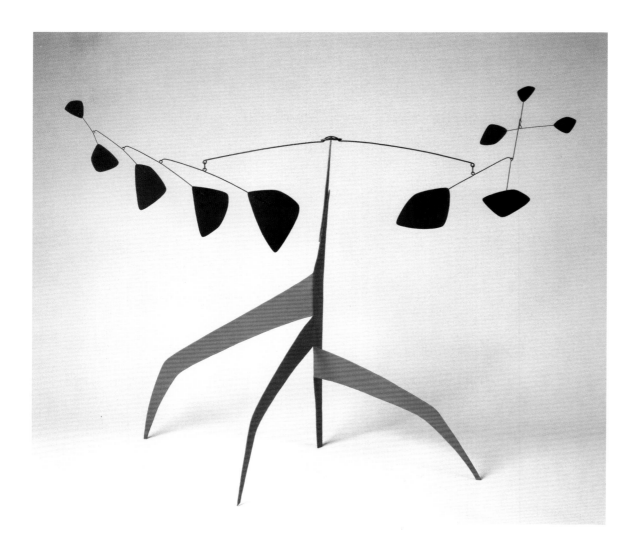

Southern Cross (maquette) | 1963 | 32 × 31 × 17 inches

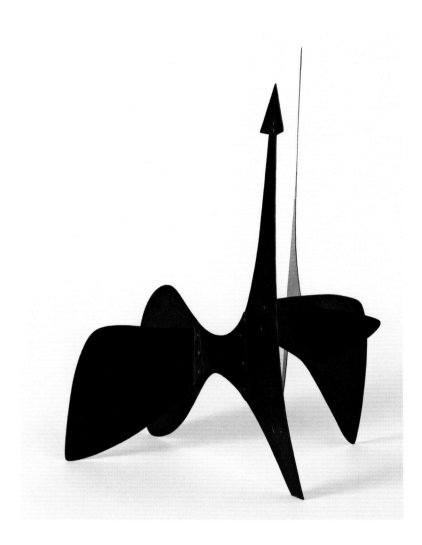

Teodelapio (maquette II) | 1962 | 23 ½ × 15 ¼ × 15 ¾ inches

Les Arêtes de Poisson (maquette) | 1965 | 14 ½ × 17 ½ × 10 ½ inches

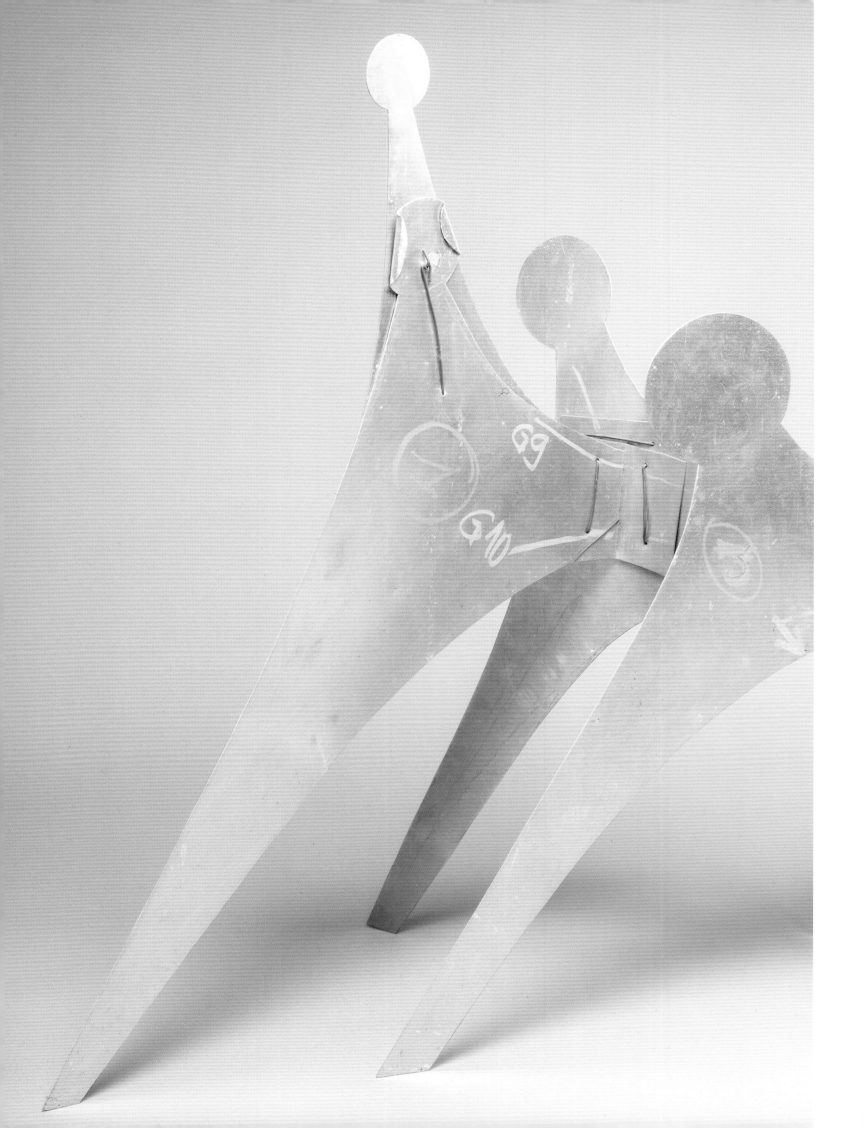

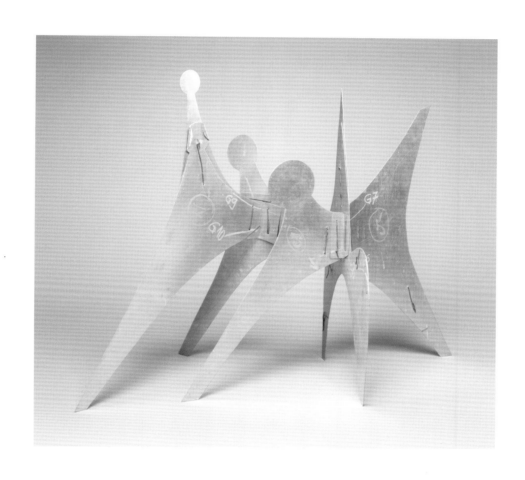

Trois disques (maquette) | 1966 | 29 ¼ × 33 ½ × 20 inches, and detail

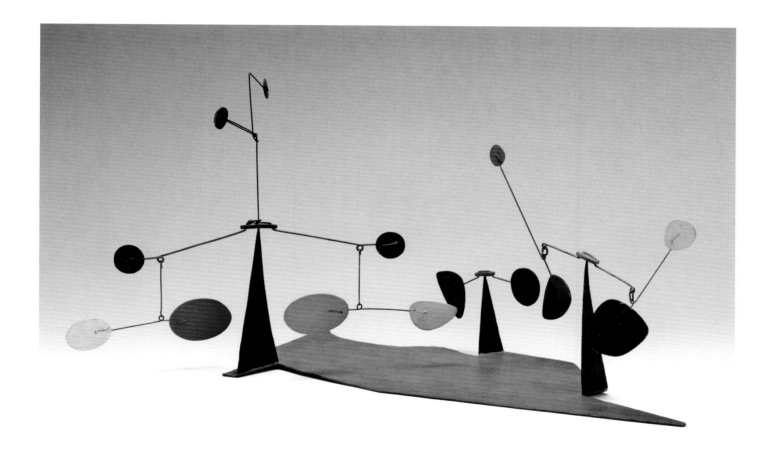

Three Quintains (*Hello Girls*) (maquette) | 1964 | 10 ¼ × 17 ½ × 13 ½ inches

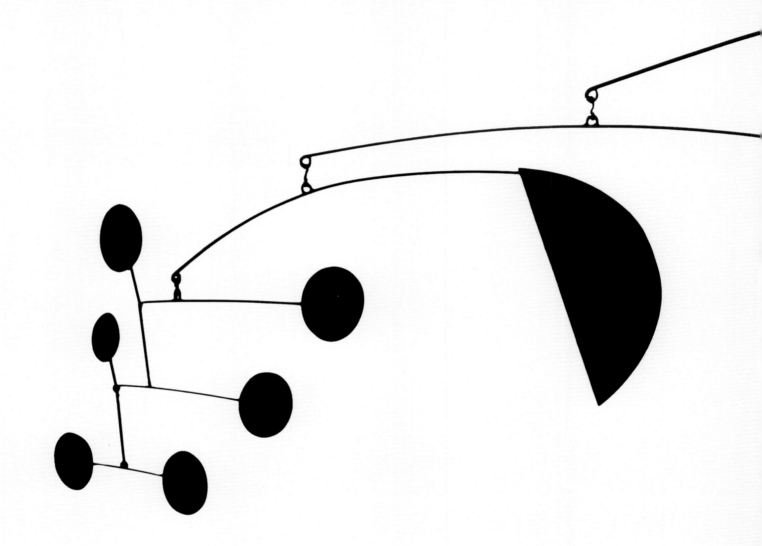

Three Segments | 1973 | 79 × 200 inches

Trois Pics (intermediate maquette) | 1967 | 96 × 63 × 70 ³⁄₁₆ inches

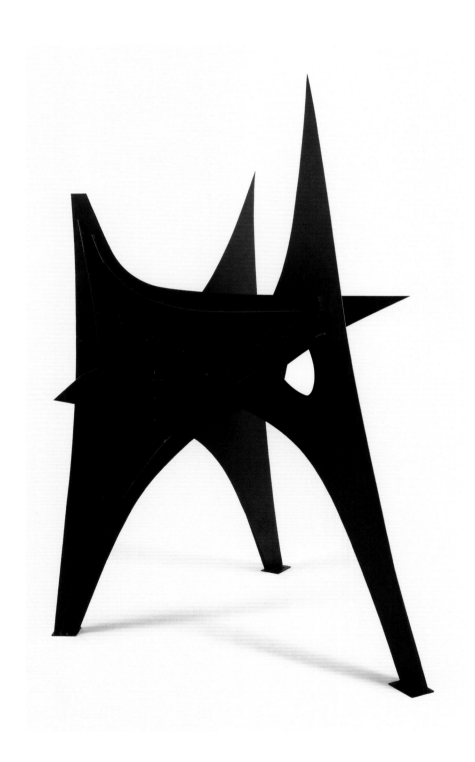

La Grande vitesse (intermediate maquette) | 1969 | 102 × 135 × 93 inches

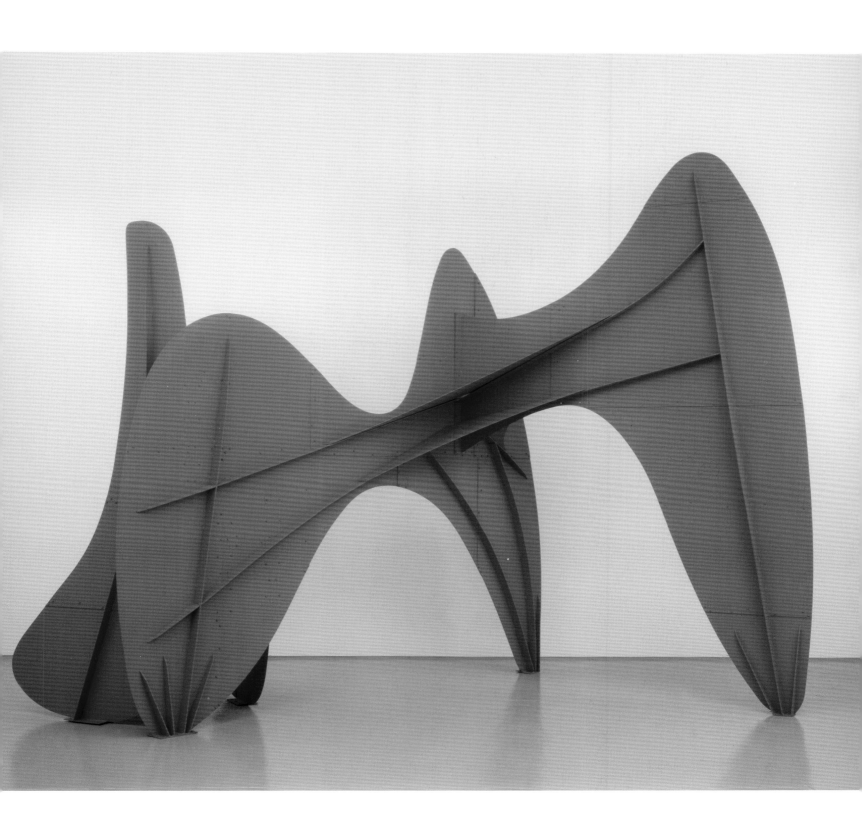

Angulaire | 1975 | 141 × 117 × 67 inches

Three Quintains (Hello Girls) | 1964 | 275 × 288 inches, in its current location (following pages)

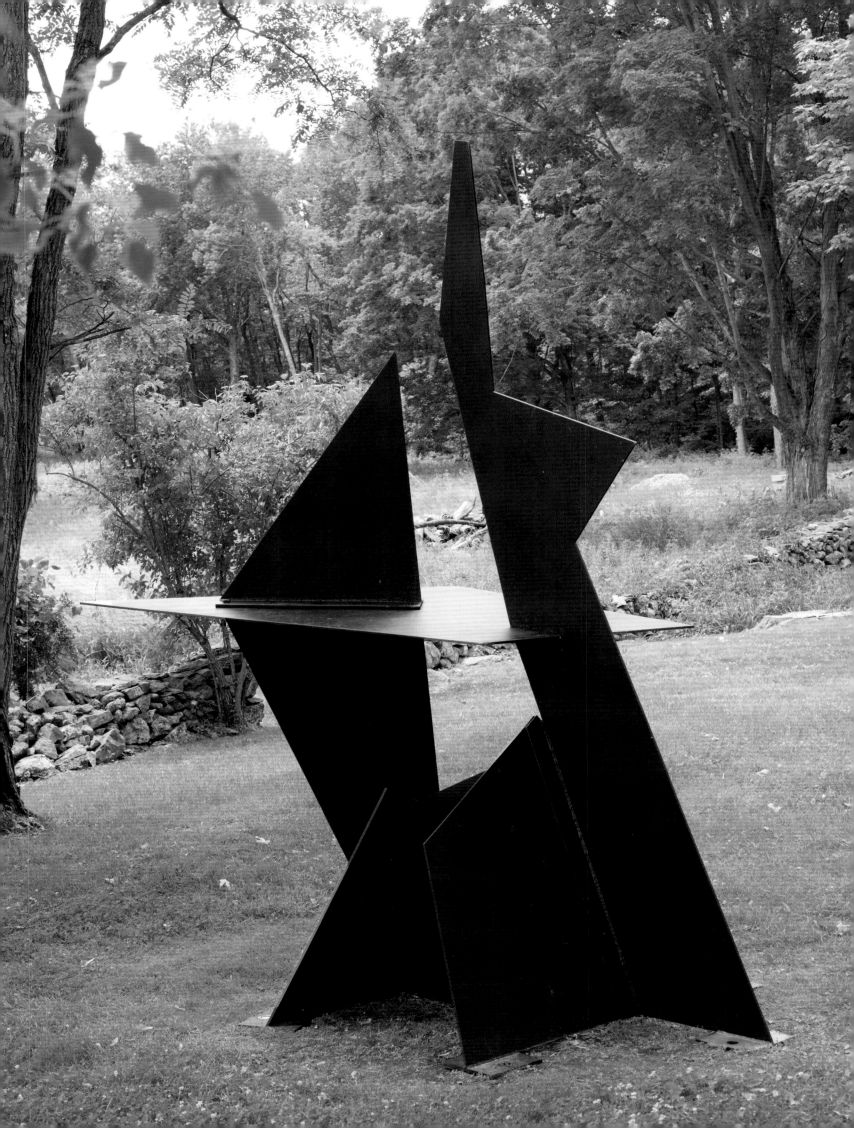

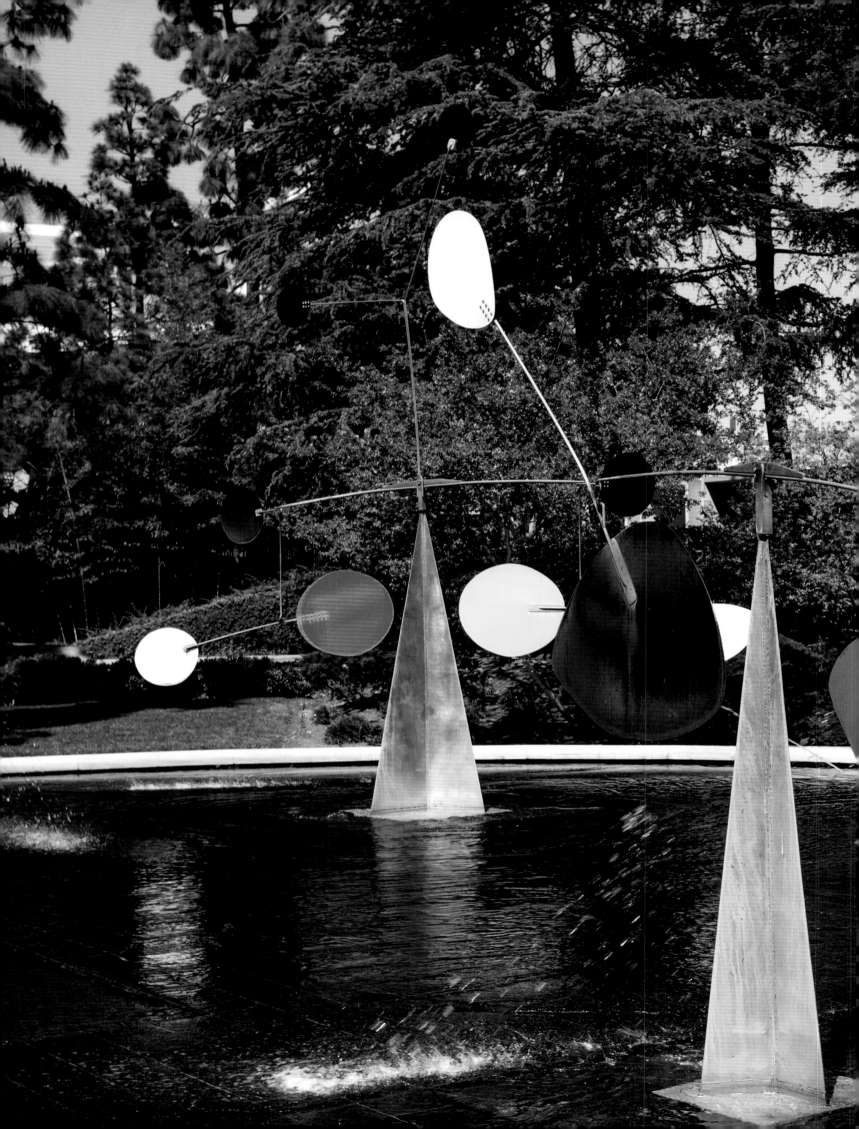

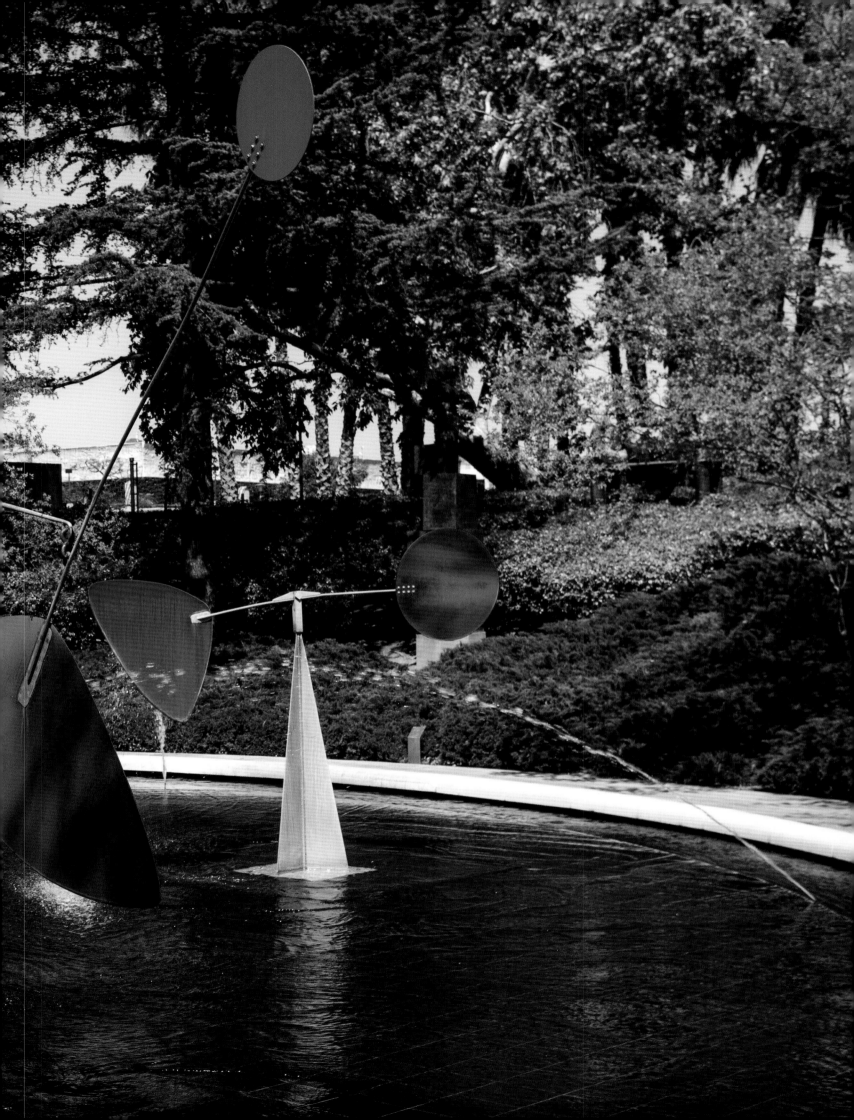

Height precedes width, which precedes depth.
Mobiles were measured while laying flat
and dimensions vary while hanging; only height
and width are indicated for those works.

Sculptures

Croisiére, 1931
Wire, wood, and paint
37 × 23 × 23 inches
Calder Foundation, New York

Object with Red Ball, 1931
Wood, sheet metal, rod, wire,
and paint
61 ¼ × 38 ½ × 12 ¼ inches
Calder Foundation, New York

Small Feathers, 1931
Wire, wood, lead, and paint
38 ½ × 32 × 16 inches
Calder Foundation, New York

Untitled, 1934
Sheet metal, wire, lead, and paint
113 × 68 × 53 inches
Calder Foundation, New York

4 Woods (Diana), 1936
Walnut with steel pins, iron base
30 ½ × 17 ¾ × 19 ¼ inches
Museum of Fine Arts, Boston,
Frederick Brown Fund, 60.956

Gibraltar, 1936
Lignum vitae, walnut, steel rods, and
painted wood
51 ⅞ × 24 ¼ × 11 ⅜ inches
The Museum of Modern Art, New York,
Gift of the artist, 847.1966.a–b

Snake and the Cross, 1936
Sheet metal, wire, wood, string, and paint
81 × 51 × 44 inches
Calder Foundation, New York

White Panel, 1936
Plywood, sheet metal, tubing, wire, string,
and paint
84 ½ × 47 × 51 inches
Calder Foundation, New York; Bequest
of Mary Calder Rower, 2011

Red Panel, c. 1938
Plywood, sheet metal, rod, string, and paint
48 × 30 × 24 inches
Calder Foundation, New York

Untitled, c. 1938
Sheet metal, rod, wire, and paint
31 × 48 × 39 inches
Collection of Jon and Mary Shirley

La Demoiselle, 1939
Sheet metal, wire, and paint
58 ½ × 21 × 29 ½ inches
Glenstone

Untitled, 1939
Sheet metal, rod, wire, and paint
55 ½ × 64 ½ inches
Calder Foundation, New York

Eucalyptus, 1940
Sheet metal, wire, and paint
94 ½ × 61 inches
Calder Foundation, New York;
Gift of Andréa Davidson, Shawn
Davidson, Alexander S. C. Rower,
and Holton Rower, 2010

Boomerangs, 1941
Sheet metal, wire, and paint
45 × 117 inches
Calder Foundation, New York

Un effet du japonais, 1941
Sheet metal, rod, wire, and paint
80 × 80 × 48 inches
Calder Foundation, New York

Tree, 1941
Sheet metal, wood, glass, mirror,
plastic, wire, string, and paint
94 × 54 × 51 inches
Calder Foundation, New York;
Gift of Anna Maria Segretario
and Holton Rower, 2008

Yucca, 1941
Sheet metal, wire, and paint
73 ½ × 23 × 20 inches
Solomon R. Guggenheim Museum,
New York, Hilla Rebay Collection, 1971

Constellation, c. 1942
Wood, steel, wire, and paint
22 ½ × 28 ½ × 20 inches
Calder Foundation, New York

Horizontal Spines, 1942
Sheet metal, wire, and paint
54 ½ × 50 × 22 ½ inches
Addison Gallery of American Art,
Phillips Academy, Andover,
Massachusetts, Museum Purchase,
1943.121

Constellation Mobile, 1943
Wood, wire, string, and paint
53 × 48 × 35 inches
Calder Foundation, New York

Constellation with Two Pins, 1943
Wood, wire, and paint
24 × 17 ½ × 17 inches
Calder Foundation, New York

Fake Snake, 1944
Bronze
44 × 13 ½ × 15 inches
Calder Foundation, New York

The Vine, 1944
Bronze
26 × 40 × 16 ¼ inches
Calder Foundation, New York

Little Pierced Disc, c. 1947
Sheet metal, wire, and paint
11 × 14 ½ × 3 ½ inches
Calder Foundation, New York

Bougainvillier, 1947
Sheet metal, wire, lead, and paint
78 ½ × 86 inches
Collection of Jon and Mary Shirley

Gamma, 1947
Sheet metal, wire, and paint
58 × 84 × 36 inches
Collection of Jon and Mary Shirley

Laocoön, 1947
Sheet metal, wire, rod, string,
and paint
80 × 120 × 28 inches
The Eli and Edythe L. Broad Collection

Little Parasite, 1947
Sheet metal, wire, and paint
19 ½ × 53 × 18 ¾ inches
Calder Foundation, New York

Parasite, 1947
Sheet metal, rod, wire, and paint
41 × 68 × 28 inches
Calder Foundation, New York

Red Disc, 1947
Sheet metal, wire, and paint
81 × 78 inches
Frances A. Bass

Untitled, 1947
Sheet metal, wire, and paint
66 × 53 inches
Private collection

Blue Feather, c. 1948
Sheet metal, wire, and paint
42 × 55 × 18 inches
Calder Foundation, New York

Red Disc, Black Lace, 1948
Sheet metal, rod, wire, and paint
29 × 65 × 46 inches
Sheldon Museum of Art, University
of Nebraska–Lincoln, NAA, Gift of Mrs. Carl
Rohman, Mr. and Mrs. Carl H. Rohman,
Mrs. Olga N. Sheldon, Mr. and Mrs. Paul
Schorr, Jr., Mr. and Mrs. Art Weaver, Mr. and
Mrs. Thomas C. Woods, Jr., Mr. and Mrs.
Thomas C. Woods, Sr., First National Bank
of Lincoln

Snow Flurry, 1948
Sheet metal, wire, and paint
73 × 81 inches
Calder Foundation, New York

Orange Under Table, c. 1949
Sheet metal, wire, rod, and paint
72 × 82 × 82 inches
Collection Museum of Contemporary
Art, Chicago, The Leonard and
Ruth Horwich Family Loan; EL1995.11

Bifurcated Tower, 1950
Sheet metal, wire, wood, and paint
58 × 72 × 53 inches
Whitney Museum of American Art,
New York; Purchased with funds
from the Howard and Jean Lipman
Foundation, Inc., and exchange, 1973

Black Mobile with Hole, 1954
Sheet metal, wire, and paint
88 × 96 inches
Calder Foundation, New York

Escutcheon, 1954
Sheet metal, wire, and paint
45 × 35 × 29 inches
Calder Foundation, New York

Little Face, 1962
Sheet metal, wire, and paint
42 × 56 inches
Los Angeles County Museum of Art,
gift of the Joseph B. and Ann S. Koepfli
Trust in honor of the museum's 40th
anniversary, M.2011.139

Portrait, 1964
Steel plates
52 ¼ × 37 × 25 inches
Museum of Contemporary Art,
Los Angeles. The Rita and Taft Schreiber
Collection, given in loving memory
of her husband, Taft Schreiber, by Rita
Schreiber, 89.11

Three Quintains (Hello Girls), 1964
Sheet metal and paint with motor
275 × 288 inches
Los Angeles County Museum of Art,
Art Museum Council Fund, M.65.10

Trois Pics (**intermediate maquette**), 1967
Sheet metal, bolts, and paint
96 × 63 × 70 ³⁄₁₆ inches
Calder Foundation, New York

La Grande vitesse (**intermediate
maquette**), 1969
Sheet metal, bolts, and paint
102 × 135 × 93 inches
Calder Foundation, New York

Three Segments, 1973
Sheet metal, rod, wire, and paint
79 × 200 inches
Calder Foundation, New York

Angulaire, 1975
Sheet metal, bolts, and paint
141 × 117 × 67 inches
Calder Foundation, New York

Small-Scale Maquettes

Teodelapio (**maquette II**), 1962
Sheet metal and paint
23 ½ × 15 ¼ × 15 ¾ inches
The Museum of Modern Art, New York,
Gift of the artist, 392.1966

Southern Cross (**maquette**), 1963
Sheet metal, wire, and paint
32 × 31 × 17 inches
Calder Foundation, New York; Bequest
of Mary Calder Rower, 2011

Three Quintains (*Hello Girls*)
(**maquette**), 1964
Sheet metal and paint
10 ¼ × 17 ½ × 13 ½ inches
Los Angeles County Museum of Art,
gift of Alexander Calder, M.66.93

Les Arêtes de Poisson (**maquette**), 1965
Sheet metal and paint
14 ½ × 17 ½ × 10 ½ inches
Calder Foundation, New York

Trois disques (**maquette**), 1966
Sheet metal
29 ¼ × 33 ½ × 20 inches
Calder Foundation, New York;
Bequest of Mary Calder Rower, 2011

Selected Exhibition History

Compiled by *Lauren Bergman*

This selected exhibition history was developed in collaboration with the Calder Foundation, New York. For a comprehensive listing, please visit the Calder Foundation's website at www.calder.org.

1925

New York Society of Independent Artists, Waldorf-Astoria, New York. *Ninth Annual Exhibition of the Society of Independent Artists*, March 6–29, catalogue.

1926

Artists Gallery, New York, January.

New York Society of Independent Artists, Waldorf-Astoria, New York. *Tenth Annual Exhibition of the Society of Independent Artists*, March 5–28, catalogue.

Anderson Galleries, Whitney Studio Club, New York, *Whitney Studio Club Eleventh Annual Exhibition of Paintings and Sculpture by Members of the Club*, March 8–20, catalogue.

Anderson Galleries, New York, May, curated by Karl Freund.

1927

Galerie La Boétie, Paris, *Salon des Humoristes*, March 6–May 1.

Galleries of Jacques Seligmann and Company, Paris, August.

1928

Salon de la Société des Artistes Indépendants, Paris, January 20–February 29, catalogue.

Weyhe Gallery, New York, *Wire Sculpture by Alexander Calder*, February 20–March 3.

New York Society of Independent Artists, Waldorf-Astoria, New York. *Twelfth Annual Exhibition of the Society of Independent Artists*, March 9–April 1, catalogue.

Galleries of Jacques Seligmann and Company, Ancien Hôtel de Sagan, Paris, *The Salon of American Artists*, July 2–13, catalogue.

1929

Salon de la Société des Artistes Indépendants, Grand Palais, Paris, *40me Exposition Annuelle*, January 18–February 28, catalogue.

Galerie Billiet-Pierre Vorms, Paris, *Sculptures bois et fil de fer de Alexander Calder*, January 25–February 7, catalogue.

Weyhe Gallery, New York, *Wood Carvings by Alexander Calder*, February 4–23.

Galerie Neumann-Nierendorf, Berlin, *Alexander Calder: Skulpturen aus Holz und aus Draht*, April 1–15, catalogue.

Salon des Tuileries, Paris, May, catalogue.

Harvard Society for Contemporary Art, Cambridge, Massachusetts, *An Exhibition of Painting and Sculpture by the School of New York*, October 17–November 1, catalogue.

Fifty-Sixth Street Galleries, New York, *Alexander Calder: Paintings, Wood Sculpture, Toys, Wire Sculpture, Jewelry, Textiles*, December 2–14, catalogue.

1930

Salon de la Société des Artistes Indépendants, Paris, January 17–March 2, catalogue.

Harvard Society for Contemporary Art, Harvard Cooperative Building, Cambridge, Massachusetts, *Wire Sculpture by Alexander Calder*, January 27–February 4.

Galerie G. L. Manuel Frères, Paris, *11e Salon de l'Araignée*, May, catalogue.

Parc des Expositions, Porte de Versailles, Paris, *Association Artistique les Surindépendants*, October 25–November 24, catalogue.

The Museum of Modern Art, New York, *Painting and Sculpture by Living Americans (Ninth Loan Exhibition)*, December 2, 1930–January 20, 1931, catalogue with foreword by Alfred H. Barr, Jr.

1931

Galerie Percier, Paris, *Alexander Calder: Volumes–Vecteurs–Densités; Dessins–Portraits*, April 27–May 9, catalogue.

Künstlerhaus, Berlin, July.

Parc des Expositions, Porte de Versailles, Paris, *Association Artistique les Surindépendants*, October 23–November 22, catalogue.

1932

Galerie Vignon, Paris, *Exposition de dessins*, January 15–28, catalogue.

Parc des Expositions, Porte de Versailles, Paris, *"1940,"* January 15–February 1, catalogue.

The Renaissance Society at the University of Chicago, *The Fifth Annual Exhibition of Modern French Painting*, February 7–21.

Galerie Vignon, Paris, *Calder: ses mobiles*, February 12–29.

Julien Levy Gallery, New York, *Calder: Mobiles, Abstract Sculptures*, May 12–June 11, catalogue.

Berliner Sommerschau, Berlin, July.

opposite: *Alexander Calder: Paintings, Wood Sculpture, Toys, Wire Sculpture, Jewelry, Textiles*, Fifty-Sixth Street Galleries, New York, 1929

below: *Alexander Calder: Volumes–Vecteurs–Densités; Dessins–Portraits*, Galerie Percier, Paris, 1931

1933

L'Association Artistique Abstraction-Création, Paris, *Première série*, January 19–31.

Amics de l'Art Nou, Galeries Syra, Barcelona, February.

Galerie Pierre Colle, Paris, *Présentation des oeuvres récentes de Calder*, May 16–18.

Galerie Pierre, Paris, *Arp, Calder, Miró, Pevsner, Hélion, and Seligmann*, June 9–24, curated by Anatole Jakovsky, catalogue.

1934

Rockefeller Center, New York, *The First Municipal Art Exhibition*, February 28–March 31, catalogue.

Pierre Matisse Gallery, New York, *Mobiles by Alexander Calder*, April 6–28, catalogue.

The Renaissance Society at the University of Chicago, *A Selection of Works by Twentieth-Century Artists*, June 20–August 20, curated by James Johnson Sweeney, catalogue.

The Museum of Modern Art, New York, *Modern Works of Art: Fifth Anniversary Exhibition*, November 20, 1934–January 20, 1935, catalogue.

1935

The Renaissance Society at the University of Chicago, *Mobiles by Alexander Calder*, January 14–31, curated by James Johnson Sweeney.

Wadsworth Atheneum, Hartford, *American Painting and Sculpture of the 18th, 19th & 20th Centuries*, January 29–February 19, catalogue.

The Arts Club of Chicago, *Mobiles by Alexander Calder*, February 1–26, curated by James Johnson Sweeney.

Kunstmuseum Luzern, *Thèse, antithèse, synthèse*, February 24–March 31, catalogue.

Art Institute of Chicago, *The Fourteenth International Exhibition of Watercolors, Pastels, Drawings, and Monotypes*, March 21–June 2, juried by Rainey Bennett, George Grosz, and Charles Burchfield, catalogue.

Wadsworth Atheneum, Hartford, *Abstract Art*, October 22–November 17, catalogue.

1936

Albright Art Gallery, Buffalo Fine Arts Academy, New York, *Art of Today*, January 3–31, catalogue with foreword by Gordon Bailey Washburn.

Pierre Matisse Gallery, New York, *Mobiles and Objects by Alexander Calder*, February 10–29.

Gallery 41, Oxford, England, *Abstract and Concrete: An Exhibition of Abstract Painting and Sculpture Today*, February 15–22, curated by Nicolette Gray, traveled to University of Liverpool, School of Architecture, March 2–14; Alex Reid & Lefevre, Ltd., London, April; Gordon Fraser Gallery, Cambridge, England, May 28–June 13.

The Museum of Modern Art, New York, *Cubism and Abstract Art*, March 2–April 19, curated by Alfred H. Barr, Jr., traveled to San Francisco Museum of Art, July 27–August 24; Cincinnati Art Museum, October 19–December 27; Minneapolis Institute of Arts, November 29–December 27; Cleveland Museum of Art, January 7–February 7, 1937; Baltimore Museum of Art, February 17–March 17, 1937; Rhode Island School of Design, Museum of Art, Providence, March 24–April 21, 1937; Grand Rapids Art Gallery, Michigan, April 29–May 26, 1937, catalogue.

Gallery of Living Art at Paul Reinhardt Galleries, New York, *Five Contemporary American Concretionists: Biederman, Calder, Ferren, Morris, Shaw*, March 9–31, catalogue.

The Museum of Modern Art, New York, *Modern Painters and Sculptors as Illustrators*, April 27–September 12, catalogue edited by Monroe Wheeler.

Vassar College, Poughkeepsie, New York, *Sculpture by Alexander Calder*, May 5–June 8.

Worcester Art Museum, Massachusetts, *Art of the Machine Age*, May 15–October 18, curated by Walter Baermann, catalogue.

Galerie Charles Ratton, Paris, *Exposition surréaliste d'objets*, May 22–29, catalogue.

New Burlington Galleries, London, *International Exhibition of Surrealism*, June 11–July 4.

The Museum of Modern Art, New York, *Fantastic Art, Dada, and Surrealism*, December 7, 1936–January 17, 1937, curated by Alfred H. Barr, Jr., traveled to Pennsylvania Museum of Art, Philadelphia, January 30–March 1, 1937; Institute of Modern Art, Boston, March 6–April 3, 1937; Museum of Fine Arts, Springfield, Massachusetts, April 14–May 10, 1937; Milwaukee Art Institute, May 19–June 16, 1937; University Gallery, University of Minnesota, Minneapolis, June 26–July 24, 1937; San Francisco Museum of Art, August 6–September 3, 1937, catalogue.

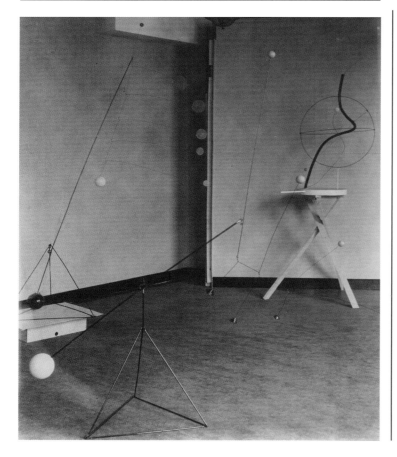

1937

Kunsthalle Basel, *Konstruktivisten*, January 16–February 14, curated by Georg Schmidt, catalogue.

Pierre Matisse Gallery, New York, *Calder: Stabiles & Mobiles*, February 23–March 13.

Pavillon de la République Espagnole, Paris, *L'Exposition Internationale*, May 24–November 26, pavilion designed by Josep Lluís Sert and Luis Lacasa.

London Gallery, London, *Constructive Art*, July.

Musée du Jeu de Paume, Paris, *Origines et développement de l'art international indépendant*, July 30–October 31, curated by André Dezarrois in collaboration with Paul Eluard, Christian Zervos, Georges Huisman, and Jean Cassou, catalogue.

Artek Gallery, Helsinki, *Fernand Léger/Alexander Calder*, November 29–December 12, catalogue.

The Mayor Gallery, London, *Calder: Mobiles and Stabiles*, December 1–24.

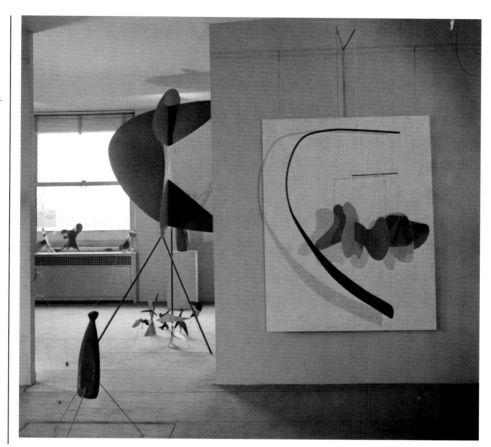

1938

Stedelijk Museum, Amsterdam, *Tentoonstelling Abstracte Kunst*, April 2–24, catalogue.

Galerie Guggenheim Jeune, London, *Contemporary Sculpture: Brancusi, Laurens, Pevsner, Henry Moore, Duchamp-Villon, Hans Arp, Calder, Taeuber-Arp*, April 8–May 2.

Katharine Kuh Gallery, Chicago, May.

Musée du Jeu de Paume, Paris, *Trois siècles d'art aux États-Unis*, May 24–July 31, organized in cooperation with the Museum of Modern Art, New York, curated by A. Conger Goodyear assisted by Alfred H. Barr, Jr., and Dorothy C. Miller, catalogue.

George Walter Vincent Smith Gallery, Springfield, Massachusetts, *Calder Mobiles*, November 8–27, catalogue.

Artek Gallery, Helsinki, *Alexander Calder: Jewelry*, December.

opposite left: *Mobiles by Alexander Calder*, Pierre Matisse Gallery, New York, 1934

opposite right: *American Painting and Sculpture of the 18th, 19th & 20th Centuries*, Wadsworth Atheneum, Hartford, 1935; from left to right: Fernand Léger, Louisa Calder, Simone Herman, and Alexander Calder; in the background: *Little Blue Panel* (1934)

above: *Calder: Stabiles & Mobiles*, Pierre Matisse Gallery, New York, 1937; from left to right: *Tightrope* (1936), *Big Bird* (1937), and *White Panel* (1936); photograph by Herbert Matter

left: *L'Exposition Internationale*, Pavillon de la République Espagnole, Paris, 1937, Alexander Calder with *Mercury Fountain* (1937) and Pablo Picasso's *Guernica* (1937)

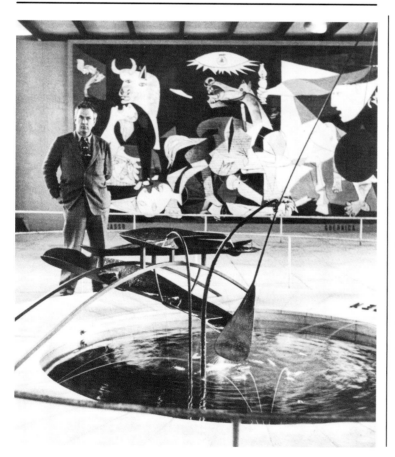

1939

São Paulo, Brazil, *III Salão de Maio*, catalogue.

Division of Decorative Arts, Department of Fine Arts, San Francisco, *Golden Gate International Exposition, Decorative Arts*, February 18–October 29, catalogue.

Rohm and Haas, Hall of Industrial Science, Flushing Meadows–Corona Park, *New York World's Fair*, April 30–October 26.

Pierre Matisse Gallery, New York, *Calder Mobiles–Stabiles*, May 9–27, catalogue.

1940

Pierre Matisse Gallery, New York, *Calder*, May 14–June 1.

Philadelphia Museum of Art in collaboration with Fairmount Park Art Association, *Second International Exhibition of Sculpture*, May 18–October 1.

Division of Contemporary Painting and Sculpture, Department of Fine Arts, San Francisco, *Golden Gate International Exposition, Contemporary Art*, May 25–September 29, catalogue.

Willard Gallery, New York, *Calder Jewelry*, December 3–25.

Buchholz Gallery, New York, *Exhibition of American Sculpture Today*, December 30, 1940–January 18, 1941, catalogue.

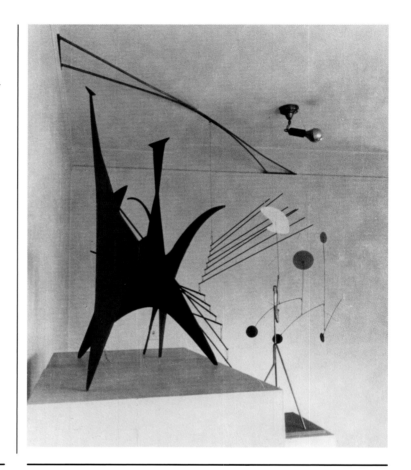

1941

Springfield Museum of Fine Arts, Massachusetts, *American Plastics*, January 20–February 20.

Arts and Crafts Club of New Orleans, *Alexander Calder: Mobiles, Jewelry* and *Fernand Léger: Gouaches, Drawings*, March 28–April 11, catalogue.

Pierre Matisse Gallery, New York, *Alexander Calder: Recent Works*, May 27–June 14, catalogue.

Design Project, Los Angeles, *Calder: Mobiles, Stabiles, Jewelry; A Few Paintings by Paul Klee*, September 27–October 27.

Montclair Art Museum, New Jersey, *Twentieth-Century Sculpture and Constructions*, October 2–26, organized by the Museum of Modern Art, New York, traveled to Honolulu Academy of Arts, Hawaii, December 2–14, 1941; Vassar College, Poughkeepsie, New York, May 20–June 15, 1942; Museum of Modern Art, New York, October 2–26, 1942; University Art Gallery, University of Minnesota, Minneapolis, November 3–24, 1942; Cincinnati Modern Art Society, December 10–31, 1942; Skidmore College, Saratoga Springs, New York, January 31–February 21, 1943.

San Francisco Museum of Art, *Mobiles by Alexander Calder, Stabiles and Jewelry*, November 4–19.

Willard Gallery, New York, *Calder Jewelry*, December 8–25.

1942

Arts Club of Chicago, *Nine American Artists*, February 3–28, traveled to Cincinnati Art Museum, April 7–May 3, catalogue.

The Museum of Modern Art, New York, *A Children's Festival of Modern Art*, March 11–May 10.

Helena Rubinstein New Art Center, New York, *Masters of Abstract Art*, April 1–May 15, curated by Stephan C. Lion, catalogue.

Pierre Matisse Gallery, New York, *Calder: Recent Work*, May 19–June 12.

Solomon R. Guggenheim Foundation, Museum of Non-Objective Painting, New York, *Fifth Anniversary Exhibition*, June 25–October 1.

France Forever (The Fighting French Committee in the United States), Washington, DC, *Calder*, October 14–November 1.

Coordinating Council of French Relief Societies, Whitelaw Reid Mansion, New York, *First Papers of Surrealism*, October 14–November 7, organized by André Breton and Marcel Duchamp, catalogue.

Arts Club of Chicago, *Calder Drawings*, November 6–27, traveled to Willard Gallery, New York, December 1–24.

Whitney Museum of American Art, New York, *Annual Exhibition of Contemporary Art*, November 24, 1942–January 6, 1943, catalogue.

The Metropolitan Museum of Art, New York, *Artists for Victory: An Exhibition of Contemporary American Art*, December 7, 1942–February 22, 1943, catalogue.

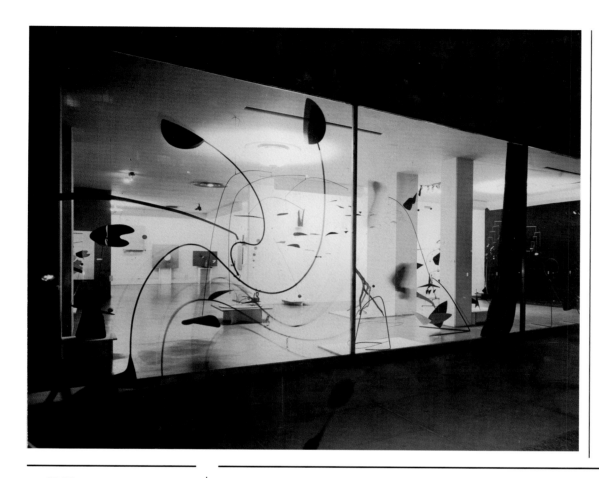

1943

The Museum of Modern Art, New York,
Arts in Therapy, February 2–March 7,
curated by James Thrall Soby, designed
by Herbert Bayer.

Pierre Matisse Gallery, New York,
Calder: Constellations, May 18–
June 5.

Addison Gallery of American Art,
Andover, Massachusetts, *17 Mobiles
by Alexander Calder*, May 28–July 6,
catalogue.

The Museum of Modern Art,
New York, *Alexander Calder:
Sculptures and Constructions*,
September 29, 1943–January 16,
1944, curated by James Johnson
Sweeney in collaboration with
Marcel Duchamp, catalogue.

Whitney Museum of American Art,
New York, *Annual Exhibition
of Contemporary American Art*,
November 23, 1943–January 4, 1944,
catalogue.

Arts Club of Chicago, *Jewelry by
Alexander Calder*, December 3–27.

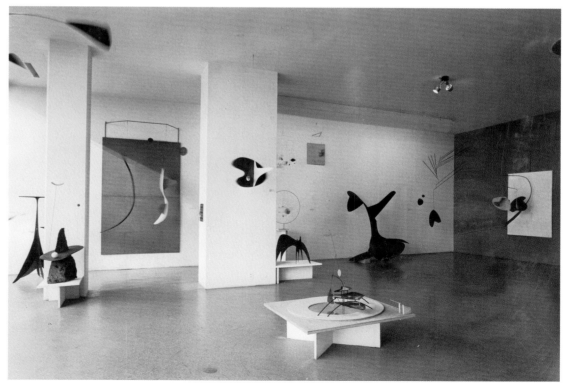

1944

France Forever (The Fighting French Committee in the United States), Washington, DC, *Calder: Paintings, Mobiles, Stabiles, and Jewelry*, March 27–April 9.

The Renaissance Society at the University of Chicago, *Drawings by Contemporary Artists*, May 20–June 19, catalogue.

The Museum of Modern Art, New York, *Art in Progress: The Fifteenth Anniversary of the Museum of Modern Art*, May 23–October 7, catalogue.

San Francisco Museum of Art, *Abstract and Surrealist Art in the United States*, September 6–24, curated by Sidney Janis, catalogue.

Buchholz Gallery/Curt Valentin, New York, *Recent Work by Alexander Calder*, November 28–December 23, catalogue.

Julien Levy Gallery, New York, *Imagery of Chess: A Group Exhibition of Paintings, Sculpture, Newly Designed Chessmen, Music, and Miscellany*, December 12, 1944–January 31, 1945.

San Francisco Museum of Art, *Alexander Calder: Watercolors*, December 28, 1944–January 16, 1945.

right: *Alexander Calder: Mobiles, Stabiles, Constellations*, Galerie Louis Carré, Paris, 1946

opposite: *Calder*, New Gallery, Charles Hayden Memorial Library, Massachusetts Institute of Technology, Cambridge, 1950–51

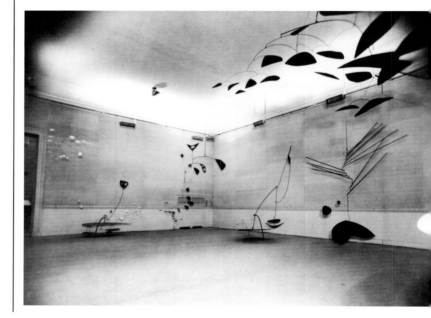

1945

Whitney Museum of American Art, New York, *Annual Exhibition of Contemporary American Sculpture, Watercolors, and Drawings*, January 3–February 8, catalogue.

Buchholz Gallery/Curt Valentin, New York, *Recent Work by American Sculptors*, February 6–24, catalogue.

The Museum of Modern Art, New York, *First Exhibition of the Museum Collection of Painting and Sculpture*, June 19–November 4, curated by Alfred H. Barr, Jr.

Santa Barbara Museum of Art, California, *Contemporary Sculpture*, August, exhibition assembled and loaned by Curt Valentin/Buchholz Gallery, New York.

Samuel M. Kootz Gallery, New York, *Gay, Fantastic Gouaches by Calder*, September 10–October 6.

Buchholz Gallery/Curt Valentin, New York, *Alexander Calder*, November 13–December 1, catalogue.

1946

Detroit Institute of Arts, *Origins of Modern Sculpture*, January 22–March 3, traveled to City Art Museum of St. Louis, March 30–May 1, catalogue.

The Museum of Modern Art, New York, *Modern Jewelry Design*, September 18–November 17, curated by Jane Sabersky, designed by Charlotte Trowbridge, traveled to Rhode Island School of Design, Providence, November 27–December 18; Northwestern University, Evanston, Illinois, January 2–23, 1947; University of New Hampshire, Durham, February 6–27, 1947; Isaac Delgado Museum of Art, New Orleans, March 13–April 3, 1947; San Francisco Museum of Art, April 15–May 6, 1947; Baltimore Museum of Art, May 22–June 12, 1947; City Art Museum, Saint Louis, August 25–September 15, 1947; University of Michigan, Ann Arbor, September 29–October 20, 1947; Ohio University, Athens, November 3–24, 1947; J. B. Speed Museum of Art, Louisville, Kentucky, December 8–29, 1947; Ohio State University, Columbus, January 12–February 2, 1948; University of Delaware, Newark, February 16–

March 8, 1948; Currier Gallery of Art, Manchester, New Hampshire, March 22–April 12, 1948; Addison Gallery of American Art, Andover, Massachusetts, April 26–May 17, 1948; George Walter Vincent Smith Art Museum, Springfield, Massachusetts, May 31–June 21, 1948.

Cincinnati Modern Art Society, *4 Modern Sculptors: Brancusi, Calder, Lipchitz, Moore*, October 1–November 15, curated by Curt Valentin, catalogue.

Galerie Louis Carré, Paris, *Alexander Calder: Mobiles, Stabiles, Constellations*, October 25–November 16, catalogue.

1947

Mattatuck Historical Society, Waterbury, Connecticut, *Alexander Calder*, March 10–28, catalogue.

Kunsthalle Bern, *Calder, Léger, Bodmer, Leuppi*, May 4–26, curated by Arnold Rüdlinger, catalogue.

The Stable, New Haven, Connecticut, *Alexander Calder*, opened May 26.

Palais des Papes, Avignon, France, *Exposition de peintures et sculptures contemporaines*, June 27–September 30, curated by Christian Zervos, organized by Yvonne Zervos, Jacques Charpier, René Girard, catalogue.

Galerie Maeght, Paris, *Le Surréalisme en 1947*, opened July 7, catalogue.

Stedelijk Museum, Amsterdam, *Alexander Calder/Fernand Léger*, July 19–August 24, catalogue.

Buchholz Gallery/Curt Valentin, New York, *Alexander Calder*, December 9–27, catalogue.

1948

Venice, *XXIV Biennale di Venezia*, June 6–September 30, catalogue.

Museu de Arte Moderna do Rio de Janeiro, Ministério da Educação e Saúde, *Alexander Calder*, September, traveled to Museu de Arte Moderna, São Paulo, Brazil, October–November, catalogue.

Galerie d'Art Moderne, Basel, *Calder, Picasso, Steinwender*, December 1948–January 1949.

Buchholz Gallery/Curt Valentin, New York, *Alexander Calder: Recent Mobiles, 1948*, December 11, 1948–January 3, 1949.

1949

Museu de Arte Moderna, São Paulo, Brazil, *Do Figurativismo ao Abstracionismo*, March 8–31, catalogue.

Philadelphia Museum of Art in collaboration with Fairmount Park Art Association, *Third International Exhibition of Sculpture*, May 15–September 11.

Margaret Brown Gallery, Boston, *Calder*, October 25–November 12.

Virginia Museum of Fine Arts, Richmond, *Calder and Sculpture Today*, October 28–December 11, traveled to Mary Baldwin College, Staunton, Virginia, December 13–21; University of Virginia, Charlottesville, January 1–15, 1950.

Buchholz Gallery/Curt Valentin, New York, *Calder*, November 30–December 17, catalogue.

1950

Galerie Maeght, Paris, *Calder: Mobiles & Stabiles*, June 30–July 27, traveled to Stedelijk Museum, Amsterdam, October 6–November 15; Galerie Blanche, Stockholm, December; Lefevre Gallery, London, January 1951; Neue Galerie, Vienna, May 10–June 15, 1951, catalogue.

New Gallery, Charles Hayden Memorial Library, Massachusetts Institute of Technology, Cambridge, *Calder*, December 5, 1950–January 14, 1951, installed by James Johnson Sweeney.

Buchholz Gallery, New York, *The Heritage of Auguste Rodin, An Exhibition Assembled in Honor of the Diamond Jubilee of the Philadelphia Museum of Art*, December 6, 1950–January 6, 1951, catalogue.

1951

Stedelijk Museum, Amsterdam, *Surréalisme + Abstraction*, January 19–February 26, traveled to Palais des Beaux Arts, Brussels, March, catalogue.

The Museum of Modern Art, New York, *Abstract Painting and Sculpture in America*, January 23–March 25, curated by Andrew Carnduff Ritchie, traveled to Dallas Museum of Fine Arts, October 1–22; St. Paul Gallery and School of Art, Minnesota, November 5–26; Winnipeg Art Gallery, Canada, December 10–31; Toledo Museum of Art, Ohio, January 14–28, 1952; J. B. Speed Art Museum, Louisville, Kentucky, February 18–March 10, 1952; Southern Illinois University, Carbondale, March 24–April 14, 1952, catalogue.

The Metropolitan Museum of Art, New York, *The 75th Anniversary Exhibition of Painting & Sculpture by 75 Artists Associated with the Art Students League of New York*, February–April, catalogue.

Institute of Contemporary Arts, Washington, DC, *Sculptures by Alexander Calder*, April 17–June 2.

Contemporary Arts Museum of Houston, *Calder–Miró*, October 14–November 4, catalogue.

Museu de Arte Moderna, São Paulo, Brazil, *I Bienal do Museu de Arte Moderna de São Paulo*, October 20–December, catalogue.

Palais de Charlottenborg, Copenhagen, *Klar Form*, December 8–26, traveled to Konsthallen, Helsinki, January 10–31, 1952; Liljewalchs Konsthall, Stockholm, March 10–27, 1952; Kunstnernes Hus, Oslo, May 1952.

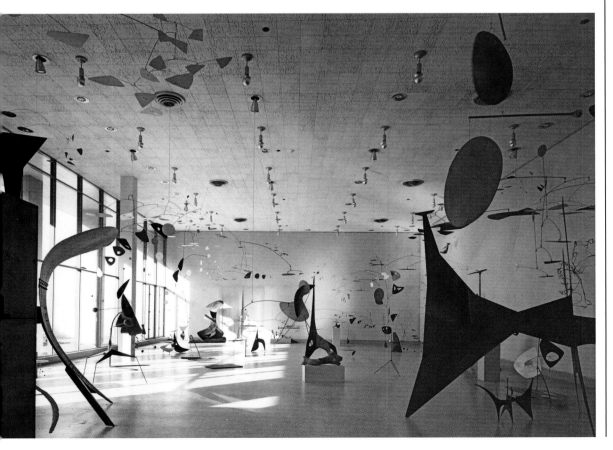

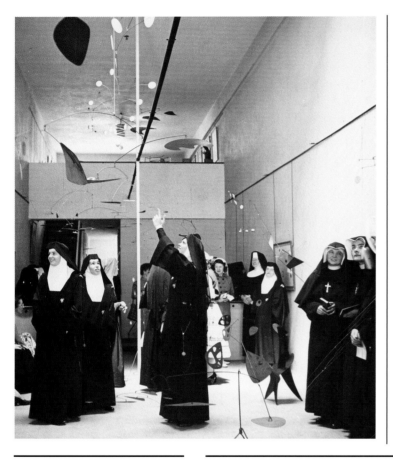

1952

Allen Memorial Art Museum, Oberlin, Ohio, *Calder Mobiles*, January 15–February 5.

Curt Valentin Gallery, New York, *Alexander Calder: Gongs and Towers*, January 15–February 10, traveled to Margaret Brown Gallery, Boston, March 10–29, catalogue.

Galerie Maeght, Paris, *Alexander Calder: Mobiles*, May 6–10.

Galerie Parnass, Wuppertal, Germany, *Calder Mobile*, June 5–20, traveled to Galerie Rudolf Hoffmann, Hamburg, June 28–July 15; Moderne Galerie Otto Stangl, Munich, July 18–August 28; Overbeck-Gesellschaft, Lübeck, August 30–September 14; Württembergischer Kunstverein und Staats Galerie, Stuttgart, September 25–October 15; Galerie der Spiegel, Cologne, October 16–November 29; Galerie Springer, Berlin, December 1, 1952–January 6, 1953; Galerie Otto Ralfs in cooperation with Städtisches Museum, Braunschweig, Germany, January 22–February 18, 1953; Hanna Bekker vom Rath/Frankfurter Kunstkabinett,

Frankfurt am Main, February 22–March 22, 1953; Karl-Ernst-Osthaus-Museum, Hagen, Germany, March 22–April 19, 1953; Museum am Ostwall, Dortmund, Germany, June 6–30, 1953; Studio für zeitgenössische Kunst, Kaiser-Wilhelm-Museum, Krefeld, Germany, July 5–26, 1953, catalogue.

Venice, *XXVI Biennale di Venezia*, June 14–October 19, catalogue.

Galérie la Hune, Paris, *Permanence du Cirque*, November 18–December 9.

above: *Alexander Calder Mobiles*, Frank Perls Gallery, Beverly Hills, 1953

opposite left: Alexander Calder installing works for *Aix. Saché. Roxbury. 1953–54*, Galerie Maeght, Paris, 1954; photograph by Agnés Varda

opposite right: *Le Mouvement*, Galerie Denise René, Paris, 1955

1953

Walker Art Center, Minneapolis, *Alexander Calder Mobiles*, March 22–April 19, traveled to Frank Perls Gallery, Beverly Hills, May 11–June 13; San Francisco Museum of Art, September 4–27.

Musée National d'Art Moderne, Paris, *12 Peintres et Sculpteurs Américains Contemporains*, April 24–June 7, curated by Andrew Carnduff Ritchie, traveled to Kunsthaus Zurich, July 25–August 30; Kunstsammlungen der Stadt Düsseldorf, September 20–October 25; Liljevalchs Konsthall, Stockholm, November 24–December 20; Taidehalli-Konsthallen, Helsinki, January 1–24, 1954; Kunstnernes Hus, Oslo, February 18–March 7, 1954, catalogue.

Wadsworth Atheneum, Hartford, *Alexander Calder: Mobiles; Naum Gabo: Kinetic Constructions and Constructions in Space*, October 16–November 28, catalogue.

Museu de Arte Moderna, São Paulo, Brazil, *II Bienal do Museu de Arte Moderna de São Paulo*, December 15, 1953–February 28, 1954. The United States was represented by three shows organized by the Museum of Modern Art, New York: forty-five works by Alexander Calder; paintings, drawings, and prints by sixteen artists, including William Baziotes, Willem de Kooning, Ben Shahn, and Alton Pickens; and *Built in U.S.A.*; catalogue.

1954

American University, Beirut, *Alexander Calder*, February.

Kestnergesellschaft, Hannover, Germany, *Alexander Calder: Stabiles, Mobiles, Gouachen*, March 18–May 2, curated by Alfred Hentzen, catalogue.

The Newark Museum, New Jersey, *Enjoy Modern Art I*, May 1–September 27.

Galerie des Cahiers d'Art, Paris, *Gouaches récentes de Calder*, May 5–29.

Galerie Rudolf Hoffmann, Hamburg, Germany, *Calder*, June 12–30, catalogue.

Galerie Maeght, Paris, *Aix. Saché. Roxbury. 1953–54*, November 13–December 15, catalogue.

Vancouver Art Gallery, *The Solomon R. Guggenheim Museum, A Selection from the Museum Collection*, November 16–December 12, catalogue.

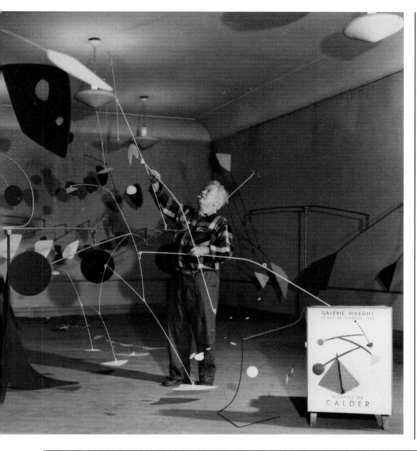

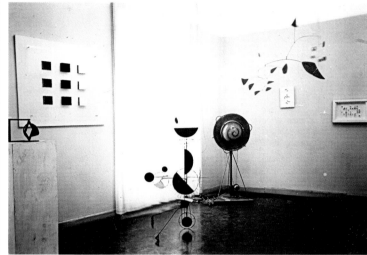

1955

Lefevre Gallery, London, *Mobiles by Calder*, January, catalogue.

Musée National d'Art Moderne, Paris, *Modern Art in the United States*, March 30–May 15, organized by the Museum of Modern Art, New York, curated by James Johnson Sweeney, divided into six sections and traveled to Kunsthaus Zurich, July 16–August 28; Palacio de la Virreina and Museo de Arte Moderno, Barcelona, September 24–October 24; Haus des Deutschen Kunsthandwerks, Frankfurt, November 13–December 11; Tate Gallery, London, January 5–February 12, 1956; Gementemuseum, The Hague, The Netherlands, March 2–April 15, 1956; Galerie Secession, Vienna, May 5–June 2, 1956; Kalemegdan Pavilion, Gallery Udurezenje Likovnih Umetnike Srbije, and Muzej Freska, Belgrade, Yugoslavia, July 6–August 6, 1956, catalogue.

Galerie Denise René, Paris, *Le Mouvement*, April 6–May 15, catalogue.

Robinson Hall, Graduate School of Design, Harvard University, Cambridge, Massachusetts, *Calder*, April 25–May 25.

Curt Valentin Gallery, New York, *Alexander Calder*, May 17–June 4, catalogue.

Museum Fridericianum, Kassel, Germany, *documenta: Kunst des XX. jahrhunderts: Internationale Ausstellung*, July 15–September 18, curated by Arnold Bode, catalogue.

Museo de Bellas Artes, Caracas, *Exposición Calder*, September 11–25, catalogue.

Milwaukee Art Institute, *Calder Mobiles and Stabiles*, December 9, 1955–January 19, 1956, traveled to Memorial Union Gallery, University of Wisconsin, Madison, February 16–March 5, 1956; Sioux City Art Center, Iowa, March 26–April 13, 1956; Beloit College, Wisconsin, May 8–June 10, 1956; University of Michigan Museum of Art, Alumni Memorial Hall, Ann Arbor, September 16–October 14, 1956; Northern Illinois State College, Department of Fine Arts, DeKalb, October 29–November 19, 1956; South Bend Art Association, Indiana, November 30–December 25, 1956; Museum of Art, University of Kansas, Lawrence, January 10–30, 1957; Fort Wayne Art School and Museum, Indiana, February 10–March 3, 1957.

1956

Perls Galleries, New York, *Calder*, February 6–March 10.

Galleria dell'Obelisco, Rome, *Calder*, March 14–31.

Galleria d'Arte del Naviglio, Milan, *Calder*, April 7–17.

Galerie Lucie Weill, Paris, *Calder*, May 3–26.

Circolo della Cultura e delle Arti, Trieste, *Calder*, June 23–July 7.

Musée Picasso, Château Grimaldi, Antibes, *Gouaches–Dessins–Mobiles de Calder*, August 1–October 1.

Institute of Contemporary Art, Boston, *Jewelry and Drawings by Alexander Calder*, October 18–November 21, catalogue.

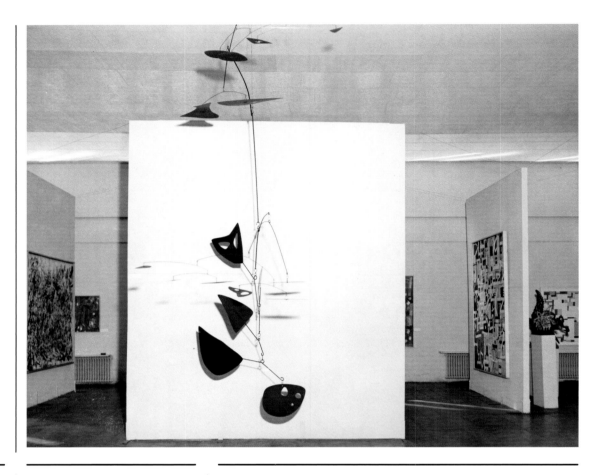

right: *Modern Art in the United States*, Kalemegdan Pavilion, Belgrade, Yugoslavia, 1956 (see entry on previous page)

opposite: *Alexander Calder, Stabilen, Mobilen*, Stedelijk Museum, Amsterdam, 1959

1957

Frank Perls Gallery, Beverly Hills, *Alexander Calder*, February 18–March 16.

World House Galleries, New York, *4 Masters Exhibition: Rodin, Brancusi, Gauguin, Calder*, March 28–April 20, catalogue.

Kunsthalle Basel, *Alexander Calder*, May 22–June 23, curated by Arnold Rüdlinger, traveled to Städelsches Kunstinstitut, Frankfurt, July 17–August 25, catalogue.

Uffici Palazzo dell'arte al Parco, Milan, *Undicesima Triennale di Milano*, July 27–November 4.

1958

Galerie Blanche, Stockholm, *Alexander Calder: Mobiles and Stabiles*.

Corcoran Gallery, Washington, DC, *Contemporary American Artists Series #27: Alexander Calder*, January 25–March 2.

Galerie Artek, Helsinki, *Alexander Calder: Exposition*, January 29–June 2, catalogue.

Perls Galleries, New York, *Calder, Recent Works*, February 10–March 8.

Brussels Universal and International Exhibition, *American Art: Four Exhibitions*, April 17–October 18, catalogue.

Carnegie Institute, Department of Fine Arts, Pittsburgh, *The 1958 Pittsburgh Bicentennial International Exhibition of Contemporary Painting and Sculpture*, December 5, 1958–February 8, 1959, catalogue.

1959

Galerie Maeght, Paris, *Calder: Stabiles*, March 6–April 13, catalogue.

Galerie des Cahiers, Paris, and US Centre Culturel American, *Les Années Vingt: Les Écrivains Américains a Paris et leur Amis, 1920–1930*, March 11–April 25, catalogue.

Stedelijk Museum, Amsterdam, *Alexander Calder, stabilen, mobilen*, May 15–June 22, traveled to Kunsthalle Hamburg, Germany, July 18–August 30; Museum Haus Lange, Krefeld, Germany, September 13–October 25; Kunsthalle Mannheim, Germany, November 7–December 13; Haus der Jugend, Wuppertal-Barmen, Germany, January 10–February 21, 1960; Palais des Beaux-Arts, Brussels, April 3–May 1, 1960; Kunstgewerbemuseum, Zurich, May 21–June 26, 1960, catalogue.

Museum Fridericianum, Orangerie, Schlon Bellevueschloß, Kassel, Germany, *II. documenta '59. Kunst nach 1945: Malerei, Skulptur, Druckgrafik international Ausstellung*, curated by Arnold Bode, July 11–October 11, catalogue.

Museu de Arte Moderna do Rio de Janeiro, *Alexander Calder: Escultura, Guache*, September 23–October 25, catalogue.

1960

Perls Galleries, New York, *Alexander Calder "1960,"* March 15–April 9, catalogue.

1961

Wilmington Society of Fine Arts, Delaware Art Center, *Calder: Alexander Milne, Alexander Stirling, Alexander*, January 7–February 19, catalogue.

Perls Galleries, New York, *Alexander Calder–Joan Miró*, February 2–April 1, catalogue.

Stedelijk Museum, Amsterdam, *Bewogen–Beweging*, March 10–April 17, curated by Pontus Hultén, traveled to Moderna Museet, Stockholm, May 17–September 3; Louisiana Museum of Modern Art, Humlebaek, Denmark, September–October, catalogue.

Katonah Gallery, New York, *Alexander Calder*, October 15–November 14.

Lincoln Gallery, London, *Alexander Calder: Gouaches*, November, curated by Nicholas Guppy, catalogue.

Joan Peterson Gallery, Boston, *Calder*, November 29–December 30.

1962

Arkansas Arts Center, Little Rock, *The Works of Alexander Calder*, March 1–April 1.

Perls Galleries, New York, *Alexander Calder: 1962*, March 20–April 21.

Galerie Blanche, Stockholm, *Mobiles*, May–June.

Martha Van Rensselaer Art Gallery, Cornell University, Ithaca, New York, *Works of Alexander Calder*, May 7–June 1, catalogue.

Galerie la Hune, Paris, *Michel Butor, "Cycle" sur neuf gouaches d'Alexandre Calder*, June 5, catalogue.

Fifth Festival of Two Worlds, Festival Foundation, Spoleto, Italy, *Sculptures in the City*, June 21–July 22, curated by Giovanni Carandente.

Brook Street Gallery, London, *Alexander Calder: Gouaches 1948–1962*, July, catalogue.

Arts Council of Great Britain, Tate Gallery, London, *Alexander Calder: Sculpture–Mobiles*, July 4–August 12, curated by James Johnson Sweeney, catalogue.

Galerie Bonnier, Lausanne, *Alexander Calder: Mobiles*, October 25.

Musée de Rennes, France, *Alexander Calder: Mobiles, Gouaches, Tapisseries*, December 4, 1962–January 20, 1963, catalogue.

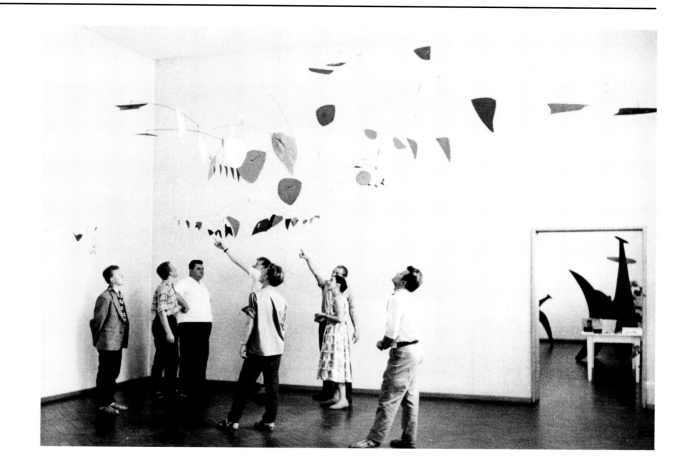

1963

Frank Perls Gallery, Beverly Hills, *Calder: Mobiles, Stabiles, and Gouaches*, March 13–April 12.

Perls Galleries, New York, *Alexander Calder: 1963*, March 19–April 27, catalogue.

Galerie Alex Vömel, Düsseldorf, *Gouachen von Calder*, May–June, catalogue.

Galerie d'Art Moderne Marie-Suzanne Feigel, Basel, *Arp, Calder, Marini*, May 11–September 30, catalogue.

Galerie Maeght, Paris, *Alexander Calder: Stabiles*, November 22, catalogue.

1964

Galleria del Naviglio, Milan, *Alexander Calder: Gouaches 1963–1964*, May 25–June 5, traveled to Galleria Cavallino, Venice, July 13–31.

Alte Galerie, Museum Fridericianum, Orangerie, Kassel, Germany, *documenta III: Malerei und Skulptur*, June 27–October 5, curated by Arnold Bode and Werner Hofmann, catalogue.

Grosvenor Gallery, London, *Miró: Graphics, Calder: Mobiles, Ch'i Pai-shih: Paintings*, October 28–November 20, catalogue.

Solomon R. Guggenheim Museum, New York, *Alexander Calder: A Retrospective Exhibition*, November 6, 1964–January 31, 1965, curated by Thomas M. Messer, exhibition divided into two parts. Part I traveled to Washington University Art Gallery, St. Louis, February 21–March 26, 1965; Art Gallery of Toronto, May 1–30, 1965. Part II traveled to Milwaukee Art Center, February 25–March 28, 1965; Des Moines Art Center, April 28–May 30, 1965. Another version of the exhibition traveled to Musée National d'Art Moderne, Paris, July 8–October 15, 1965, catalogue.

Museum of Fine Arts, Houston, *Alexander Calder: Circus Drawings, Wire Sculpture, and Toys*, November 24–December 13, curated by James Johnson Sweeney, catalogue.

1965

Brook Street Gallery, London, *Vasarely, Calder*, July–September, catalogue.

1966

Perls Galleries, New York, *Alexander Calder: Recent Gouaches, Mobiles, Stabiles*, February 8–March 12.

Galerie Maeght, Paris, *Calder: Gouaches et Totems*, February 18, catalogue.

Hayden Library, Massachusetts Institute of Technology, Cambridge, April.

Richard Gray Gallery, Chicago, *Alexander Calder*, April 29–May 29, catalogue.

Lobby 7, Massachusetts Institute of Technology, Cambridge, May, part of the dedication ceremony for *La Grande voile (The Big Sail)*.

Galerie Jan Krugier & Cie, Geneva, *Alexander Calder*, June 9–July 30, catalogue.

Berkshire Museum, Pittsfield, Massachusetts, *Mobiles by Alexander Calder*, July 2–31, curated by Stuart Henry, catalogue.

Institute of Contemporary Arts, London, *Calder, The Painter*, September 29–October 29, catalogue.

First City National Bank, Houston, *Five Sculptors*, October 3–28, organized by Museum of Fine Arts, Houston, introduction by James Johnson Sweeney, catalogue.

James Goodman Gallery, Buffalo, New York, *Calder*, October 8–29, traveled to Donald Morris Gallery, Detroit, November 13–December 10, 1966.

Centre Culturel Municipal de Toulouse, *Calder (Le Mois USA)*, October 26–November 28, catalogue.

Perls Galleries, New York, *Calder: Jewelry*, November 15–December 17.

Galerie Françoise Mayer, Brussels, *Totems, mobiles et gouaches récentes*, November 19–December 17, catalogue.

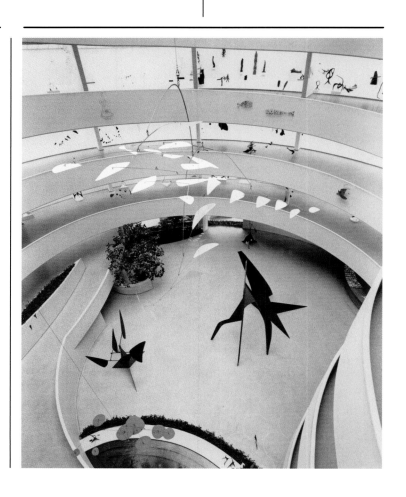

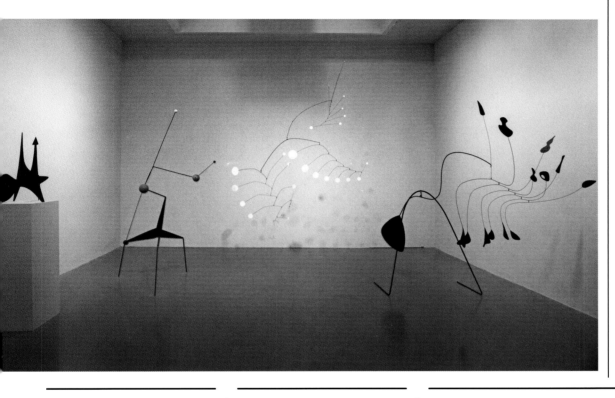

1967

Obelisk Gallery, Boston, *Alexander Calder: Gouaches, Mobiles*, January 17–February 4.

The Museum of Modern Art, New York, *Calder: 19 Gifts from the Artist*, February 1–April 5, curated by Dorothy C. Miller.

Openluchtmuseum voor Beeldhouwkunst Middelheim, Antwerp, *Totems et Gouaches*, February 10–March 5, catalogue.

Phillips Collection, Washington, DC, *Recent Stabiles by Alexander Calder*, April 8–May 30, catalogue.

Arco d'Alibert, Studio d'Arte, Rome, *Calder*, April 21–May 28, catalogue.

Akademie der Künste, Berlin, *Alexander Calder*, May 21–July 16, curated by Dr. Herta Elisabeth Killy, catalogue.

New York Cultural Showcase Festival, New York, *Sculpture in Environment*, October 1–31, catalogue.

Perls Galleries, New York, *Calder: Early Work—Rediscovered*, November 14–December 23, catalogue.

1968

Maison de la Culture, Bourges, France, *Calder: Mobiles, Stabiles, Sculptures, Gouaches*, March 9–May 13, traveled to Musée des Augustins, Toulouse, September.

Dayton's Gallery 12, Minneapolis, in collaboration with Perls Galleries, New York, *Calder*, April 17–May 11, catalogue.

Kiko Galleries, Houston, *Calder*, Fall, catalogue.

Galerie Maeght, Paris, *Flèches*, October 10–November, catalogue.

Perls Galleries, New York, *Calder, Space: Drawings 1930–1932; Gouaches 1967–1968*, October 15–November 9, catalogue.

The Museum of Modern Art, New York, *The Machine as Seen at the End of the Mechanical Age*, November 25, 1968–February 9, 1969, curated by Pontus Hultén, traveled to University of St. Thomas, Houston, March 25–May 18, 1969; San Francisco Museum of Art, June 23–August 24, 1969.

1969

Gimpel Fils, London, *Alexander Calder: Standing Mobiles, 1968*, February 18–March 15, catalogue.

Fondation Maeght, Saint-Paul-de-Vence, *Calder*, April 2–May 31, traveled to Louisiana Museum of Modern Art, Humlebaek, Denmark, June 29–September 7; Stedeljik Museum, Amsterdam, October 4–November 16, catalogue.

Grand Rapids Art Museum, Michigan, *Alexander Calder: Mobiles and Stabiles*, May 18–August 24, catalogue.

Fundación Eugenio Mendoza, Caracas, *Calder en Venezuela*, July 6–August 3, catalogue.

Perls Galleries, New York, *Alexander Calder: Bronze Sculptures of 1944*, October 7–November 8, catalogue.

The Museum of Modern Art, New York, *A Salute to Alexander Calder*, December 22, 1969–February 15, 1970, curated by Bernice Rose, traveled to Museo de Arte Moderno, Bogotá, October 29–December 13, 1970; Museo Nacional de Artes Plásticas, Montevideo, April 1–29, 1971; Museo Nacional de Bellas Artes, Buenos Aires, May 6–June 6, 1971; Museo Nacional de Bellas Artes, Santiago, August 12–September 12, 1971; Museo Universitario de Ciencias y Arte, Mexico City, October 28–November 28, 1971; Columbus Gallery of Fine Arts, Ohio, January 13–February 27, 1972; Tyler Museum of Art, Texas, March 20–April 30, 1972; Joslyn Art Museum, Omaha, September 7–October 22, 1972; Oakland Museum, California, November 14, 1972–January 1, 1973.

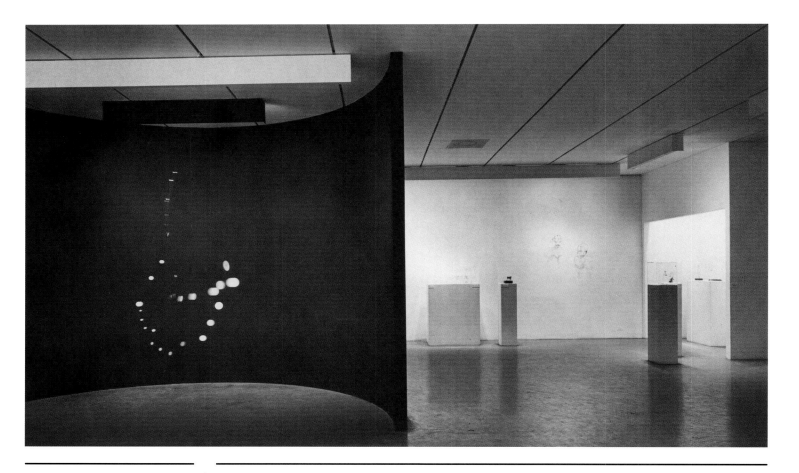

above and right: *A Salute to Alexander Calder*, The Museum of Modern Art, New York, 1969–70

opposite: Alexander Calder standing on the terrazzo sidewalk that he designed in front of the Perls Galleries building on the occasion of the opening for *Alexander Calder: Recent Gouaches–Early Mobiles*, New York, 1970

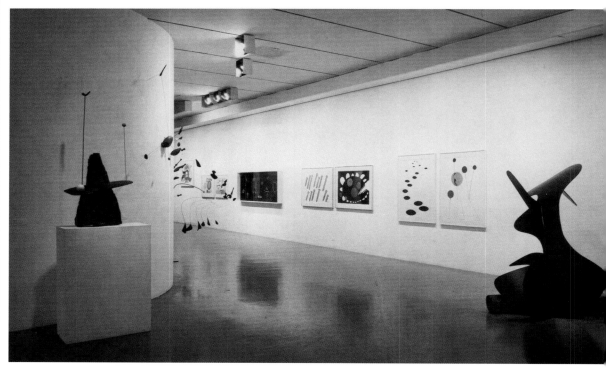

1970

Galerie Blanche, Stockholm, *Alexander Calder: Mobiler, Stabile-Mobiler, Gouacher 1961–1970*, catalogue.

Long Beach Museum of Art, California, *Calder Gouaches: The Art of Alexander Calder*, January 11–February 8, traveled to Fine Arts Gallery of San Diego, California, February 27–March 29; Phoenix Art Museum, May 1–31, catalogue.

Château de Ratilly, Nièvre, France, *Calder/Bazaine*, June 19–September 10, catalogue.

Galerie Vömel, Düsseldorf, *Calder*, July 1–August 31, catalogue.

Galerie Gunzenhauser, Munich, *Calder*, opened September 24, catalogue.

Galerie Semiha Huber, Zurich, *A. Calder: Mobile, Bilder, Graphik, Teppiche*, October.

Perls Galleries, New York, *Alexander Calder: Recent Gouaches–Early Mobiles*, October 20–November 28, catalogue.

1971

Galerie Maeght, Paris, *Calder: Stabiles, Animobiles*, opened February 12, catalogue.

Society of the Four Arts, Palm Beach, Florida, *Alexander Calder, Louise Nevelson, David Smith*, March 6–April 5, catalogue.

Studio Marconi, Milan, *Calder*, April–May, catalogue.

Galerie d'Art Moderne Marie-Suzanne Feigel, Basel, *Alexander Calder: Mobiles, Mobiles/Stabiles, Bronzes, Gouaches et Lithographies*, April 3–June 5, catalogue.

Gimpel Fils, London, *Alexander Calder: Sculptures and Gouaches*, April 15–May 15, catalogue.

John Berggruen Gallery, San Francisco, *Alexander Calder*, May 13–June 14, catalogue.

American Academy of Arts and Letters, and National Institute of Arts and Letters, New York, *Exhibition of Work by Newly Elected Members and Recipients of Honors and Awards*, May 27–June 20, catalogue. Calder was awarded the Gold Medal for Sculpture.

Galleria dell'Obelisco, Rome, *Calder*, June, catalogue.

Musée Toulouse-Lautrec, Albi, France, *Calder*, June 23–September 15, traveled to Maison des Arts et Loisirs, Sochaux, France, September 25–November 9, catalogue.

Badischer Kunstverein, Karlsruhe, Germany, *Alexander Calder: Mobiles, Stabiles, Bilder, Teppiche*, August 29–October 3, catalogue.

Perls Galleries, New York, *Calder: Animobiles–Recent Gouaches*, October 5–November 6, catalogue.

Whitney Museum of American Art, New York, *Alexander Calder: Tapestries*, October 5–November 14, traveled to Corcoran Gallery of Art, Washington, DC, December 3, 1971–January 2, 1972; Parker Street 470 Gallery, Boston, March 19–April 8, 1972; Leonard Hutton Galleries, New York, April 14–May 31, 1972, catalogue.

Taft Museum, Cincinnati, *Alexander Calder, Early Works c. 1927–1944*, December 12, 1971–January 31, 1972, catalogue.

1972

Galerie Verrière, Paris, *Calder: Tapisseries*, February 23–March 19.

Whitney Museum of American Art, New York, *Calder's Circus*, April 20–June 11, curated by Jean Lipman, catalogue.

The Museum of Fine Arts, Houston, *A Child's Summer with Calder and Miró*, June 14–August 20.

L'eglise du Château, Felletin-Creuse, France, *Calder Tapisseries et Mobiles*, June 23–September 10.

Sala Pelaires, Palma de Mallorca, Spain, *Calder*, September–October, catalogue.

High Museum of Art, Atlanta, *Calder in Atlanta*, October 1–29.

Perls Galleries, New York, *Alexander Calder: Oil Paintings*, October 10–November 11, catalogue.

Delta International Art Center, Rome, *Alexander Calder*, October 27–November 22, catalogue.

Fuji Television Gallery Co., Ltd., Tokyo, *Calder, Miró*, November 15–30, catalogue.

The Arts Club of Chicago, *Aubusson Tapestries by Alexander Calder*, November 15–December 30, organized in cooperation with Art Vivant, New Rochelle, New York, catalogue.

Galerie Beyeler, Basel, *Miró/Calder*, December 1972–January 1973, catalogue.

1973

Galerie Maeght, Paris, *Calder: Recent Mobiles*, January 24–February 24, catalogue.

Galerie Der Spiegel, Cologne, *Calder: 22 Teppiche aus den Ateliers Pinton Aubusson*, traveled to Kunsthalle Bielefeld, Germany, February 8–March 8; Kubus, Hannover, Germany, March–April 15, catalogue.

Jacques Damase Gallery, Brussels, *Calder*, February 19–March 21.

Art Institute of Chicago, *Alexander Calder*, April 23. Calder presented his maquette for *Flamingo* in a one-night exhibition.

Palais des Beaux-Arts, Charleroi, Belgium, *Calder: Sculptures en plein air: Plaine des Manoeuvres; Gouaches et petits mobiles: Bibliothèque communale*, May 13–July 15, catalogue.

Galerie Maeght, Zurich, *Alexander Calder: Retrospektive*, May 24–July, catalogue.

Solomon R. Guggenheim Museum, New York, *Calder Airplanes*, August 9–October 7, traveled to Wharton Graduate School, Vance Hall, University of Pennsylvania, Philadelphia, December 4–20.

Sala Gaspar, Barcelona, *Calder: Escultures; Exposició Calder Pintures*, September, catalogue.

Perls Galleries, New York, *Calder at 75–Works in Progress*, October 3–November 3.

Joseloff Gallery, Hartford Art School, University of Hartford, West Hartford, Connecticut, *Alexander Calder*, October 8–12.

Detroit Institute of the Arts, *Alexander Calder: Prints, Drawings, and Illustrated Books*, October 18–November 18.

Galleria d'Arte La Bussola, Turin, *Calder*, October 26, catalogue.

Gallery 36 (Foote, Cone & Belding), New York, *Flying Colors*, December.

Whitney Museum of American Art, Downtown Branch, New York, *3 Sculptors: Alexander Calder, Louise Nevelson, David Smith*, December 5, 1973–January 3, 1974.

1974

Centre National d'Art Contemporain, Paris, *Calder: Mobile et Lithographies*, February 9–March 24, curated by Serge Lemoine and Jacqueline Hériand Dubreuil, catalogue.

Katonah Gallery, New York, *Alexander Calder*, February 9–March 24.

Studio d'Arte Condotti, Rome, *Calder*, March 4.

Centre Culturel de Saint-Pierre-des-Corps, France, *Calder*, April.

Musée Municipal, Limoges, France, *Calder: Mobiles, Gouaches, Tapisseries, Assiettes, Lithographies*, June.

Salle des Ecuries de Saint-Hugues et Musée Ochier, Cluny, France, *Calder*, June 21–September 8.

Hokin Gallery, Chicago, *Calder Paintings, Sculpture, Graphics*, October 15–November 16.

Perls Galleries, New York, *Alexander Calder: Crags and Critters of 1974*, October 15–November 16, catalogue.

Denise René/Hans Meyer, Düsseldorf, *Alexander Calder: Mobiles, Stabiles, Gouachen*, October 17–November 22, catalogue.

Museum of Contemporary Art, Chicago, *Alexander Calder: A Retrospective Exhibition, Work from 1925 to 1974*, October 26–December 8, curated by Ira Licht, catalogue.

Galerie Court Saint-Pierre, Geneva, November 1974–January 1975.

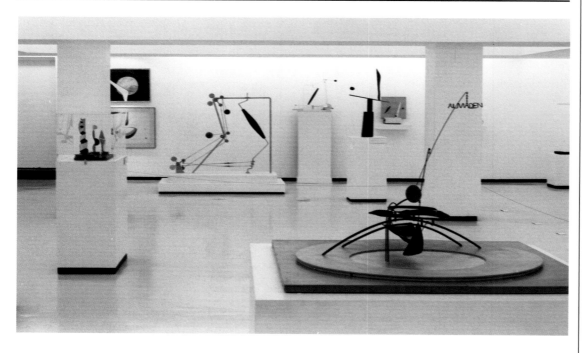

1975

Hooks-Epstein Galleries, Houston, *Calder and Miró: Works on Paper 1957–1974*, January 7–February 15.

Pace Gallery, New York, *5 Americans: Calder, Cornell, Nevelson, Noguchi, Smith: Masters of Twentieth Century Sculpture*, January 11–February 22.

Galerie Maeght, Paris, *Calder: Crags and Critters*, January 22–February 23, catalogue.

Bhirasi Institute of Modern Art, Bangkok, *Calder's Circus*, January 29–February 16, co-organized by the National Collection of Fine Arts, Smithsonian Institution, Washington, DC, and Whitney Museum of American Art, New York.

Center for the Arts Gallery, Wesleyan University, Middletown, Connecticut, *Alexander Calder: Tapestries*, January 31–March 1, catalogue.

Galleria Morone 6, Milan, *Opere di Alexander Calder*, February, catalogue.

Portland School of Art, Maine, *Outdoor Sculpture Exhibition Series: Alexander Calder*, March–July.

Galleria Medea, Milan, *Calder e Mathieu*, April 1–20, catalogue.

Moderne Galerie Otto Stangl, Munich, *Calder, Hartung*, May.

Haus der Kunst, Munich, *Calder*, May 10–July 13, 1975, curated by Maurice Bessett, traveled to Kunsthaus Zurich, August 23–November 2

Galerie Maeght, Zurich, *Calder: Crags and Critters*, September–October, catalogue.

Renaissance du Vieux Bordeaux, France, *Calder: Tapisseries-Mobiles*, October 3–26, catalogue.

Perls Galleries, New York, *Alexander Calder: Recent Mobiles and Circus Gouaches*, October 14–November 15, catalogue.

Galerie Artek, Helsinki, *Calder: Mobiles, Bijoux, Lithographies/Léger: Huiles, Gouaches, Lithographies*, October 15–November 2, catalogue.

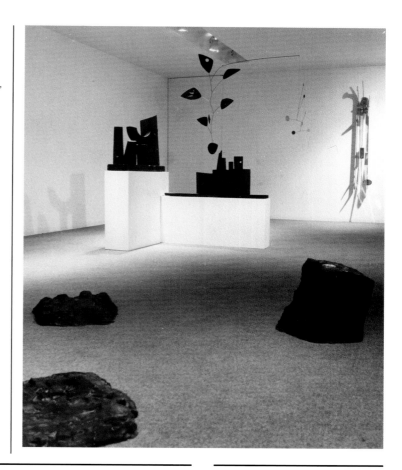

1976

Galeria Bonino, Rio de Janeiro, *Alexander Calder. Redes-Tapecarias*, March 23–June 17, catalogue.

Galleria Marlborough, Rome, *Alexander Calder: Arazzi e amache*, April, catalogue.

Artcurial, Paris, *Calder: Tapisseries Choisies*, April 7–30, catalogue.

Gallery Wien, Jerusalem, *Calder*, April 10–May 10.

Galleria Rondanini, Rome, *Dai Mobiles ai Critters*, April 12, catalogue.

Fort Wayne Museum of Art and L. S. Ayres & Co., Indiana, *A Calder Occasion*, September 20–25.

The Greater Philadelphia Cultural Alliance, *Alexander Calder Festival*, October 1–10, festival included dedication of *White Cascade* at the Federal Reserve Bank and the premiere of *Under the Sun*, a dance tribute to Calder performed by the Pennsylvania Ballet.

Whitney Museum of American Art, New York, *Calder's Universe*, October 14, 1976–February 6, 1977, curated by Jean Lipman and Richard Marshall, traveled to High Museum of Art, Atlanta, March 5–May 1, 1977; Walker Art Center, Minneapolis, June 5–August 14, 1977; Dallas Museum of Fine Arts, September 14–October 30, 1977. A reduced version traveled to San Jose Museum of Art, California, April 2–May 21, 1978; Portland Art Museum, Oregon, June 14–July 30, 1978; Phoenix Art Museum, August 27–October 8, 1978; Joslyn Art Museum,

Omaha, November 4–December 17, 1978; Loch Haven Art Center, Orlando, January 7–February 25, 1979; Hirshhorn Museum and Sculpture Garden, Smithsonian Institution, Washington, DC, March 15–May 13, 1979; Currier Gallery of Art, Manchester, New Hampshire, June 2–July 29, 1979. Another version traveled to Seibu Museum of Art, Tokyo, September 23–October 29, 1979; Kita-kyushu Municipal Museum of Art, Japan, November 3–25, 1979; Prefectural Museum of Modern Art, Hyogo, Kobe, Japan, December 2, 1979–February 3, 1980; Yokohama City Gallery, Japan, February 10–March 9, 1980, catalogue.

Galerie Maeght, Paris, *Calder: Mobiles and Stabiles*, December 1, 1976–January 8, 1977, catalogue.

opposite: *Alexander Calder: A Retrospective Exhibition, Work from 1925 to 1974*, Museum of Contemporary Art, Chicago, 1974

above: *5 Americans: Calder, Cornell, Nevelson, Noguchi, Smith: Masters of Twentieth Century Sculpture*, Pace Gallery, New York, 1975

1977

Albright-Knox Gallery, Buffalo, New York, *Graphics by Calder*, January 4–February 27.

Galeria Maeght, Barcelona, *Calder: Exposició Antologica (1932–1976)*, April–May, catalogue.

Galerie Saint-Martin, Paris, *Hommage à Calder, Tapisseries d'Aubusson*, May 13–June 5.

Billy Rose Pavilion, Israel Museum, Jerusalem, *Homage to Calder*, September 5, 1977–January 7, 1978.

Brewster Gallery, New York, *Homage to Calder*, November 12–December 3.

American Academy and Institute of Arts and Letters, New York, *Alexander Calder Memorial Exhibition*, November 14–December 30, catalogue.

1978

Musée National d'Art Moderne, Centre Georges Pompidou, Paris, *Images de Calder*, February 17–March 27.

Galeria del Centro Colombo-Americano, Bogotá, *Alexander Calder*, April 27–May 31.

Galerie Tokoro, Tokyo, *Alexander Calder: Mobiles and Gouaches*, September 4–October 7, catalogue.

M. Knoedler & Co., Inc., New York, *Alexander Calder: Sculpture of the 1970s*, October 4–November 2, catalogue.

1979

Théâtre Maxime Gorki, Petit Quevilly, France, *Calder: lithographies, mobiles, stabiles*, March 2–April 10, catalogue.

Rolly-Michaux Gallery, Boston, *Alexander Calder—The Man and His Work*, April 29–June 16, catalogue.

Rutgers University Art Gallery, New Brunswick, New Jersey, *Vanguard American Sculpture 1913–1939*, September 16–November 4, curated by Joan M. Marter, Roberta K. Tarbell, and Jeffrey Wechsler, traveled to William Hayes Ackland Art Center, University of North Carolina, Chapel Hill, December 4, 1979–January 20, 1980; Joslyn Art Museum, Omaha, February 16–March 30, 1980; Oakland Museum, California, April 15–May 25, 1980, catalogue.

M. Knoedler & Co., Inc., New York, *Alexander Calder–Fernand Léger*, October 4–27, catalogue.

Rolly-Michaux Gallery, New York, *Alexander Calder*, October 10–November 10.

Galleria Pieter Coray, Lugano, Switzerland, *Calder*, October 26–November 24, catalogue.

1980

Chapelle de la Charité, Arles, France, *Calder*, June 29–September 21.

M. Knoedler & Co., Inc., New York, *Alexander Calder: Standing Mobiles*, December 4, 1980–January 2, 1981, catalogue.

Galerie Brusberg, Hannover, Germany, *Alexander Calder: Mobiles, Stabiles, Grafik, und Critters*, December 6, 1980–March 1, 1981, catalogue.

Galeria Jean Boghici, Rio de Janeiro, *Alexander Calder: Mobiles, Pintura, Guaches*, December 18, 1980–January 18, 1981, catalogue.

1981

Whitney Museum of American Art, New York, *Alexander Calder: A Concentration of Works from the Permanent Collection at the Whitney Museum of American Art*, February 17–May 3, curated by Patterson Sims, catalogue.

The Mayor Gallery and Waddington Galleries, London, *Calder*, April 1–25, catalogue.

Galerie Maeght, Paris, *Calder*, October 16–25, catalogue.

Marisa del Re Gallery, New York, *Calder: Mobiles, Stabiles, Gouaches*, December 22, 1981–January 23, 1982.

1982

Galerie Maeght, Zurich, *Calder*, April 16–June, catalogue.

M. Knoedler & Co., Inc., New York, *Alexander Calder: Small Scale Works and Gouaches*, May 15–June 3, catalogue.

Museo de Arte Moderno, Mexico City, *Tapices de Alexander Calder*, July 20–August 29, catalogue.

University Art Museum, Berkeley, California, *Alexander Calder*, November 3, 1982–January 16, 1983, curated by Norma Schlesinger, catalogue.

1983

Flint Institute of Arts, Michigan. *Alexander Calder: Mobiles, Stabiles, Gouaches, Drawings from the Michigan Collections*, February 20–March 27, curated by Christopher R. Young, catalogue.

M. Knoedler & Co., Inc., New York, *Alexander Calder: Stabiles*, May 14–June 2, catalogue.

Palazzo a Vela, Turin, *Calder: Mostra retrospettiva*, July 2–September 25, curated by Giovanni Carandente, installation design by Renzo Piano Workshop, catalogue.

Greenberg Gallery and Missouri Botanical Garden, St. Louis. *Calder in Retrospect*, September 1–October 2.

Musée National d'Art Moderne, Centre Georges Pompidou, Paris, *Des Stabiles et des Mobiles de Calder*, October 26, 1983–January 2, 1984.

M. Knoedler Zurich AG, *Alexander Calder: Sculptures, Works on Paper*, December 3, 1983–January 21, 1984.

1984

Whitney Museum of American Art, Fairfield County, Stamford, Connecticut, *Calder: Selections from the Permanent Collection of the Whitney Museum of American Art*, January 20–March 21, curated by Pamela Gruninger Perkins and Susan Lubowsky, traveled to Whitney Museum of American Art at Philip Morris, New York, May 17–July 11, catalogue.

Grand Rapids Art Museum, Michigan, *Calder in Grand Rapids*, June 1–17, exhibition celebrated the fifteenth anniversary of the installation of Calder's *La Grande vitesse*. Included a program at Vandenberg Center, June 1–3, with premiere performances of *A Festival Piece for Alexander Calder* by Jack Fortner and *Inaugural Fanfare* by Aaron Copland.

Herbert Palmer Gallery, Los Angeles, *Calder Gouaches and Mobiles*, June 16–August 18.

Solomon R. Guggenheim Museum, New York, *From Degas to Calder: Sculpture and Works on Paper from the Guggenheim Museum Collection*, July 30–September 8, curated by Thomas M. Messer, catalogue.

x187

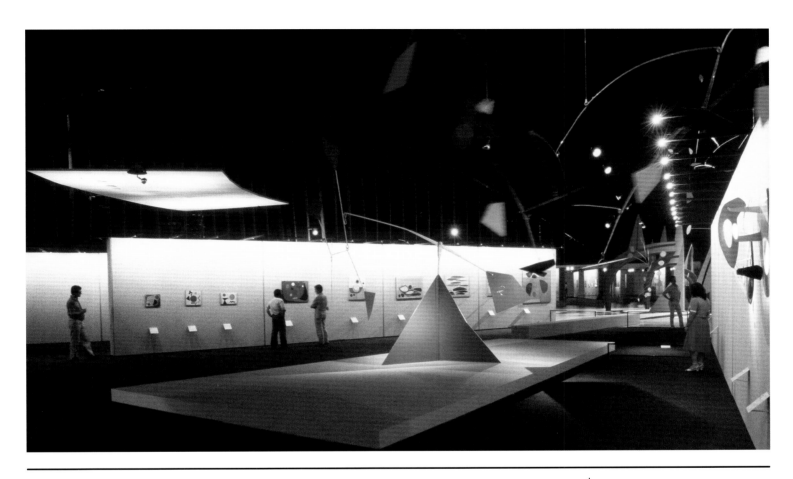

above and left: *Calder: Mostra retrospettiva*, Palazzo a Vela, Turin, 1983

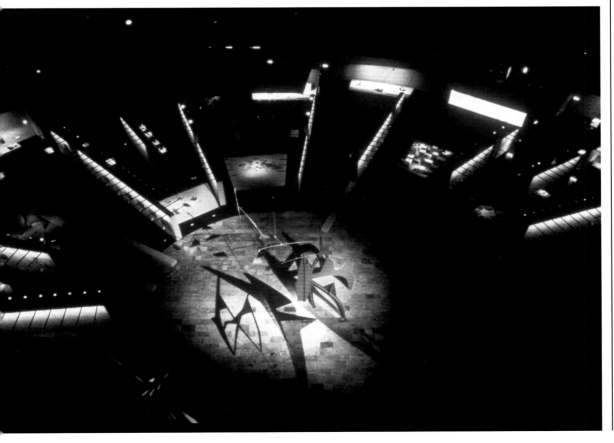

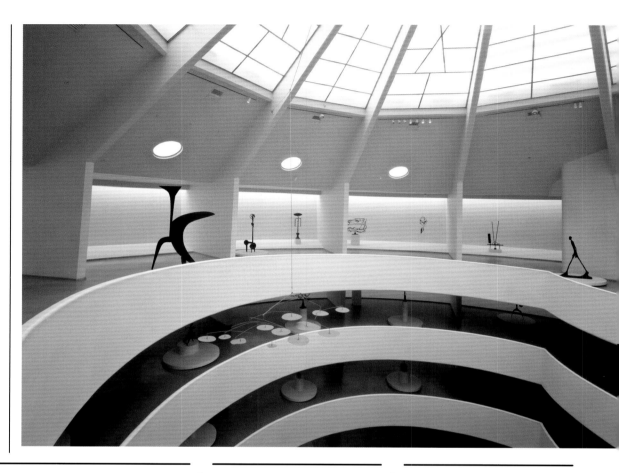

right: *Picasso and the Age of Iron,*
Solomon R. Guggenheim Museum,
New York, 1993

1985

Peggy Guggenheim Collection, Venice, *Six Modern Masters from the Guggenheim Museum New York*, March 10–April 8, curated by Thomas M. Messer, traveled to Padiglione d'Arte Contemporanea, Milan, May 5–July 26; Peggy Guggenheim Collection, Venice, November 1–December 30, catalogue.

Pace Gallery, New York, *Calder's Calders*, May 3–June 8, catalogue.

Galerie Maeght Lelong, Paris, *Calder*, May 14–June 8.

Barbara Krakow Gallery, Boston, *Alexander Calder: Mobiles and Gouaches*, May 18–June 13.

Hudson River Museum in cooperation with the Whitney Museum of American Art, Yonkers, New York, *Calder Creatures Great and Small*, July 21–September 15, curated by Jean Lipman with Margi Conrads, traveled to Delaware Art Museum, Wilmington, September 27–November 10; Montclair Art Museum, New Jersey, May 11–June 29, 1986, catalogue.

Galería Theo, Madrid, *Doce esculturas Calder/Miró diez pinturas*, December 5, 1985–January 1986, catalogue.

1986

Bakalar Sculpture Gallery, List Visual Arts Center, Massachusetts Institute of Technology, Cambridge, *Alexander Calder: Artist As Engineer*, January 31–April 13, curated by Joan M. Marter, catalogue.

Le Château Biron, Dordogne, France, *Calder*, June 14–September 30, catalogue.

Ancienne Ecole, bourg de Plouguiel, Côtes du-Nord, France, *Calder à La Roche-Jaune: Mobiles, Gouaches, Bijoux*, July 14–August 15, catalogue.

Sheldon Memorial Art Gallery, University of Nebraska, Lincoln, *Alexander Calder: An American Invention*, September 13–November 16, curated by Vivian Kiechel and George W. Neubert, catalogue.

Artcurial, Munich, *Calder: Mobiles, Gouachen, Lithographien*, October 15–December 20.

1987

Pace Gallery, New York, *Alexander Calder Bronzes*, March 20–April 14.

Equitable Gallery, Miami, *Calder Park: An Exhibition of Maquettes by Alexander Calder*, April 22–May.

Galerie Adrien Maeght, Paris, *Calder*, June 18–August 10, catalogue.

Château du Roi René, Tarascon, France, *Calder*, July–September 27.

Whitney Museum of American Art, New York, *Alexander Calder: Sculptures of the Nineteen Thirties*, November 14, 1987–January 17, 1988, curated by Richard Marshall, catalogue.

Linssen Gallery, Cologne, *Calder Retrospective: 1898–1976*, November 25, 1987–January 1988, curated by Werner Linssen, catalogue.

1988

State Street Gallery, Westport, Connecticut, *Calder: Comprehensive Exhibition of over Fifty Works of Art*, April 2–May 28.

Barbara Mathes Gallery, New York, *Calder: Drawings, Mobiles, and Stabiles*, September 16–October 22.

Gallerie Seno, Milan, *Alexander Calder: Standing and Hanging Mobiles 1945–1976*, October 6–November 16, traveled to Edward Totah Gallery, London, December, catalogue.

Galérie Louis Carré & Cie, Paris, *Alexander Calder–Mobiles; Fernand Léger–Peintures*, October 13–November 26, catalogue.

Arnold Herstand and Co., New York, *Alexander Calder: Selected Works*, December 1, 1988–February 11, 1989.

1989

Galeria Maeght, Barcelona, *Calder*, February–March, catalogue.

Musée des Arts Décoratifs, Paris, *Calder Intime* (The intimate Calder), February 15–May 21, curated by Daniel Marchesseau, traveled to El Centro Cultural/Arte Contemporáneo, Mexico City, June 1–August 15; Cooper-Hewitt National Design Museum, Smithsonian Institution, New York, October 17, 1989–March 11, 1990; Minneapolis Institute of Arts, May 6–July 15, 1990; Seibu Museum of Art, Tokyo, August 3–28, 1990, catalogue.

Greenberg Gallery, St. Louis, *Alexander Calder*, March 10–April 22.

Galeria Theo, Madrid, *Calder*, March 16–31, catalogue.

Gallery Urban, New York, *Miró: Major Works and Calder: Mobiles and Gouaches*, April 1–May 31, traveled to Gallery Urban, Paris, September 26–November 10.

Pace Gallery, New York, *Calder: Stabiles*, May 5–June 17, catalogue.

1990

Jack Rutberg Fine Arts Inc., Los Angeles, *Alexander Calder: Sculptures, Paintings and Gouaches*, December 8, 1990–January 31, 1991.

1991

Gallery Urban, New York, *Calder: Gouaches, Tapestries*, February–March.

Whitney Museum of American Art, New York, *Celebrating Calder*, November 13, 1991–January 2, 1992, curated by Jennifer Russell, traveled to Royal Academy of Arts, London, March 13–June 7, 1992; IVAM, Centre Julio Gonzalez, Valencia, Spain, September 12–November 8, 1992; Sonje Museum of Contemporary Art, Kyongju, Korea, June 21–September 19, 1993; Musée du Québec, September 29, 1994–January 15, 1995; Baltimore Museum of Art, October 4, 1995–January 7, 1996; Albright-Knox Gallery, Buffalo, New York, March 9–May 5, 1996, catalogue.

Galerie Maurice Keitelman, Brussels, *Calder Mobiles*, November 29, 1991–February 1, 1992, catalogue.

1992

Crane Gallery, London, *Calder: Oils, Gouaches, Mobiles and Tapestries*, March 5–May 1, catalogue.

Galerie Municipale Prague, *Alexander Calder*, June 23–August 30, catalogue.

Fondation Maeght, Saint-Paul-de-Vence, *L'Art en Mouvement*, July 4–October 15, curated byJean Louis Prat, catalogue.

La Défense, Parvis de La Défense et Galerie Art 4, Paris, *Les Monuments de Calder*, October 7, 1992–January 3, 1993, traveled to Kunst-und Ausstellungshalle, Bonn, April 2–September 30, 1993, catalogue.

Museum of Contemporary Art, Chicago, *Alexander Calder from the Collection of the Ruth and Leonard J. Horwich Family*, November 21, 1992–January 31, 1993, curated by Lynne Warren, catalogue.

1993

Hirshhorn Museum and Sculpture Garden, Smithsonian Institution, Washington, DC, *Calder Gallery Installation*, January 1993–May 1994.

Solomon R. Guggenheim Museum, New York, *Picasso and the Age of Iron*, March 19–May 16, curated by Carmen Giménez, traveled to Modern Art Museum of Fort Worth, August 1–October 17, catalogue.

Kunst-und Ausstellungshalle, Bonn, *Der Andere Calder*, April 30–September 30, curated by Daniel Abadie and Pontus Hulten, catalogue.

O'Hara Gallery, New York, *Alexander Calder: Sculpture, Paintings, Works on Paper*, May 1–May 30.

Musée Picasso, Château Grimaldi, Antibes, *Calder: Mobiles, stabiles, gouaches, bijoux...*, July 2–September 27, curated by Danièle Bourgois and Luc Deflandre, catalogue.

Gagosian Gallery, New York, *Monumental Sculpture*, September 18–October 30, catalogue.

1994

Haus der Kunst, Munich, *Elan vital oder Das Auge Der Eros: Kandinsky, Klee, Arp, Miró, Calder*, May 20–August 14, curated by Christoph Vitali, catalogue.

Bibliothèque Municipale and Abbaye Saint-Germain, Auxerre, France, *Calder*, opened May 27.

William Beadleston, Inc., New York, in association with Susanna Allen Fine Art, London, *Alexander Calder: Mobiles, Stabiles*, June 7–July 1.

Ho Gallery, Hong Kong, *Calder*, September 9–October 29.

Musée du Québec, *L'Homme de Calder*, September 29, 1994–January 15, 1995, curated by Daniel Drouin, catalogue.

O'Hara Gallery, New York, *Alexander Calder: Selected Works 1932–1972*, October 18–December 3, catalogue.

1995

Galerie des Cahiers d'Art, Paris, *Sculptures de Calder vues par Marc Vaux, Hugo Herdeg and Herbert Matter*, March 15–April 6.

Grosvenor Gallery, London, *Henry Moore O.M. 1898–1986; Alexander Calder 1898–1976*, March 15–April 13, catalogue.

Bruce Museum, Greenwich, Connecticut, *The Mobile, the Stabile, the Animal; Wit in the Art of Alexander Calder*, September 14–December 31, curated by Nancy Hall-Duncan, catalogue.

Louisiana Museum of Modern Art, Humlebaek, Denmark, *Alexander Calder: Retrospective*, October 6, 1995–January 21, 1996, curated by Lars Grambye, traveled to Moderna Museet, Stockholm, March 30–May 27, 1996; Musée d'Art Moderne de la Ville de Paris, July 10–October 6, 1996, catalogue.

PaceWildenstein, Beverly Hills, *Alexander Calder: The 50's*, November 9–December 29, traveled to PaceWildenstein, New York, January 19–February 17, 1996, catalogue.

1996

Galerie Proarta, Zurich, *Calder 1898–1976, Mobiles Bilder Lithographien*, March 2–May 1.

The Phillips Collection, Washington, DC, *Americans in Paris (1921–1931): Man Ray, Gerald Murphy, Stuart Davis, Alexander Calder*, April 27–August 18, curated by Elizabeth Hutton Turner, catalogue.

Donjon de Vez, France, *Calder au Donjon de Vez*, May 26–September 29, catalogue.

590 Madison, New York, *Alexander Calder*, June 3, 1996–February 14, 1997, organized by PaceWildenstein, New York.

Indianapolis Art Center, Indiana, *Indiana Collects Calder*, September 13–December 1, curated by Julia Mooney Moore, catalogue.

Indiana University Art Museum, Bloomington, *Calder at Indiana University*, October 9, 1996–February 2, 1997.

below and opposite: *Alexander Calder: 1898–1976*, National Gallery of Art, Washington, DC, 1998

1997

Galerie du Golf-Hôtel in Les Hauts de Gstaad-Saanenmöser, Switzerland, *Tel est Calder*, February 8–March 16.

National Gallery of Art, Washington, DC, *Alexander Calder: The Collection of Mr. and Mrs. Klaus Perls*, March 9–July 6, curated by Marla Prather, catalogue.

Galería Senda, Barcelona, *Alexander Calder*, April 16 – May 17, traveled to Salas de Exposiciones de la Sociedad Económica de Amigos del País, Obra Socio Cultural de Unicaja, Málaga, Spain, May 23–June 19.

Palais Bénédictine, Fécamp (Seine Maritime), France, *Exposition Calder*, June 20– September 21, organized by Galerie Maeght, Paris, catalogue.

Fundació Joan Miró, Barcelona, *Calder*, November 20, 1997– February 15, 1998, curated by Joan Punyet Miró, catalogue.

1998

Fundação Arpad Szenes-Vieira da Silva, Lisbon, *Calder*, March 19–May 24, catalogue.

National Gallery of Art, Washington, DC, *Alexander Calder: 1898–1976*, March 29–July 12, curated by Marla Prather and Alexander S. C. Rower, traveled to San Francisco Museum of Modern Art, September 4–December 1, curated by Gary Garrels, catalogue.

Nassau County Museum of Art, Roslyn Harbor, New York, *Calder and Miró*, June 7–September 13, curated by Constance Schwartz and Franklin Hill Perrell, catalogue.

Scottsdale Museum of Contemporary Art, Arizona, *Alexander Calder: Le Grand Cirque*, December 19, 1998–March 21, 1999, catalogue.

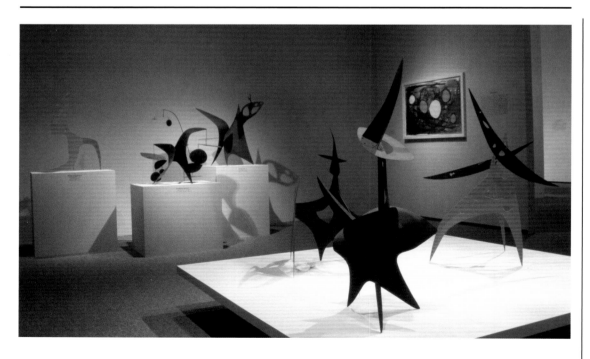

1999

San Francisco Museum of Modern Art, *Focus on Calder: Selected Works from the 30's & 40's*.

Galería Elvira González, Madrid, *Alexander Calder/Yves Tanguy*, January 21–February 27, catalogue.

The Phillips Collection, Washington, DC, *An Adventurous Spirit: Calder at The Phillips Collection*, January 23–July 18, curated by Elizabeth Hutton Turner, catalogue.

Lever House, New York, *Alexander Calder Sculpture*, January 27–May 31, curated by Richard Marshall.

Montreal Museum of Fine Arts, *Cosmos: From Romanticism to the Avant-Garde*, June 17–October 17, curated by Jean Clair, catalogue.

O'Hara Gallery, New York, *Motion–Emotion: The Art of Alexander Calder*, October 21–December 4, catalogue.

Arizona State University, Tempe, *Eye of the Collector: Works from the Lipman Collection of American Art*, November 20, 1999–February 13, 2000, curated by Marilyn A. Zeitlin, catalogue.

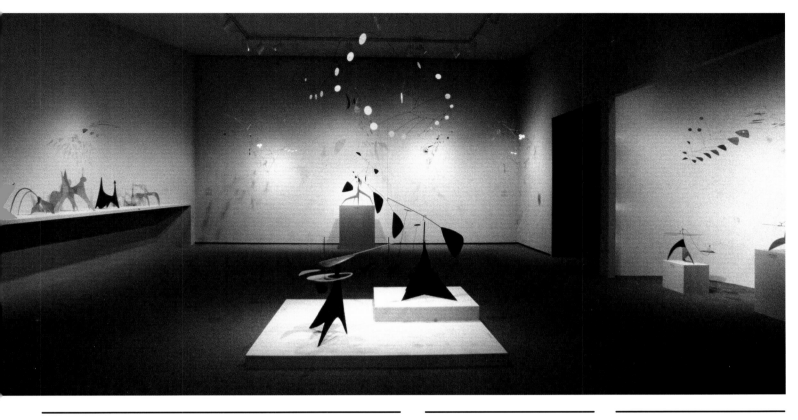

2000

PaceWildenstein, New York, *Earthly Forms: The Biomorphic Sculpture of Arp, Calder, and Noguchi*, February 18–March 20, catalogue.

Wadsworth Atheneum, Hartford, *Calder in Connecticut*, April 27– August 6, curated by Eric Zafran, catalogue.

Darga & Lansberg Galerie, Paris, *Calder*, May 26–July 30.

Galerie Maeght, Paris, *Calder*, June 9–July 29.

Sala Pelaires, Palma de Mallorca, Spain, *Calder*, October, catalogue.

Iwaki City Art Museum, Japan. *Alexander Calder: Motion and Color*, November 3–December 17, organized by JACA (Japan Art & Culture Association), curated by Richard Marshall and Alexander S. C. Rower, traveled to Museum of Modern Art, Toyama, April 6–May 13, 2001; Hokkaido Obihiro Museum of Art, May 22–June 17, 2001; Museum of Art, Kochi, June 26–August 26, 2001; Hiroshima Prefectural Art Museum, Hiroshima-City, September 2– October 14, 2001; Kawamura Memorial Museum of Art, Chiba, October 20–December 16, 2001; Kumamoto Prefectural Museum of Art, December 22, 2001–February 11, 2002; Nagoya City Art Museum, February 20–April 7, 2002, catalogue.

Museum of Contemporary Art, Chicago, *Alexander Calder in Focus*, December 13, 2000–August 19, 2001.

2001

Storm King Art Center, Mountainville, New York, *Grand Intuitions: Calder's Monumental Sculpture*, May 21, 2001–November 15, 2003, curated by Alexander S. C. Rower with David Collens.

Galerie Thomas, Munich, *Calder and Miró*, June 25–August 11.

Wadsworth Atheneum, Hartford, *Images from the World Between: The Circus in 20th Century American Art*, October 19, 2001–January 6, 2002, organized by the American Federation of Arts, curated by Donna Gustafson, traveled to John and Mable Ringling Museum of Art, Sarasota, Florida, February 1–May 12, 2002; Austin Museum of Fine Art, Texas, June 7– August 19, 2002, catalogue.

2002

Bellagio Gallery of Fine Art, Las Vegas, *Alexander Calder: The Art of Invention*, January 25–July 24, curated by Alexander S. C. Rower and Marc Glimcher, catalogue.

PaceWildenstein, New York, *Calder '76: The Cutouts*, February 14–March 16, catalogue.

Ameringer & Yohe Fine Art, New York, *Calder: Four Maquettes, Two Stabiles & a Little Bird Too*, September 19– October 12, catalogue.

2003

Van de Weghe Fine Art, New York, *Calder: A Modern Definition of Space*, February 21–May 23, catalogue.

Fundación del Museo Guggenheim Bilbao, *Calder: Gravedad y la Gracia* (Calder: Gravity and Grace), March 18–October 12, curated by Carmen Giménez and Alexander S. C. Rower, traveled to Museo Nacional Centro de Arte Reina Sofía, Madrid, November 27, 2003–February 18, 2004, catalogue.

Gagosian Gallery, Beverly Hills, *Alexander Calder*, May 3–June 21.

Gerald Peters Gallery, Santa Fe, New Mexico, *The Whimsical World of Alexander Calder*, July 25–August 30, traveled to Gerald Peters Gallery, Dallas, September 10–October 10.

Musée de Lodève, France, *Calder, gouaches, sculptures, dessins, tapisseries*, November 15, 2003–February 15, 2004, curated by Maïthé Vallès-Bled, catalogue.

Kukje Gallery, Seoul, *Calder: Poetry in Motion*, December 18, 2003–February 7, 2004, catalogue.

2004

Fondation Beyeler, Riehen, Switzerland, *Calder–Miró*, May 2–September 5, curated by Elizabeth Hutton Turner and Oliver Wick, traveled to the Phillips Collection, Washington, DC, October 9, 2004–January 23, 2005, catalogue.

590 Madison, New York, *Large Scale Calders at 590*, May 2, 2004–January 31, 2005, organized by PaceWildenstein, New York.

Locks Gallery, Philadelphia, *Alexander Calder Sculpture*, May 4–29.

Benjamin Franklin Parkway, Philadelphia, *Calders on the Parkway*, November 4, 2004–December 31, 2005, organized by Philadelphia Museum of Art.

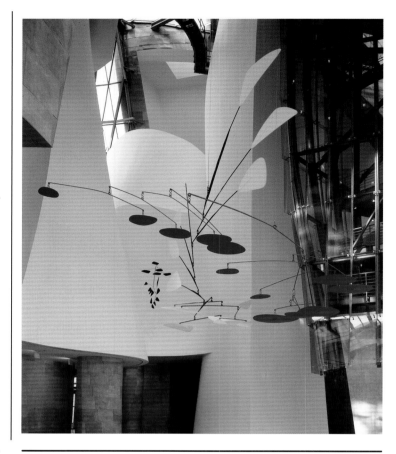

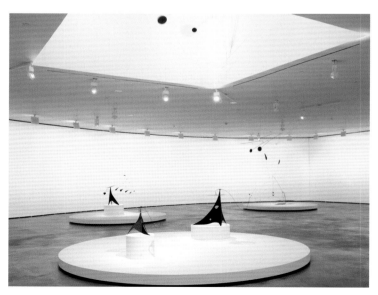

2005

Samuel Vanhoegaerden Gallery, Knokke, Belgium, *Alexander Calder 1898–1976*, March 19–May 16.

Thomas Dane, London, *Calder: The Forties*, April 12–May 21, catalogue.

Galleria Gió Marconi, Milan, *Alexander Calder 60's–70's*, April 14–May 7.

Gagosian Gallery, New York, *Alexander Calder: Two Monumental Sculptures*, June 4–July 29.

Hôtel Dassault, Paris, *Calder ou l'équilibre poétique*, June 30–September 15, catalogue.

The Menil Collection, Houston, *The Surreal Calder*, September 30, 2005–January 8, 2006, curated by Mark Rosenthal, traveled to San Francisco Museum of Modern Art, March 3–May 21, 2006; Minneapolis Institute of Arts, June 11–September 10, 2006, catalogue.

Galerie Gmurzynska, Zurich, *Alexander Calder: The Modernist*, November 11, 2005–January 31, 2006, catalogue.

Museum of Contemporary Art, Chicago, *Alexander Calder in Focus: Works from the Leonard and Ruth Horwich Family Loan*, November 12, 2005–June 25, 2006, curated by Julie Rodrigues Wildhom. Reinstalled annually.

2006

PaceWildenstein, New York, *Calder: From Model to Monument*, February 3–March 4, catalogue.

Institute for the Humanities, University of Michigan, Ann Arbor. *Fêtes: Alexander Calder / Jacques Prévert*, March 6–April 7.

John Berggruen Gallery, San Francisco, *Alexander Calder: Sculpture and Works on Paper*, April 4–26.

City Hall Park, New York, *Alexander Calder in New York*, April 24, 2006–March 18, 2007, organized by Public Art Fund, New York.

Jonathan O'Hara Gallery, New York, *Alexander Calder: Mobiles*, May 9–June 16.

Whitney Museum of American Art, New York, *I Think Best in Wire: Alexander Calder*, June 29–September 10.

Pinacoteca do Estado de São Paulo, Brazil, *Calder no Brazil* (Calder in Brazil), August 24–October 15, curated by Roberta Saraiva Coutinho, traveled to Paço Imperial, Rio de Janeiro, November 21, 2006–February 11, 2007, catalogue.

PaceWildenstein, New York, *Calder Gouaches: 1942–1976*, September 22–October 21, catalogue.

Centro de Arte Tomás y Valiente, Madrid, *Calder: La Forma y El Sueño*, November 29, 2006–January 28, 2007, curated by Maïthé Vallès-Bled, catalogue.

Fórum Eugénio de Almeida, Évora, Portugal, *Alexander Calder: A Forma e o Sonho*, December 6, 2006–April 1, 2007, catalogue.

2007

Irish Museum of Modern Art, Dublin, *Alexander Calder and Joan Miró*, April 3–June 30, curated by Alexander S. C. Rower and Enrique Juncosa, catalogue.

The Museum of Modern Art, New York, *Focus: Alexander Calder*, September 14, 2007–April 14, 2008, curated by Anne Umland with Veronica Roberts.

Jonathan O'Hara Gallery, New York, *Simplicity of Means: Calder and the Devised Object*, October 25–December 8, catalogue.

opposite left and below: *Calder: Gravedad y la Gracia*, Fundación del Museo Guggenheim Bilbao, 2003

below: *Calder: From Model to Monument*, PaceWildenstein, New York, 2006

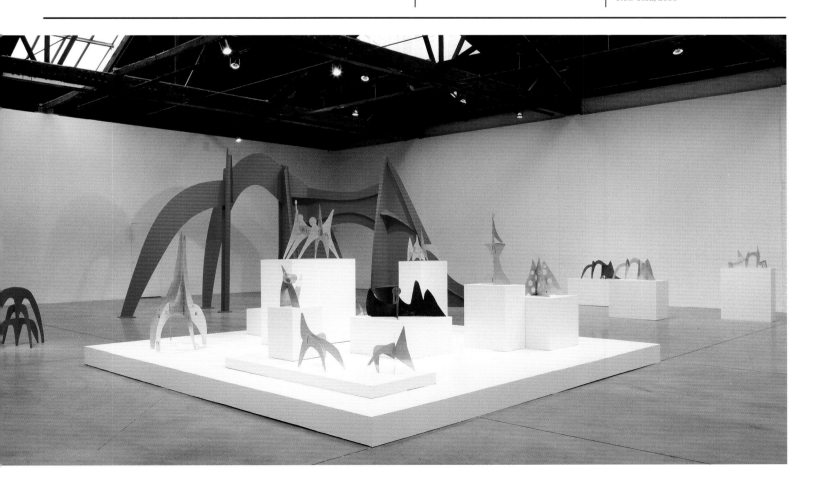

2008

Norton Museum of Art, West Palm Beach, Florida, *Calder Jewelry*, February 23–June 15, curated by Mark Rosenthal and Alexander S. C. Rower, traveled to Philadelphia Museum of Art, July 12–November 2; Metropolitan Museum of Art, New York, December 8, 2008– March 1, 2009; Irish Museum of Modern Art, Dublin, March 31–June 22, 2009; San Diego Museum of Art, July 25, 2009–January 3, 2010; Grand Rapids Art Museum, Michigan, January 29– April 18, 2010.

Lehmann Maupin, New York, *You & Me, Sometimes…*, March 20–May 3, curated by Sandra Antelo-Suarez, catalogue.

Galerie Gmurzynska, Zurich, *Alexander Calder*, April 19–May 24.

Musées Royaux des Beaux-Arts de Belgique, Brussels, *Expo 58. l'Art Contemporain à l'Exposition Universelle*, May 16–September 21, catalogue.

Vintage20/Tina Kim Gallery, New York, *Calder–Nakashima*, May 22–June 28.

Brame & Lorenceau, Paris, *Calder Gouaches*, May 22–July 4, catalogue.

Château de Tours, France, *Alexander Calder en Touraine*, June 6–October 19, catalogue.

Royal Academy of Arts, London, *Miró, Calder, Giacometti, Braque; Aimé Maeght and His Artists*, October 2008– January 2009, curated by Ann Dumas, designed by Sophie Hicks Architects.

Whitney Museum of American Art, New York, *Alexander Calder: The Paris Years, 1926–1933*, October 16, 2008–February 15, 2009, curated by Brigitte Léal and Joan Simon, traveled to Centre Georges Pompidou, Paris, March 18–July 20, 2009, and Art Gallery of Toronto, October 3, 2009– January 10, 2010, catalogue.

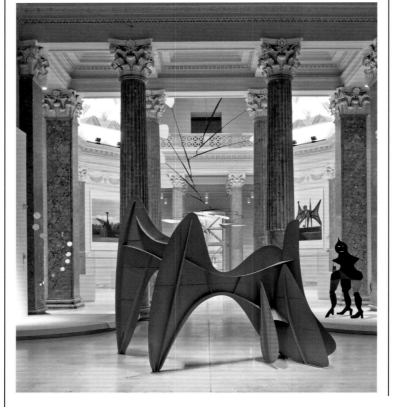

2009

Frederik Meijer Gardens & Sculpture Park, Grand Rapids, Michigan, *Alexander Calder: 1969 The Fortieth Anniversary of La Grande vitesse*, June 3–September 7.

San Jose Museum of Art, *Alexander Calder: Color in Motion*, August 1– December 13, 2009.

Seattle Art Museum, *Alexander Calder: A Balancing Act*, October 15, 2009–April 11, 2010, curated by Michael Darling.

Palazzo delle Esposizioni, Rome, *Calder: Sculptor of Air*, October 23, 2009–February 14, 2010, curated by Alexander S. C. Rower, catalogue.

Palazzo delle Esposizioni, Rome, *Alexander Calder nelle fotografie di Ugo Mulas*, October 23, 2009– February 14, 2010, curated by Pier Giovanni Castagnoli.

Gagosian Gallery, Rome, *Alexander Calder: Monumental Sculpture*, October 29, 2009–January 30, 2010, catalogue.

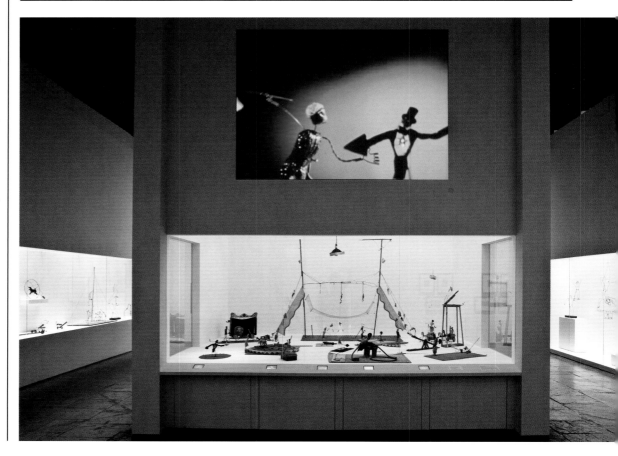

2010

Gagosian Gallery, New York, *Alexander Calder*, February 26–April 10, 2010.

L&M Arts, New York, *Tanguy Calder: Between Surrealism and Abstraction*, April 20–June 12, 2010, catalogue.

Centre Cultural Caixa Terrassa, Spain, *Calder–Miró: Una Experiència de Respecte i Amistat*, April 22–July 4, 2010, catalogue.

Storm King Art Center, Mountainville, New York, *The View from Here: Storm King at 50*, June 5, 2010–April 1, 2011.

Museum of Contemporary Art, Chicago, *Alexander Calder and Contemporary Art: Form, Balance, Joy*, June 24–October 17, curated by Lynne Warren, traveled to Nasher Sculpture Center, Dallas, December 11, 2010–March 6, 2011; Orange County Museum of Art, Newport Beach, California, April 10–September 4, 2011; Nasher Museum of Art at Duke University, Durham, North Carolina, February 16–June 17, 2012, catalogue.

San Francisco Museum of Modern Art, *Calder to Warhol: Introducing the Fisher Collection*, June 25–September 19, curated by Gary Garrels, catalogue.

Gerald Peters Gallery, Santa Fe, *Alexander Calder*, July 22–October 2, 2010.

Van de Weghe Fine Art, New York, *Alexander Calder*, September 14–November 13, 2010.

The Pace Gallery, New York, *50 Years at Pace*, September 17–October 23, catalogue.

Galería Elvira González, Madrid, *Calder*, December 22, 2010–January 29, 2011, catalogue.

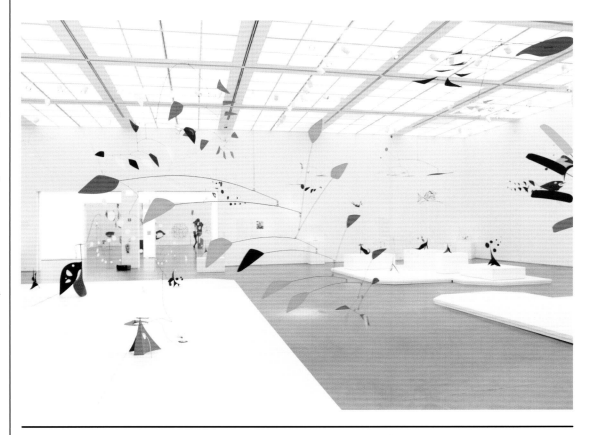

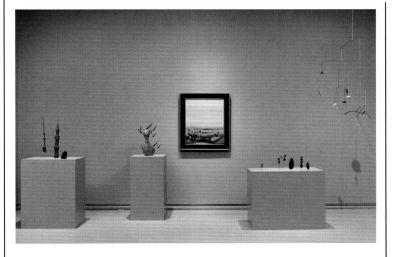

opposite above: *Calder: Sculptor of Air*, Palazzo delle Esposizioni, Rome, 2009–10; center: *La Grande vitesse* (intermediate maquette, 1969)

opposite left: *Alexander Calder: The Paris Years, 1926–1933*, Whitney Museum of American Art, New York, 2008

above: *Alexander Calder and Contemporary Art: Form, Balance, Joy*, Museum of Contemporary Art, Chicago, 2010

left: *Tanguy Calder: Between Surrealism and Abstraction*, L&M Arts, New York, 2010

2011

Gagosian Gallery, London, *Calder*, February 8–March 26.

National Portrait Gallery, Smithsonian Institution, Washington, DC, *Calder's Portraits: A New Language*, March 11–August 14, curated by Barbara Beth Zabel, catalogue.

Albright-Knox Gallery, Buffalo, New York, *Spotlight on the Collection–Artists in Depth: Arp, Miró, Calder*, March 25, 2011–April 15, 2012, curated by Holly E. Hughes.

Huntington Museum of Art, West Virginia, *Calder*, June 4–August 7, curated by Jenine Culligan.

Museum of Arts and Design, New York, *Picasso to Koons: The Artist as Jeweler*, September 20, 2011–January 8, 2012, curated by Diane Venet, catalogue.

Fondation Beyeler, Basel, *Surrealism in Paris*, October 2, 2011–January 29, 2012, curated by Philippe Büttner, catalogue.

High Museum of Art, Atlanta, *Picasso to Warhol: Fourteen Modern Masters*, October 15, 2011–April 29, 2012, curated by Jodi Hauptman in collaboration with David Brenneman, Michael Rooks, and Samantha Friedman, catalogue.

The Pace Gallery, New York, *Calder 1941*, October 21–December 23, catalogue.

Helly Nahmad Gallery, New York, *Alexander Calder: The Painter*, November 5–December 23, 2011, catalogue.

2012

Gemeentemuseum, The Hague, The Netherlands, *Alexander Calder: De grote ontdekking*, February 11–May 28, 2012, curated by Doede Hardeman, catalogue.

The Pace Gallery, New York, *Mythology and the Origins of Abstract Expressionism*, February 22–April 14, catalogue.

Arca Di San Marco, Vercelli, Italy, *Great Masters of the Avant-Garde: Miró, Mondrian, Calder, and the Guggenheim Collections*, March 2–June 10, curated by Luca Massimo Barbero, catalogue.

L&M Arts, Los Angeles, *Alexander Calder*, April 27–June 16.

Crane Kalman Gallery, London, *Alexander Calder*, May 24–June 30.

Fondation Beyeler, Riehen, Switzerland, *Calder Gallery*, May 25, 2012–May 25, 2013, curated by Theodora Vischer.

Ordovas, London, *Calder in India*, May 31–August 3, catalogue.

Kukje Gallery, Seoul, Korea, *Calder NOIR*, July 12–August 17.

Museo Nacional Centro de Arte Reina Sofía, Madrid, *Encounters with the 1930s*, October 3, 2012–January 7, 2013, catalogue.

L&M Arts, New York, *Calder: The Complete Bronzes*, October 25, 2012–February 9, 2013, catalogue.

Whitney Museum of American Art, New York, *American Legends: From Calder to O'Keeffe*, December 22, 2012–May 2013, curated by Barbara Haskell.

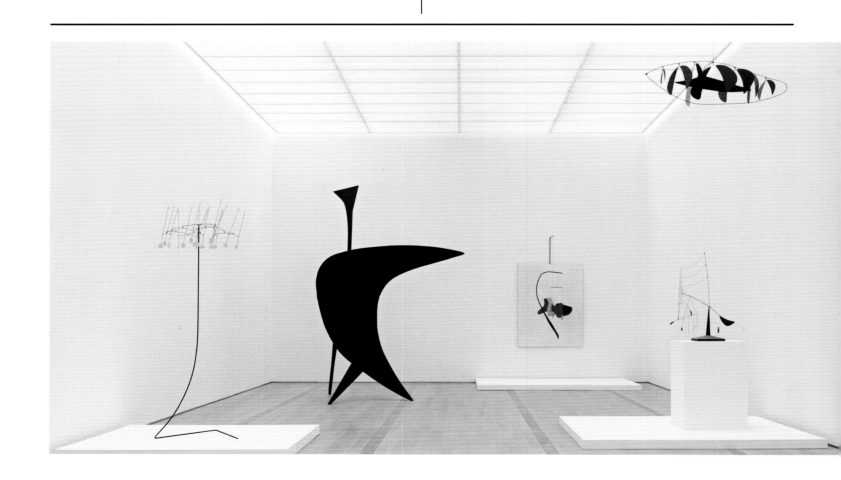

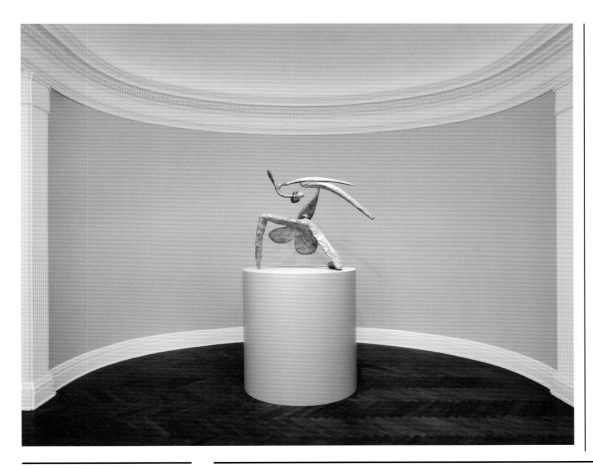

opposite: *Calder Gallery*, Fondation Beyeler, Riehen, Switzerland, 2012

left: *Calder: The Complete Bronzes*, L&M Arts, New York, 2012–13

below: *Calder after the War*, Pace London, 2013

2013

Pace London, *Calder after the War*, April 19–June 7, catalogue.

Fondation Beyeler, Riehen, Switzerland, *Calder Gallery II: Trees–Naming Abstraction*, June 8, 2013–January 12, 2014, curated by Oliver Wick, catalogue.

Leeum, Samsung Museum of Art, Korea, *Calder*, July 18–October 20, catalogue, curated by Tae Hyun Sun and Alexander S. C. Rower.

Kunstsammlung Nordrhein-Westfalen, Düsseldorf. *Alexander Calder–Avant-Garde in Bewegung* (Alexander Calder–Avant-Garde in Motion), September 7, 2013–January 12, 2014, curated by Susanne Meyer-Büser, catalogue.

Los Angeles County Museum of Art, *Calder and Abstraction: From Avant-Garde to Iconic*, November 24, 2013–July 27, 2014, curated by Stephanie Barron, traveling to Peabody Essex Museum, Salem, Massachusetts, September 6, 2014–July 4, 2015, catalogue.

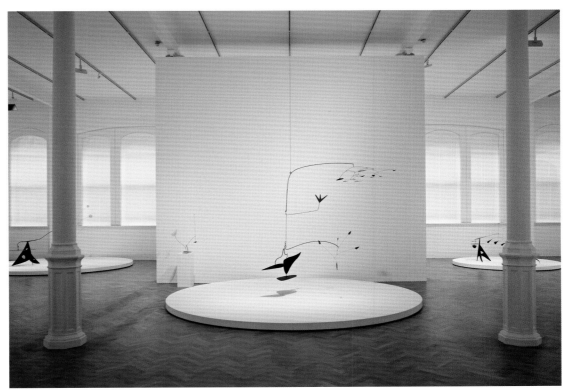

Selected Readings

Compiled and annotated by *Aleca Le Blanc*

The literature about Alexander Calder is both vast and varied, partly because his life spanned the better part of the twentieth century and his work falls into many areas of modern art. For anyone just beginning to research Calder and his career, getting acquainted with the extensive historiography is a formidable task—one that the curators and essayists writing for this volume faced at the outset of the project.

The list of selected readings that follows was a natural outgrowth of the research conducted. The list is by no means exhaustive. As comprehensive bibliographies can be found in a number of publications—as well as on the Calder Foundation's website (calder.org)—the list here has instead been culled and separated into seven categories, which reflect six areas of concentration in the extant literature along with writings by the artist.

In addition to the Calder Foundation website, there are three principal volumes that provide especially rich and wide-ranging material. They are the 1998 exhibition catalogue from the National Gallery of Art's retrospective, Calder's own 1966 autobiography, and the 1943 exhibition catalogue from the Museum of Modern Art's retrospective, all cited in the Biography section below. Another significant publication is Joan M. Marter's in-depth scholarly study *Alexander Calder*, of which individual chapters are highlighted under Kinetic Art, Politics, and Public Commissions. In general, the research on Calder has been driven by exhibitions, so museum catalogues dominate the historiography. In an attempt to make these multi-author publications and their contents more accessible, essays have been entered individually rather than as entire volumes.

Architecture

Brillembourg, Carlos. "Architecture and Sculpture: Villanueva and Calder's Aula Magna." In *Latin American Architecture, 1929–1960: Contemporary Reflections*. New York: Monacelli Press, 2004.

In his essay, which is drawn from a conference paper delivered at the New School in New York, the author describes architect Carlos Raúl Villanueva's University City project and Calder's contribution to the campus's Aula Magna in 1952, specifically through excerpts drawn from their epistolary relationship.

Larrañaga, Enrique. "Toward the Visibility of the Invisible: Notes on Caracas, Modernity, and the University City of Caracas by Carlos Raúl Villanueva." In *Cruelty and Utopia: Cities and Landscapes of Latin America*, edited by Jean-Francois Lejeune. New York: Princeton Architectural Press, 2005.

Larrañaga discusses the process of modernization in Venezuela's capital, Caracas, within the larger context of postwar modern architecture. Among other examples of urbanism, he describes the construction of the University City campus, touching on Calder's contribution to the Aula Magna.

Wick, Oliver. "Je Vais T'emporter En Amérique. Prépare-toi": A Long Road to Monumental Dimensions—Beyond Painting." In *Calder, Miró*. London: Philip Wilson Publishers in collaboration with the Phillips Collection and Fondation Beyeler, 2004.

This essay describes how longtime friends Calder and Joan Miró contributed works to Josep Lluís Sert's Spanish Pavilion at the 1937 Paris World's Fair and Skidmore, Owings, and Merrill's Terrace Plaza Hotel in Cincinnati. Wick argues that they "shared an attempt to achieve a new dimension," each pushing the boundaries of their respective mediums, sculpture and painting. For Calder this related directly to the growing scale of his three-dimensional works and for Miró this translated into mural painting.

The Avant-Garde

Baker, George. "Calder's Mobility." In *Alexander Calder and Contemporary Art: Form, Balance, Joy*, edited by Lynne Warren. London: Thames & Hudson, 2010.

Baker's formalist reading begins with a discussion of Clement Greenberg's distaste for Calder. He goes on to discuss Calder's connection with Dada through his friendships with Marcel Duchamp and Jean Arp, ultimately stating that his creations are hybrid objects, "abstract and figurative, Constructivist and Dadaist." Baker concludes his catalogue essay by connecting these early avant-garde impulses to Calder's monumental works of later decades.

Calvo Serraller, Francisco. "Calder: Gravity and Grace." In *Calder: Gravity and Grace*, edited by Carmen Giménez and Alexander S. C. Rower. Madrid: Tf Editores, 2003. (Reprinted by Phaidon Press, 2004.)

This essay takes up the issue of gravity, treating it as a discrete medium in Calder's works. The author contextualizes him art historically, principally with respect to the Parisian avant-garde and figures such as Pablo Picasso, Julio González, Marcel Duchamp, Piet Mondrian, Henri Matisse, and even Jean Auguste Dominique Ingres, among others. The text reviews the canonical narrative of the European avant-garde, weaving a story about Calder's relationship to the Italian Futurists, Russian Constructivists, Dadaists, and Surrealists, and makes reference to a wide range of historical thinkers including Immanuel Kant, Karl Marx, and J. C. Friedrich von Schiller, Mikhail Bakhtin, and Charles Baudelaire.

Ellis, Elizabeth Garrity. "The View from Paris." In *Americans in Paris (1921–1931): Man Ray, Gerald Murphy, Stuart Davis, Alexander Calder*. Washington, DC: Counterpoint, in association with the Phillips Collection, 1996.

The author details the situation of French artists in the capital with the arrival of American artists and tourists en masse during the 1920s, outlining the landscape of the art market and affiliations among artists. Her essay provides an alternative view, looking out from France; another essay in the same catalogue (by Elizabeth Hutton Turner) considers the perspective of American artists.

Karmel, Pepe. "The Alchemist: Alexander Calder and Surrealism." In *Alexander Calder: The Paris Years, 1926–1933*, edited by Joan Simon. New York: Whitney Museum of American Art; Paris: Centre Pompidou; New Haven, CT: Yale University Press, 2008.

Karmel narrates a nuanced history of Surrealism, highlighting the fissures and inconsistencies in the standard definitions of the movement, which tend to focus on André Breton. He describes Calder's sculptural works from the 1920s and his time in Paris, specifically with respect to the materials he chose to work with, and connects him to the Surrealist movement through these decisions.

O'Hare, Mary Kate. "Constructive Spirit: Abstract Art in South and North America, 1920s–50s." In *Constructive Spirit: Abstract Art in South and North America, 1920s–50s*. Newark, NJ: Newark Museum; San Francisco: Pomegranate, 2010.

O'Hare's essay outlines the curatorial vision for her exhibition of the same title. Her interpretation reorients some of the literature on Calder in that she situates him within the Americas, rather than Europe. She also focuses on his relationship to artists working with Constructivist formal languages. Rather than tie him to the historical avant-garde in Europe, O'Hare argues for his relevance to the development of art within the Western Hemisphere in the first half of the twentieth century.

Rose, Bernice. *A Salute to Alexander Calder; Sculpture, Watercolors and Drawings, Prints, Illustrated Books, and Jewelry in the Collection of the Museum of Modern Art*. New York: Museum of Modern Art, 1969.

In this small, single-author exhibition catalogue, Rose begins her essay by contextualizing Calder within the Parisian avant-garde. Yet she does so without arguing for one interpretation over another. Instead, she writes that what sets Calder apart from other artists of his generation was his ability to synthesize such seemingly oppositional schools of thought as Constructivism and Surrealism. The majority of her essay is dedicated to the evolution of his approach to sculpture, however, moving from mobiles to stabiles and giving particular attention to the details of their construction.

Rosenthal, Mark. "The Surreal Calder: A Natural." In *The Surreal Calder*. Houston: Menil Collection, 2005.

Rosenthal's catalogue essay details Calder's association with various Surrealist artists in Paris, focusing on a period from 1926 to 1947. He argues for Calder's greatness because of his ability to fuse Surrealism with abstraction. This is a tightly circumscribed argument made with art historical terminology that asserts Calder's importance within the European avant-garde.

Turner, Elizabeth Hutton. "Paris: 'Capital of America.'" In *Americans in Paris (1921–1931): Man Ray, Gerald Murphy, Stuart Davis, Alexander Calder*. Washington, DC: Counterpoint, in association with the Phillips Collection, 1996.

This essay describes the circumstances by which four prominent artists from the US migrated to Paris in the 1920s, and the conditions they found upon arrival. It details how, because of their expatriate status, they were unencumbered by French artistic tradition and were able to contribute to the European avant-garde in otherwise unimaginable ways.

Warren, Lynne. "Alexander Calder and Contemporary Art." In *Alexander Calder and Contemporary Art: Form, Balance, Joy*. London: Thames & Hudson, 2010.

As the title essay of this exhibition catalogue suggests, the curator argues for the relationship between contemporary artists and Calder, describing a range of examples for how artists today look to him for inspiration and rearticulate many of his findings.

Biography

Arnason, H. H. *Calder*. Princeton, NJ: Van Nostrand, 1966.

This publication is a collaboration by an author, a photographer, and a book designer. Arnason's biographical text, which focuses on Calder's relationship to the Parisian avant-garde and offers anecdotes about his friendships, is interspersed with photographs of Calder by Pedro Guerrero and quotes by the sculptor. The book's designer, Alexey Brodovitch, incorporated graphic elements designed by Calder, making it a unique text.

Brennan, Marcia. *Curating Consciousness: Mysticism and the Modern Museum*. Cambridge, MA: The MIT Press, 2010.

James Johnson Sweeney's curatorial practice is the focal point of Brennan's rich study. Sweeney, who championed Calder's work on several occasions, was also a close personal friend of the artist and this relationship figures prominently in the introduction to the book, providing a framework for the six chapters that follow, which are dedicated to individual twentieth-century artists.

Calder, Alexander, and Jean Davidson. *Calder, An Autobiography with Pictures*. New York: Pantheon Books, 1966.

This book is Calder's own account of his life, as narrated to his son-in-law, Jean Davidson. Roughly chronological, the narrative follows the sculptor's memories of childhood, and his travels, projects, and friendships within the international art world.

Guerrero, Pedro E. *Calder at Home: The Joyous Environment of Alexander Calder*. New York: Stewart, Tabori & Chang, 1998.

This publication is a photo-essay by Guerrero, one of Calder's close friends, accompanied by a brief text by the photographer detailing the history of their friendship. Included are images of Calder's homes, family members, personal belongings, and exhibitions.

Hayes, Margaret Calder. *Three Alexander Calders: A Family Memoir*. Middlebury, VT: P. S. Eriksson, 1977.

This four-part book by Calder's older sister is a biographical account based on a series of personal letters of three generations of sculptors in the Calder family: Alexander Calder; his father, Alexander Stirling Calder; and his grandfather, Alexander Milne Calder.

Lipman, Jean. *Calder's Universe.* New York: Viking Press in cooperation with the Whitney Museum of American Art, 1976.

This exhibition catalogue was published on the occasion of a retrospective exhibition at the Whitney Museum of American Art shortly before Calder's death. Organized and written by Jean Lipman, a close friend and private collector of his works, the essay has a very personal tone, with anecdotes about her friendship with the sculptor.

Marchesseau, Daniel. *The Intimate World of Alexander Calder.* New York: S. Thierry, 1989.

This substantial volume is organized into thematic chapters, some having to do with the domestic spaces he inhabited, such as "Calder at Home" and "Roxbury and Saché."

Messer, Thomas. *Alexander Calder: A Retrospective Exhibition [by] the Solomon R. Guggenheim Museum, New York, [and] Musée National D'art Moderne, Paris.* New York: Solomon R. Guggenheim Museum, 1964.

Thomas Messer, then director of the Solomon R. Guggenheim Museum, wrote a short introductory essay for this traditional retrospective catalogue, which is organized according to medium, including drawings, watercolors, and lithographs, and formal styles such as abstract constructions, mobiles, constellations, stabiles, and towers. Messer describes Calder's formal development from the line to sculptural volume to movement, briefly touching on each medium.

Prather, Marla, and Alexander S. C. Rower. *Alexander Calder, 1898–1976.* Washington, DC: National Gallery of Art, 1998.

This catalogue was published on the occasion of a large-scale centennial retrospective exhibition. The text is divided into five chronological sections, with brief essays by Prather, each of which features a detailed chronology authored by Rower.

Rower, Alexander S. C. *Calder Sculpture.* New York: Universe, 1998.

Published on the occasion of the centenary of Calder's birth, this monograph, written by the artist's grandson, is an account of Calder's sculptural progression, from his figurative wire sculptures and abstract mobiles and stabiles to his monumental public works.

Rower, Alexander S. C. *Calder by Matter.* Paris: Editions Cahiers d'Art, 2013.

This volume is a photo-biography of Calder's life from the 1930s to the 1950s, with images shot by avant-garde photographer and close friend Herbert Matter. Photographs show Calder's works at different stages of their realization, as well as intimate images of the artist at work in his studios and at home with his family.

Saraiva, Roberta. *Calder no Brasil: Crônica de uma amizade.* São Paulo: Cosac Naify, 2006.

Saraiva's narrative chronology traces Calder's engagement with the Brazilian cultural world, beginning in 1939 and lasting until the 1980s. The catalogue, which was published on the occasion of an exhibition at the Pinacoteca do Estado de São Paulo, is a rich source of materials with photographs of Calder in Brazil, installation shots of his exhibitions there, reprints of his critical reception, and detailed accounts of his friendships.

Sweeney, James Johnson. *Alexander Calder.* New York: Museum of Modern Art, 1943.

This exhibition catalogue was published on the occasion of Calder's major retrospective at the Museum of Modern Art in 1943. Written by curator and critic James Johnson Sweeney, one of Calder's most committed supporters, the catalogue was revised, enlarged, and issued as a monograph in 1951.

Kinetic Art

Bordier, Roger. "New Proposals: The Movement, the Transformable Work." In *Le Mouvement: Vom Kino Zur Kinetik,* edited by Thomas Tode. Heidelberg, Germany: Kehrer, 2010.

Bordier's essay was first published in 1955 as a review of what would become a landmark exhibition of Kinetic art, *Le Mouvement,* at the Galerie Denise René in Paris. In it he discusses the various artists involved in the show, crediting Calder as an early pioneer in the realm of kineticism and asserting that with him, movement was transformed from experiment into art.

Galerie Denise René. *Le Mouvement = The Movement, Paris, Avril 1955: Agam, Bury, Calder, Duchamp, Jacobsen, Soto, Tinguely, Vasarely.* Paris: D. René, 1975.

This book was published on the occasion of an exhibition that commemorated the 1955 *Le Mouvement* exhibition. It contains many installation photographs of the original show, giving a sense of how Calder's mobiles were in dialogue with the work of other artists, including those mentioned in the title.

Marter, Joan M. "Calder as Choreographer, 1936–1942." In *Alexander Calder.* New York: Cambridge University Press, 1991.

This chapter from Marter's scholarly monograph on Calder discusses his involvement with dance and stage productions, including the creation of mobiles as set designs for Martha Graham's dance company as well as his own "early attempts to devise a mechanical ballet," in response to Fernand Léger's *Ballet Mécanique* (1923–24) and Bauhaus precedents. She argues that these experiments expanded his understanding of the merging of biomorphic forms and kineticism.

Petroski, Henry. "Calder as Artist-Engineer: Vectors, Velocities." In *Alexander Calder: The Paris Years, 1926–1933,* edited by Joan Simon. New York: Whitney Museum of American Art; Paris: Centre Pompidou; New Haven, CT: Yale University Press, 2008.

In this essay, the author frames Calder's sculptural practice in relation to his training in mechanical engineering at the Stevens Institute in New Jersey. He draws an important distinction between civil engineering, the more common specialty at the time, and mechanical engineering, which was concerned with machines in motion, and argues that this provided Calder with the foundational knowledge to create his later kinetic and large-scale sculptures.

Pierre, Arnauld. "Staging Movement." In *Alexander Calder, 1898–1976,* edited by Marla Prather and Alexander S. C. Rower. Washington, DC: National Gallery of Art, 1998.

In Pierre's formulation, choreography and performance serve as unifying tenets of Calder's oeuvre. While this essay focuses principally on works from the 1930s, the author draws pointed connections between Calder's introduction of movement into his sculptures and the theatrical designs he executed for such dancers as Martha Graham.

Pierre, Arnauld. "Painting and Working in the Abstract: Calder's Oeuvre and Constructive Art." In *Alexander Calder: The Paris Years, 1926–1933,* edited by Joan Simon. New York: Whitney Museum of American Art; Paris: Centre Pomidou; New Haven, CT: Yale University Press, 2008.

As a counterpart to Karmel's essay in the same volume, Pierre argues that Calder is a Constructivist artist, as opposed to a Surrealist. He locates the origin of this story with a famous visit by Calder to Mondrian's studio in 1930 and posits that his exposure to Constructivist concepts ultimately led to his invention of Kinetic art.

Politics

Marter, Joan M. "Abstract Sculpture of the Atomic Age." In *Art of Another Kind: International Abstraction and the Guggenheim, 1949–1960.* New York: Solomon R. Guggenheim Museum, 2012.

In this exhibition catalogue essay, Marter argues that the industrial materials and abstract elements in sculptures made by European and American artists during the 1940s and 1950s are directly linked to the chaos and destruction of World War II. While she describes Calder's works from the 1940s as providing a subtle commentary on the destruction of war, she posits that the set design he created for the 1952 French play *Nucléa* was far more serious and ominous.

Nelson, Adele. "Monumental and Ephemeral: The Early São Paulo Bienals." In *Constructive Spirit: Abstract Art in South and North America, 1920s–50s*, edited by Mary Kate O'Hare. Newark, NJ: Newark Museum; San Francisco: Pomegranate, 2010.

This essay, which describes in detail Calder's 1953 exhibition at the II Bienal de São Paulo, outlines the postwar political climate from a Brazilian perspective and the reasons for his large exhibition at the Bienal.

Taylor, Alex J. "Unstable Motives: Propaganda, Politics, and the Late Work of Alexander Calder." *American Art*, March 2012, 24–47.

Taylor's essay takes on the topic of Calder's political life in the postwar period. He juxtaposes the artist's own personal liberal politics with the way in which his work was marshaled by cultural institutions in the service of Cold War political posturing.

Public Commissions

Carandente, Giovanni. "Calder and Italy." In *Calder: Sculptor of Air*, edited by Alexander S. C. Rower. Milan: Motta, 2009.

The author describes the circumstances that led to Calder's first large public sculpture, *Teodelapio*, in Spoleto, Italy, in 1962, and his ensuing friendship with the artist.

Elsen, Albert Edward. *Alexander Calder, a Retrospective Exhibition: Work from 1925 to 1974*. Chicago: Museum of Contemporary Art, 1974.

This exhibition was mounted in Chicago to coincide with the city's Calder Festival, held on October 25, 1974. In addition to the exhibition, two monumental public works were dedicated in downtown Chicago that day: the stabile *Flamingo*, which stands in the Federal Center Plaza; and *Universe*, a large, multicomponent kinetic "mural" installed in the lobby of the Sears Tower. Calder was seventy-six at the time of the retrospective and Elsen's essay addresses the maturity of the artist in refreshingly candid language. Indeed, subsections of his essay include, "Why Calder Should Be Taken Seriously" and "The Hazards of Longevity and Success."

Marter, Joan M. "Calder as a Public Artist: 1940s and 1950s" and "Late Years: Monumental Works." In *Alexander Calder*. New York: Cambridge University Press, 1991.

In the two concluding chapters of Marter's study on Calder, she charts the evolution of his role as public artist from early commissions in the 1940s to his later monumental installations. She argues that as the scale of his works grew, he became less experimental with form and developed a signature style, putting his work into dialogue with contemporaneous American sculptors of the Minimalist generation. She positions his work within the larger art market, describing how his commissions evolved to include many large corporate collectors.

Mikulay, Jennifer Geigel. "Another Look at *La Grande vitesse*." *Public Art Dialogue* 1, no. 1 (2011): 5–23.

Mikulay writes about Calder's large-scale sculpture in Grand Rapids, Michigan, arguing that the range of quotidian activities that takes place in its proximity, such as festivals and weddings, demonstrates its power of address and lasting vitality.

Selected Writings by Alexander Calder
Entries are arranged chronologically. These texts can also be found on the Calder Foundation's website (calder.org/life/selected-texts).

"Comment réaliser l'art?" *Abstraction-Création, Art Non Figuratif*, no. 1 (1932).

After accepting an invitation to join the Abstraction-Création group in June of 1931, Calder wrote this text for the first issue of its journal. He describes the elements that inspired him: mass, color, and velocity. These words seemed to foreshadow the scale and complexity that his future mobiles would take.

"Un 'Mobile.'" *Abstraction-Création, Art Non Figuratif,* no. 2 (1933).

In this brief text in list form, Calder offers a detailed description of the physical characteristics and various movements of *Cadre rouge* (1932, no longer extant).

Statement in *Modern Painting and Sculpture: Alexander Calder, George L. K. Morris, Calvert Coggeshall, Alma de Gersdorff Morgan.* Pittsfield, MA: Berkshire Museum, 1933.

In this early statement, composed for the Berkshire Museum's exhibition catalogue, Calder writes about plastic objects in motion, acknowledging important conceptual precedents by the Italian Futurists, Léger, and Duchamp.

"Mobiles." In *The Painter's Object,* edited by Myfanwy Evans. London: Gerold Howe, 1937.

At the outset of the essay, Calder establishes what he perceives to be the difficulties with artist statements and the subsequent challenges that arise when an artist publishes his or her theories. For this reason, he purposely avoids explaining his then-current investigations and instead reflects on his education, his development as an artist, and some early projects.

"Mercury Fountain." *Stevens Indicator* 55, no. 3 (May 1938).

Calder describes the inception, construction, and operation of the *Mercury Fountain*, commissioned by Catalan architect Josep Lluís Sert for the Spanish Pavilion at the Paris World's Fair in 1937.

"A Water Ballet." *Theatre Arts Monthly,* August 1939.

Calder discusses the commission from Wallace K. Harrison and Jacques André Fouilhoux, architects of Consolidated Edison's pavilion at the 1939 New York World's Fair, to design a "water ballet" for the building's fountain.

Statement in *17 Mobiles by Alexander Calder.* Andover, MA: Addison Gallery of American Art, 1943.

The brief statement in this exhibition catalogue touches upon the early development of abstraction, flexibility, motion, and choreography.

"A Propos of Measuring a Mobile" (manuscript, Archives of American Art, Smithsonian Institution, Washington, DC, October 7, 1943).

In this text, Calder states that his visit to Mondrian's studio was seminal to his own transition to abstraction and that from that one encounter "stellar relationships" became a guiding principle in his work. He then discusses materials typical of the medium of sculpture as well as the concept of motion in his mobiles.

"What Abstract Art Means to Me." In *The Museum of Modern Art Bulletin* 18, no. 3 (Spring 1951).

This text, which reviews some of the material covered in his "A Propos of Measuring a Mobile," was written for a symposium at the Museum of Modern Art, New York, in conjunction with the exhibition "Abstract Painting and Sculpture in America."

Statement in *4 Masters Exhibition: Rodin, Brancusi, Gauguin, Calder.* New York: World House Galleries. 1957.

Calder's text in its entirety reads: "A long time ago I decided, indeed, I was told that primitive art is better than decadent art. So I decided to remain as primitive as possible, and thus I have avoided mechanization of tools, etc. (in spite of having been trained as an engineer).

This, too, permits of a more variable attack on problems, for when one has an elegant set of tools one feels it a shame, or a loss, not to use them.

When I am at a loss for inspiration I think of what Sweeney, or Sartre, or perhaps one or two others, have written on my work and this makes me feel very happy, and I go to work with renewed enthusiasm."

Interview transcript in Katharine Kuh, *The Artist's Voice: Talks with Seventeen Artists.* New York and Evanston, IL: Harper & Row, 1962.

Calder touches upon a number of dynamic subjects in this interview transcript, including concepts of nature, realism, and immateriality. He speaks specifically about some of his public commissions and the importance of site specificity to all of his works, no matter their scale.

Index

Lenders to the Exhibition

Addison Gallery of American Art,
Phillips Academy, Andover, Massachusetts

Calder Foundation, New York

The Eli and Edythe L. Broad Collection

Frances A. Bass

Glenstone

The Leonard and Ruth Horwich Family

Los Angeles County Museum of Art

Museum of Contemporary Art, Chicago

Museum of Contemporary Art, Los Angeles

Museum of Fine Arts, Boston

The Museum of Modern Art, New York

Sheldon Museum of Art,
University of Nebraska–Lincoln

Jon and Mary Shirley

Solomon R. Guggenheim Museum, New York

Whitney Museum of American Art, New York

and those who wish to remain anonymous

Photo Credits

Colophon

Published in conjunction with the exhibition *Calder and Abstraction: From Avant-Garde to Iconic* at the Los Angeles County Museum of Art, Los Angeles, California (November 24, 2013–July 27, 2014).

This exhibition was organized by the Los Angeles County Museum of Art, in cooperation with the Calder Foundation, New York.

Sponsored by:

Additional support was provided by LACMA's Art Museum Council and Phillips.

Publication support by Lloyd and Margit Cotsen.

Exhibition Itinerary
Los Angeles County Museum of Art
November 24, 2013–July 27, 2014

Peabody Essex Museum, Salem, MA
September 6, 2014–January 4, 2015

Co-published by the Los Angeles County
Museum of Art
5905 Wilshire Boulevard
Los Angeles, California 90036
(323) 857-6000
www.lacma.org

For LACMA
Head of Publications: Lisa Gabrielle Mark
Editor: Jennifer MacNair Stitt
Senior Rights and Reproductions Associate:
Dawson Weber
Creative Director: Lorraine Wild
Art Director: Stuart Smith
Indexer: Kathleen Preciado

For DelMonico Books/Prestel
Production Manager: Karen Farquhar

Separator: GHP, West Haven, Connecticut
Printing: Midas Printing Group, Hong Kong

This book is typeset in Sentinel

Published in 2013 by Los Angeles County Museum of Art and DelMonico Books, an imprint of Prestel Publishing

Prestel, a member of Verlagsgruppe Random House GmbH

Prestel Verlag
Neumarkter Strasse 28
81673 Munich
Germany
Tel.: +49 (0)89 41 36 0
Fax: +49 (0)89 41 36 23 35

Prestel Publishing Ltd.
14–17 Wells Street
London W1T 3PD
Tel: +44 20 7323 5004
Fax: +44 20 7323 0271

Prestel Publishing
900 Broadway, Suite 603
New York, NY 10003
Tel.: +1 212 995 2720
Fax: +1 212 995 2733
E-mail: sales@prestel-usa.com

www.prestel.com

Library of Congress Cataloging-in-Publication Data

Calder and abstraction : from avant-garde to iconic / co-edited by Stephanie Barron and Lisa Gabrielle Mark ; with essays by Stephanie Barron, Ilene Susan Fort, Aleca Le Blanc, Jed Perl, Harriet F. Senie ; exhibition organized by Stephanie Barron. — First [edition].
 pages cm
 Summary: "Published in conjunction with the exhibition Calder and Abstraction: From Avant–Garde to Iconic at the Los Angeles County Museum of Art, Los Angeles, California (November 24, 2013 - July 27, 2014). This exhibition is organized by the Los Angeles County Museum of Art, in cooperation with the Calder Foundation, New York"—Provided by publisher.
 ISBN 978-3-7913-5309-8 (hardback)
 1. Calder, Alexander, 1898-1976--Exhibitions. 2. Sculpture, Abstract--United States--Exhibitions. I. Barron, Stephanie, 1950- editor of compilation. II. Mark, Lisa Gabrielle, editor of compilation. III. Calder, Alexander, 1898-1976. Sculptures. Selections. IV. Los Angeles County Museum of Art.
 NB237.C28A4 2013
 730.92--dc23
 2013024299

ISBN 978-3-7913-5309-8

Printed and bound in China.

front cover | Alexander Calder, *Red Disc*, 1947;
81 × 78 inches

p. 2 | Alexander Calder, *Gibraltar*, 1936;
51⅞ × 24¼ × 11⅜ inches

p. 4 | Alexander Calder, *Snow Flurry*, 1948;
73 × 81 inches

back cover | Alexander Calder and ironworker Chippy Ieronimo overseeing the installation of *Three Quintains (Hello Girls)*, 1964